Perceptions and Evocations:
The Art of
ELIHU VEDDER

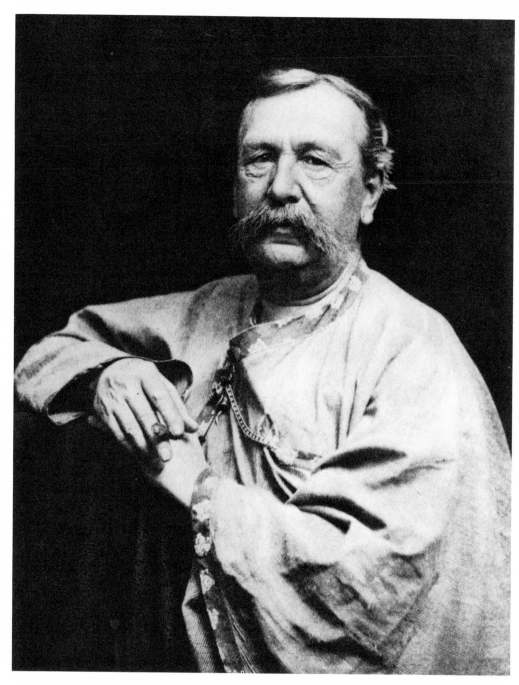

Perceptions and Evocations:
The Art of
ELIHU VEDDER

WITH AN INTRODUCTION BY

REGINA SORIA

AND ESSAYS BY

JOSHUA C. TAYLOR

JANE DILLENBERGER

RICHARD MURRAY

PUBLISHED FOR THE

NATIONAL COLLECTION OF FINE ARTS

BY THE

SMITHSONIAN INSTITUTION PRESS

WASHINGTON, D. C.

1979

Published on the occasion of an exhibition at the

NATIONAL COLLECTION OF FINE ARTS

SMITHSONIAN INSTITUTION

Washington, D. C.

October 13, 1978—February 4, 1979

and

THE BROOKLYN MUSEUM

New York

April 28—July 9, 1979

LIBRARY OF CONGRESS CATALOGING IN PUBLICATION DATA

Vedder, Elihu, 1836-1923.
 Perceptions and evocations.
 "Published in conjunction with an exhibition at the National Collection of Fine Arts, Smithsonian Institution, October 13, 1978-February 4, 1979 and the Brooklyn Museum, New York, April 28-July 9, 1979."
 1. Vedder, Elihu, 1836-1923—Exhibitions. I. Taylor, Joshua Charles, 1917- II. Dillenberger, Jane. III. Murray, Richard, 1942- IV. Smithsonian Institution. National Collection of Fine Arts. V. Brooklyn Institute of Arts and Sciences. Museum. VI. Title.
N6537.V43A4 1978 709'.2'4 78-9915

ISBN 0-87474-902-6
ISBN 0-87474-903-4 (pbk)

COVER:

Detail from *The Cup of Death* (fig. 137).

FRONTISPIECE:

Elihu Vedder. From *The Digressions of V.*

Designer: Gerard A. Valerio, Bookmark Studio

Editors: Carroll S. Clark, NCFA; Louise Heskett, SI Press

Contents

Foreword

The career of Elihu Vedder, who was born in New York City in 1836 and died in Rome, Italy, in 1923, spanned some sixty-five years. He began to paint when Courbet was a name to enflame the young and raise the hackles of critics, and died when Cubism had already become academic. His work related to neither. Although he was quite aware of the various art currents of his time, he was far too concerned with his own perceptions, dreams, and inventions to stay long with any particular vogue. Living most of his life in Italy, Vedder was in many ways a truly expatriate artist; he realized early that art itself provided a homeland and to it he was a loyal citizen. For him, Italy was the closest approximation of that land to be found on earth.

Vedder has been remembered for several different accomplishments but rarely as a unified artistic personality. His extraordinary illustrations to accompany Omar Khayyám's *Rubáiyát*, published in 1884, are an early and persuasive lesson in the compelling, evocative powers of a decorative style. His disarmingly simple, richly colored glimpses of the Italian landscape, however, celebrate the pleasures of direct perception. His work seems to be rooted firmly in two opposing traditions, each revolutionary in its way in the nineteenth century. Yet probably the most revolutionary aspect of Vedder was his refusal to take sides, to admit that the perceptual and the visionary were at odds with each other. As he said of himself, he could never have lived wholly in the intense visionary world of Blake, although he looked upon the pines of Bordighera and the Umbrian hills as visual poetry.

To this was added his belief in the artist as maker. Unlike many of the American contemporaries of his youth, he was at no time willing to give up control over the artistic fabric in an effort to lose himself in the appearance of nature. He believed in the artist's obligation to fabricate an object, either visual or verbal, that spoke directly to the mind, not something that pretended to be what it was not. So he built his mosaics of colored paint that conjure up the brilliance of the luminous Italian landscape, he evoked the pageantry of the Renaissance in jewellike panels, or he turned and twisted lines in an irresistible, expressive dance that brought walls alive or hauntingly spoke of man and his

fate. When he no longer felt the urge to paint he turned to words, which he put together with the same creative care as he had color and line.

Seen thus as a creator of poetic objects, Vedder ceases to be the puzzle his various media of expression imply. In fact, there is remarkable consistency in Vedder's approach to the dual worlds of vision and imagination from the earliest works to the last. His point of view did not change—although his sense of values matured. Rather, the wide range of experiences that he encountered were modified as they were examined in terms of his duality of interest. The process of creation was a means for testing and understanding the ramifications for eye and mind of each new idea, perception, or doctrinaire thought.

All of this self-awareness and probing, however, was hidden under a disarming manner that emphasized the trivial and boasted of a casual amiability. Vedder was a sociable man and enjoyed good food, good liquor, and good friends. He was a lively companion and accomplished storyteller. He was saved, he said, by his sense of humor from being trapped by his dreams. Yet the dreams were always there as was an undeniable sense of loneliness, the private moorings of a reluctantly modern man.

The present volume is published on the occasion of the first really comprehensive exhibition of Vedder's works to be held since 1937. At that time, the American Academy of Arts and Letters presented a large exhibition commemorating the centennary of Vedder's birth. In 1955, the academy distributed many small works and studies, the bequest of Anita Vedder, to museums and libraries throughout the country, but many of them were not shown and some are no longer traceable. The discovery of Vedder's letters, documents, and small drawings and paintings by Regina Soria in 1957, described by Dr. Soria in the introduction, added vastly to the knowledge of Vedder's work. Some few of these works were shown throughout the country between 1966 and 1968 by the Smithsonian Institution Traveling Exhibition Service in an exhibition organized by Dr. Soria. Many more are reproduced here for the first time.

Because of Dr. Soria's extensive catalogue raisonné published with her biography of Vedder in 1970, *Elihu Vedder, American Visionary Artist in Rome (1836-1923)*, we have not included a catalogue in this publication. The catalogue number from Soria's volume is given in the captions of works reproduced following the letter "S"; if no number is included the work does not appear in her catalogue.

Jane Dillenberger has been responsible for assembling the many works by Vedder for this publication and the exhibition that occasioned it, and traveled throughout the country to locate and study a great number of paintings and drawings, most of which have not been shown in many years. In assembling the material, we have had the help and cooperation of many institutions and indi-

viduals. Especially helpful in all aspects of the preparation were Mr. and Mrs. Lawrence Fleischman and Mr. and Mrs. Harold O. Love, who made their extensive Vedder material available. We are grateful to, among others, Lee Anderson, Mrs. John G. Booton, Mrs. John Breck, Mrs. Julian Ganz, Jr., Mrs. Francis T. Henderson, Edgar P. Richardson, Philip V. Rogers, Robert C. Vose, Jr., and Graham Williford. Our particular thanks go also to Mark S. Davis, The Century Association; Linda Ferber, The Brooklyn Museum; and Hortense Zera, American Academy and Institute of Arts and Letters.

JOSHUA C. TAYLOR

Director, National Collection of Fine Arts

Perceptions and Evocations:
The Art of
ELIHU VEDDER

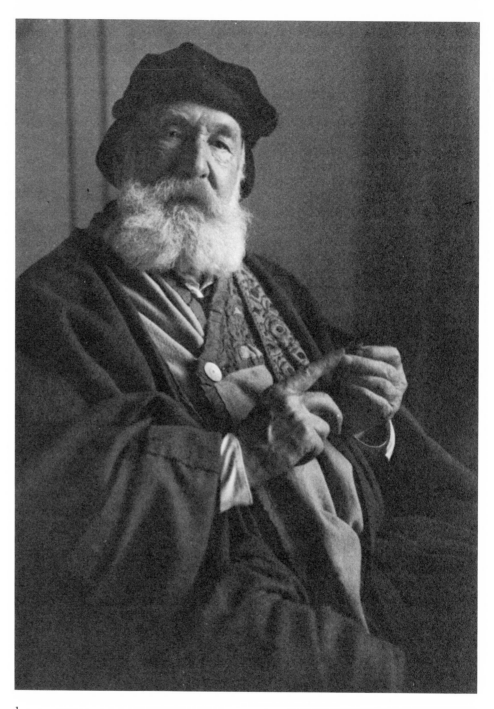

1.
Elihu Vedder at about eighty years of age.

Introduction

REGINA SORIA

A DISCOVERY

For twenty years now I have been living with Elihu Vedder. I became acquainted with him in 1957, exactly one hundred years after he arrived in Rome for the first time, barely twenty-one years old. After his marriage, he settled in Rome near the Piazza di Spagna and lived there for over fifty years. And there the vast hoard of his drawings and correspondence remained until I came along.

Since Vedder's death in 1923 the *fond d'atelier* of this American painter in Rome had been sitting in trunks in an apartment above the Caffè Greco. The fact that nobody had ever asked about it or inquired from Vedder's daughter, Anita, who lived at the family residences in Rome and Capri until 1954, speaks volumes regarding the lack of interest in the interrelations between nineteenth-century American art and Italy. Fortunately, through the efforts of E. P. Richardson, the Vedder papers have since been acquired for the Archives of American Art and the *fond d'atelier* drawings and sketches bought by Lawrence A. Fleischman and Harold O. Love. It was not until 1970, however, that I found a publisher for my life of Vedder and catalogue raisonné of his works. In recent years some of his works were exhibited by the Smithsonian Institution Traveling Exhibition Service, and now, thanks to Joshua C. Taylor of the National Collection of Fine Arts, twenty years after the discovery of the papers and drawings Vedder is finally being given a major exhibition.

In 1957 I began research on the nineteenth-century American artists in Rome. I had often wondered at the fate of these artists, who had roamed the hills around the city sketching those so very "paintable" views and making quite a decent living by selling them to their fellow Americans. Twenty years ago only a few of these painters had resisted the erosion of time, and even these few had not escaped being labeled "expatriate"—perhaps a way of suggesting that they were mildly un-American for preferring the Roman campagna to the western prairies, Tivoli's waterfalls to Niagara. In comparison, their German, French, English, Swiss, Spanish, and Scandinavian artist brothers were never

thought less faithful to their own homelands for having painted the Roman sky. Their works, lovingly collected by national art associations, were shown in Rome with increasing frequency and were donated to the Museo di Roma, eager proof that the artists had fallen under the spell of the Eternal City and were inspired by it. Roman streets were named after the more famous, and memorial tablets informed the passersby where their studios had been located. Not expatriates, these painters, but pilgrims. Not victims of an alien spell, but citizens of that true democracy of art that knows no barriers of time, language, or school. They found in Rome the eternal fountainhead of inspiration without giving up one iota of their national make-up.

I kept adding names, places, and works to my list of American artists in Rome, and the list almost daily became longer and longer. One day the merest of acquaintances asked me, quite diffidently, "I guess you would not be interested in a certain Elihu Vedder." "Why, of course," I answered, "he is about the last on my list." I was told that when I was ready to consider Vedder I should go to Via Condotti and call on the family living in the apartment just above the Caffè Greco. They were the Vedder heirs, and they welcomed me, offering to let me go through the whole *fond d'atelier*. I was the only person from the United States who had inquired of them about Vedder since the Second World War. The bulk of the Vedder material was kept in the country and I was invited to go and inspect it.

So in July 1958 I made my way to the remotest village in the Sabine Mountains, at the time known only for having been the last stronghold of the famed bandit Gasparone, and mentioned, in a literary way, only by that Rome-born American expert of Roman surroundings, F. Marion Crawford. It turned out to be a mere hamlet with a harsh-sounding name, set on a sprawling barren plateau completely separate in vegetation and mood from the rest of that region. A lunar landscape, as improbable and unreal as the background of Vedder's *The Lost Mind*.

On each side of the narrow road, deserted but for the waves of sheep, there were thick walls and grimly locked gates that seemed to lead nowhere. As we approached the post office, which used to be Gasparone's headquarters, the feeling of unreality was magnified by swarms of bearded Galileans and helmeted Romans carrying spears and shields. They were coming back from the mob scenes in *Ben Hur*, which was being filmed there.

The modern ranch house at which we stopped, however, was surrounded by grass as green as that of any self-respecting American suburb. The delightful octogenarian and her charming daughter who so graciously asked us in spoke English as perfectly as they did Italian. Dora Bretschneider and Nadia Bretschneider Tomassi were the Vedders' last and staunchest friends. Nadia had nursed Vedder's daughter Anita through her last illness and at Anita's death in 1954 became her literary and artistic executor.

Vedder's work was all over the house: in the living room was the cabinet he had designed and decorated with intricate geometrical designs carved with a penknife, an onyx cameo ring with the *Fortune*, one of his "firebacks" in front of the fireplace, silver candleholders. The cabinet held folder after folder of sketches, including the first *Jane Jackson* (the old black woman who was the original of his many versions of the *Sibyl*), the sketches for *Enoch Arden*, drawings related to the *Rubáiyát*, sketches for his autobiographical *The Digressions of V.*, and all those tiny ones—notations from his walking trips in Umbria and the Roman campagna and on the beaches, and many that nobody had seen before, done in his old age. Then there were folders of what Vedder called his "fads," such as his drawings of mushrooms. At lunch we ate off dishes he had designed for his villa at Capri, Torre Quattro Venti. Lovely and seldom used, they were brought out for me. There was no doubt that Vedder had not only artistic genius but also the mechanical dexterity and inventiveness that seeks expression in crafts and gadgets, which also was one of the characteristics of artists in the youthful exuberance of early American art, as it was of artists in the early Italian Renaissance.

Then the letters were brought out, a trunk full of them. One packet caught my attention; in Vedder's own handwriting the label read "Summer 1907." Fifty years and more ago, in a summer as hot as the one we were then experiencing, Vedder had gone over the same hundreds of letters I was examining as he was writing his *Digressions of V.* Packets and packets of letters. The handwriting on other packets was that of Carrie Vedder, the artist's extraordinary wife. She had got them together, in many instances bringing them back from the United States, undoubtedly to help her husband write his autobiography.

Perversely, in that summer of 1907 he had preferred to "digress" to his heart's content, leaving the pleasurable task of writing his life to someone else. In a penciled notation at the end of the *Digressions*—which ends abruptly at the death in 1909 of Carrie, his "little girl"—he had noted later, when past eighty, "there is enough material left for another book." Strangely enough no one undertook the task of writing it, although several people must have tried at least to identify the many correspondents whose names were on the packets, among them Charles Caryl Coleman, George Yewell, William Blake Richmond, Mrs. Herman Melville, and William Dean Howells.

As if led by Carrie's ghost and that of Anita, I set about writing the story of the Vedders. When it was finished I realized that this was not all. Still needed to complete it was a catalogue raisonné of the enormous number of works by a man who had been called "lazy" and accused of having produced too little. Writing the life was easy and pleasurable. The real work came in writing the catalogue. With the invaluable aid of Carrie Vedder's studio book and her running commentaries to her mother in Glens Falls on her husband's activities, the many folders of drawings, and the piles of sketches, catalogues, and clip-

pings, the catalogue took form. Nadia Tomassi, herself the wife of a painter, also gave immeasurable help regarding remembered friends and possible patrons, and brought light to scores of problems. With the catalogue, not definitive but complete enough to afford an overall appreciation of the various phases of Elihu Vedder's activity, the place he occupied in American art could now more easily be assessed.

Vedder enjoyed great popularity in his lifetime. Like so many of his contemporaries, however—George Frederick Watts, William Blake Richmond, Frederick Leighton, Lawrence Alma-Tadema—he outlived his fame and was almost forgotten by the time of his death. Moreover, his reputation seems to have been limited largely to his native country. In Italy, in the Rome where he lived for over sixty years, he seems to have had little public following. After his death, on the occasion of the *Seconda Biennale Romana*, an international exhibition, a one-man show of his works was held in the spring of 1923. Diego Angeli, connected with the Rossetti family of Pre-Raphaelite fame, author of *Le Cronache del "Caffè Greco,"* and surely one of the most knowledgeable Italian art critics of the time, wrote, "Elia Vedder was one of the most thoughtful painters." He compared Vedder's paintings to certain compositions of Albrecht Dürer in which each detail has a deep meaning, but he could not help adding a sensational note advising his readers that Vedder had led such a dissipated life in his youth that his relatives had sent him to Europe to recover his health. Given the variety of Vedder's inspiration, evidently, it was impossible for Angeli to believe that Vedder, who was happily married for forty years to the same woman, had led quite a respectable life.

The exhibition organized three months after his death was the only one-man show Vedder ever had in Rome. True, he exhibited extensively in Rome's "First International Exhibition" in 1911, appeared at the "In Arte Libertas" exhibitions in the 1880s, and at the second "Biennale" in Venice in 1897; also he belonged to the Golden Club founded by Nino Costa in Rome in the early 1870s. Yet after his death he seemed so little known in Rome that in the 1932 "Mostra di Roma nell'Ottocento" neither he nor, for that matter, any American except Julian Story was included. Even in 1978, the important book *I pittori dell'immaginario, Arte e rivoluzione psicologica* by Giuliano Briganti (Milan, 1977) does not mention his name, nor those of Washington Allston or Albert Pinkham Ryder.

One might infer that, besides the general cloak of obscurity under which nineteenth-century American artists in Rome have been kept, Vedder was a *grand isolé*; that his dichotomy as painter of nature and painter of visionary and religious subjects was something quite unique and for this reason difficult to classify and that, therefore, he was largely ignored. But we can now safely say that far from being a *grand isolé*, Vedder was in the mainstream of nineteenth-century art and, far from being a leftover from an academic tradi-

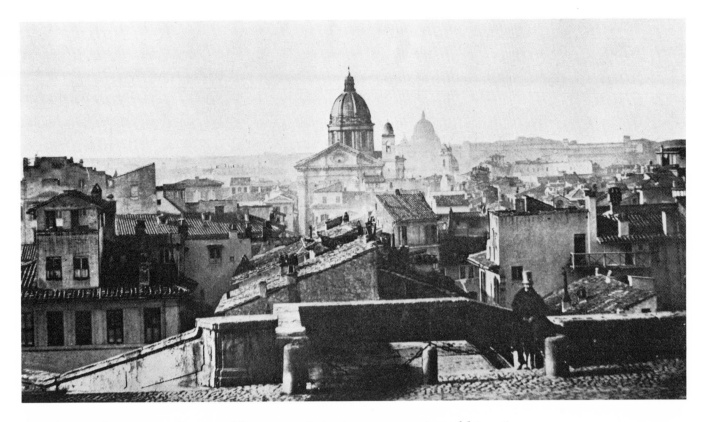

tion dead and overcome, he was, like many of the important artists of his time, instrumental in making the transition from the past to the twentieth century with its surrealism, futurism, and metaphysical and abstract art.

Vedder was always an American and, what is more, a Dutch American, with that mechanical dexterity so characteristic of nineteenth-century American artists. It is impossible, however, to understand his artistic achievement without reference to the art of his time in Rome, then still the most international city with respect to art.

2.
View of Rome from the Trinità dei Monti, circa 1850.

ROME WAS HIS WORKSHOP

The Rome in which Vedder was so confident he would make his fortune was contained in that small section that extends from the Piazza del Popolo to the Quirinale, limited on one side by the Tiber and on the other by the then great open spaces of the Ludovisi Villa, stretching behind the Pincian Hill. Since Renaissance times the popes had encouraged foreign artists to settle in the area between the Spanish Steps and Piazza del Popolo, and especially in the Via Margutta, the Via del Babunio, and the nearby streets. When a vogue for the Grand Tour spread among wealthy young Englishmen they, too, sought lodgings in this same neighborhood, which was considered the healthiest in Rome. With the passion for Claude Lorrain and Salvator Rosa at its peak at

the end of the eighteenth century and the beginning of the nineteenth, apartments on the Pincian Hill, where they are said to have painted, became the favorite address of artists who felt that by gazing at the same view they might hope to equal their eminent predecessors.

Under Napoleon, the French Academy in Rome, which had formerly been located on the Corso, was moved to the Villa Medici on the Pincio, and a few years later the Pincian Terrace with its lovely walk from Trinità dei Monti at the top of the Spanish Steps was opened. The section rapidly became the most fashionable and not only among artists, but also among wealthy wintering foreigners.

Vedder came to Rome in December 1866. It was his second visit to Europe; earlier he had visited Paris and had spent three years painting in Florence. This time, after a year in Paris during which he spent an eventful summer with William Morris Hunt painting in Brittany, he met Elizabeth Caroline Rosekrans, a twenty-one-year-old student from Glens Falls, New York, to whom he became engaged. With his fiancée Carrie, his friend and fellow artist Charles Caryl Coleman, and Coleman's mother, he stopped at Bordighera on the way to Rome and painted some of his most brilliant landscapes.

Settling in Rome, he found the American artists grouped in a well-defined social hierarchy. The permanent residents were headed by William Wetmore Story, the "dean" of American artists in Rome, a sculptor, poet, and man of many accomplishments. If his once immensely successful statues are today less admired, his *Roba di Roma* has earned him a secure place as a recorder of Rome's past. He lived in a superb apartment in the Barberini Palace and had his studio in Piazza Barberini, a sculptor's location since A. Bertel Thorwaldsen's time. Later Story built a studio at the Macao near the Termini Station in the "new" section of Rome.

In the Barberini Palace also lived John Rollin Tilton, a well-known and well-paid landscape painter. Vedder despised him and ironically dubbed him "the Tintoretto of Rome," but at Tilton's death he did not hestitate to occupy his studio in the Via San Basilio.

There were still in Rome some of the "first generation of expatriates," as Henry James called them: John Gadsby Chapman, who trained two sons in his art; James Edward Freeman, who arrived in the thirties; and Luther Terry, who married Louisa Ward, the widow of sculptor Thomas G. Crawford, and raised Crawford's children. Other sojourners, F. Marion Crawford, John Singer Sargent, and Edith Jones Wharton, would prove that Roman influences early in life could lead to extremely successful careers in the creative arts.

Vedder and Carrie were married in July 1869 at the home of her parents in Glens Falls. They had already decided to settle "temporarily" in Rome, a city to which political events encouraged the flow of artists as well as prospective patrons. During the winter of 1869-70, because of Vatican Council I,

the Roman season was indeed particularly brilliant. In the years 1870-71, the Franco-Prussian War and the siege of Paris brought most foreign travelers to Rome instead of to Paris. True, the year 1870 was a crucial one for the Kingdom of Italy, now less than ten years old. Three wars of independence – 1848, 1859, 1866 – had united the Italians into one state. Although many Italians would have preferred a republic, world diplomacy and society's preferences led to a less innovative form of government, that of a monarchy under the centuries-old House of Savoy.

For the sake of national unity the capital had been moved from Turin, capital of the Kingdom of Sardinia, to Florence. The Italians, however, wanted Rome, which was still under the pope, to be the capital. After an unsuccessful attempt by Garibaldi and his Red Shirts to take the city in 1867, the big moment for adding Rome to united Italy came in 1870, while France was occupied with fighting Prussia. The Italian "bersaglieri" entered Rome by breaching the Porta Pia on September 20, 1870. The conquest of Rome brought about, as one result, the return to Rome of Nino Costa and the forming of a congenial group of artists, of whom Vedder was a member.

On the whole one cannot say that political events, which so much affected the lives of the Italian artists with whom Vedder associated, had any particular effect on Vedder himself. As he always assured his father, he was and intended to remain a loyal American, a faithful believer in the American republic. If chasing the Grand Duke from Florence had been an exciting event in which he had participated because of the enthusiasm of his *Macchiaioli* friends, Garibaldi's unsuccessful attempt to seize Rome in 1867 was, as Vedder wrote to his father, an interruption to his work. Most American artists in Rome held the same attitude during the struggle for Italian independence, but not all. William Story was in Rome during much of the siege of 1849, when the Roman republic was defended by Mazzini and Garibaldi against the French troops that came to reinstate Pope Pius IX to his temporal throne. The Storys left, but Margaret Fuller remained and ran the Hospital Fatebenefratelli under the direction of Princess Belgioioso, who is revealed as a woman of deep charm and intelligence in Ingres's portrait. In 1849 the United States chargé d'affaires, Lewis Cass, attempted to protect republicans and "papalini" equally. American Consul William James Stillman's liberal views made him persona non grata in the 1860s and he had to give up residence in the Papal States. In 1870 David Maitland Armstrong flew his country's flag from the window of the American consulate and was among the first to welcome the new government. Both Stillman and Armstrong were artists, as had been James E. Freeman before them, for preference was given to artists and writers for this and other European consular posts during the period. There was no pay, but the benefits of a Roman post to an artist made the appointment both highly desirable and attainable, if one had good political connections. Margaret Fuller had written

of the need for an understanding ambassador once Italy became united and felt quite equal to the task should a woman ever be considered for such a post. The first minister to Italy, however, was George Marsh, not only an excellent diplomat well acquainted with Italy's aspirations but a leading conservationist who attempted to help Italy preserve her forests.

Many American artists came to live in Rome after the Civil War, settling with their young wives to raise their families. Among those closest to Vedder and his bride, Carrie, were David M. Armstrong, William S. Haseltine, Frederic Crowninshield, and Charles C. Coleman—all painters. Vedder had met Coleman in Florence during his first visit and became close friends with him, so much so that their careers ran parallel for the rest of their lives. He also maintained close friendships with the sculptors Randolph Rogers, Franklin Simmons, and Chaucey Bradley Ives—especially with Ives, whose children were brought up with the Vedders'.

Among the visitors to Rome in 1869 was a young man whose introduction to American society there was to provide him with lifelong inspiration. The young man was Henry James, and his *Roderick Hudson* gives a vivid and accurate picture of the artistic atmosphere of American Rome of the time. The novel's Miss Blanche is a lady painter who keeps at her favorite subject, a *contadina* at a wayside shrine. Miss Blanche, who presents a rear view of her subject because she can do backs well but is rather weak on faces, is a delightful satire on amateur artists, possibly on May Alcott. Indeed, one suspects this "first attempt at a novel" by James is a roman à clef filled with characters he might well have met during his first visit to Rome, or his second in 1872. The "singelton" from his novel, described as "a little, quiet, matter of fact, docile painter," could well be poor, unrecognized Cass Griswold, who thrived only in Vedder's shadow and under his constant protection. Vedder made it possible for Griswold to come to Rome in 1872 and he remained there several years, hardly ever selling anything, always in debt, always threatened with being thrown out of his studio by an angry landlady. He was periodically saved by Vedder, and even oftener by William H. Herriman, a J. P. Morgan associate who was the generous patron of all American artists in Rome. Herriman reminds us of Rowland Mallet, another fictive character from *Roderick Hudson*, who "was extremely fond of the arts and had an almost passionate enjoyment of pictures." Like Will Herriman, Mallet was immensely rich and "considered it the work of a good citizen to go abroad . . . purchase valuable specimens of Dutch and Italian schools . . . then present his treasures to an American city . . . in which there prevailed a good deal of fruitless aspiration toward an art museum." There was this difference, however—Herriman liked to purchase the works of recently deceased as well as living artists, especially those of the French school, such as Alexandre Gabriel Décamps, but he also bought a great number of works by American painters, and he enjoyed his magnificent col-

lection himself. At his death his collection went in part to the Metropolitan Museum and in part to the Brooklyn Museum.

As for Roderick Hudson himself, his personality reminds us very much of Vedder's. Like Vedder he had "charm of personal qualities, vivacity of his perceptions, audacity of his imagination, picturesqueness of his phrase," "judged instinctively and passionately but never vulgarly," and had "an instinct of investing every grain of sense or soul in the enterprise of planned production." Without any doubt one could say of Vedder, as James wrote of Roderick Hudson, that his "quick appreciation of every form of artistic beauty" reminded one "of the flexible temperament of those Italian artists of the 16th century who were indifferently painters and sculptors, sonneteers and engineers." Luckily for Vedder, his emotions were in much better control than Hudson's, his Dutch temperament far more accustomed to taking passion and beauty in stride than Hudson's thin-skinned New England conscience would permit.

Roderick Hudson's unfortunate demise is typically Jamesian and has no known counterpart in Roman artist life of that time. Some early deaths occurred, however, among the artists and although nonetheless tragic in bringing to an end brilliant promise, they were caused by illness rather than heartbreak. There was Thomas Hotchkiss, who died of tuberculosis at Taormina in 1869, and William Rinehart, who died in Rome in 1874. In his *Digressions* Vedder devoted some of his best pages to these two friends of his youth.

The Englishwoman Frances Elliot, a long-time resident of Rome and a gossip, stated, "Artists of all nationalities were received everywhere, fêted, entertained and were companions of princes, kings and potentates, when such were here. The most honored guests at the tables of the great, it brought infinite honor to be counted among them. To visit the studios was part of the Maraviglie of Rome which no stranger omitted." Patronage by Queen Victoria, Pope Pius IX, and Lady Ashburton and other aristocrats, which could make an immediate success of Story's *Sybil* or Harriet Hosmer's *Puck*, was one of the advantages of living and working in Italy, where American patrons could also be counted on to visit artists' studios. There were free classes at the French Academy, and other free or inexpensive classes or clubs, such as Gigi's Academy in Via Margutta, were formed on the initiative of the young artists themselves or by others. "Gigi" was Luigi Talarico, a former model who developed a shrewd business sense and capitalized on the burning passion for art shown by foreign artists. He opened an evening school, a club to which amateurs as well as professional artists came. William B. Richmond put it succinctly, "In Rome, art and music determine friendships."

Those who, like David Armstrong, returned after the Civil War were happy to see that "Rome was the Mecca of American Artists and there was a large colony of them, many of whom were successful, as American Art was then the fashion." They also noted with relief, however, that "nothing had

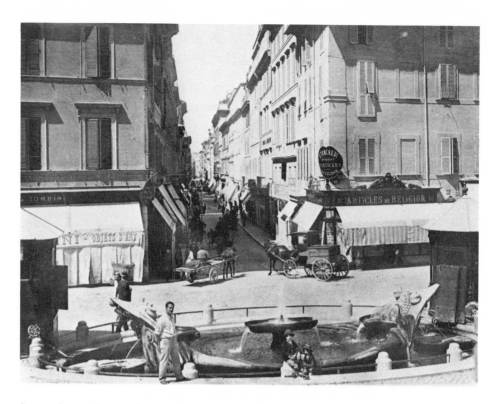

3.
View of Piazza di Spagna, Rome,
circa 1880.

been changed in a thousand years" and that, far from the hustle and bustle of progress, noise, and unrest of other metropolises, Rome was still a soothingly silent city, the place, in James's words, that offered "the aesthetic antidote to the ugliness of the rest of the world." Unchanged since its opening late in the eighteenth century was Il Caffè Greco, "a rendez-vous of congenial spirits," namely of artists of all nationalities who would appear at the café several times a day, first for their morning coffee, then for their mail, and finally for a long evening with their friends.

When old and himself, alas, the dean of American artists in Rome, Vedder wrote in his *Digressions:*

> One day . . . I bought one of the two remaining little tables of the Caffè Greco around which the boys used to sit in the good old days—for they were good old days, in spite of these superior times, and I cherish them; for they are my only inheritance.
>
> The day I bought it they were putting on the door an announcement that the Caffè had been established just one hundred years before. This little table stands by my bedside and I ought to say that I hear the murmur of voices long gone and the merry tales—but I do not. It never says one word; it knows too much.
>
> In the long room way back in the Caffè—"The Omnibus"—the American and English artists used to congregate. This room the modern proprietor has decorated with plaster bas-reliefs, portraits of great men who used to frequent it, some of whom are forgotten already. It was

very foolish, but somehow I imagined that when I left the place youth went with me. I have been there lately, and to my amazement, have found that the whole thing was being enacted over again. I suppose that when the new boys get old and drop off, a new proprietor will put up a new set of bas-reliefs.[1]

Almost invariably there is a mention of the Caffè Greco in the correspondence, the memoirs, the "life" of any artist who visited Rome, and of not a few poets and writers, including Nathaniel Hawthorne, Herman Melville, and Mark Twain; but like Pfaff's in New York, the Caffè Greco has not as yet found its historian to record accurately all the artists who gave it their patronage. Just as uncertain is the chronicle of Via Margutta and of all the artists who had their studios there. Yet it is worthy of being recorded, since so many Americans lived and worked there in the nineteenth century. Via Margutta has been defined as the heart of that "ambiente," or community, which from 1806 included the French Academy and from 1911, the Valle Giulia section with its several foreign academies of art. Although the American Academy, which at first was on the Pincian Hill at Villa Aurora, is now on the Janiculum Hill, it also should be considered, like all these other artistic centers, as an extension of Via Margutta, in the Santa Maria del Popolo parish.

4.
View of Piazza della Trinità dei Monti, circa 1847.

Before 1600 the part of the city adjacent to the Pincian Gate did not extend beyond Capo le Case (*caput domorum* or "end of the houses"). Via Margutta, Via del Bubuino, and all the adjacent little streets did not exist. In an engraving by Livino Cruyl, circa 1675, we see Piazza del Popolo in perspective with its gate, and with all that picturesque crowd so delightful to tourists: the group of women drawing water at the fountain, the water seller, the beggar, the *ricottaro* with his cheese fresh from the country, the oxen drawing a cart. In this engraving Via Margutta is clearly depicted. Artists began to flock to this part of Rome at the end of the sixteenth century, since at that time "outsiders" who established themselves there were granted a tax exemption by the popes on their professional licenses and income. The tax-free zone, in fact, included the Pincian Hill, Via Felice (now Via Sistina) between Trinità dei Monti and Santa Maria Maggiore, and that zone between Via del Babuino, or Paolina, and the Pincian Hill. The privilege was abolished in 1646 by Pope Urban VIII, but by that time the district was fully settled, its buildings were "modern" and desirable, and it grew in popularity with artists and travelers.

The first artists were Dutch, and there is a record of them in 1594. Claude Lorrain lived, it is said, at Trinità dei Monti, and there is a record of his being there in 1625. Poussin's studio from 1624 to 1640 was in Via del Babuino and in 1642 was in the nearby Via San Giacomo, or "della Fontanella." Thus, according to G. J. Hogerneff,[2] whose study on Via Margutta is the only serious one we have, if the "ideal" classical landscape was not exactly born in Via

Margutta, it was born close by, and it certainly had its greatest development there.

Via Margutta seems to have fallen into disuse during the following century. It was very short, in any case, and a great part of it was still occupied by the Giardini Cenci. Owing possibly to the great influx during the eighteenth century of tourists in coaches drawn by horses that had to be fed, the buildings in the narrow streets adjoining il Babuino and il Corso were used as haylofts. Most of these were done away with in the following century, which saw the greatest rebirth of the neighborhood. For Via Margutta, records are not very dependable, or else they have not been fully consulted by historians. It was the custom of artists during the nineteenth century to list their addresses not only with their bankers, Maquay and Hooker, but also in the guidebooks. The first guidebooks, in French and Italian, new editions of which appeared periodically through the years, were Nibby's. In the latter part of the century Murray's guidebooks became available to English-speaking tourists, followed by the celebrated *Walks in Rome* by Augustus Hare, an Englishman born in Rome, and later by Baedeker.

In general, few Americans are mentioned in these guidebooks. Nevertheless, many American artists did have their studios in Via Margutta side by side with Italian artists. At number 33 there were at various times Cesare Fracassini; Enrico Coleman, the great painter of the Roman campagna and son of an Englishman; Onorato Carlandi, a great friend of Vedder's; and the poet-painter Cesare Pascarcella. Occupying the whole first floor at number 53A and B was Achille Vertunni, who had studied at the Naples Academy and had become one of the principal exponents of the Scuola di Portici. In 1857 Vertunni arrived in Rome, where he quickly gained fame with his painting *Pia de'Tolomei*, in which the historical subject is placed in a naturally depicted landscape. Gradually he abandoned historical subjects and devoted himself to landscapes — mainly melancholy views of the Roman campagna represented with subtle luminosity. A precursor of Enrico Coleman in the transparency of shadow and the use of grays and ocher color, Vertunni became one of the most popular, successful, and wealthy artists of his time. He was visited in his studio by artistic celebrities such as Franz von Lenbach, Lord Leighton, Mariano Fortuny, Domenico Morelli, Nino Costa, Richard Wagner, and Franz Liszt. In the notes of American painters of the 1870s, including Vedder's, Vertunni is spoken of with disparagement. One senses a twinge of envy, for this artist had achieved what all painters desired: financial security, a foreign clientele, and a very creditable reputation.

Another artist whose success was looked upon with mixed feelings was Mariano Fortuny, the Spanish painter for whom Italy was a second country and who influenced so many artists of his day. Fortuny came to Rome in 1858. From his Morocco travels he made popular Arab and Spanish genre painting,

5.
Elihu Vedder, 1864.

6.
Elihu Vedder in studio, Rome.

which had a great vogue in his time. Several American painters, including Sargent, seem to have drawn inspiration from his fresh color and free brushwork. During his Paris sojourn he himself was influenced by the tiny history paintings of Meissonnier, and it was during the last phase of his career in the 1870s that his originality found its most impressive development. His followers were said to number in the hundreds and the impact of his innovations was felt by artists up to and including the young Picasso.

After arriving in Rome in 1866, Vedder rented a studio at 33 Via Margutta, in a studio building where many American artists worked at one time or another. A year later, in the winter of 1867-68, he moved up the street to the more modern Studi Patrizi at number 53, where he was able to rent a studio-apartment for three years at $20 a month. His accommodations included two large rooms, an entrance, and a small reception room, all of which he furnished himself. Since one of the two studios was rented for the winter at $6 a month he felt he had a good bargain, for, as he wrote to his father, "I also can store my things when I go home, and let the two rooms respectively for twenty and fifteen dollars. They are only too glad to get these rooms."

The period between 1867 and 1872 was one of Vedder's most fertile for the production of the sketches and ideas that served as the basis for the majority of his most interesting paintings. Augustus Saint-Gaudens affirmed that "Vedder adapted Rome to his individuality, rather than his individuality to Rome." Until the pressing responsibilities imposed by a growing family turned him temporarily away from his artistic search and forced him to do what he called "duty-painting," the landscape and atmosphere of Rome and its environs exerted a direct, stimulating effect on his inspiration.

It was in 1869 that he painted his first *Sibyl*, which David Gray described in a letter dated April 2, 1870, as being the center of attention in his library. "I believe you are the greatest American painter, by odds, and that I shall live to see it recognized in all America," he wrote in appreciation.[3]

Far from being "an artistic desert" in the second half of the nineteenth century as some have maintained, Rome was brimming with vitality and ready to afford the artist a variety of experiences and encounters. As Edwin H. Blashfield put it some years later when he helped to sell such American magnates as J. P. Morgan and W. T. Walters the idea of an American Academy in Rome, the Eternal City "unites within her walls, better than any other town" the ideal environment of "a background sympathetic to the consideration of the greatest art and the place where the best existing examples for study can be made most acceptable to the student."[4] He went on to point out that Rome's centrality to Athens, Cairo, Constantinople, Paris, London, and Madrid "[put] at the service of the student, the Greek Fountainhead of Art, the Roman development of Greek methods, the Byzantine evolution, its succession in oriental and occidental art, the mediaeval and contemporaneous art of

France, the collections of Vienna, Munich, Dresden, London, Madrid." He continued:

> No other world-city is so central to all these capital points as Rome, while Magna Graecia opens away from her very gates, the hills of Etruria may be seen in panorama from the cupola of Saint Peters, and Sicily, distant but sixteen hours journey, offers the remains of three civilizations, Greek, Arab and Norman. It is through the peculiarity of her historic evolution that Rome became and remains the natural art centre. She alone of all cities has twice held the headship of the western world, under the Caesars and under the Popes, and thus has twice received the willing service of the arts of antiquity and of the Renaissance.

It was easy to make one's home in Rome, which was still relatively cheap even when it became the capital of Italy, and occasionally to spend some months in Paris or London and make an almost yearly trip to New York. A number of residents did just that. One could thus keep in touch with the art market, dealers, exhibitions, and art currents while enjoying the advantages of a more leisurely pace of life than that afforded by America, where life appeared too materialistic, too tied to gain.

LONDON CONTACTS

Vedder's first trip to London was during his honeymoon, a wedding present offered by his very practical sister-in-law Rose Sanford. His friendships with Frederick Leighton and William B. Richmond gave him an opportunity to become further acquainted with the Pre-Raphaelite movement, of which he had heard much during his earlier visit to Florence. During the time that he had spent in the United States before his wedding, especially the period he was in Glens Falls, Vedder had given expression to what would seem to be his very own type of imagination. He especially enjoyed making minute, Dutch-like pencil drawings in which he crowded an abundance of detail on to tiny bits of paper. A number of his small drawings, which he used more than once for important works, are still in existence and are discussed by Jane Dillenberger in her essay.

In London Vedder met Pre-Raphaelite artist and writer William Davies, to whom he showed a group of his recent small drawings. There must have been a great deal of conversation between the two men and encouragement on the part of Davies, for he wrote an article on Vedder's drawings meant to be published in a book. The idea of the book had come to Vedder after he had seen the drawings of Simeon Solomon, the unlucky Pre-Raphaelite who was so admired by Oscar Wilde and who had resided in Florence until 1867. Davies, William J. Stillman, who helped to introduce the Pre-Raphaelites to America,

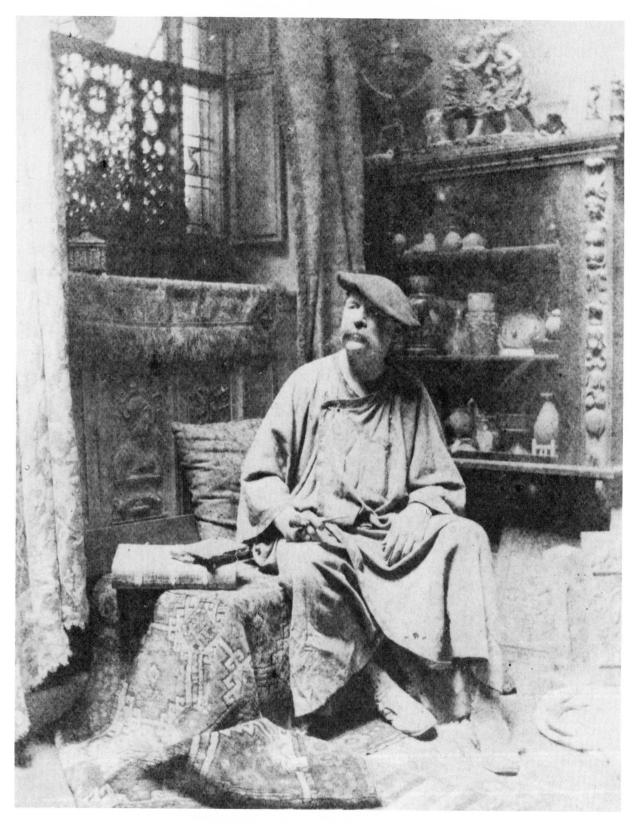

7.
Elihu Vedder in studio, Rome.

and Edwin J. Ellis are among the artists who had a great influence on Vedder, inasmuch as they admired him, encouraged him, and, in the cases of Davies and Stillman, wrote about his art. To them Vedder was willing to confide the hopes that he had centered in these small drawings, each of which was to be evolved into one or more paintings or other work of art and also used to illustrate a story.

One of the drawings was of the Medusa, another was titled *The Soul of the Sunflower*.[5] The Medusa was a subject particularly close to the hearts of the later Pre-Raphaelites. A mixture of perversity and innocence, of good and evil, this symbol of feminine temptation and ruin to man was a cherished subject during the post-Romantic era. Vedder did many versions of the Medusa, one of which appears to be close to a Medusa mosaic discovered in Rome during Vedder's stay—a demonstration, if one were needed, of how the rediscovery of classical works of art (an almost everyday occurrence in Rome) influenced and inspired his work.

Vedder's *Soul of the Sunflower* is another case in point. It will be recalled that one of the best known statues by William Henry Rinehart is his *Clythie*. According to mythology, Clythie was a nymph who fell in love with Apollo, the sun god, was deserted by him, and went nine days without food or drink—keeping always her head turned toward the sun; as consequence of her fidelity, she was changed into a sunflower. This is the classical myth of the metamorphosis or origin of the sunflower, represented in classical times, as can be seen by a cast at the British Museum, by a female figure rising from a sunflower. For his version, Rinehart made a very pleasant classical Venus and put a sunflower in her hand to justify calling her "Clythie."

Characteristically, Vedder was much more personal in his own interpretation of classical mythology. Thus, his first little drawing of *The Soul of the Sunflower* shows a face in the center of swirling rays, as if the sunflower had taken on the very appearance of the sun and its radiance. To accompany the drawing he composed a story, a companion piece to his version of the Medusa legend, in which he explained that in the old days

> *the sun's face could be seen, quite plainly, with his golden hair spread out evenly all around it, so that painters used frequently to paint him just as he was, very red, and back of his head used always to put a great golden disc; and the sculptors used to cut his portrait in white marble, making his hair up into rays, one straight and one waving, all around. . . . Now he shows only the back of his head covered with his glorious hair, and as all the light comes from his hair, it made him so bright that no one could look at him. . . . But in those happy days there was one young Sunflower in love with the Sun . . . but one day a young man kissed her, and for a while she did not look at the Sun. . . . When she remembered him, she turned her head so fast that her neck was broken. . . . The Sun told her she was punished for having been false to him, and gave*

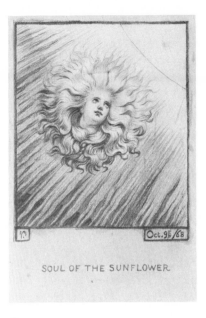

SOUL OF THE SUNFLOWER.

8.
The Soul of the Sunflower, 1868.
The Harold O. Love Family. See also figure 142.

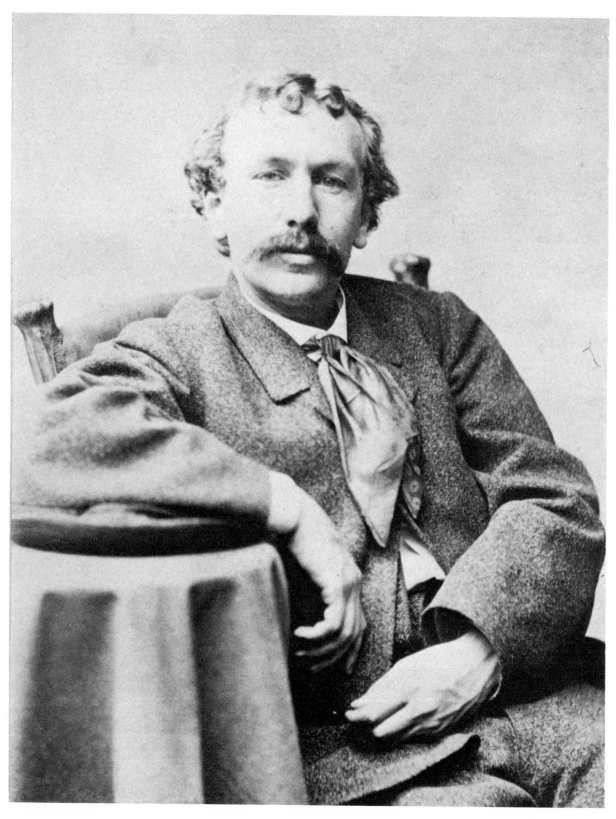

9.
Elihu Vedder, 1879.

her a choice, either become mortal or a comet and wander forever in space, which she chose to become. She wandered for hundreds of years, repenting and loving and gathering wisdom and brightness, until she ventured to circle the Sun and finally he murmured "Sunflower" and the Comet shot across the sky and buried herself in his glowing bosom.[6]

Vedder was in love with his sunflower and made it into a painting, not yet rediscovered, and then, later, into a glorious tile and a fireback.[7] His *Soul of the Chrysanthemum, Heart of the Rose,* and *Morning Glory* reflect its style, which seems an original *avant la lettre* experiment in Art Nouveau.

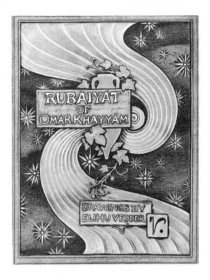

10.
Final study for cover, *The Rubáiyát of Omar Khayyám.* National Collection of Fine Arts.

The early 1870s were years of struggle for Vedder, not because he was looking for a style in which to express his visions but because he was looking for a style that would be marketable. As artists go he was extremely well informed as to the trends of the time, and was stirred to make a name for himself. He was urged on by Kate Field, who wanted him to illustrate Dickens, and by Francis D. Millet, who wanted him to leave the easy Roman life and come to London to paint and sell. There was a constant conflict in Vedder—a dichotomy by no means unique in the history of nineteenth-century painters. His tendency was toward the visionary and toward landscape, yet the market seemed to require antiquarian paintings, such as those done by Leighton and Alma-Tadema.

Possibly this explains the fact that the three figures in his *The Phorcydes,* which were truly—as he himself put it—"weird and horrid" in the tiny drawing of the theme that he had made in the sixties, became rather luscious if repulsive young women in the elaborate version that he painted in 1876 for Mr. and Mrs. Theodore Shillaber. He could not make the subject of his *Cumaean Sibyl* attractive, fortunately, but it was a great wonder when he sold it to Wellesley College in 1880, by which time he had recovered enough nerve to do his *Sphinx of the Seashore.*

Vedder began to paint very much like Frederick Leighton; after all, both had had the same solid academic training in Florence. Leighton had had the great good fortune to have studied with Giuseppe Bezzuoli who, it will be remembered, was a friend of Ingres's. Vedder had studied with the much less renowned Raffaello Bonaiuti, but he saw many of Ingres's works and heard much about him. Vedder's early paintings of women, his *Etruscan Sorceress, Greek Actor's Daughter, Dancing Girl,* and *Girl with a Lute,* suggest Ingres's, in a way. As in works by Ingres, there is the coquetry of the subjects' headdresses and their look of mystery—an expression always morbid and strange, a nostalgic languor, a sorrowful voluptuousness. There is a poetic quality, a deep lyric feeling in Vedder's women, as in his landscapes. The drapings, the costumes, the rich backgrounds were above all what a contemporary of Vedder's termed "the lovely song of a sinuous line, and a perfect rhythm together with a mysterious and passionate accent."

Vedder's conflict between his need to pursue his own artistic interests and

his obligation to paint works that would sell was intensified by the birth of his first child in 1870 while the Vedders were paying another visit to London. Within the next five years three more children (one of whom died in infancy) were born to the Vedders. The artist's increasing financial responsibilities during this period were not eased by his refusal to paint portraits and his unwillingness to exert salesmanship toward possible patrons. The inner distress caused by his conflict became anguish in 1875 when his first-born, Philip—his adored "Pillichino"—died. After the death of Philip, Vedder fell into a terrible depression—one of those "moods," as he called them, which from then on periodically seized him.

In 1876 Vedder sent to London his *Cumaean Sibyl,* which was refused by the Royal Academy. He was then encouraged to go to London with Coleman and the devoted Davies. There he visited Alma-Tadema, John Everett Millais, and others of Davies's friends. Another of his admirers and sponsors in England was Amelia Edwards, writer and newspaperwoman. His good friends Frank D. Millet and Kate Fields were also in London, and his spirits revived. In 1878 the adverse criticism meted out to him at the Paris International Exhibition finally provided the impetus he needed to break away. In the wake of publicity over the criticism, the indignant responses to it from his loyal artist friends, and his own widely circulated "artist's protest," he decided to depart for America.

Vedder arrived in New York City in November 1879 for his first visit to his native country in ten years. An exhibition of his paintings in Boston the following year was a great success and launched him into two decades of relative prosperity and moral satisfaction. Although he returned to Rome some months later, he was to spend long periods in the United States during the 1880s and make almost yearly visits there during the 1890s.

THE LATER YEARS

As is well known, artists in America often became prosperous through means other than their art. Like Mark Twain, Vedder in the very early 1880s attempted various "inventions" and even sold one of them to Tiffany; his tiles and firebacks proved too costly to be continued, but are things of beauty. His illustrations for an edition of *The Rubáiyát of Omar Khayyám* in the translation by Edward Fitzgerald was an undertaking that struck gold, for its publication in 1884 assured him of the fame he had always desired.

The 1880s and 1890s in America proved to be a very congenial climate for Vedder. Although he had never been to college he had a native refinement and had acquired a deep culture during his long stay in Europe, where he had consorted with members of the intellectual world—American, English, Italian, French, and Spanish. He easily fitted into the world of the Century Club, the Tile Club, the Players Club, the literary circles centered around *The Century*

and *Harper's*, and the other artistic, theatrical, and literary groups and activities that formed an important, if not the most important, part of the intellectual life of New York.

Vedder's Italian experience and his acquaintance in Rome with the great actors Salvini and Ristori, together with his gift for storytelling, made him an extremely popular after-dinner speaker. Although Vedder was sometimes beset with moods of doubt and despair, his great joviality when he was among his friends and his delight in feminine companionship place him squarely with the best known bon vivants of the time, Augustus Saint-Gaudens and Stanford White. The vogue for Renaissance palaces and luxurious decorations caused Vedder to be very much sought after by White, Charles F. McKim, W. Rutherford Meade, and other architects. His murals, as Richard Murray points out in his essay on Vedder's decorative art, proved to be the most appropriate of any of the time to the style of architecture they were meant to decorate.

The fact that he did not live in America seemed to Vedder to be a tremendous handicap, as he wrote from New York to his faithful friend William Graham, then in Buffalo, in a letter dated January 12, 1900.

> *I did not contemplate coming over just now, counting on my London Exhibition. That was a flat failure and I think something gave way in my heart—for I have never felt the same since. Of course I must not say so, and with my nature it makes things worse. The position is simply this, I cannot live in Rome and cannot afford to move over and live here, except on condition of the banishment of Carrie and Anita to the country.*

Graham, the old philosopher, calmly replied on January 13, 1900:

> *It was evident to everybody that if you had stayed in New York years ago when you made the new title page for* Harper's *[evidently he meant* Century*] and one or two drawings, that you would be a power in New York if you did settle down there. You did not settle down there and I am the last one to criticize you on that point, deeming your comfortable home in Rome and your position there a fair equivalent for all the money or local standing you might have in the States. So you may imagine my surprise to have you now speaking so despondently of Rome. I don't understand the horn of the dilemma.... About London, there was no great cause for wonder. You were not fresh in their minds; if you had repeated your shows there, the London public would have acquired the habit [of seeing your things].... So many American artists are settled there ... a few years earlier you would have had a different story to tell.*[8]

At the time it had seemed certain Vedder would receive a commission to decorate at least one room of the Baltimore Court House should he wish to do so, but he was not inclined to accept a modicum for his work. As had hap-

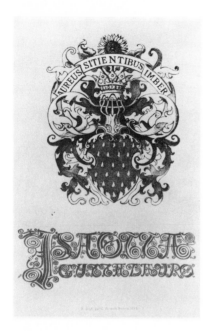

11.
Giuseppe Cellini (1866-1940),
design for cover of *l'Isaotta
Guttadauro.*

pened before "he was always the last to be asked," and in this case only if John
LaFarge declined to do the work, which he did not. Vedder was given some important commissions for murals, however, which he executed in Rome, where
in the studio formerly held by Mariano Fortuny off the Piazza del Popolo he
had all the necessary facilities. Yet, when the American church of Saint Paul's
Within the Walls in Rome had its interior walls decorated, it was Edward C.
Burne-Jones, called from England, who was commissioned for the work rather
than Vedder. Vedder was a vestryman of this American Episcopal church, the
first Protestant church built within the walls of Rome—a symbol of the religious tolerance of the new Italian state. Enoch, Vedder's youngest child, was
the first baby to be baptized there. It may be that Vedder was not asked simply
because he was out of town or busy with commissions at the time. An oil
sketch just come to light in Rome, however, shows that Vedder did have at
least an idea of what he would have done to that wall just above the entrance.
Had he received or accepted the commission, his name would have become
better known in Rome and his fame less obscure.

Looking back at art in Rome in the last two decades of the nineteenth
century, the keynote is a Pre-Raphaelitism of a distinct Anglo-Saxon brand—
that of Rossetti and Burne-Jones, not at all the chaste style associated with the
Nazarene or Purism movement that had dominated the earlier part of the century. The artistic climate in Rome has been defined as Byzantine, that is to say,
eclectic, postclassical, but still with many classical elements. Its prophet was
the young poet Gabriele D'Annunzio, and among its artists were some of
Vedder's acquaintances, including his old friend Vincenzo Cabianca, as well as
Onorato Carlandi, Adolfo De Bosis, and Giulio Aristide Sartorio. The later
English Pre-Raphaelites were "discovered" by the Roman public in the "In
Arte Libertas" exhibition of 1890, the first of their exhibitions to be held at the
Palazzo delle Esposizioni in Via Nazionale. The society In Arte Libertas was
founded in 1885 by Nino Costa; Vedder and Coleman were counted among the
group.

In the same year as the first "In Arte Libertas" exhibition, 1886, a major
publication appeared in Rome, *l'Isaotta Guttadauro,* a poem by D'Annunzio
illustrated by many of the leading Roman artists. An examination of this volume reveals the great affinity between its drawings and those of Vedder's
Rubáiyát, published two years earlier. Animators of the project were Angelo
Conti who, influenced by John Ruskin and the Pre-Raphaelites, was led back to
the Italian Quattrocento, and Mario de Maria, who lived for many years in
Paris, studied in Germany and England, and arrived in Rome in 1880. Through
his friendship with Vincenzo Cabianca, de Maria participated in the In Arte
Libertas society and its exhibitions. Like Vedder's, his training was academic
but his goal was romantic and, as with Vedder, this brought him to the creation
of symbolic visionary, somber, and weird pictures. Older than Conti and de

Maria, Vincenzo Cabianca [9] was born in 1827, nine years before Vedder. Vedder had known him and worked with him among the *Macchiaioli* in Florence. Cabianca's training closely resembles Vedder's, as do the subjects and techniques of his landscapes.

In the 1880s Cabianca's imagination ran to swans, but serpents in their spiral coils were very present in the works of Giuseppe Cellini, a younger artist born in Rome in 1885, who knew Vedder and was undoubtedly influenced by him. Cellini lived until 1940, and his son, Pico, also an artist, is still living and recalls Vedder well.

Another artist who participated in the D'Annunzio venture and was a friend of Vedder's was Giulio Aristide Sartorio, who discovered the works of Jean-François Millet and Jean-Baptiste Camille Corot later in the 1880s in Paris and thus realized his affinity to Nino Costa and Vedder, by whom he was influenced. Another, Onorato Carlandi, was a dear friend of Vedder's and visited him often at Capri. Carlandi studied with Domenico Morelli in Naples, was a follower of Garibaldi's, and from 1880 on went almost yearly to London where he exhibited frequently, as he did also in Berlin, Brussels, and Munich.

To conclude the story of the D'Annunzio book, Cellini designed the cover with an elaborate coat-of-arms of Renaissance flavor surmounted by a sunflower, and with the title lettered in a florid, decorative medieval script. To get all the artists to complete their designs and get the book out was something of a tour de force. It was considered ''a triumph for the author, the illustrators and the printer, who broke with the Elzevir tradition to dare to publish a book in a manner never before done. The photoengravings appear excessively imperfect today, but thirty-five years ago they seemed and really were a miracle. Equally miraculous is that today *l'Isaotta Guttadauro* is among the rarities of Italian bibliography.'' Thus wrote Diego Angeli in 1939 in *Le Cronache del Caffè Greco* (p. 108).

One wonders where Vedder was all this time, during which his friend Davies at the Caffè Greco, according to Diego Angeli, was indoctrinating the young artists in the ways of his beloved Rossetti. Why was Vedder not asked to contribute to this enterprise? Possibly, since the venture had a literary origin and the poet was an Italian, only Italian artists were invited to contribute. Yet Vedder may have met D'Annunzio at William Story's salon. D'Annunzio described Story's apartment in the Barberini Palace in his famous novel *Il Piacere*, the story of Andrea Sperelli, an artist who wants to make of his life a work of art. Whatever the situation, the similarities in style and spirit between Vedder's *Rubáiyát* designs and those for D'Annunzio's *l'Isaotta Guttadauro* remain worthy of note.

Vedder was to have a belated recognition in 1895 when Adolfo De Bosis published two long, lavishly illustrated articles on Vedder's art in *Il Convito*. This publishing venture was founded in January 1895 by a group of artists,

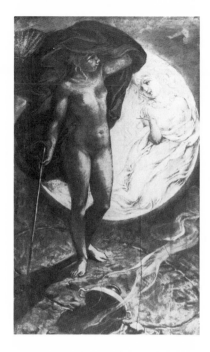

12.
Giuseppe Cellini (1866-1940),
illustration from *l'Isaotta
Guttadauro.*

13.
Vedder's studio at Capo le Case.

writers, and painters "with a sincere cult for the noblest forms of Art." It was to appear every month as an elegant book with prose, poetry, and drawings selected with great care and printed with elegance of style and paper. Among the announced collaborators were no less than Giosuè Carducci, the greatest Italian poet of the time; D'Annunzio, who promised a novel; and artists de Maria, Sartorio, Cellini, Eugenio Benson, and others. The editor was Adolfo De Bosis, a young poet and art critic who had married an American girl from Albany, New York, and was the best friend of the American sculptor Moses Ezekiel. Ezekiel occupied for a number of years a section of the Baths of Diocletian in the Piazza delle Terme near the railroad station, which he had

14.
The Vedders' villa, Torre Quattro Venti, on Capri.

arranged as studio and residence. There, every Sunday, he had extraordinarily successful parties at which the best of the international intelligentsia in Rome could be met. De Bosis devoted two numbers of *Il Convito* to Vedder and his enthusiastic critique of Vedder's art remains valid, even though it was expressed in the florid style of the time.

It is disappointing that today the exhibition catalogue *Pittori Dannunziani, letteratura e immagini*,[10] in commenting on the style in which the *Isaotta* was illustrated, fails to bring out the influence of the *Rubáiyát* published two years earlier. Instead, the authors write that Cellini must have rediscovered the same sources as William Morris and harkened back to Renaissance miniatures and the like. Even today Vedder is ignored in Rome.

Yet the fin de siècle spirit that moved D'Annunzio and inspired his artist friends is close to Vedder's. It is easy today to point out those who undoubtedly profited by Vedder's example: Cellini, whose spiritual but luxuriantly decorative style is so very like Vedder's; even closer, the much younger Adolfo de Carolis, who, even though his medium was zilography, seems to have been the most influenced by Vedder—especially the Vedder of the two books of illustrated poems. Like Vedder, these artists returned to classical art through the medium of a Pre-Raphaelite spirit. In a simplistic and evident way the classical is seen in the Latin mottoes inscribed in elegant script on very elegant frames. *Love Ever Present* is one of Vedder's best examples of this English-Roman fin de siècle composition, and the original frame, recently discovered in Rome, was inscribed "Amor Omnia Vincit." It closely resembles those of Alma-

27

Tadema and Cellini, and probably any number of those delightful "Liberty" or "Art Nouveau" frames now seldom to be found.

Proof of Vedder's standing in the Roman artistic community of his day can still be had by word of mouth from living artists such as Pico Cellini, the artist son of Giuseppe Cellini. Research now in progress, specifically that by Sandra Berresford, a doctoral candidate of the University of London, is bringing out other instances of Vedder's importance in artistic Rome. Possibly it will be proved that his failure to participate more actively in exhibitions was owing in part to his not joining artists' groups such as the Circolo Artistico and "I XXV della Campagna Romana." But his studio was always full of people of consequence, as signatures in the studio books from 1877 to 1910 prove. These include Pierpont Morgan, Frances E. Trollope, Francisco Pradilla, Bernard Berenson, George Ticknor, the Spanish artist José Villegas, and the Italian artists Mario de Maria, Luigi Serra, and Carlo Ferrari. More important, there is the testimony of other artists, especially those of the American Academy in Rome. Again, why was Vedder never asked to participate at the academy or take any part in the planning? Among those working for its establishment, Frederic Crowninshield was one of his best friends, as was Frank D. Millet, and Samuel A. B. Abbott, who married Maria Dexter, one of the long-time residents of Rome. Possibly the unsympathetic attitude of Charles F. McKim, which caused Vedder to be omitted from the decoration of the Boston Public Library— an omission that to this day hurts Boston more than Vedder—caused him to be ignored when the planning for the academy was begun. And yet McKim and, especially, Stanford White were always asking Vedder's advice when they came to Italy on buying expeditions, and they freely admitted Vedder's infinitely superior knowledge of mural art, be it Raphael's or Carpaccio's.

Although Vedder was never officially part of the American Academy in Rome, he provided one of the most important Roman experiences for the various fellows who were clever enough to seek him out and spend long hours in his studio. Such were George Breck, Barry Faulkner, and Albin Polášek. Polášek, the sculptor, made the bust of Vedder now at the Hall of Fame. As Ruth Sherwood related in Polášek's biography:

> Polášek had brought clay, and during this visit [to Vedder's Villa Quattro Venti on Capri] he made a head of Vedder, for whom he had always felt the greatest admiration, both for the man and the painter. He [Vedder] still drew with remarkable spirit—he showed some masterly drawings of heads and some carefully executed landscapes of Capri—but in his perfectly equipped studio he painted not at all. To Albin's question he answered: "I am through with this world. How can I send my things to exhibitions with all this modern art?"
>
> So he had turned toward poetry, which he wrote for himself and a few friends, with no thought of the public. He gave Albin a book of poems and philosophical essays which the younger man treasured as the beautiful expression of the rich life.[11]

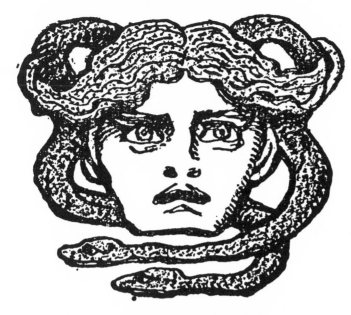

15.
Design (Medusa) from *Doubt and Other Things* (1922).

I had good fortune to visit Albin Polášek in his old age at his home in Winter Park, Florida, and to hear from him the confirmation of what he had written. Also Charles Keck's wife recorded for me the extraordinary experience Vedder had been for her husband, whose bust of Vedder at the Metropolitan Museum of Art is well known. Myron Nutting, who came across the *Rubáiyát* in his teens and who as a young man knew Vedder in Capri, told me that Vedder had a decided influence on him at that time. Another of Vedder's friends with whom I talked was Albert A. Van Buren, the archaeologist, who had come to Rome in 1902 as a classical student with a fellowship from Yale. He returned in 1908 to the School of Classical Studies in Rome and after its merger with the American Academy remained associated with the academy until his death in 1968. Dr. Van Buren told me about his conversations with Elihu Vedder in a restaurant in the Via Sistina, where a small group of people from the School of Classical Studies met regularly for dinner at the beginning of the century. Vedder would drop in at least once a week to express his opinions on art and especially on Michelangelo, whom he familiarly called "Mike."

Vedder returned to Rome from his final trip to the United States on March 22, 1901. He was then sixty-five years old and his major achievements in art lay behind him. The rest of his life was spent mainly in Rome, with a few summers in Viareggio and the rest mostly at his villa in Capri. Although he continued to sketch and paint, writing absorbed an ever-increasing amount of his time. His greatest success after the *Rubáiyát* was his delightful collection of reminiscences, with his own illustrations, *The Digressions of V.*, published in 1910. The writing of poetry, in particular, proved to be a great solace to Vedder after the deaths of Carrie in 1909 and his son Enoch ("Nicho") in 1916. Two volumes of his verse, illustrated with his own sketches, were published: *Miscellaneous Moods in Verse* in 1914 and *Doubt and Other Things* in 1923.

That Vedder never found the certainty he sought throughout his life is attested by the title of his last book of poetry, which is illustrated with some of his most expressive and abstract sketches, and by the interest he developed late in his life in Eastern and occult mysticism.

Notwithstanding his personal conflicts, Vedder's later years were serene ones. Lovingly cared for by his daughter Anita and surrounded by congenial friends—among whom were many of the prominent artists and writers who resided in or passed through Rome, or summered in Capri—he was looked upon by his younger colleagues in art and letters as a venerable and picturesque figure. His death on January 29, 1923, received wide attention in Rome and the United States, and was the subject of numerous long articles about the man and his art in newspapers and periodicals.

So well known in his lifetime, why so forgotten ever since? This is the question I kept asking myself when compiling the catalogue of Vedder's works. In answer to my question Mario Praz, the outstanding Italian critic, wrote in his review of my *Elihu Vedder: American Visionary Artist in Rome* that "perhaps the reason Vedder's fame underwent such an eclipse is because so much of his art is so similar to that of Watts, who, too, cultivated allegory, and to that of Leighton and Alma-Tadema, who, like Vedder, adored the pure neo-classical nudes." [12] Yet Watt's *Hope* is one of the best known English paintings and everybody remembers Alma-Tadema's Roman *Idylls* and Leighton's *Venus Disrobing for the Bath.* Vedder's affinity with Walter Crane is also remarkable, but according to Praz nobody would remember Walter Crane were it not for his delightful children's books. In other words, Vedder is too easily lost on the one hand in the large crowd of Pre-Raphaelite painters and on the other in the group of eclectic painters who, even in Rome, showed a definite ambivalence between the murky realm of their imagination and the sunny, smiling world of nature.

Yet Vedder's art has an indestructible quality. The man is full of surprises. With so many of his paintings long buried in private collections and only now coming to light at the death of their original owners or heirs, it is with a shock of pleasure that we apprehend the originality of Vedder, whose style was so much his own that even a customs officer could spot it at first glance. The *Sea Breeze*, newly reappeared, has no parallel among the Victorian greats, neither has *The Keeper of the Threshold*, that "mysteriously hypnotic" picture that has always been a great favorite and has the most uncanny contemporary flavor for us. The coiled serpent, the large open lily from which rises an exhalation like a flame, the palpitating blade that the subject holds in his hand and the palpitating disk of light behind his head, fascinated the crowd at the Chicago Art Institute when it was first shown there in 1900 as they fascinate us today. The same can be said of the newly discovered *Greek Head*, and the *Greek Actor's Daughter.* To judge from photographs of works still missing, it can also be said of some of his best "girls," such as the *Dancing Girl* or the *Strega*

he exhibited in Rome in 1911, and of the poetic *Dying Sea Gull and Its Matè* long believed lost, and the appealing picture he called *Memory*.

Vedder saw the world as image and symbol. "Some certain significance lurks in all things," Melville said in *Moby Dick*, "else all things are little worth, and the world itself but an empty cipher." [13] The faith that the world has meaning and the search for that meaning gave visual significance to Vedder's pictures. It also led him to meditate and seek explanation in Eastern thought. His activity never ceased; he was in his eighties when in Capri he met Earl and Achsah Brewster, artist-Buddhists and metaphysical painters.[14]

Vedder's artistic experience is a singularly rich one. Eclectic in his search for expression, with close affinities to the best of the Victorians — Watts, Leighton, Alma-Tadema — he nonetheless was strongly individual in the formulation of his content and style. To Vedder, as to Melville and Hawthorne, myth gave a disciplining form in which to shape his thoughts and visions and enabled him to bring a universal value to his dreams, hopes and fears. Like Melville and Hawthorne he shaped into myths the forms he found "wandering in the little world of [his] imagination." These he wove into that atmosphere of hallucinating reality firmly and immediately recognized by his contemporaries as "vedderesque" and discernible in all the manifestations of his landscapes and the hundreds of drawings that are extraordinary proof of the creativity and untiring vitality of his artistic temperament. Dramatic, flamboyant, restless, and sensuous, he was perennially wavering between the hell of weird and macabre myths and the heaven of visible nature and the calming landscape.[15]

NOTES

1. Elihu Vedder, *The Digressions of V.* (Boston and New York: Houghton Mifflin Company, 1910), pp. 332-33.

2. G. J. Hogerneff, "Via Margutta, centro de vita artistica," *Revista di Studi Romani* 1, no. 2-3 (1953).

3. Papers of Elihu Vedder, Archives of American Art, Smithsonian Institution, Washington, D.C.

4. Typescript, Saint-Gaudens Archives, Dartmouth College Library, Hanover, New Hampshire.

5. Regina Soria, "Mark Twain and Vedder's *Medusa*," *American Quarterly* 16 (Winter 1964).

6. Elihu Vedder, "The Story of the Sunflower." Unpublished typescript owned by Regina Soria.

7. Barbara White Morse, "Elihu Vedder's Soul of the Sunflower," *The Antiques Journal* 29, no. 11 (November 1974), and Morse, "John G. Low and Elihu Vedder as Artist Dreamers," *Spinning Wheel* 32, no. 4 (May 1976).

8. Regina Soria, *Elihu Vedder: American Visionary Artist in Rome (1836-1923)* (Cranbury, N.J.: Fairleigh Dickinson University Press, 1970), pp. 93-94.

9. Dario Durbé, introduction to *Vincenzo Cabianca (1827-1902)* (Rome: Galleria Nazionale d'Arte Moderna, 1976). Exhibition catalogue.

10. Maurizio Fagiolo and Maurizio Marini, eds., *Pittori Dannunziani, letteratura e immagini tra 800 e 900* (Rome, 1977). Exhibition catalogue.

11. Ruth Sherwood, *Carving His Own Destiny, The Story of Albin Polášek* (Chicago: R. F. Seymour, 1954).

12. Mario Praz, "Un artista visionario," *Il Tempo* (Rome), February 17, 1972.

13. Herman Melville, *Moby Dick*, ed. W. Somerset Maugham (Philadelphia and Toronto: J. C. Winston Co., 1949), p. 285.

14. Regina Soria, *Dictionary of American Artists in Rome (1760-1914)*, forthcoming.

15. Regina Soria, introduction to *Paintings and Drawings by Elihu Vedder* (Washington, D. C.: Smithsonian Institution Traveling Exhibition Service, 1966). Exhibition catalogue.

16.
Volterra, 1860, oil on canvas,
12¼ x 25½. National Collection
of Fine Arts.

Dimensions given for the works of
art shown in the illustrations are
in inches, with height preceding
width and depth.

Perceptions and Digressions

JOSHUA C. TAYLOR

In 1856 the twenty-year-old Elihu Vedder left New York for Europe, bent on studying painting. His instruction thus far had been rudimentary and remained on an elementary level through his winter in Paris. In the studio maintained by the elderly François-Edouard Picot he mostly drew from casts and, although he was delighted enough with Paris, he later remembered his life outside the studio with greater affection than his studies of art. It was only on reaching Italy in the spring of 1857 that Vedder seems to have been seriously awakened as an artist; although he continued to draw from the figure, a fascination with landscape became the key to his new awareness of artistic values. "I loved landscape," he later wrote, "but was eternally urged to paint the figure; and the figure suffered by my constant flirting with the landscape." [1]

Vedder was born in New York City in 1836 and spent much of his early life there or in Schenectady with his grandfather. For a short time he studied drawing with Tompkins Harrison Matteson, a modest but competent painter of genre in Sherbourne, New York, and at one point flirted briefly with the idea of becoming an architect. Throughout his childhood and youth he spent many periods in Cuba, where his father, who was a dentist, had settled, thus tempering his Dutch ancestral background with a tropical, Latin environment. As a result of his Cuban sojourns, he seems to have taken for granted—although he spoke of it not without relish—much that his northern companions must have regarded as fantastic and exotic. Sixty years later, when he settled down to write his reminiscences, the carefree life and lush images of Matanzas and Havana were still vivid in his mind. Certainly the decision to go to Europe was less momentous for so well traveled a young man than it would have been for someone brought up wholly in a northern American city. Once abroad he felt quite at his ease and eventually settled in Italy for the greater part of his life.

With some eight months of "art life" in Paris behind him, Vedder left France in April 1857 for Italy. Accompanied by another young American painter, Joseph Lemuel Rhodes, he went on foot from Nice to Genoa, savoring the magnificent countryside along the way. From Genoa, which he reached early in May, he went to Rome, Florence, and Venice, returning to Florence in August,

17.
Last Sketch in Paris, 1857, pencil on paper mounted on paper, 5 13/16 x 3 9/16. S D5. The Harold O. Love Family.

dazzled by the quantity and quality of art that he had seen. In Florence he remained until late in 1860.

Why Florence? American painters had been going to Italy to study and paint for many years, ever since Benjamin West spent his formative years there between 1759 and 1763. All spent time in Florence, of course, but most chose to settle in Rome, which provided classical models, a well-recognized and historicized landscape, and a lively international market for art. There were notable exceptions. Among them were Robert Weir, who had chosen to study with Pietro Benvenuti, director of the Florentine academy, in 1826, and Thomas Cole, who chose the academy there in preference to Rome to sharpen his drawing in 1831. Walter Gould settled in Florence in 1849 and spent most of his life in the city. Among the sculptors, both Horatio Greenough and Hiram Powers, friends of the distinguished sculptor Lorenzo Bartolini, worked there and Powers was still active during Vedder's stay. But Florence was not the same in 1857. Benvenuti and the spirited Luigi Sabatelli were gone, as was the able painter Giuseppe Bezzuoli. The academy had lost its sense of direction, and its patronage had been rendered uncertain. Although the Grand Duke had been returned in triumph in 1849, the relationship between the people and their ruler was hardly cordial. As anyone who read the reports from Tuscany in American and English newspapers was aware, the political situation was in a state of ferment, and most of the English and American observers were sympathetic to the growing sentiment of Italian nationalism that had been gaining strength throughout the country. Although the officers of the occupying Austrian troops stirred the hearts of some visiting young ladies, their presence was generally regarded as sinister. For those who were at all politically alert, Florence did not offer a setting of uninterrupted contemplation. Yet whatever his reason, Vedder's choice to settle there proved fortunate in the light of his later work.

On arriving he settled down to study drawing with a sound but undistinguished academic painter, Raffaello Bonaiuti. Bonaiuti's chief attraction for Vedder was the proficiency he had gained in working from the classical sculptures in Rome, but the conscientious Bonaiuti was devoted as well to Fra Angelico, copies of whose works he sold to make a living. Vedder recalled that when he was with him the Italian painter was engaged in an endless series of studies for what he intended as his masterpiece, *The Temptation on the Mount (L'ultima tentazione di Satana)*. When the work was chosen for the Exposition Universelle in Paris in 1867, Telemaco Signorini remarked, "One could call the picture a concept worthy of Michelangelo, drawn in many areas by someone from the seventeenth century, and painted by a bad student of Fra Angelico." [2] Vedder's real instruction, however, came not from his eclectic master but from the group of young Italian artists with whom he seems quickly to have allied himself. There were many proper Americans and Englishmen living in Florence,

but Vedder was not inclined to join the gossiping expatriate circle. "You see, I did not then see Florence through books," he later wrote. "My Florence was a beautiful city filled with figures fresh from the frescoes of Ghirlandaio or Giotto or Cimabue—its hills covered with the villas of Boccaccio's fair ladies, or when bare and rugged inhabited by the lean Fathers of the Desert." [3] Later he came to accept, or at least recognize as valid, the life led by notable foreigners in Florence, but in the 1850s he was too much a part of the young artistic scene to regard it seriously. "They were all intellectual, highly cultured, literary and artistic—above all *literary*," he complained. Except for the really great, they "seemed to live a little, fussy, literary life, filled with their sayings and doings. . . ." [4] Nothing could contrast more with this characteristic expatriate existence than the turbulent lives of those with whom—through some marvelous circumstance—Vedder was to find companionship.

Not far from the Accademia on what is now the Via Cavour was a café that, in the ten years or so before Vedder reached Florence, had become a noted center of political and cultural opposition. Called the Caffè Michelangiolo, it was the meeting place, from about 1855, of a group of artists who shared a fiery sense of nationalism and a rebellious attitude toward existing Italian art. [5] Initially they were not too sure of their aesthetic direction, but they knew what they despised. Emphatically they opposed any aesthetic principle based wholly upon traditional art, much as they might admire the accomplishments of the Italian past. They knew of the pronouncements of Courbet and the activity of the Barbizon painters of France but, fortunately for their sense of individual achievement, most had seen little of contemporary French painting. They were enflamed with the idea of natural truth as an antidote to repeated artistic formulae and went out to discover it on their own.

At what point Vedder first made contact with the group at the Caffè Michelangiolo is not known. He had not been long in Florence before many of the young artists went off to join the Piedmontese army in the struggle for Italian unity. Not until after the armistice of Villafranca in 1859 was the full complement again to be found in the smoky annex of the café that had been taken over by the artists. It was also in 1859 that the patriot painter Giovanni (Nino) Costa stopped by Florence to spend a few days on his return to Rome and spent the larger part of ten years. Costa became a particular friend of Vedder's, and they went on at least one painting trip together before Vedder left Italy at the end of 1860 and Costa took his first trip to Paris.

Nino Costa, who came from a distinguished Roman family, had divided his active life so far between painting and the continual struggle for the liberation of Italy. [6] A lively and robust young man, ten years older than Vedder, he shared with Vedder a hearty dislike of all pomposity and affectation. He had become a friend of the English painter Frederick Leighton in Rome in 1853, and had gone on many painting excursions with the Englishman George Mason,

18.
Florence, Building along the Arno,
circa 1858-60, pencil on paper,
6¹¹⁄₁₆ x 3⅞. S D5. The Harold O.
Love Family.

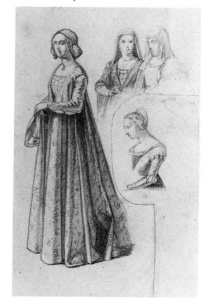

19.
Study after Domenico
Ghirlandaio, circa 1858, pencil on
paper mounted on paper, 8⁵⁄₁₆ x
4¾. The Harold O. Love Family.

20.
Giovanni Costa (1827-1903),
Women Loading Wood at Anzio,
1852, oil on canvas, 31½ x 47½.
Galleria d'Arte Moderna, Rome.

whose paintings of the time were very close to those of Costa. Brought up in the long tradition of Roman landscape painting, Costa began to paint directly from nature out-of-doors in the late 1840s. According to custom he set out with his small panels to paint as immediately as possible the effects of light and the bold patterns of the Roman landscape. In 1852 he had finished his first major painting, *Women Loading Wood at Anzio,* which embodied many of the characteristics that would distinguish his work for some years.

Following a manner that had become common around Rome by the 1840s and '50s, Costa would paint small studies directly from nature in which he attempted to catch the total effect of the scene. Forms were not modeled, but took on substance wholly through the spatial suggestion of carefully related colored patches of paint. It was this organization of flat areas of color that formed the theme of the painting, and when he later developed more detailed versions of his work in the studio, Costa took care that the total impression, which had given his small studies their character, should not be lost. The study itself was never painted over or "developed"; it remained the control by which the final painting, no matter the quantity of added detail, could retain its natural integrity.

Painters had been working directly from nature in the environs of Rome for a great many years, but they followed two distinct, although sometimes intermingled, traditions. One procedure was based on the careful drawing of isolated objects that would later become the motifs for composed paintings. For the organization of the scene the artist might even use a *camera lucida* or some other device, verbally indicating the colors with care in marginal notes.

This was the method followed by many of the German painters and the Italian *puristi*, who continued the exacting discipline well past the middle of the century. It was not unlike the method of the English Pre-Raphaelites, even though the latter might actually complete the painting out-of-doors. Light—often brilliant light—was only so good as it brought out the exact appearances of things. The other tradition, which also goes back at least to the late eighteenth century, was that of attempting to capture directly in paint the specific effect of forms in light, considering the total luminous effect of the scene, not the particularized objects, as the artistic motif. In some ways this broader procedure was akin to the academic method of laying out a history painting in broad patches of color—the goal was a striking visual unity of forms—but there was a fundamental difference. For the landscape painter devoted to effect, the patchwork unity was to be discovered in nature, not constructed by the artist. The visual impact of the formal pattern was, to the artist's way of thinking, produced by nature, not by art. Artists set out to surprise nature, they liked to say, in its most telling moments.

Although he used them as themes for studio paintings, Costa obviously valued his direct studies from nature for themselves, and when he settled in

21.
Vincenzo Cabianca (1827-1902), *Liguria*, 1861, oil on paperboard, 8¹¹⁄₁₆ x 9⅞. Galleria d'Arte Moderna, Rome.

Florence he invited the younger artists to see not only his prized *Women Loading Wood* but also his small painted panels.

The painters who gathered at the Caffè Michelangiolo were quite prepared to admire Costa's studies. Their battle cry was "truth," whether they were depicting scenes from Italian history or recording the landscape around Florence. Under the leadership of the articulate and alert painter and critic Telemaco Signorini they discussed endlessly their goals for a new art. When Vedder joined the group their interest was divided between a clear and luminous representation of subjects of historical or social significance, and broadly but exactly painted views of nature. Cristiano Banti, a particular friend of Vedder's, had painted a *Galileo before the Inquisition* in 1857, Vincenzo Cabianca painted his sentimental but sober *The Abandoned* in 1858, and Giovanni Fattori, who was to become one of the most distinguished painters of the group, finally terminated his elaborate painting, *Mary Stuart on the Battlefield of Crookstone*, in 1861. Meanwhile, Serafino de Tivoli, who had been in Paris in 1855-56, was painting freshly viewed landscapes and Telemaco Signorini, having purged his interest in Walter Scott romanticism in such paintings as *The Puritans* of 1855, was producing startling studies from nature using simple broad patches of color. The borders between the kinds of painting were not finely drawn. At the same time he was laboring over *Mary Stuart*, Fattori painted astonishingly simple and bold studies of army life in which a few richly colored spots evoked brilliant sunlight and fell into patterns that gave an inexplicable sense of aesthetic order. Cabianca gave up his sentimental themes by 1859 for effects of blinding sun and sharp, clear colors. The presence of Costa with his small spontaneous studies helped to tip the scales in favor of the directly recorded glimpses of nature presented in terms of unmodulated patches of carefully adjusted color. By the time that works by many of these painters were shown in the first great Italian exhibition in Florence in 1861, the painters of the Caffè Michelangiolo were already known for painting in spots, in *macchie*. They were dubbed *Macchiaioli*.[7]

From the few landscapes that can be attributed securely to Vedder's first stay in Florence, it is clear that he was much impressed by the idea of catching the effect of nature with a relatively few simple shapes. The *Italian Landscape with Sheep and Florentine Well* in the Boston Museum of Fine Arts, which once belonged to Charles Sumner, is doubtless, as has been suggested, the painting he mentioned in a letter to his father dated March 13, 1860.[8] In the long horizontal format preferred also by Vedder's Italian colleagues, it creates its effect with a few strongly silhouetted forms. As so often in the landscapes of Costa, it moves through a series of horizontal striations with none of the usual *repoussoirs* common to classical landscape painting. The painting's charm is in its pattern of rather shaggy shapes, not in the character or detail of its objects. Unlike American painters who earlier sought dramatic views of

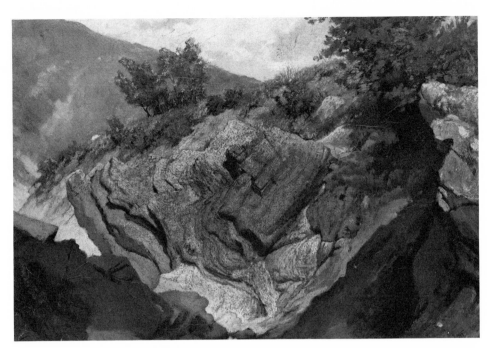

22.
Study of Rocks, Bed of Torrente Mugnone, near Florence, circa 1858-60, oil on canvas, 10½ x 15. S 6. Davison Art Center, Wesleyan University, Connecticut.

23.
Italian Landscape with Sheep and Florentine Well, circa 1858-60, oil on canvas, 14 x 28. S 1. Museum of Fine Arts, Boston; bequest of Charles Sumner.

classical sites around Rome, in his small landscapes Vedder seemed to prefer unspectacular subjects and well-worn forms, whose muted rhythms provide the theme of the picture. Instead of recording the well-known monuments of Florence or trying to capture the spectacular panorama of the city from the hills as had many of his predecessors, he joined his Italian friends in searching out more humble areas that revealed the age-old quiet of the Tuscan countryside.

By following the Via Larga (now the Via Cavour) for some distance beyond the Caffè Michelangiolo, one reached the old Porta San Gallo, which Vedder recorded in at least one sketch, and beyond it the Torrente Mugnone, a stream that meandered between high stone reactments along what was then the northern outskirts of the city. From here a road wound up the hill to Fiesole. Vedder recalled: "On the high banks of this stream, overlooking the country bounded by the great bare hills from which in winter came those icy blasts that gave us all sore eyes . . . we walked and settled all the great questions of the day."[9] Edouardo Borrani, Silvestro Lega, Giovanni Fattori, and others eventually recorded this favorite spot with its old walls, eroded banks, and marshy stream, which still retains much of its original character even though it is overshadowed for most of its length by tall buildings. Vedder's handsome painting dated 1859 (fig. 24, now in the Detroit Institute of Arts), with its subdued colors and effect of soft clear light and transparent shadows, is evidence that he shared with his Italian fellows a sensitivity to the area's humble charms. "Following up the stream," Vedder later wrote, "you finally reached the spot where it passes under a bridge at the foot of the long ascent which leads to Fiesole. It was here I painted two of my best studies, and also a little picture I thought highly of."[10]

The little picture based on the Mugnone of which Vedder thought so highly and which he believed was destroyed in the collapse of a gallery at Madison Square Gardens, was, said he, "really a sketch I made on a dark stormy day, of Fiesole with the road and cypresses coming down from it." Following his inclination to join imagination with his vision of nature, he added three Dominican friars to the scene because their "black and white garments carried out the feeling seen in hillside and sky."[11] It is as if the inhabitants of the Florentine environment were a product of the historical hills themselves for Vedder. No matter how intensely he studied the effects of nature, his lively powers of association were not to be denied. He was interested not only in natural panoramas but in the extended experience of the imagination.

The Detroit painting (fig. 24) presents a much more complex vision. As in many of the paintings of the Florentine group, large areas of the landscape are depicted in open shade with enough reflected light to effect a vibrant sense of color. For the most part the painters preferred to find their motif in full sun in order to work from a bold pattern of light and shade. Shadows then could be subtly modulated and light areas bleached of detail to emphasize that the organizing design was the product of nature, of the sun, not of the painter's

24.
Fiesole, 1859, oil on canvas, 15 x 29¼. S 7. The Detroit Institute of Arts; gift of Mr. and Mrs. James S. Whitcomb.

25.
Three Monks Walking in a Garden at Fiesole, circa 1859, oil on canvas, 12¼ x 10¼. S 25. Mr. and Mrs. John D. Rockefeller 3rd.

26.
Drawing of Monk, circa 1859, pencil on paper, 5⅝ x 3⅛. The Harold O. Love Family.

27. ABOVE
Frederick Leighton (1830-96),
*Cimabue's Celebrated Madonna
is Carried in Procession through
the Streets of Florence*, 1853-55,
oil on canvas, 87½ x 205.
Royal Collection, London.

28. RIGHT
Bernardo Celentano (1835-63),
Il Consiglio dei Dieci, 1861, oil on
canvas, 28⅜ x 80⅞. Galleria
d'Arte Moderna, Rome.

caprice. Often, as in Vedder's painting, the shadows create variegated patterns
across the horizontal stretch of the canvas, inviting the viewer to lose himself
in the areas of color rather than to push at once into the depth of the scene.
Vedder's painting offers unexpected visual rewards in the shadowed portions,
with many slight modulations of color and tone to beguile the eye, although
the brushstrokes do not call attention to themselves as such. Somehow their
constant shifting in tone is transferred to the substance they depict, the un-
even path and the old stucco walls, and yet their quality as painterly assertions
is never lost.

Surely this painting was the result of much study; it is not one of Vedder's
spontaneous outdoor sketches. Yet it radiates a relaxed kind of unity that does
not seem contrived. A part of this effect derives from the narrow horizontal
format. Just how this shape was first developed remains conjectural, but by the
1850s it had become especially popular in Italy for historical paintings as well
as landscape studies. For historical compositions it made possible a dramatic

29.
Bed of Torrente Mugnone, 1864,
oil on academy board, 6 x 15⅝
(sight). S 33. Mr. and Mrs. John
D. Rockefeller 3rd.

sequence or procession, as in Frederick Leighton's *Cimabue's Celebrated Madonna is Carried in Procession through the Streets of Florence*, much praised when seen in Rome in 1855, and Bernardo Celentano's *Il Consiglio dei Dieci* of 1861 with its dramatic broken rhythms. In such compositions lateral space seems unlimited; although the figures or the forms interact among themselves there is no sense of containment. What is seen in the picture is a happy coming together of parts in what is implied as a more extensive environment than that bounded by the picture frame.

Doubtless, precisely this sense of expansion is what appealed to the landscape painter. In defiance of art-academy triangular or pyramidal structures, he could relate his vivid glimpse of nature to the entire countryside, to the normal act of seeing. As a result, the harmonious unity of his pictorial fragment seemed all the more miraculous, occurring, as it was suggested, in the broad context of an ordinary experience in nature. The possible drama provided by such a format was not lost on Vedder and he used it later, not only for recollections of the Mugnone or the Italian Riviera, but for some of his more mysterious evocations as well. In America it was being adapted for panoramic views that proclaimed nature more fascinating than art.

At one point Vedder was living in a house on the Mugnone, together with an Englishwoman, Mrs. Hay, and a dapper South Italian history painter ten years his senior, Saverio Altamura (1826-1897). This would seem to be a strange group to be sharing talk about art, but it suggests the complexity of Vedder's artistic interests at the time.

Jaine Eleonor Benham Hay was a young Englishwoman with two children who had left her husband in London and traveled to Italy in pursuit of the beauties of nature as seen according to Ruskinian principles. Vedder remembered her as "a strong Pre-Raphaelite and a woman of great talent . . . a lover

of the clear dawn and the bright day, and of Fra Angelico."[12] In Florence she became a friend of Altamura's Greek wife, Elena Bocuri, and, at some point, Mrs. Altamura returned to Greece with Altamura's younger children, leaving the expansive artist in the hands of Mrs. Hay, who remained his companion.[13]

From her major work, it would seem that Mrs. Hay was more devoted to the Fra Angelican aspects of Pre-Raphaelitism than to "clear dawn" or "bright day." In 1867 she unveiled her masterpiece in her studio located beside that of Altamura, and advertised widely for Florence to come to see it. Its title was *A Florentine Procession during Carnival in 1489*, and she wrote out an extensive description of the work available in several languages.[14] She and Altamura had made careful studies after the works of fifteenth-century artists in Pisa, Siena, and elsewhere in preparation for the painting, spurred by what Altamura called the "tenacious will power of the Anglo Saxon race."[15] Not just a historical work, however, it was a sermon in favor of a holy art that elevates and purifies in contrast to an art that serves a corrupt culture. Savonarola, in Mrs. Hay's thinking, was a kind of fifteenth-century John Ruskin who was not opposed to art but only to its profane and corrupting aspects. The merchant class was shown despising the new sacred, ascetic order for which Savonarola stood because it threatened their business in worldly luxuries. Telemaco Signorini published a lengthy criticism of the painting and searched hard for an argument that might justify it. It was filled with "so many knowledgeable details," but somehow the sense of the whole was lost in the parts. So far as the composition was concerned, he assumed that the inconsistencies in perspective were part of a deliberate effort to imitate fifteenth-century painting. It showed, above all, an intense love of art. "When one errs as a consequence of excessive love," wrote Signorini, "it can be said that Mrs. Hay, like the Magdalene, has sinned because she loved too much."[16] Altamura remarked in later years that the painting provided "much sympathy in the intelligent Florentine public, intensified possibly by the condition of the artist, being a woman and a foreigner."[17]

Vedder's reaction to Mrs. Hay's painting would doubtless have been not unlike Signorini's since he was not at all convinced by the persuasive rhetoric of the Pre-Raphaelites concerning truth and verisimilitude. In his *Digressions* Vedder recalled first having seen Pre-Raphaelite painting in the works of Thomas Charles Farrer before leaving New York, but this cannot be since Farrer reached the city only in 1860. He doubtless was aware of Ruskin's ideas, however, if only from reading *The Crayon*. Then he came to know the English painter John William Inchbold (1830-1888) in Florence. "Of course we regarded all his doings with great interest and I became well acquainted with him and in fact counted him among my friends," he wrote.[18] There was much in Ruskin's teaching of specific drawing that appealed to Vedder, but he doubted the final results. The paintings seemed "needlessly hard and crude when representing things in their nature soft and harmonious, and therefore I looked on it as an

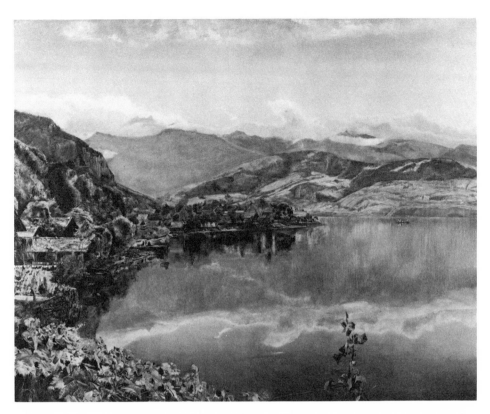

30.
John W. Inchbold (1830-88), *Lake of Lucerne*, 1857, oil on wood, 14 x 19¼. Victoria and Albert Museum, London.

affectation." [19] With regard to Inchbold's conscientious rendering of nature he observed that "his conscience had an elastic quality; the fact is that the P.R.B. did not so much aim at representing Nature faithfully as they did to give their work the look or stamp of the 'movement' they represented." [20] "I could never get from Inchbold," he complained, "a clear definition of what constituted Pre-Raphaelitism. Going back to the art previous to Raphael? Not quite that. In fact, put it as I would there was always something in which the Pre-Raphaelites differed from other men — and I have not been able to settle the point yet, except that in their art they must differ from all others and their pictures must have 'the look'." [21] Of course this was written long after the fact, well beyond the time that Vedder could look with sympathy at the tight, detailed painting of the followers of Ruskin. Yet it is true that Vedder never tried to emulate the Ruskinian manner in his painting, although he admitted to have been "deeply affected by it." [22] "With me it worked well," he recalled, "as can be seen by my studies at that time, and badly in that I went on filling my studio with careful studies I have never used." [23] (His meticulous pencil drawing of Volterra, from 1860, is one such.) His concept of how natural truth related to art was far different, however. "In Florence," he said, "Hotchkiss and myself were painting as faithfully as we knew how; and particularly that Pointeau [24] — he who used to come in from his painting from Nature about the time the rest of us were

31.
Volterra, circa 1860, pencil on
paper, 7 x 8¾ (sight). S D23.
The Harold O. Love Family.

taking our breakfast, bringing back with him drawings, veritable photographs
from Nature, only better. Therefore the works of Inchbold, needlessly insisting
upon unessential details at the expense of the general effect, and what appeared
an exaggeration of colour, led us to think, not unnaturally, that his object was
dictated more by a desire to give the style of the P.R.B. than by a love of Truth
or Nature."[25]

To judge from Signorini's commentary, Mrs. Hay also found truth in the
part, not in the whole, and did indeed convey the P.R.B. devotion to a style.

In spite of his strictures on the English Pre-Raphaelites and their devotion
to "a look," Vedder was not insensitive to antiquarian concerns. Although his
fellow painters of the Caffè Michelangiolo were devoted to the here and now,
a part of their present was the Italian past. The German scholars were the first
to emphasize the importance of fourteenth- and fifteenth-century Italian art,
and when Italian artists began to follow their lead they were accused of being
gothic and pro-German, but by the 1840s the Italian movement, which held
that Giotto was a major model for artists to follow, was widely recognized, if
not always respected. Beginning in 1840, Antonio Marini (1788-1861) had
uncovered the frescoes in the chapel of the Palazzo del Podestà (the Bargello),
which were by tradition attributed to Giotto. There, in a depiction of Paradise,
he uncovered a portrait of Dante which, although in very poor condition, was
much heralded.[26] For the rest of his life he divided his time between uncovering

32.
Antonio Marini (1788-1861),
*Study for Torquato Tasso Meeting
Bernardo Buontalenti*, 1861, oil
on canvas, 9⅞ x 20⅞. Galleria
d'Arte Moderna, Rome.

and restoring fourteenth-century frescoes and painting works that were in pious harmony with the works he restored. His greatest triumph (although not considered so by later historians) was in uncovering and restoring the Giotto frescoes in the Peruzzi Chapel of Santa Croce from the layer of whitewash under which they had been hidden since 1714.

In the 1840s and '50s, frescoes in most of the prominent early buildings in Florence were cleaned and restored, and they became the center of much public attention among Italians and foreigners alike. In 1857 the Palazzo del Podestà was restored to its early form and in 1859 the Provisional Government made it into a museum for sculpture and decorative arts, which it remained, known as the Bargello. Late Medieval and early Renaissance Florence, coming again to life, took the place of classical Rome in the hearts of many writers and artists. Vedder was not untouched. He made drawings of fifteenth-century costumes for future reference and made small paintings of Renaissance life in which he merged Venetian and Florentine images. One of his studies from Florence was titled *Page Playing a Guitar* and he remembered a "very romantic" picture of a woman with a strange headdress on a stair that he had given to Kate Field at Christmas in 1860.[27] Throughout his career there were references in his work to his imaginings of the Florentine past. Among his friends he fondly remembered Gaetano Bianchi and his wife, a friendship that had little to do with his landscape interests.[28] Bianchi (1819-1892), like Marini, was both a "purist" painter and a restorer of fourteenth-century frescoes. He also worked in Santa Croce in the 1850s on the Giotto frescoes in the Bardi Chapel, and in many other buildings as well, including the Bargello. Regardless of how they may have distorted Giotto's intentions, his restorations were in a style so sympathetic to the originals that when in recent years they were removed and shown separately it was a shock to note how extensive they were and how often they had been confused with Giotto's own work. Originally from Florence, he had studied in Rome in the early 1840s when the movement called "Purism," centering on Tommaso Minardi, Friedrich Overbeck, and Pietro Tenerani, was

33.
Study for decorative plaque, circa
1858-60, pencil on paper, 7¾ x 5⅝.
The Harold O. Love Family.

34.
Tracing of Florentine fifteenth-century costumes, circa 1858, pencil on paper mounted on paper, 7 x 5¼. S D30. The Harold O. Love Family.

meeting its noisiest opposition in the press. Minardi had said earlier that a painter should have the direct, innocent vision of a child and the spiritual motivation of a Christian adult, and held Giotto as the artist most worthy of emulation. In his statements could be found both advocacy of direct, unmannered representation and the romance of living within the confines of a medieval spiritual community. Vedder too, although he painted his Tuscan scenes from nature, liked to see them inhabited with monks and hermits, finding no discrepancy in combining what the eye saw with what the mind imagined. Later he wrote, "The white clouds seen through the dark cypresses glowed with Venetian warmth and colour, for I had the Venetian eye then, and the real people were very much alive and of their day; but the city with its real or imaginary inhabitants was held in an atmosphere of my own invention which to me hangs round it still." [29] Bianchi, living within the tradition of the fourteenth century, was as much a part of his Florentine world as Vincenzo Cabianca or Nino Costa, who daily went out to record the unexpected harmonies of light on the Italian countryside.

Even Saverio Altamura, the third inhabitant in the house on the Mugnone, contributed to this historic and imaginative side of Florence. Probably one reason Vedder liked him was for his hearty view of life, a heartiness that some-

35.
San Gimignano, 1858, oil on canvas, 17 x 13¾. S 3. Joseph Jeffers Dodge.

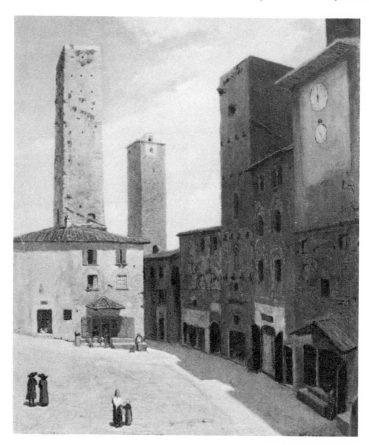

36.
Study after Domenico
Ghirlandaio, 1858, pencil on
paper, 5 9/16 x 7⅝. The Harold O.
Love Family.

37.
Study after Fra Angelico, circa
1858, pencil on paper, 7¾ x 5 9/16.
The Harold O. Love Family.

38.
Study after Cenni di Francesco,
circa 1858, pencil on paper, 9½ x
12⅛. The Harold O. Love Family.

39.
Study of Youth in Red Jacket,
1857-60, oil on academy board,
10 x 6¼. S 12. American
Academy and Institute of Arts
and Letters, New York.

40.
Saverio Altamura (1826-97), *The Funeral of Buondelmonte*, 1860, oil on canvas, 42½ x 85¹⁄₁₆. Galleria d'Arte Moderna, Rome.

times seems to have overshadowed his art.[30] Originally from Foggia, he had studied in Naples and won a prize to study in Rome. On his return to Naples he had become associated with the revolutionary movement of Italian independence and, having been forced to leave under pain of arrest, had gone into political exile in Tuscany. A highly emotional man, he had his periods of great enthusiasm and hard work, and others of debilitating depression. Through it all, however, he proved himself to be an able painter of literary scenes, many from Roman and Italian history, sometimes startling in their clear hard light and unusual composition. In Naples he had been acquainted with the painters of the Posillipo, who painted their studies of light out-of-doors, and was a close friend of Domenico Morelli. Although some of his works were conventional, others showed him to be in sympathy with the willfully revolutionary trends. When Vedder knew him he was working on his trilogy of Buondelmonte. As Altamura remarked in his autobiographical notes, the spirit of Florence had conquered him. "Finally I was not able to remain deaf to the medieval echos that every minute, at every street corner, the Florentine monuments and chronicals whispered to me." *The Funeral of Buondelmonte*, which was alternately titled *The Origin of the Guelf and Ghibelline Factions in Italy*, received much acclaim when it was shown at the great Italian exhibition in Florence in 1861. A processional composition reminiscent of Frederick Leighton's *Cimabue's Celebrated Madonna* (fig. 27), it includes a sweeping vista of the hills around Florence painted from studies such as those which Vedder was making

at the same time. The flatly applied brushstrokes exploit a broad palette of fresh but carefully harmonized color, which is not diminished by an excessive modeling of forms. But Altamura's production was strangely inconsistent.

In an affectionate lecture on him, Mattia Limoncelli was moved to say that if some devote their efforts to art and some to life, Altamura would have to be listed among the latter.[31] It was a quality that the young Vedder would have had little difficulty in admiring.

Altamura's chief contribution to Vedder, however, was doubtless his reenforcement of the consciously Italian and specifically Florentine side of Vedder's experience. Vedder had, through his friends of the Caffè Michelangiolo, an introduction to the Italian mythos such as few other Americans ever had.

Of course the more literary Anglo-American group in Florence was quite conscious of the Italian past and of present nationalistic aspirations as well. Robert Browning in particular was fascinated by the Florentine Renaissance. As Vedder noted later with some regret, however, he did not associate with this group. He had little to do with the heights of Bellosguardo, but immersed himself in the artist's life of the city. His only real contact with the more elegant and literary Anglo-American colony was through a lively and audacious young American woman, Kate Field. Supported by an affluent aunt, Miss Field was studying voice in Florence and had become a much discussed figure in the rather staid society for her youthful vitality and impetuous actions. She was attracted to Vedder, the poor artist with his strange associates, and wanted to introduce him to the intellectual delights of Florence. To help him financially, she arranged that he be commissioned to paint her portrait. This he did,

41.
Kate Field. Unlocated. Photograph reprinted with permission from Regina Soria, *Elihu Vedder: American Visionary Artist in Rome (1836-1923)* (Cranbury, N.J.: Fairleigh Dickinson University Press, 1970). © 1970, Associated Universities Presses, Inc.

51

creating a likeness of Renaissance simplicity with a ripe Venetian look. In the background of the tondo portrait he showed the center of Florence with the Duomo and the campanile, but Kate Field dominates the view. It was Kate Field on her hill and Florence at her feet. But in spite of Kate Field's efforts, Vedder did not become a part of the English-speaking literary group.

From his wide and varied circle of painting friends during his youthful days in Florence, one American was later remembered by Vedder with particular affection. In part his feelings were colored by the fact that the young man died, as yet unknown, at an early age. But Vedder also professed a genuine belief in the quality of the works, and regretted that history had not accorded him a place. His name was Thomas H. Hotchkiss.[32] Born about 1834, he came to Florence probably in the summer of 1860.[33] "He was a very tall, spare, delicate-looking young man," remembered Vedder, "who had evidently suffered in his youth, for he had worked in a brickyard under a hard relative who was strongly opposed to his artistic tendencies. . . ." Asher Brown Durand had been his mentor, and he had been close to John Durand and others associated with *The Crayon*. It is thus not surprising that Vedder should remark, "His art at this time was the pure product of the teaching of Ruskin." He went on to observe, "It is strange—or has been in my experience—how unsatisfactory that teaching turned out."[34] Nonetheless, it cannot be long after Hotchkiss reached Florence

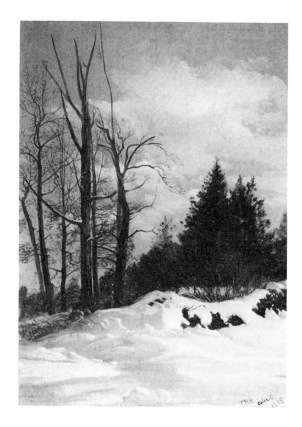

42.
Thomas H. Hotchkiss
(1834?-69), *Catskill Winter
Landscape*, 1858, oil on canvas
mounted on paperboard, 11 x 7¾.
The New-York Historical Society,
New York.

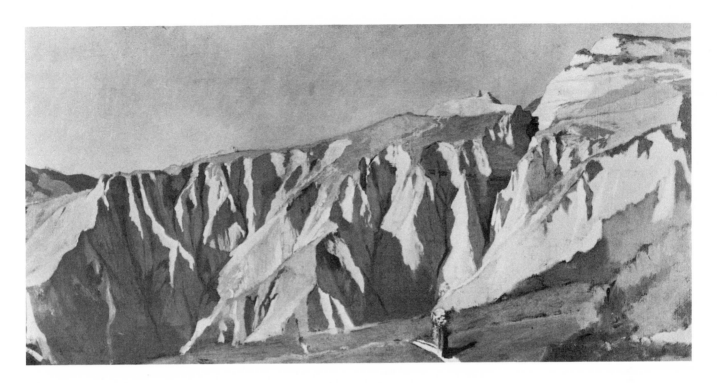

that he joined Vedder and Nino Costa on a sketching trip to Volterra, and Vedder produced some of his most Ruskinian studies.

The paintings that remain from Hotchkiss's early work in the United States bear out Vedder's comments: they are self-consciously Ruskinian, with as much observed detail as possible crowded into the picture. The painting of Vedder and Costa must have come as something of a shock to Hotchkiss because it was neither mannered in the traditional way nor crowded with Pre-Raphaelite detail. Vedder was willing to draw as tightly and neatly as any Ruskinian, but when it came to painting he adhered to the principle of the *macchia*, painting in subtly related flat patches of color even so precise a study as *Cliffs of Volterra.* Vedder's cliffs make a sharp contrast with Hotchkiss's painting *Catskill Winter Landscape* of 1858.

With considerable satisfaction Vedder recorded that ultimately, however, Italian breadth won out over Pre-Raphaelite minuteness. When Vedder again met Hotchkiss, in Rome in 1867, he found that since they had painted careful studies together on the Mugnone, Hotchkiss had changed both in his character and in his painting. Although he had spent much time in England in 1865 with the Pre-Raphaelite painters and had been pleased that Holman Hunt had approved of his work, in his Roman years he more and more identified himself with the Italian landscapists. According to Vedder, Hotchkiss "vented his indignation in unmistakable terms" [35] when he considered how he had been misled by Ruskin. They now, in 1867, painted together and thought alike, sometimes sharing the same motif.

43.
Cliffs of Volterra, 1860, oil on canvas mounted on paperboard, 12 x 25. S 14. The Butler Institute of American Art, Youngstown, Ohio.

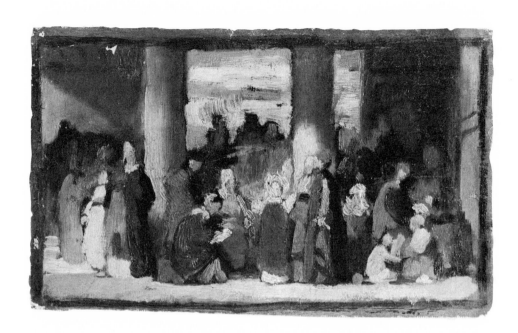

44.
Christ in the Temple, circa 1860,
oil on canvas, 5⅜ x 9. Mr. and
Mrs. Lawrence A. Fleischman.

By the time it became clear in 1860 that he must soon leave Florence,
Vedder had amassed a quantity of paintings and studies, and now debated
seriously his next step. His father had made it clear that he could no longer
support him abroad and wished him to come back to Cuba. Were he to leave
Italy, Vedder preferred New York as his next stop, but even before that he wished
to exhibit his work in Florence. He purchased a large canvas and sufficient
paint to render a major exhibition piece of *Christ in the Temple,* but never got
around to finishing it although he carried the study for it back to New York.[36]
He questioned whether it would, in fact, be better to complete more paintings
in Florence or continue to make studies that he could develop into paintings on
reaching the United States. For the most part it is impossible to know which
of the Italian subjects that he sold in New York in the early 1860s were actually
painted in Italy, and which were based on Italian studies made for later elabora-
tion. At least several doubtless date from his Florentine years and were simply
put in shape to sell in the United States, and his Italian themes gleaned in
Florence colored much of his American work.

Whatever his equivocations, Vedder did finally exhibit in Florence and in
an exhibition that was to be of considerable importance. He was elated to find
himself listed in the catalogue, and would have sent his father a copy to prove
his success but the catalogue weighed too much.[37] The *Promotrice* exhibition
of 1860 in Florence was the first to show some of the new paintings of nature
produced by Vedder's fellows of the Caffè Michelangiolo. Pointeau showed
three works, including a *Motivo del Vero nel Mugnone, effetto della mattina;*
Cabianca, Signorini, Altamura, Serafino de Tivoli, Banti, and Borrani were all
represented, some with historical and literary works as well as landscape

studies.[38] It was the public beginning of a whole new movement in painting in Italy. For Vedder also it was an important step since he now was publicly on record as an artist and had exhibited abroad. He would return to the United States a confirmed artist.

Protesting every mile of the way, Vedder left Italy for Cuba at the end of 1860. "And thus I left Eden," he later wrote. "The world was all before me, but as to the where—I had no choice; so I followed the Arno to where it is lost in the sunset, and at Leghorn embarked for home." [39] His protracted journey took him to Spain, where he made a few sketches and tiny pencil studies for future paintings, and finally to Havana early in 1861. In Cuba he seems to have painted nothing, much to his brother Alexander's disgust for, as he pointed out, Cuban subjects might very well sell in New York.[40] Vedder had no intention of settling in Cuba where, he claimed, people wanted only a painting that "must be from the bible and must have a *naked woman* in it." [41] By early June he was trying to get settled in New York.

Vedder's optimism was smartly trimmed by his desperate financial situation. His closest friend was Ben Day, who was chiefly concerned with illustration and print processes, and Vedder made his way for some time drawing illustrations, caricatures, and any bits of commercial design that came his way. He shared quarters with others and had little opportunity even to carry out the studies he had made in Florence. "Some prominent in art say it is a shame he is designing not painting," he wrote reproachfully to his father in November.[42] His economic condition seems not to have impeded his social expansion, however. He quickly became part of the artistic and literary circles of New York, carrying on there in much the same way as he had in Florence with his Italian friends at the Caffè Michelangiolo. In the late 1850s a lively self-styled Bohemian group had grown up in New York, gathering at the German beer cellar on lower Broadway run by the genial Charlie Pfaff. At one point Vedder lived and worked close by and mixed frequently with the rebellious writers and artists who liked to feel themselves free spirits in a restrictive society. But Vedder had missed the most spirited period of Pfaff's, which saw the publication of Henry Clapp's influential journal *The Saturday Press* and the brilliant moments of the notorious Ada Clare. His return to the United States coincided with the beginning of the Civil War, which had a sobering effect on Bohemian activities. Vedder, because of an earlier injury, could not think of army duty but was not without Union sympathies. As in Florence, the serious side of his nature was strengthened at this moment, too, by the reappearance of Kate Field, who had little patience with his Bohemian dalliance. Her letters were filled with unsolicited advice, quotations from Hammerton, and friendly lectures on the higher reaches of art. Her journalistic connections also were of benefit to Vedder.

By the early spring of 1862, Vedder was settling down again to serious

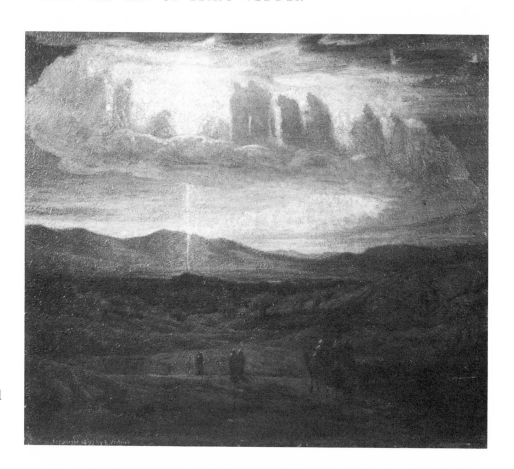

45.
Star of Bethlehem, circa 1863, oil
on canvas, 10½ x 12⅝. S 34.
The J. B. Speed Art Museum,
Louisville, Kentucky.

activity. In May he showed six works at the National Academy of Design, all of
them evidently from his Italian years. They included his painting of Dominican
monks in a convent garden near Fiesole, which was especially well received.
The next year, although he sent one Italian work, he included two paintings
that significantly expressed the elusive qualities that would characterize much
of his art in the future.

Although the small work, *Star of Bethlehem*, ostensibly was a painting of
traditional theme, in Vedder's hands it became a haunting personal statement.
The tiny figures of the Wise Men are almost lost in a vast barren plain, with
only the ray of light from the star to give promise to an otherwise fruitless
landscape. In the lowering clouds above, shadowy figures are grouped in rever-
ence around the star as if both heaven and earth were paying homage to the
newborn child. The image provokes a personal reexperiencing of what other-
wise might be thought of as a traditional doctrinal moment. Another painting
of about this time, *Christ on the Cross at Midnight*, must have been similar
in effect. Jarves described it as showing "the prophets and patriarchs, having
risen from their graves, looking up in solemn wonder at the divine sacrifice,
to know what it portends to them." [43] Vedder had begun what was to have
been a major painting on a religious theme in Florence, but it was of a much

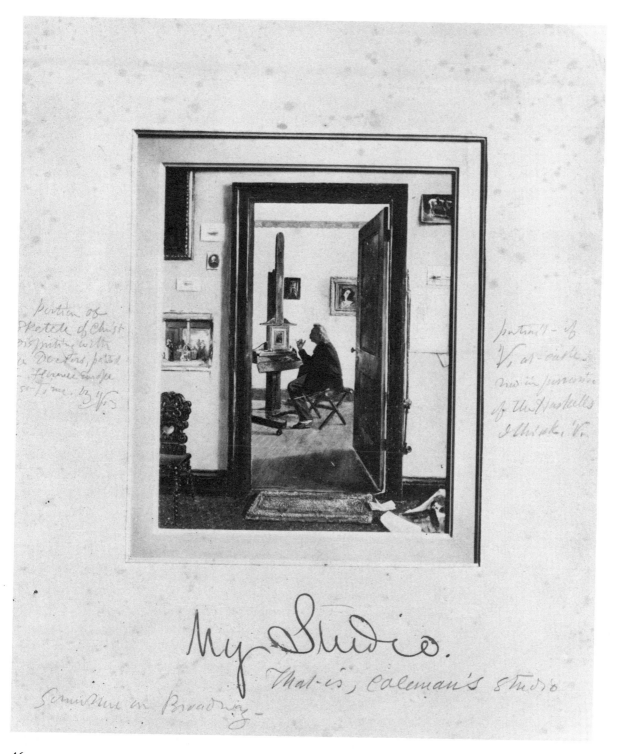

46.
Charles C. Coleman (1840-1928),
Artist in the Studio, 1864.
Unlocated.

more conventional sort. Although he bought a large canvas and stretchers for it, it never got beyond a study, which adorned the walls of the studio he occupied with Charles C. Coleman in New York. In the margins of a photograph of Coleman's meticulous painting of the studio (fig. 46), which was exhibited at the National Academy in the spring of 1864, Vedder pointed out the study for his *Christ Disputing among the Doctors* as an abandoned effort.[44] It did not offer him the chance for moody expressiveness that now seemed important to him. He seems to have had in mind, in fact, a whole series based on the Crucifixion that would unite the dead with the living in a rethinking of the spirituality of Christ. Many studies exist for related scenes, particularly for a painting, evidently planned in New York but developed later, called *The Ninth Hour.* This showed the crowd leaving the site of the Crucifixion and included the dead walking among the living. He reproduced a later version of it in his book *The Digressions of V.,* published in 1910. There were also a *Deposition* and one called *The Eleventh Hour,* among others. The fourth of his *Enoch Arden* compositions also presented a mystic vision of the Crucifixion. Quite probably only his *Christ on the Cross at Midnight* was carried far enough for exhibition while he was still in New York.

Even more significant as a forecast of his future direction, however, was a large painting—by Vedder's standards—entitled *The Questioner of the Sphinx,* shown at the National Academy of Design in 1863. Certainly the subject reflected more the ideas of his New York literary associates than it did his Italian experience. Its Egyptian reference was timely since there had been great agitation in New York over the past few years to raise money for the purchase of Dr. Henry Abbott's extensive collection of Egyptian art and antiquities for The New-York Historical Society. The objects were finally purchased and placed on exhibition at the society by April 1861, and Vedder doubtless knew them.

Vedder had not yet been to Egypt, but he had formed a clear notion in his mind of what the country was like. Of course there were many photographs and engravings he could draw upon, but he probably relied more on his own studies of landscape viewed with a rich overcast of imagination. Whatever his sources, he succeeded in creating the barren landscape in so convincing a manner that it seems to be personally observed. The matter-of-factness of the vision, much like that evidenced in his Italian landscapes, is hardly preparation for an incident that had ancient and mysterious overtones. Although the head of his sphinx is isolated in the sands as once was the Great Sphinx at Giza before the extensive excavations carried out in the 1850s, it is a more complete and sympathetic countenance than that of the famous monument as it gazes contentedly into the void. His model was probably found at the Historical Society; its surface and time-worn features are too closely rendered to be wholly a matter of imagination. Oddly, Vedder's sphinx does not at first seem

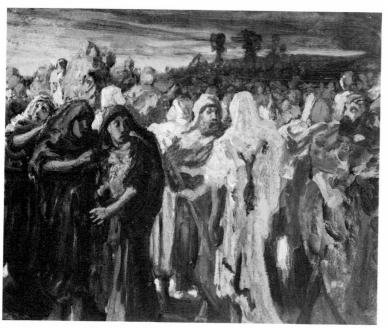

47.
Study for *The Ninth Hour*, circa 1863-65, oil on paper mounted on canvas, 7¾ x 9. Kennedy Galleries, Inc., New York.

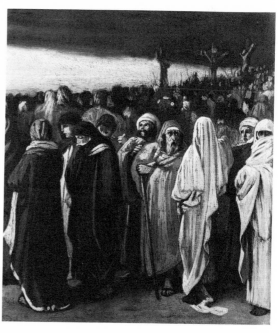

48.
Study for *The Ninth Hour: Crucifixion*, circa 1863-65, oil on paper mounted on canvas, 9½ x 8½. Kennedy Galleries, Inc., New York.

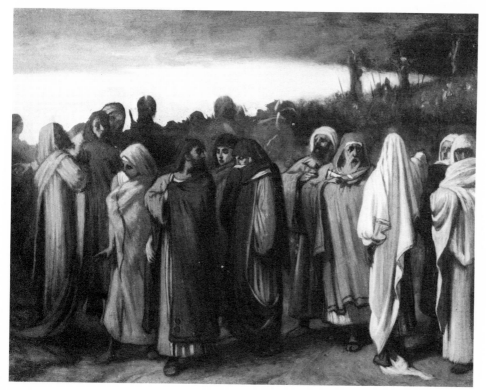

49.
Study for *The Ninth Hour: The Return from Calvary*, circa 1863-65, oil on wood, 9½ x 12¾. Graham Gallery, New York.

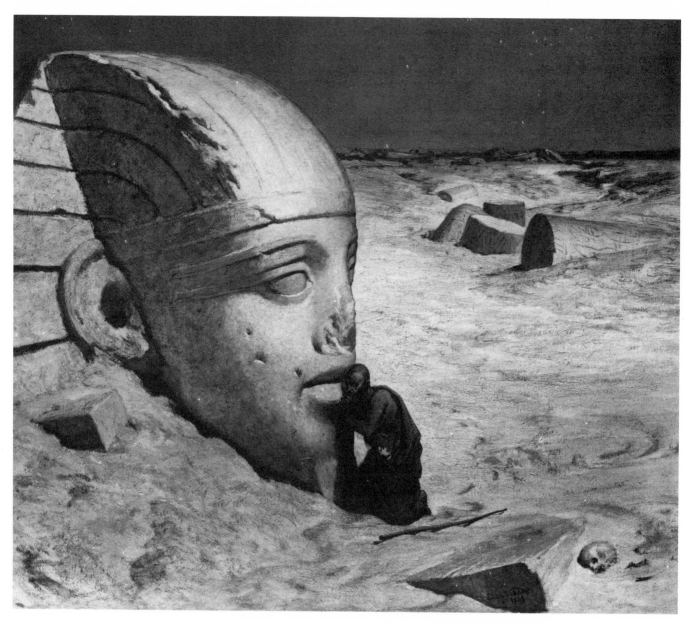

50.
The Questioner of the Sphinx,
1863, oil on canvas, 36 x 41¾.
S 30. Museum of Fine Arts,
Boston; bequest of Mrs. Martin
Brimmer.

especially large; rather, the crouching figure of the questioner seems insignifi-
cant and small. A critic at the time objected to the fact that the sphinx is not
shown to be as large as the well-known Giza figure, but it is large enough to
create a contrast that transforms an otherwise literal work into a nagging and
evocative image. Vedder was already enjoying himself in seeing the unreal in
the real, the mysterious in the material fact, that was to characterize much of
his later painting. The head is stony and hard, with no romantic enlivening of
its archaeological existence, and yet it takes on all of the mysterious conno-
tations associated with the sphinx, from the story of Oedipus to speculation on

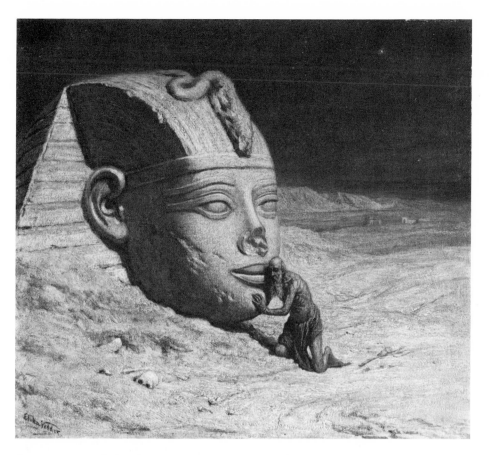

51.
The Questioner of the Sphinx,
1875, oil on canvas, 10¾ x 12⁵/₁₆.
S 265. Worcester Art Museum,
Massachusetts; gift of
Mr. and Mrs. Stuart Riley, Jr.

the meaning of the Egyptian monument isolated in the desert. In it, wrote
Jarves, "a naked Arab puts his inquiring lips to the mouth of the inscrutable
statue, and asks to know the Great Secret of life, but receives no answer except
the devouring silence, solitude, and death that encompass him." [45]

Probably one should not attempt to read too much into the painting; it
was the work of a young man living in precarious circumstances who took a
spirited, somewhat cynical, view of life. He loved double meanings and ironic
incidents and, like others in his group, was a practical joker. Yet for all his
flamboyance and high spirits, there was always an unexpressed depth of seri-
ousness in Vedder that early showed itself in his work. Rather than a specific
philosophical strain, however, his direction suggests more a penchant for the
inexplicable and a fascination with the illogical that defies explanation. Re-
flecting on a much later trip to Egypt in which he could satisfy his curiosity
about that exotic landscape and culture, he remarked of the great monuments,
"It is their unwritten meaning, their poetic meaning, far more eloquent than
words can express; and it sometimes seemed to me that this impression would
only be chilled or lessened by a greater unveiling of their mysteries, and that
to me Isis unveiled would be Isis dead." [46] The sphinx gave promise of inner
meaning, but did not illustrate the resolution of some philosophical truth.

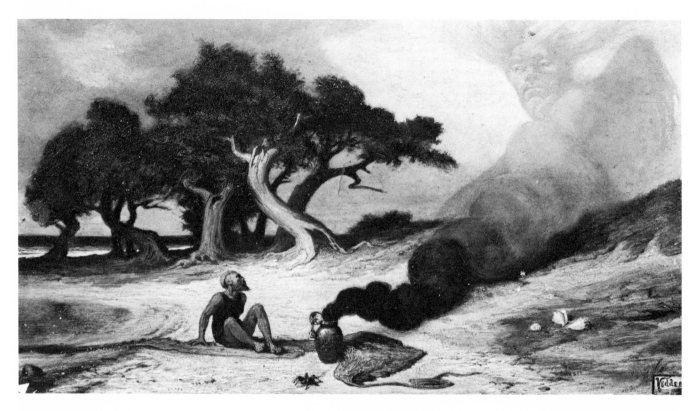

52.
Fisherman and the Genie, 1863,
oil on wood, 7½ x 13¾.
Museum of Fine Arts, Boston.

It was also in 1863 that Vedder produced two paintings based on the Arabian Nights. The eminent specialist in Arabic culture Edward William Lane, who had produced his popular work on the modern Egyptians in 1836, brought out his new, annotated translation of *The Thousand and One Nights* in the late 1830s, but the tales had been known in English for many years. At this moment, the exotic fantasy of the settings caught the imagination much as did Irving's *Tales from the Alhambra,* in which the unexpected becomes the normal. Fitz-Hugh Ludlow, a frequentor of Pfaff's, cited hashish as characteristically Eastern because of the way it extended the perception beyond normal Western limits, although there is little in his hashish visions, published in 1857 as *The Hasheesh Eater,* that resembles the enigmatic images by Vedder. This fascination with the improbable was a different aspect of the Arabic world than that which fascinated many painters and writers of the time, who delighted in the color and daring they associated with the modern sheiks. In fantasy the exotic took second place to shared human qualities that made Eastern thought directly accessible to the Western mind. For Vedder the Eastern images fit naturally into the realm of his active imagination and he made them very much his own.

Both *The Fisherman and the Genie* and *The Roc's Egg,* which were shown at an exhibition held in New York in the winter of 1863, combine the observed with the marvelous without stylistic apology. The landscape of twisted trees

53.
Two studies: *The Fisherman and the Genie*, circa 1863, pencil on paperboard, 8½ x 9⁹⁄₁₆ (sheet size). SD51. The Harold O. Love Family.

and patchy dunes in which the fisherman uncorks the magical bottle could have been painted directly from nature on the Italian coast, and yet the miraculous happening seems quite in keeping with the natural scene. Unlike many of his contemporaries, Vedder did not create a setting as background for an incident, but allowed the story to grow from the scene itself as a natural digression—a word he obviously liked. The empty Egyptian landscape, not the human remains, posed the real question that the sphinx failed to answer. The absurdity of the immense roc's egg is accepted without amazement by the dwarfed inhabitants of the beach where it lies as no less a fact of nature than the dunes themselves, yet its potentialities rather stagger the mind. The story of Sinbad was not what dictated the painting, but the existence of a kind of natural paradox. Vedder seemed to delight in pushing possibility to the point at which it devastates reason, and the stories of the Arabian Nights, as might have the stories of Poe, fit nicely into his unsettling scheme. So far as the public was concerned, it should be remembered that these were the years in which spirit rapping, clairvoyance, and communication with the dead were matters of popular discussion. Mystery was the complement to a persistent materialism.

Another preoccupying painting that Vedder conceived at this time emphasized futility and the concern with death that he later admitted to have haunted him from childhood. Jarves recorded early in 1864, "One of his latest paintings is the Alchemist, who, having discovered the illusive secret of his science, dies from the excess of emotion, with no witnesses of his joy or his pangs except the mysterious agents of his success in the bottles of his laboratory." [47] This tiny painting was later translated into an elaborate work in Rome, including many fascinating accouterments not available to Vedder in his sim-

63

54.
The Roc's Egg, 1863, oil on wood,
5¼ x 10½. S 32. Museum of
Fine Arts, Boston.

55.
The Roc's Egg, 1868, oil on
canvas, 7 x 16. S 166. The
Chrysler Museum at Norfolk,
Virginia; gift of Walter P.
Chrysler, Jr.

56.
The Dead Alchemist, 1864, oil on
canvas mounted on composition
board, 6¼ x 8½. S 134A. Martin
Memorial Library, York,
Pennsylvania.

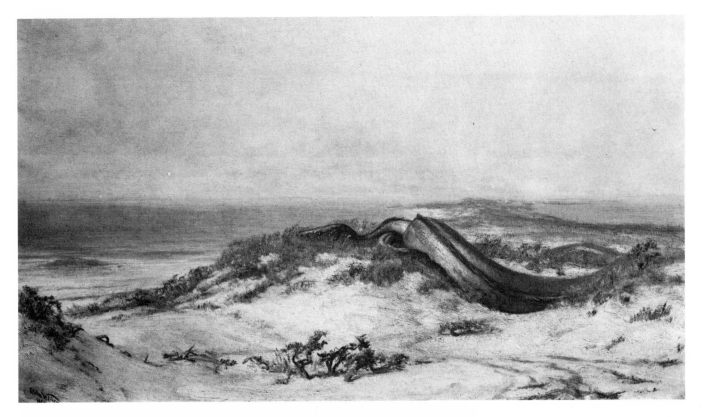

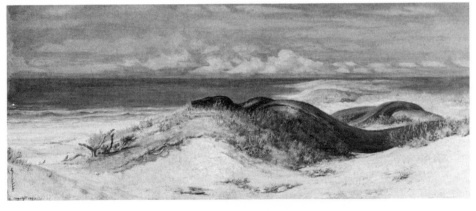

57.
The Lair of the Sea Serpent, 1864,
oil on canvas, 21 x 36. S 36.
Museum of Fine Arts, Boston;
bequest of Thomas G. Appleton.

58.
The Lair of the Sea Serpent, circa
1889, oil on canvas, 12 x 30.
S 448. The Metropolitan Museum
of Art, New York; gift of
Mrs. Harold G. Henderson, 1976.

ple New York studio, but the spare first statement carries the full pathetic
impact. Years before as a child he had encountered in an isolated room the
slumped dead body of an elder friend of whom he was fond; he had never for-
gotten the incident. Vedder's philosophy, such as it was, was homegrown.

By the time Vedder showed his *The Lair of the Sea Serpent* at the National
Academy in the spring of 1864, the public expected provocatively enigmatic
works from the young artist, and they were not disappointed. Again a surprising
discrepancy in scale turns a faithful representation of nature into an unresolv-
able and threatening puzzle. Over the familiar forms of seaside dunes a huge

serpent is snugly nestled. Neither the setting nor the serpent seem in any way fantastic, yet their juxtaposition is alarmingly upsetting to a complacent view. Critics might differ in their interpretation of the painting, but they were forced to grapple with the possibilities of a special meaning. One fascinated viewer, F. C. Ewer, wrote a long letter to Vedder praising him for having "lifted the low life of earth into a monarch, and endowed the repulsive with grandeur." He went on to say, "The whole picture is asleep. It is, if I may say so, greater in what it *suggests*—in the dim marvelous with which it fills the mind—than in what it *exhibits*. . . . This is an attainment in art which few of our American painters are equal to, and which *none* so far as I have seen have presented specimens at all comparable with either the 'Lair of the Sea-Serpent' or 'The Sphinx'. Furthermore," continued his enthusiastic follower, "the picture awes in the land—it awes in the sea—it awes in the solitary monster—it is filled with God." [48] A critic writing in *The Round Table,* however, contended that "the serpent lying there with its sleepless eye is like an affront to faith, to virtue, to love. It is the evil of a man's life." However, he went on to say, "He has succeeded in quickening thought, in arousing feeling. The best art cannot do more." [49]

The dramatic works of Gustave Doré, the French painter and illustrator, were well known in New York, and some critics went out of their way to suggest that Vedder's strange creations were closely allied to Doré's turbulent scenes. Others pointed out that Vedder's color was much richer and, quite correctly, that his imagination was of quite a different kind.[50]

Vedder had returned to New York at a moment in which a sharp controversy was waging over the direction of art in general and American art in particular. Some believed that art must follow the great Renaissance traditions in allowing the artist free personal expression in the fabrication of works that were great because they communicated the artist's own insights to his fellows. Others, strongly impressed with the admonitions of John Ruskin, maintained that the artist must subordinate all consciousness of self to an exact rendering of the thing seen. In May 1863, the month in which Vedder exhibited his *Questioner of the Sphinx* at the National Academy, a combative little monthly journal made its appearance called *The New Path,* published by the newly organized Society for the Advancement of Truth in Art. With a self-righteous belief in their own tenets, its critics harshly pointed out the deficiencies in artists who they believed were following erroneous paths, even though their works were acclaimed by the public, and extolled the works of their own followers. They were particularly incensed when George Inness exhibited his *The Sign of Promise* late in 1863 accompanied by a printed statement that said in part, "The highest beauty and truest value of the landscape painting are in the sentiment and feeling which flow from the mind and heart of the artist." [51] This accorded with the critical views of James Jackson Jarves, anathema to the

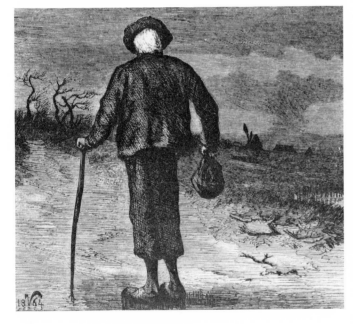

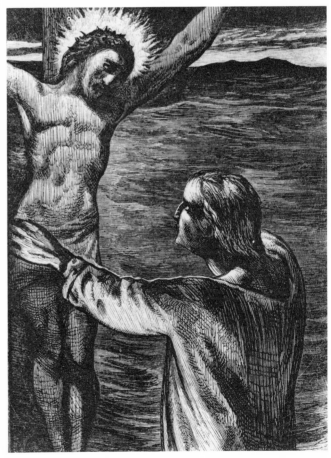

59.
Illustrations for *Enoch Arden*.
Reprinted from Alfred Tennyson,
Enoch Arden (1865). Top left, *The
Rescue*; top right, *Building the
Canoe*. Bottom left, *The Return*;
bottom right, *Enoch Passes Away*.

FAR IN THE NOTHERN LAND
BY THE WILD BALTIC'S STRAND,

OFT TO HIS FROZEN LAIR
TRACKED I THE GRISLY BEAR,

WAVING HIS ARMÈD HAND
SAW WE OLD HILDEBRAND,

AS WITH HIS WINGS ASLANT
SAILS THE FIERCE CORMORANT,

MID-SHIP WITH IRON KEEL
STRUCK WE HER RIBS OF STEEL;

A FEW
SKETCHES FOR LONGFELLOW'S
SKELETON IN ARMOUR,
MADE DURING "THE WAR"
AND DISCONTINUED FOR SOME
REASON NOW FORGOTTEN.
V.

60.
Drawings for Longfellow's "The Skeleton in Armor," circa 1862-65, pencil on paper mounted on paper, 12 x 9^{15}/$_{16}$ (sheet size).
The Harold O. Love Family.

New Path group, who had been publishing thoughtful essays on art for some years and was to bring out his provocative *The Art-Idea* in the spring of 1864. In fact, Jarves's remarks about this particular painting were included in the statement issued by Inness. "It develops the fact from the idea, giving the preference to subjective thought over the objective form of its fundamental motive," Jarves had written in the *Boston Transcript*. "His picture illustrates phases of mind and feelings. He uses nature's forms simply as language to express thought." [52] This was so directly—and deliberately—opposed to Ruskin's dicta as interpreted by *The New Path* that the magazine had to mount a counterattack. Everyone agreed that there were two schools in contemporary art, but whether the one—that which *The New Path* supported—was to be considered a statement of God's truth or passed by as a mere "clever imitation" that "calls for no loftier tribute than admiration of scientific knowledge or dexterous manipulation" [53] was a matter for acrimonious debate. "The one school, of which Inness is as much a type as is Church of the other, *believes;* the other *sees,*" [54] said Jarves.

Interestingly enough, both *The New Path* critics and Jarves praised the work of Vedder. Jarves, who had known Vedder's work in Italy, praised his color and individuality, and his imagination, which he described as "active and acute in its pantheistic sympathy with the mysterious, grand, terrible, or desolate in nature." He liked his solitudes "that recall primal desolations, where no living thing could be, unless it was some monster more fearful even than the awful silence of a nature dumb with the terror of its own creation." [55] But, recognizing the division in the art world, he suggested that Vedder would find a more sympathetic market for his suggestive art in Boston than in New York. *The New Path* found "the technical merit" of *The Lair of the Sea Serpent* "considerable," praising the exact representation in both the sea serpent and the landscape.[56] Ignoring the terror, the critic spoke of the literalness of the rendering, objecting only to the fact that the serpent was too blunt-headed to make much speed. *The New Path* could accept the element of imagination because it was based not on fantasy but on the seen—and the critic denied that imagination could otherwise be set in motion or find form. *The New Path* critics had already pointed out that imagination for them could be only the product of literal vision. In his paintings, then, Vedder had done the seemingly impossible: he had united *The New Path*'s "simply seen" with the highly individual expression required by Jarves and been judged successful on both counts.

Vedder's particular talent was appreciated elsewhere, too. In 1864 he was made an associate of the National Academy of Design and in the next year a full member. He joined the Athenaeum Association and in 1864 became a member of its Art Committee.[57] His illustrations for Tennyson's *Enoch Arden* of the same year won him a sizable check and much praise from the publishers, Ticknor and Fields, who wanted him further to illustrate a book of his own

61. RIGHT
The Lost Mind, 1864-65, oil on
canvas, 39⅛ x 23¼. S 57. The
Metropolitan Museum of Art,
New York; bequest of Helen Lister
Bullard in memory of Laura Curtis
Bullard, 1921.

62.
The Lost Mind, 1865, oil on wood,
12½ x 7¾. Helen Foresman
Spencer Museum of Art,
University of Kansas.

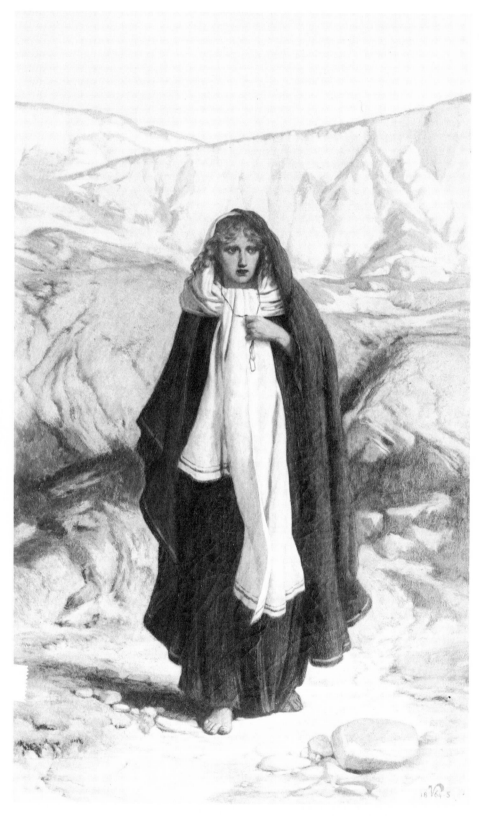

63.
Drawings related to *The Lost Mind.* Left, 1866, 2¼ x 2⅜; S D68. Right, circa 1866, 2⁹∕₁₆ x 2¼. Pencil on paper mounted on paperboard. The Harold O. Love Family.

choosing (he suggested Longfellow's "Skeleton in Armor" and made at least five drawings for the work).[58] In a little less than two years Vedder had won a special place in American art.

The harsh and lonely landscape gave Vedder the emotional environment for another disturbing picture in 1864, equally silent and probing. *The Lost Mind* was quickly purchased shortly after it was completed in 1865 and became a memorable image in the repertory of American art. There is nothing overtly histrionic about the picture, yet there is no question about the deep inner disturbance of the lone figure. Nor is there any doubt that more is involved than her having lost her way in an inhospitable landscape. Yet no specific changes in the observed material can be detected. The strange rock forms, possibly remembered from Volterra or the dry, eroded forms along the Mugnone, do mimic the contours of the heavy robes, and the overabundant folds of the scarf and cloak suggest more motion than the figure, yet the effect is one of inhibition and uncertainty. The expressionless, classical face with unfocused eyes is fixed like an enigmatic symbol so that the picture seems less that of a figure walking than the startling juxtaposition of a hypnotic face with a directionless landscape. The strange, somewhat Pre-Raphaelite drapery blocks out all sense of the body beneath and renders it helpless. The huge scarf creates a horizontal barrier over which the face peers as if across an unbreachable frontier. And the whole is seen with a feverish intensity that permits no escape. Possibly it is this relentlessness of the observed image, not allowing the intent viewer means for expressive escape, that gives the painting its peculiar force. Certainly it is an example in which nature provides no solace to the mind; to the lost mind nature offers no healing reason. It stolidly remains not soul but matter.

As a kind of pendant to *The Lost Mind,* Vedder created a similarly disturbing image in his small painting *The African Sentinel,* also finished in 1865. The

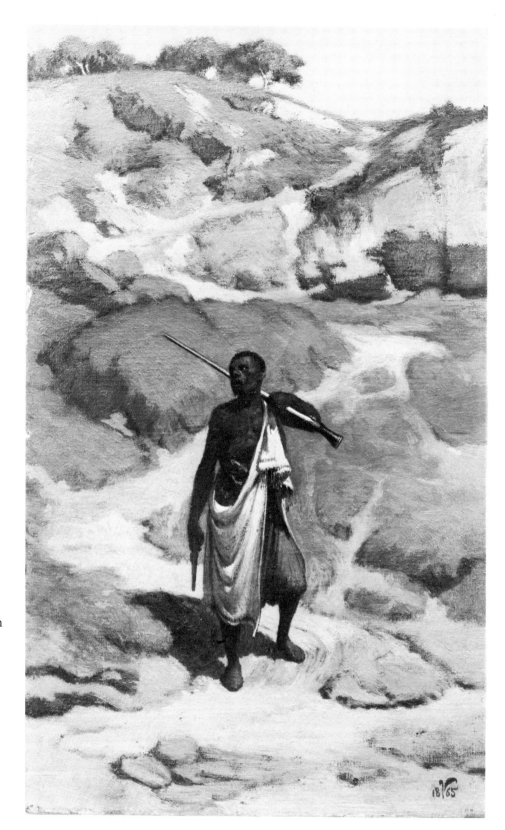

64.
The African Sentinel, 1865, oil on
canvas, 14¼ x 8⁹⁄₁₆. S 56. The
Metropolitan Museum of Art,
New York.

65.
Cohasset, Boys and Barrels, 1864,
oil on wood, 4 x 6½. S 43.
National Academy of Design,
New York.

66.
Cohasset, 1864, oil on wood,
4 x 7½. S 44. National Academy
of Design, New York.

stark figure of a half-nude black stands isolated in a brilliantly lit, harsh land-
scape, and, although the soldier is fully armed, the sense of impending attack
from an undetermined source makes him seem vulnerable and frighteningly
alone. Like *The Lost Mind* it found a purchaser immediately.

Tempting as it might be to describe Vedder at this point as a painter given
over to the enigma or even to a lurking sense of paranoia, it must be noted that
he was not to be so typed. He was still willing to paint landscapes that did not
turn the viewer back upon himself, such as those he painted at Newport and
Cohasset in 1864. To be sure, even in these richly colored little scenes there is
often a hint of extra meaning, but it is more to be sensed as an emotional over-
tone than as an identifiable significance.

Then as good salable items he continued to paint scenes from the Italian

68. RIGHT
The Lonely Spring, 1865, oil on canvas, 10 x 14¼. S 59. Kennedy Galleries, Inc., New York.

67.
Study of a Broken Down Tree, Newport, 1864, oil on wood, 7⅜ x 9½. S 54. Davison Art Center, Wesleyan University, Connecticut.

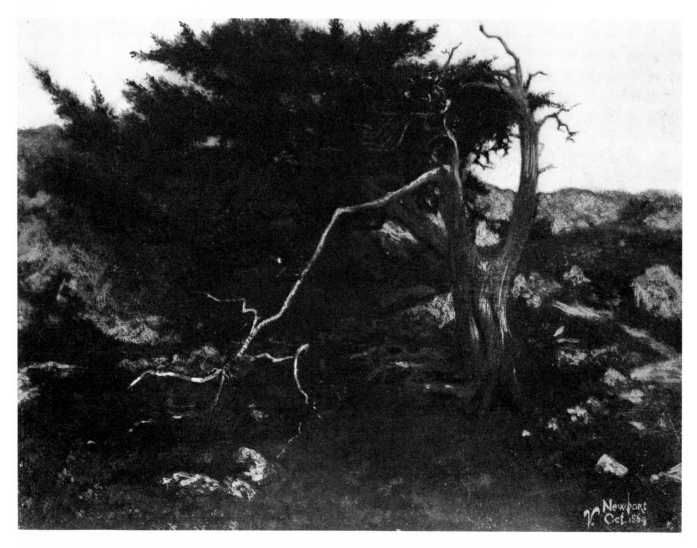

69.
Musical Party, circa 1865, oil on canvas mounted on paperboard, 7¾ x 10¼. S 72. Staten Island Museum, New York.

Renaissance and literary glimpses, such as *The Knight's Signature, Jealousy,* and *Young Bacchus* (all exhibited in 1864) or *The Revelers,* finished in Boston in 1865. In addition to his painting and illustrating he turned to sculpture in his early days in New York, producing two reliefs, *Endymion* and *The Arab Slave,* and a sculpture described by Jarves as the *Tree Imps,* "exquisitely beautiful, ludicrous, and poetical." Said Jarves, "We know of nothing more characteristic in Grecian art, or better conceived, in spite of modern humor being superadded to the grotesqueness of the antique idea." [59] In fact, once Vedder left the United States and returned to Europe he seems to have lost interest in creating works such as *The Questioner of the Sphinx* or *The Lost Mind;* his personal expressiveness found other means. His understated, enigmatic works belong to a brief period of some two or three years spent in New York or Boston. In this short time he had begun and terminated a phase of his work that some would accept as his most characteristic expression.

By 1864 Vedder was already thinking of returning to Europe. Paris was his immediate goal this time, in spite of the fact that his father wrote warning him of the pitfalls of that sinful city, and his earlier experiences there had not been particularly gratifying. But some critics suggested that his technique needed strengthening, and Paris had become the center for sound painting methods. Besides, he longed to get back to Europe.

70.
Girl with a Lute, 1866, oil on
canvas, 16 x 9. S 78. Jo Ann and
Julian Ganz, Jr.

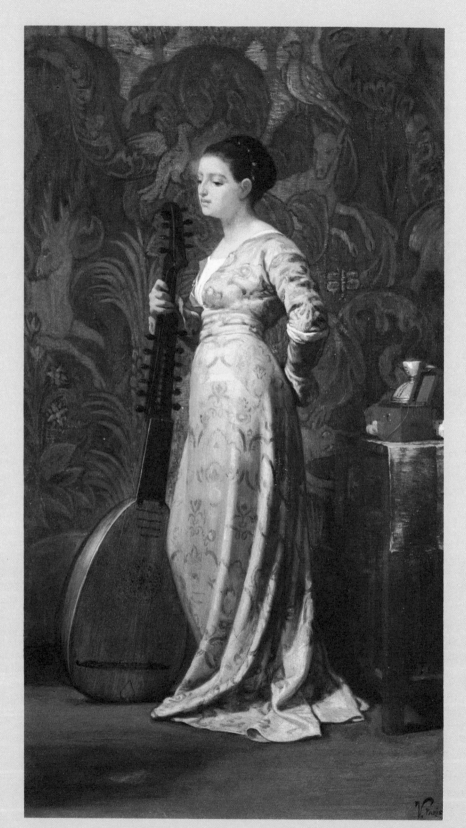

In Paris, where he arrived at the very end of 1865, he quickly settled down to work, fending off the American friends and well-wishers who threatened to take up his time. Although he recognized the values others found in Paris, he remained there "with the vision of Italy ever before my eyes." [60] In his effort to satisfy his critics and make an appeal to the market, he produced a carefully studied and richly executed little painting (fig. 70) that was to be the first of a recurring theme. The subject was simply that of a pensive young woman in Renaissance costume holding an antique stringed instrument that rests on the floor, standing before an elaborately figured tapestry. There is a much greater sense of substance than in any earlier work, and the color is rich and varied. Unlike his fifteenth-century subjects, however, the antique aspects of the painting serve no particular story; they simply provide a historical detachment for an appealingly sensuous dream. It was to this vaguely designated time and place—historical without specific epoch—that Vedder habitually returned when he wanted to concentrate on physical beauty. The remnants of past grandeur that he now began to collect (he had bought the lute for $200) helped to create an art-historical neverland that provoked reminiscences of Florence but was unhampered by unnecessary historical information. The atmosphere of *Girl with a Lute* is that of a provocatively stocked studio, not a historical room. This is not a shortcoming but a positive contribution. The pensive young woman lives not in Florence but in a world of art, a world of artistic perception. There is no story to tell, and yet the senses and the imagination are transported to an arrested eddy of time in which their exercise had full rein.

The painting was purchased at once by a recently organized company that promised to give Vedder the support he needed but which quickly failed. With an eye to the market, his new patrons encouraged him to carry out a project that he had conceived on his way back from Italy in 1860 while stranded in Cádiz. This was a set of nine panels illustrating Aesop's fable of "The Miller, his Son and the Donkey." "At Cadiz I was homesick for Italy," he wrote, "and in that mood I drew all the designs in little for 'The Miller, his Son and the Donkey,' as a sort of *in memorium* farewell testimonial." [61] Only now, it seems, on his way back to Italy, was he encouraged to develop them into paintings. At least one was finished in Paris and sold there, the second panel in the series. He continued with the project in Rome although he was hardly away from Paris when he received a letter from Mr. Chapin, his would-be supporter, telling him not to spend time on the fable but to paint more single figures.[62] Paintings such as the *Girl with a Lute* apparently had more attraction on the market, much to Vedder's often expressed annoyance. Vedder believed his calling was that of a landscape painter, and he continued throughout his life to paint the small, freshly observed landscapes such as he had begun in Florence. Yet all of his major paintings from now on would deal with the figure. Many would refer back in character to the little painting from Paris, the *Girl with a*

71.
Drawings for *The Fable of the Miller, His Son and the Donkey*, numbers 1-7 and 9, 1860-61, pencil on paper, each approximately 3 5/16 x 5 7/8. S D33-40. Mr. and Mrs. Lawrence A. Fleischman.

Lute, even though his fiancée expressed impatiently to Vedder's father that she would prefer his finishing works like *The Ninth Hour* instead of paintings like "the Lute Player and Italian Peasant Girls." [63]

At Dinan and Vitré, long the haunts of artists in Brittany, Vedder resumed his landscape painting with C. C. Coleman and William Morris Hunt, creating again the simple, direct studies by which he kept in contact with the nature around him. In December 1866, stopping in Bordighera on the way to Rome, he rediscovered the twisted olive trees and coastal pines of his earlier Italian stay, painting them now with a new vigor and self-confidence. He showed, moreover, a sure sense of color and a delight in using rather complicated structures of planar forms. Once in Rome he resumed his association with Thomas Hotchkiss and Nino Costa and professed himself as never so happy as when he and his companions were searching out new motifs in Perugia, Gubbio, or other spots in the Roman or Umbrian hills.

To talk about "development" in Vedder's landscapes is misleading. In general it is possible to sort them by period of execution, but differences are more the result of the motif—how it affected Vedder's imagination or with whom he was painting—than of consistent change. First of all are those simple luminous panels, often tiny, that remain true to tenets of his *Macchiaioli* friends in Florence and his companion Costa. The beautiful little view *Outside Porta San Lorenzo, Rome*, with its ambiguous flat planes and deep perspective, and deep shade and brilliant sun, could almost have been painted by Sernesi or Lega. Its long narrow composition recaptures the effect of Vedder's Mugnone paintings of some eight years before. Yet it does show a greater confidence in painterly suggestion, a somewhat more rugged use of contours, and a greater degree of expressiveness.

In July and August of 1867, Vedder took a trip to the area around Perugia, which made an extraordinary impression on him. Possibly in part it was the joy

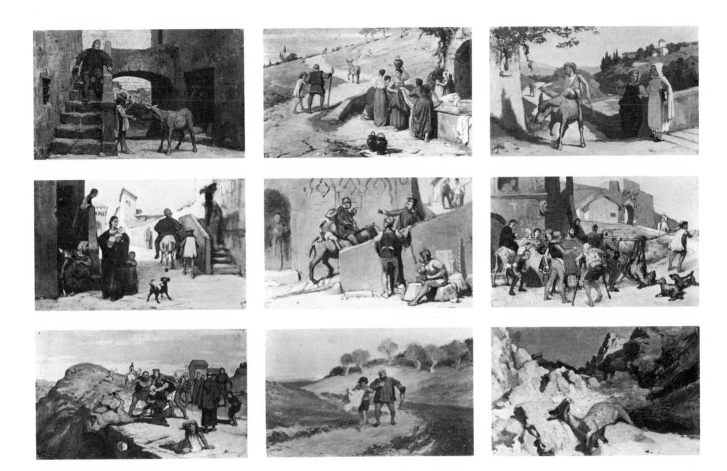

of finding himself once more in the hilly Italian landscape that he had remembered throughout his years in the United States, and then he found that Hotchkiss had mellowed to become an inspiring companion on such a jaunt. Forty years later he still remembered vividly the evening he discovered a tiny hill town that both at once saw in terms of their own painting. It was, he wrote, "one of those little hermit-like hamlets left over from the Middle Ages. . . . It was evening: and so it was in a vast shadowed foreground, while the pale barren mountains back of it had taken on a rosy glow." [64] Both he and Hotchkiss painted the scene — although Vedder had found it, Hotchkiss "begged to be allowed to paint it also" — but although they may have begun in more or less the same mode, what Vedder developed from his studies must have seemed a bit strange to a follower of Holman Hunt, even though Hotchkiss had somewhat relaxed his Pre-Raphaelite manner. For Vedder, looking back while writing his *Digressions,* the painting that best summarized the magical scene was much simpler than the views he painted on the spot. The barren hills have become a simple succession of colored planes, the trees are massed to build a soft, atmospheric pattern, and in the foreground a group of haystacks, improbably placed but effective in pushing the little town back in space — and seemingly in

72.
The Fable of the Miller, His Son and the Donkey, circa 1867-68, oil on canvas, 6½ x 10¾. S 148-56. John and Enza Kiskis. (Arranged left to right, top to bottom.)

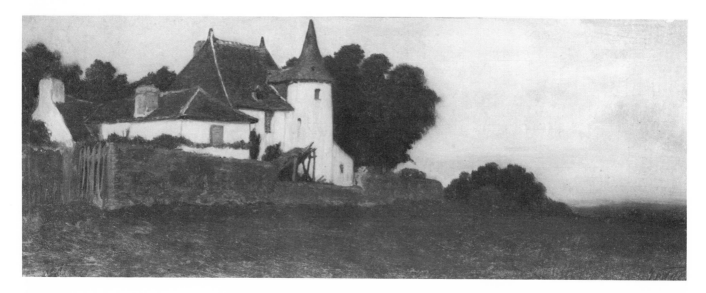

73.
Old White Houses, Vitré, 1866,
oil on canvas mounted on
paperboard, 5⅛ x 12. S 85. The
New-York Historical Society,
New York.

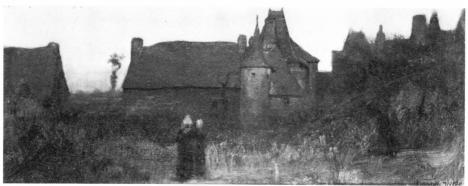

74.
Vitré, France, Evening, 1866, oil
on canvas, 5 x 13. S 87. National
Academy of Design, New York.

75.
*Woman Planting a Flower Pot,
Vitré,* 1866, oil on canvas
mounted on paperboard, 7¾ x
11¼. S 93. The Hudson River
Museum, Yonkers, New York;
gift of American Academy of Arts
and Letters, 1955.

76.
Girl Sewing, circa 1865, oil on
wood, 8¾ x 6¾. S 74. National
Academy of Design, New York.

79.
Detail of Old Building, circa 1866,
oil on wood, 8¾ x 5¾. S 5.
Kennedy Galleries, Inc.,
New York.

77.
San Remo: Old Stairway, 1866,
oil on canvas, 12¼ x 5⅛. S 101.
The Museums at Stony Brook,
New York; gift of American
Academy of Arts and Letters,
1955.

78.
San Remo — Old Tower, 1896
(after original of 1866), oil on
canvas, 14⅞ x 5⅞. S 99. The
University of Virginia Art
Museum.

80.
The Old Mill, Bordighera, 1869,
oil on canvas, 12¾ x 16½.
Graham Gallery, New York.

81.
*Windswept Olive Trees,
Bordighera,* 1869, oil on canvas,
5 x 12½. S 104. The Museums at
Stony Brook, Stony Brook, New
York; gift of American Academy
of Arts and Letters, 1955.

82. RIGHT
Outside Porta San Lorenzo, Rome,
circa 1867, oil on canvas, 4 x 10.
The New Britain Museum of
American Art, Connecticut; gift
of American Academy of Arts and
Letters.

83.
Outside Porta San Lorenzo, Rome,
circa 1867, oil on wood, 14 x 25½.
S 126. The J. B. Speed Art
Museum, Louisville, Kentucky.

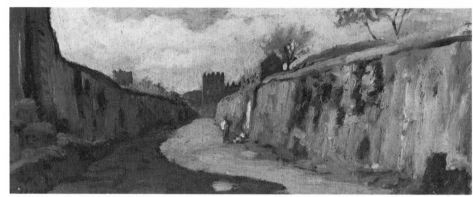

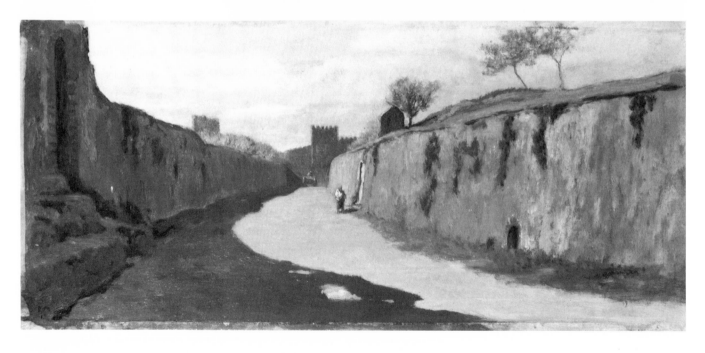

84. ABOVE
Perugia on way to Gubbio, 1867,
oil on paper mounted on canvas,
5¾ x 11½. S 123. The J. B.
Speed Art Museum, Louisville,
Kentucky.

85. BELOW
Le Casacce or *By the World
Forgot*, 1867, oil on paperboard,
12⅝ x 11⅝. S 120. The Smith
College Museum of Art,
Massachusetts; gift of American
Academy of Arts and Letters,
1955.

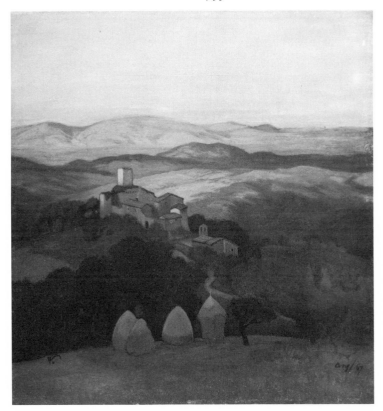

86. RIGHT
Near Perugia, 1867, oil on canvas,
16¾ x 7. S 122. Mr. and Mrs.
John H. Brooks.

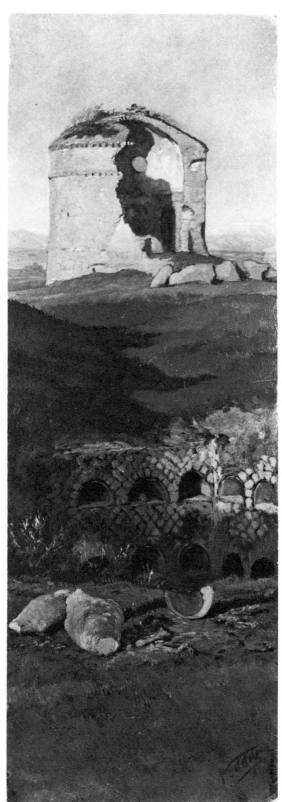

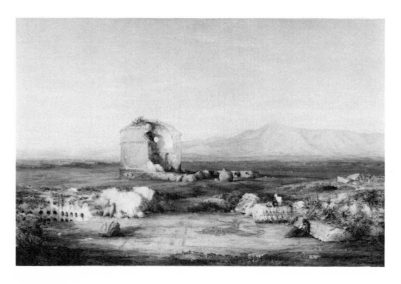

87.
Thomas H. Hotchkiss (1834?-69),
Torre di Schiavi, 1865, oil on
canvas, 22¼ x 34¾. National
Collection of Fine Arts.

88.
Ruins, Torre de' Schiavi, circa
1868, oil on wood, 15½ x 5¼.
S 146. Munson-Williams-Proctor
Institute, Utica, New York; gift of
Mr. Robert Palmiter.

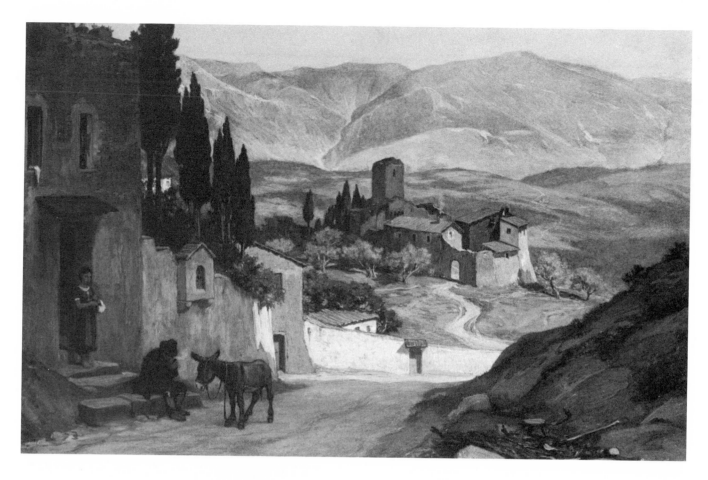

time—set a kind of rhythmic pattern for the design. *By the World Forgot,* Vedder called the painting when he reproduced it.

89.
Near Perugia, 1870, oil on academy board, 8⅜ x 13⅜. S 198. Mr. and Mrs. Otto Wittman.

The contrast between the two artists is instructive. A year or so before Vedder returned to Rome, Hotchkiss had painted one of his favorite subjects, the Torre de'Schiavi on the Roman campagna, recording with loving care the foreground details and the clear atmosphere in a way that Vedder much admired. Yet when Vedder set out to paint the same scene, fully aware of its association with Hotchkiss, he saw it as a haunting pattern, specific in its shapes and mood, but noncommittal when it came to the specific surfaces of things.

Nor was Vedder concerned about the accurate recording of detail—accurate, that is, in a geographical or geological sense. For this reason it is not always easy to be specific about the locale of his paintings, and they would never serve as guides for the stone by stone reconstruction of a disappeared monument. His goal was the construction of an artistic object that had evocative powers, rich in reminiscence, and he rarely deviated from it. Whether he was painting directly from nature or composing or completing a work in his studio, he retained a fresh, simple manner of painting that convinces the viewer that he himself is looking creatively. Once he had seen and recorded a landscape, it

became a part of his thinking and might be called upon later to complete the theme or mood on which he was working. The appealing cluster of buildings near Perugia, for example, appeared a few years later in the background of an elegantly finished landscape (fig. 89) of which the foreground was compounded of material from other sources. Yet the painting has a convincing unity because all of the parts came together as a single image in Vedder's imagination. By the 1870s Vedder had acquired a personal repertory of Italian landscape images that could be summoned when needed to merge into a persuasive new identity. For example, something of the same house forms that appear on the left in his painting *Near Perugia* of 1870 are a reversal of houses that he had studied in 1867 which he used in slightly different form in his street scene in Bordighera of 1872 (fig. 90). Yet in each case the elements are quite at home. Of course in *Near Perugia* he created a few cypress trees behind his favorite cluster of buildings "by the world forgot" in order to relate them better to the new foreground.

90.
Bordighera Street, 1872, oil on canvas, 27½ x 15. S 226. The Currier Gallery of Art, Manchester, New Hampshire.

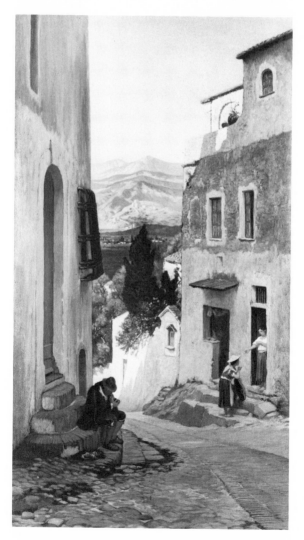

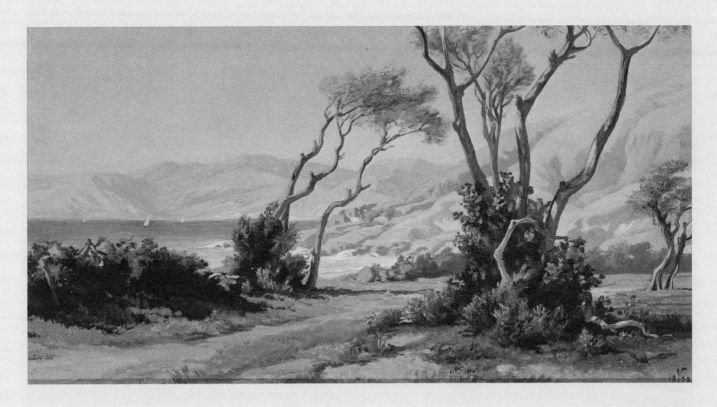

91.
Windswept Olive Trees,
Bordighera, 1872, oil on canvas,
9 x 16⅝. S 225. Graham
Williford.

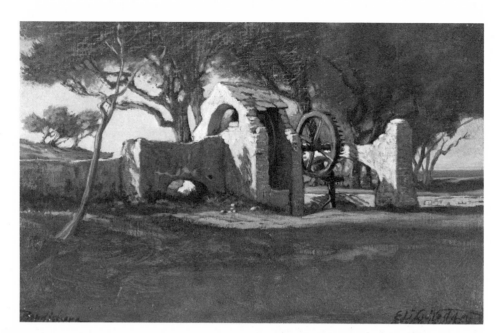

92.
Old Mill Wheel, Bordighera, circa
1866, oil on canvas mounted on
paperboard, 8½ x 13. S 186.
Davison Art Center, Wesleyan
University, Connecticut.

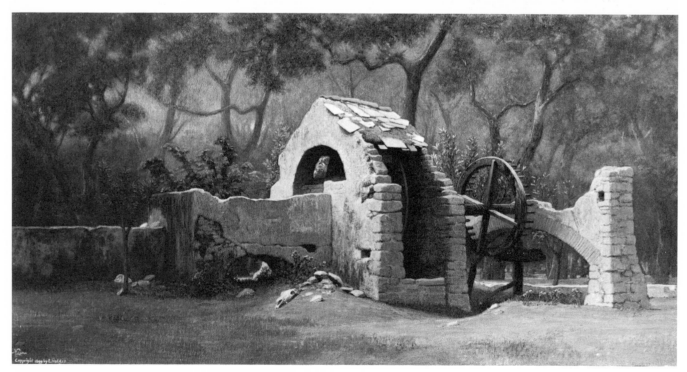

93.
Old Mill Wheel, Bordighera, circa
1879, oil on canvas, 19¼ x 38¾.
S 185. The Detroit Institute of
Arts; gift of Mr. and Mrs. Harold
O. Love.

In looking at the brilliant little painting of Bordighera dated in 1872 (fig. 91) one cannot but be persuaded that the artist was painting with the glowing scene before his eyes, yet the composition and the principal rhythmic trees come from the spirited study Vedder made on his way back to Italy in 1866. What one sees through the trees, however, is quite different. The middle-ground rocks reaching into the sea are different in form and have different buildings, and across the sparkling stretch of water a sun-swept stretch of hills appears that was not so much as hinted at in the earlier study. Vedder has, moreover, added dramatic interest to his foreground shapes, twisting a wily root and branch through the clump of foliage at the right, which is echoed in a new entanglement of bushes on the left and commented on by the reshaped tree in the right distance. Vedder could make such transformations because he saw nature not as a collection of things but as a series of striking visual impressions. The identity as thing followed; it did not precede the persistent impression.

Sometimes in a landscape by Vedder, specificity belongs to the fabricated part, the remembered impression is that relating to nature. A good many years after painting a picturesque old mill at Bordighera in a free, luminous fashion, he created a detailed painting of the scene in which every stone and falling tile is given due concern. In order that the new, detailed textures would stand out as they should, he created a whole new forest behind the mill. Yet for all its finish, the later painting remains a unified vision of nature and does not become a visual inventory of natural fact.

Vedder's way of working makes it difficult and, in fact, very nearly irrelevant to talk of his development as a landscape painter or to trace his wanderings through his paintings. He continued to paint from nature and to compose his landscapes until the end of his life, still referring back to earlier motifs at least as late as 1911. Rather than falling into temporal or geographical categories, his landscapes more readily divide into thematic groups according to form. There are the twisted, rhythmical trees from Bordighera or Anzio, where he painted with Nino Costa, there are the planar, vertical compositions that naturally seem to grow from hill towns—Colognola, Perugia, Tivoli—and there are the open expanses with successive layers of nicely profiled hills drawn from the campagna, the towns around Rome, or the rolling vistas of Umbria and Tuscany. Each had its own kind of lyrical principle. Later in his life Vedder tended to pay more attention to rough texture, as in some of the views at Viareggio, but for the most part his vision was surprisingly constant.

In the winter of 1889 Vedder was invited by George F. Corliss to join him on a trip up the Nile and for the first time Vedder had a chance to see the country he had depicted so provocatively in one of his earliest successful paintings. The landscapes that resulted from the trip were a kind of confirmation of his youthful imaginings. Stark and gaunt, they seem places of ghostly enchant-

94.
Tivoli, Near Rome, circa 1878, oil on canvas mounted on paperboard, 9 x 4½. S 326. The Butler Institute of American Art, Youngstown, Ohio.

95.
Little Shrine Subiaco, circa 1878, oil on canvas mounted on wood, 10 x 4. S 329. The Butler Institute of American Art, Youngstown, Ohio.

96.
Montefiascone, circa 1879, oil on
canvas, 11¼ x 15¼. Mr. and Mrs.
Wentworth Darcy Vedder.

97. OPPOSITE LEFT
Italian Scene—Pompeo, 1879, oil
on canvas, 12½ x 9¼. S 350.
Museum of Art, Rhode Island
School of Design, Providence;
Museum Works of Art Fund.

98. ABOVE
Landscape at Palo, 1874, oil on
paper mounted on canvas, 8³/₁₆ x
16¹³/₁₆. S 246. The University of
Michigan Museum of Art; Paul
Leroy Grigaut Memorial
Collection.

99. RIGHT
Bordighera, circa 1880, oil on
wood, 12½ x 8. St. Augustine
Historical Society, Florida.

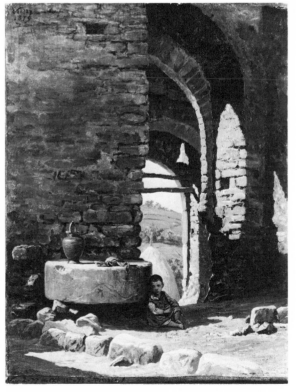

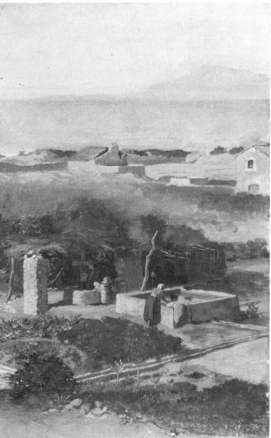

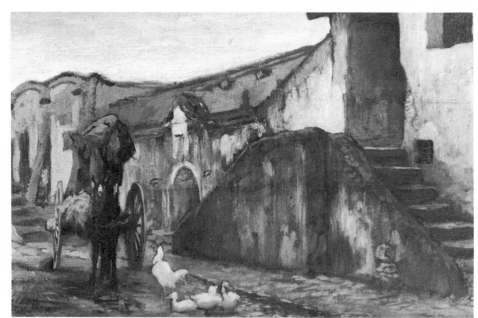

100.
The Wine Cart—Monte Testaccio,
1872, oil on canvas, 8¼ x 13⅛.
S 328. Staten Island Museum,
New York.

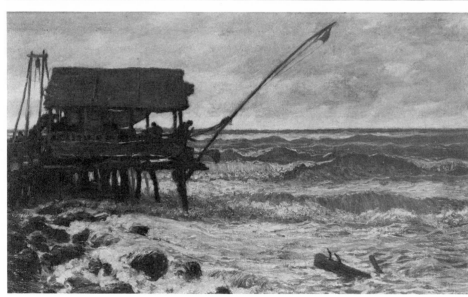

101.
Fishing Hut on Pierhead,
Viareggio, 1880-1911, oil on
canvas, 7⁹⁄₁₆ x 12¹⁄₁₆. S 406.
The Harold O. Love Family.

ment. There is little foliage and few traces of living beings. It must have
seemed to Vedder that he had returned to the imagery of his youth, but now
found it actually before his eyes. He recognized it at once and made the most
of it.

All of Vedder's landscapes are small, many of them tiny, and this has its
effect. Although one might attempt to justify their diminutive size by pointing
out that many were painted on the spot and thus had to be portable, many of
them that are equally small were clearly not immediate records. There is a
special charm in a small painting, as Meissonier in France well recognized,

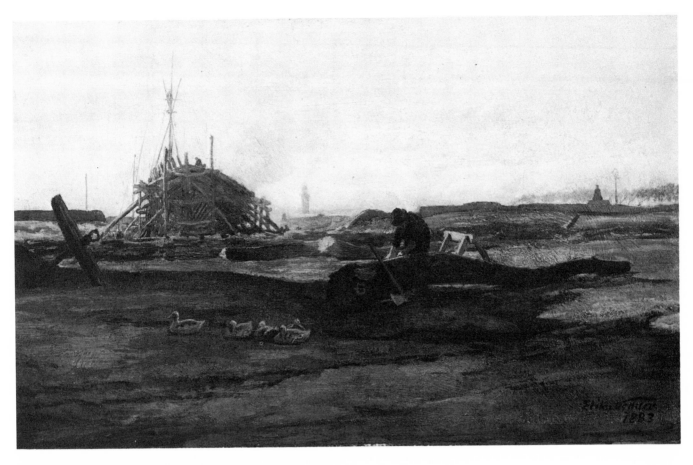

102.
Shipyard, Shipbuilding or *Dockyard, Outer Port, Viareggio*,
1883, oil on canvas, 9½ x 15½. Graham Gallery, New York.

103.
Viareggio, circa 1880-83, pencil on
paper, 3⅜ x 5⁷⁄₁₆. S D170.
Mr. and Mrs. Lawrence A. Fleischman.

104.
Viareggio, circa 1880-83, pencil on
paper, 3⅜ x 5½. S D170.
Mr. and Mrs. Lawrence A. Fleischman.

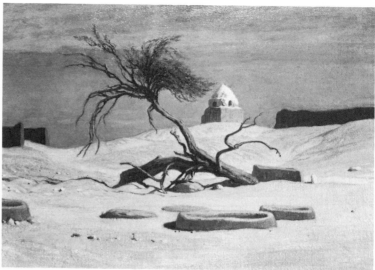

105. ABOVE, LEFT
Assuan, Egyptian Tomb at Moonlight, 1890, oil on canvas, 12 x 13. S 460. Kennedy Galleries, Inc., New York.

106. ABOVE, RIGHT
Old Tree on Way to Tel El Armarna, 1890-91, oil on canvas, 11½ x 17. S 463. Kennedy Galleries, Inc., New York.

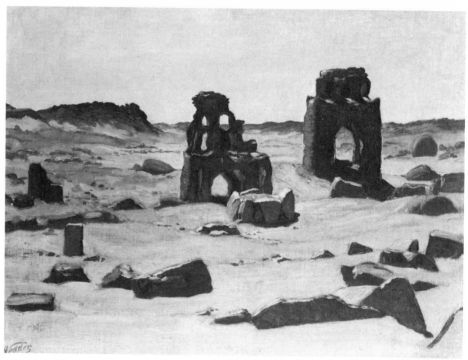

107.
Tombs at Assuan, 1890, oil on canvas, 11 x 14¾. S 458. Kennedy Galleries, Inc., New York.

since it demands a close scrutiny that effectively cuts off all awareness of the surroundings. The viewer is invited to push in, to become a part of the tiny universe within the frame. Unlike Meissonier, however, Vedder rarely offered the rapt observer a dense collection of eye-catching detail. On the contrary, he presented only a total luminous environment, often rich in color, in which the general effect was sustained without the interference of distracting identifications. Trees became trees more through their rhythm or shadowy density than through a description of their leaves and bark. The simple planes of color did

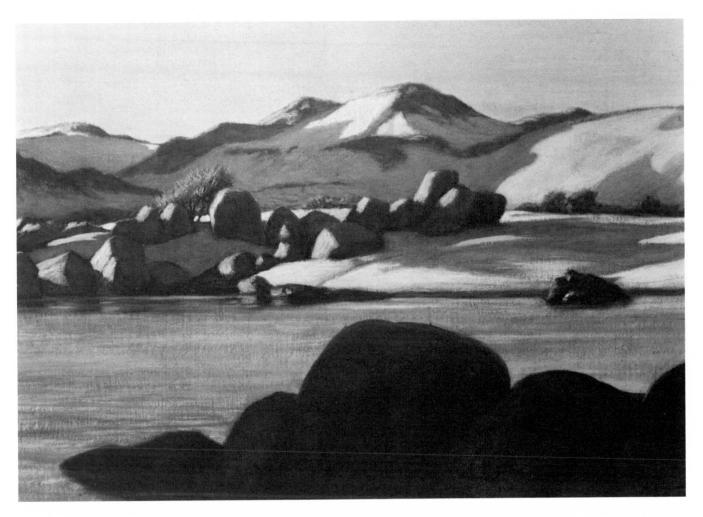

108.
Egyptian Nile, 1890, oil on
canvas, 10½ x 15. S 457.
Kennedy Galleries, Inc.,
New York.

little to articulate the nice distinctions between leaf and leaf. As a result, the
mind does not assess the parts but is left free to speculate, to remember. Many
of Vedder's landscapes have a kind of nostalgic appeal as if, although they are
vivid to the eye, they speak in a past tense. "By the world forgot" might be a
general title for all of these little landscapes, which preserve a calm and simple
beauty that was threatened with extinction by the business of modern life even
at the time they were painted.

Distracting as were his pleasurable painting trips with friends to the
countryside, Vedder continued after his return to Rome in the 1860s with his
somber speculations on the more desolate aspects of human life. His *The
Philosopher* or *Hermit in the Desert*, which he sold in Rome in February 1867,
was a continuation of his New York mood. The rocky landscape with its rhyth-
mically painted boulders could be an extension of the hostile spaces of *The Lost
Mind*. The hermit crouches close to the rocks as if to seek a warmth that they
cannot provide. In what might be considered a sequel, he painted probably in

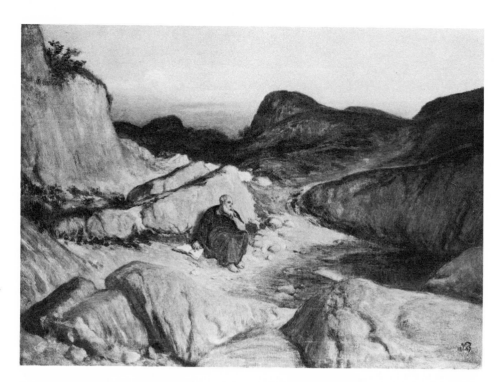

109.
The Philosopher or *Hermit in the Desert*, 1867, oil on canvas, 14⅞ x 21. S 106. The Newark Museum, New Jersey.

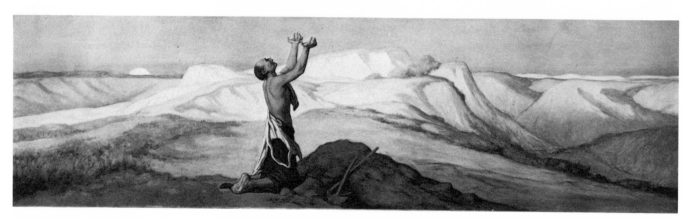

110.
Prayer for Death in the Desert, circa 1867, oil on canvas, 14 x 49½. S 114. The Brooklyn Museum, New York; gift of American Academy of Arts and Letters.

the same year a rather melodramatic *Prayer for Death in the Desert* in which once more an isolated figure is cut off from human contact and looks toward the continuation of life without hope.

Looking back on these paintings of desolation in his *Digressions* of 1910, Vedder noted that "there was not lacking that rich, romantic sadness of youth. I had it very badly and enjoyed it immensely; otherwise how account for my preparations for dying young, preparations for which event were amply provided for in numberless subjects I then conceived, but, with few exceptions, never executed: the alchemist dying just as he had made his grand discovery; the young hermit praying for death; the old man at the gate of a graveyard; the end of a misspent life; and a lot of other things. What I mean is that in a great

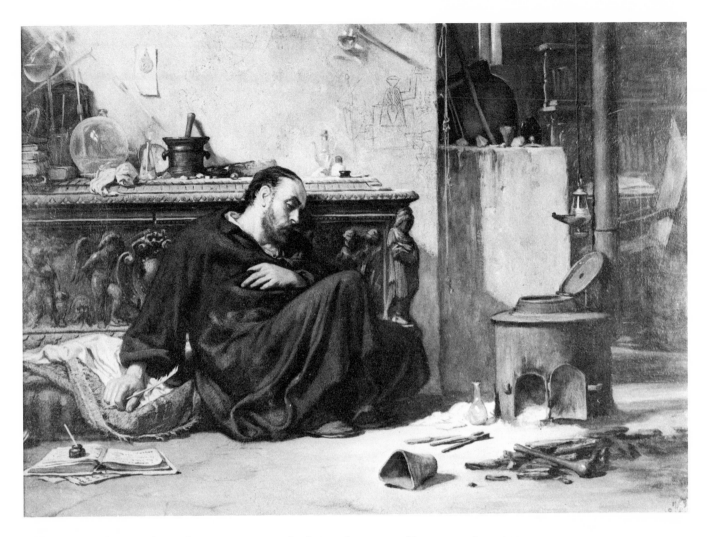

111.
The Dead Alchemist, 1868, oil on wood, 14½ x 20⅜. S 134. The Brooklyn Museum, New York; bequest of William H. Herriman.

many of the things I have done since prevails that sadness peculiar to youth, and its survival shows how much of youth I yet retain." [65]

The final painting of *The Dead Alchemist*, finished in Rome in 1868, added his new Paris specificity of technique to the affecting composition he had devised in New York four or five years before. Like the *Girl with a Lute* (fig. 70), the panel is richly crowded with significant things, although in this picture they are there to tell the story. The elaborately carved cassone, the carefully selected flasks and retorts, the heavy cloth on which the alchemist's hand has come to rest, so beguile the eye that some of the dramatic force is lost. Death seems to come more gracefully in a well-appointed laboratory; the thrust of the arm is less abrupt, the robe more elegantly disposed, and the hand no longer clutches. But in spite of the attention to a multitude of specific things, the grim notion of futility comes through.

Characteristic of the melancholy turn of Vedder's imagination as a young man is his account of painting *The Plague in Florence*. [66] According to his story,

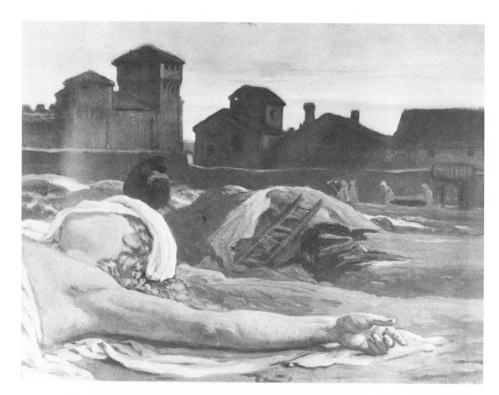

112.
The Plague in Florence, circa 1867, oil on canvas, 8½ x 11½. S 113. Lee B. Anderson.

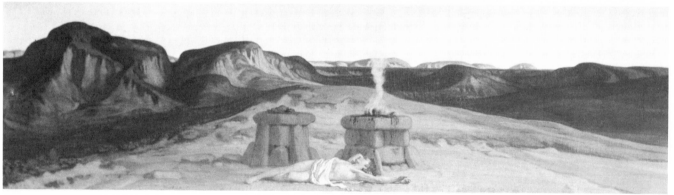

113.
The Dead Abel, 1869, oil on canvas, 12¼ x 45¾. S 174. Mr. and Mrs. John D. Rockefeller 3rd.

wanting to paint a study of an arm, he decided to use the blank foreground area of a painting with houses and a sunset. "No sooner had I painted in this arm lying stretched on the ground," he wrote, "than I foresaw the picture." He added the half-burned rags and a group of monks, partially covered the head, identified the skyline with the silhouette of the campanile in Florence, and he had his grim picture of the plague. Actually the painting he was working on at the time, for which he was making a study of the arm, was not much less melancholy. It was his depiction of *The Dead Abel*, the lifeless body stretched out in the foreground of a characteristically gloomy and resistant landscape. It was at this time also that he conceived of his *Cumaean Sibyl* and while he was in New York in 1869 he was commissioned by David Gray to paint a small

version of it. Already having burned six of the sacred books that Rome has refused, the persistent sibyl is striding across the dark landscape to offer the last three to an unheeding humanity. The whole effort is that of pending doom.

The final version of this painting was executed in Rome in 1876. The figure shows the rumpled linear style of drapery and the forceful drawing that characterized many of Vedder's allegorical works beginning in the late 1860s, yet it belongs to his series of vengeful landscapes in which the drama is carried as much by the setting as by the figure. It has a richness of texture, however, that quite separates it from the Italian views and even from such paintings as *The Lost Mind.* By the mid-1870s Vedder had developed a rich and decorative manner of painting for his subject pieces and tended to regard some of his earlier, more simply painted works, as unfinished. Equally dramatic in color and tone although somewhat simpler in form was his haunting painting of 1879, *Sphinx of the Seashore.* Different from his early enigmatic paintings, the depiction of nature here is lush and overtly dramatic. Although the format is not especially different, Vedder in this painting is already blending the style of his symbolic and allegorical painting with his view of landscape. Yet it should be noted that this was a matter of selective mode. At the same time he continued to paint his innocent studies of the Italian countryside.

Another mode evident in Vedder's painting of the 1870s was the continuation of what for want of a better term might be called human still lifes, begun with his appealing *Girl with a Lute* of 1866. These were sometimes centered on a single figure surrounded usually by a patterned environment, but more often consisted of the somewhat abstractly painted head of a woman shown against a carefully chosen background. He called these latter "ideal heads," but they were not ideal in any classicizing sense of the term. They were ideal only in the aura of detachment he succeeded in giving them. Like the *Girl with a Lute* they express a disembodied beauty, sensuous but more allied with art than with nature. One of the most congenial is *Eugenia*, which depicts the head and shoulders of a young woman dressed in Renaissance costume, posed against a stamped leather background. In handling it much suggests the Paris painting although it is even richer in color and texture. More typical are the more smoothly painted heads that emphasize neat contours and compact shapes, although the painting of a sultry young woman in a cap of 1882 (fig. 126) continues the richly worked surface. All of these heads suggest a specific, often exotic, milieu and are quite different from the paintings of seductive beauties that were made popular through widely circulated prints. Attractive though they may be, Vedder's young women remain aloof in their artistic enchantment.

Not unrelated to these silent beauties is the little painting of a nude model (fig. 127) surrounded by artifacts suggesting Venice, painted in that city in 1878. Obviously a studio piece (there is even a vase with brushes), it makes no

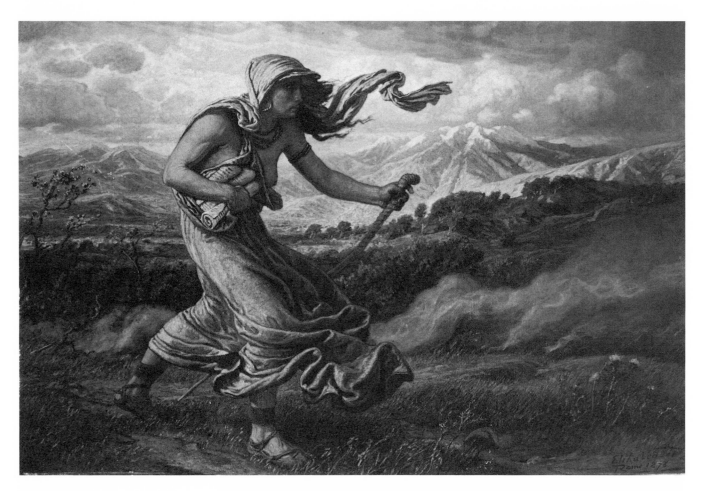

114.
The Cumaean Sibyl, 1876, oil on
canvas, 38 x 59. S 298. The
Detroit Institute of Arts;
Founders Society Purchase.

115.
The Cumaean Sibyl, 1872,
watercolor on paper, 12 ⁵/₁₆ x 20¾.
S D99. The Brooklyn Museum,
New York; bequest of William H.
Herriman.

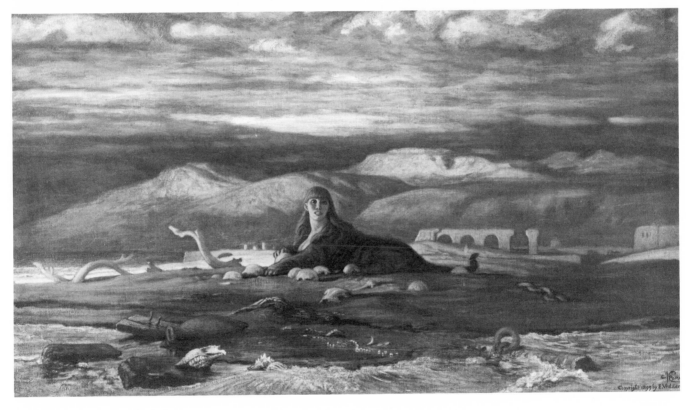

116. ABOVE
Storm in Umbria, 1875, oil on
canvas, 13 x 45. S 259. The Art
Institute of Chicago; Friends of
American Art Collection.

117. BELOW
Sphinx of the Seashore, 1879-80,
oil on canvas, 16¼ x 28¼ (sight).
S 379. Mr. and Mrs. John D.
Rockefeller 3rd. (See also
figure 180.)

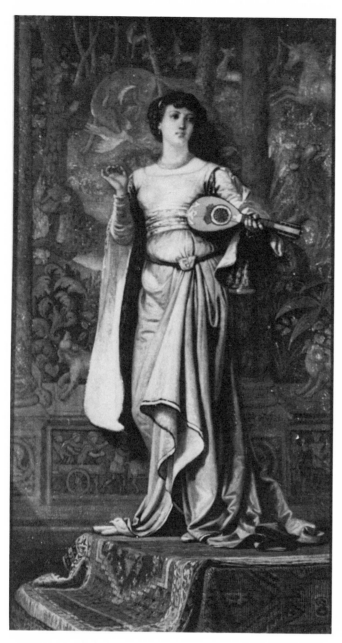

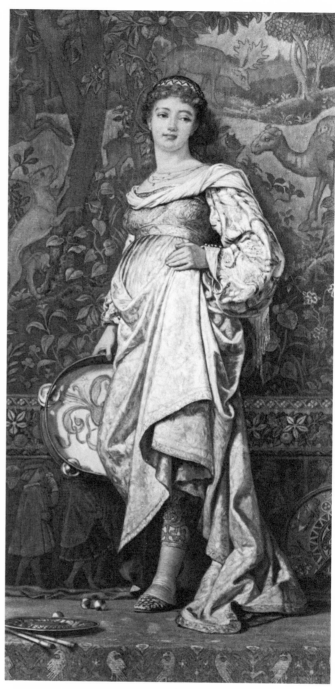

118.
Musical Inspiration, 1875, oil on
canvas, 28½ x 15½. The
Parthenon, Nashville, Tennessee;
James M. Cowan Collection.

119.
Dancing Girl, 1871, oil on canvas,
39 x 20. S 207 or 209.
Barbara B. Millhouse.

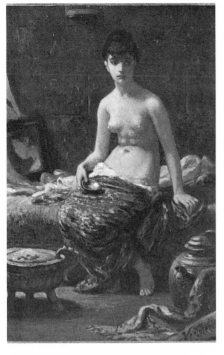

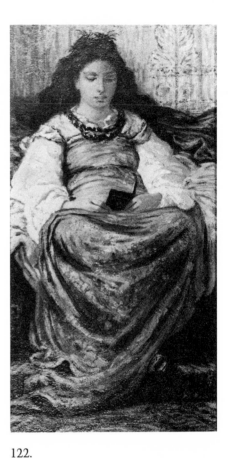

121.
Ideal Head (Eugenia), 1879, oil on
wood, 11¾ x 9¾. S 346.
Museum of Fine Arts, Boston.

120.
Nude, circa 1868, oil on wood,
9⅛ x 6 (sight). S 141.
The Harold O. Love Family.

122.
*Girl Reading in XVth Century
Costume*, circa 1879, oil on paper
mounted on canvas, 11½ x 5½.
S 344. The Hyde Collection,
Glens Falls, New York.

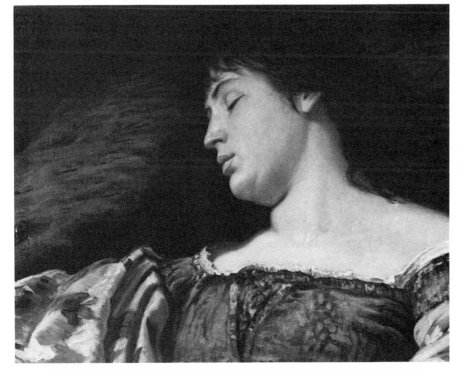

123.
The Sleeping Girl, 1879-83, oil on
canvas, 18¼ x 15. S 345. Akron
Art Institute, Ohio.

124.
Ideal Head, 1872, oil on canvas,
14½ x 14. S 231. Mr. and Mrs.
E. P. Richardson.

126. RIGHT
Ideal Head, 1882, oil on canvas,
14⁵⁄₁₆ x 13⁵⁄₈. S 394. The
Brooklyn Museum, New York;
gift of Mrs. Harold G. Henderson.

125.
Giorgina, circa 1886, oil on
paperboard, 12 x 10½. S 429.
Delaware Art Museum,
Wilmington.

pretense of harboring a narrative or having a significance beyond its sensuous charm. Yet like the ideal heads it exists in an environment of art, the nude human figure being looked at with the same detachment as the carved figurehead. The picture of a Venetian barge and sketch of a gondola relate, of course, to the truncated figurehead and serve to conjure up a particular nostalgic ambience, but that alone would seem to be their purpose. What counts is a sentiment of objects, not a narrative.

A rare still life of these years carries this suggestive realm of things even farther. In 1871 Vedder recorded having received three trunks of Japanese materials, the effects of his recently deceased brother who had been serving for some years as a naval surgeon in Japan, and then as physician to the court.[67] The *Japanese Still Life,* signed in 1879, is doubtless the assembly of some of the most precious of the objects, each painted with close attention to its texture and detail. It is not, however, to be seen as only a play on forms and color, nor

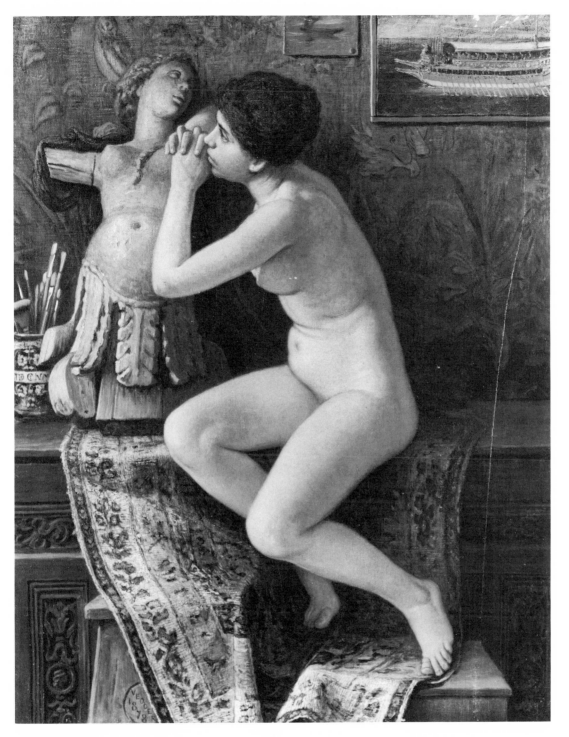

127.
The Little Venetian Model, 1878,
oil on canvas, 18 x 14¾. S 322.
Columbus Gallery of Fine Arts,
Ohio; Schumacher Fund Purchase.

128.
Narcissi, 1869, oil on paperboard,
11 x 5⅛. S 177. The Harold O.
Love Family.

130.
Pansies and Spirea, 1882, oil on
canvas, 28³/₁₆ x 16⁵/₁₆. S 389.
Yale University Art Gallery; gift
of Jo Ann and Julian Ganz, Jr.

129.
Japanese Still Life, 1879, oil on
canvas, 21½ x 34¾. S 387.
Los Angeles County Museum of
Art; gift of American Art Council.

in any practical way is there suggested a reason for these objects to be together.
The objects produce their own kind of life in the imagination: the brocaded
flowers bristle and the herons stalk. Vedder invited the viewer to enter imagi-
natively into the life of things, in this case particularly exotic things. In a way
the painting is art admiring art, confusing the boundary between the repre-
sentation and the objects shown, a double appeal to the sensuously triggered
imagination. Vedder looked at objects of art as he did at nature, as if at any
moment an expressive transformation would take place, and yet the depiction
is precise and undistorted. In this mode, the transformation takes place in the
imagination, not in the eye.

The decade of the 1870s proved to be a particularly rich period in Vedder's
work, and one in which a gradual but persistent change became evident. What
might be called his perceptual painting—painting which took its departure
from a visual experience in nature, although it is evident that for Vedder per-
ception and imagination were inseparable—reached its fullest expression but,
at the same time, began to play a smaller part in relation to his total production.
His fantasy was projected in terms of bold rhythmic forms which themselves

109

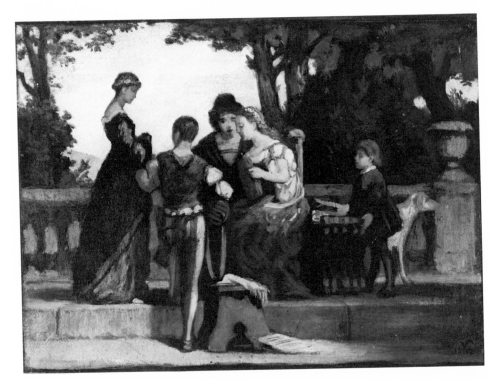

131.
The Music Party, 1868, oil on
canvas, 8½ x 11⁹/₁₆. S 129.
The Brooklyn Museum,
New York; bequest of William H.
Herriman.

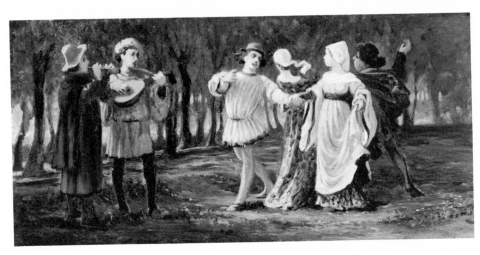

132.
Dance Under the Ilex Trees or
Burghers Dancing or *The Lovers—
Villa Borghese*, 1874, oil on wood,
6½ x 12¾. S 254. Schweitzer
Gallery, New York.

seemed possessed of a secret vitality. Already they are strongly present in *The
Cumaean Sibyl* of 1876, and in *Greek Girls Bathing*, dated 1877 (fig. 161), and
in the large painting *The Phorcydes*, signed in 1878 (fig. 153), the rhythmic
vitality dominates the canvas. And yet the calm studies of nature go on, as if
they were the constant that provided stability for Vedder's fertile imagination.
Although he delighted in the role of *improvisatore*, he found a different kind
of freedom in being absorbed into the constant beauty of the Italian landscape.

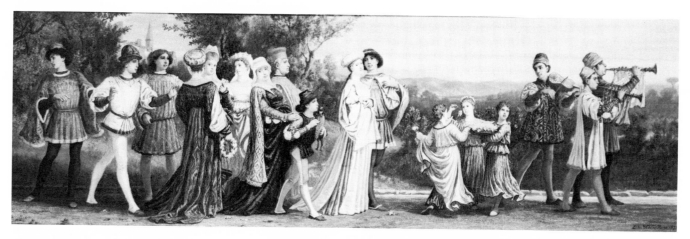

133.
Wedding Procession, 1875, oil on
canvas, 18⅛ x 58¹⁵/₁₆. S 223.
The Brooklyn Museum,
New York; bequest of William H.
Herriman.

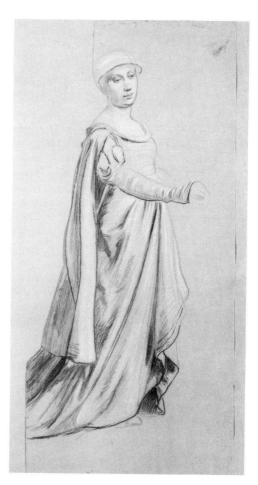

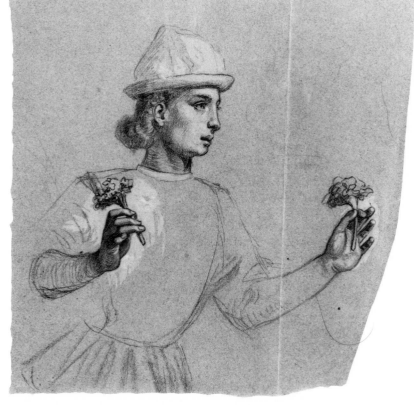

134. LEFT
Woman in costume; study for
figure in *Wedding Procession*,
1871-72, crayon on paper mounted
on paper, 16¾ x 7¹¹/₁₆. S D112-20.
The Cooper-Hewitt Museum of
Design and Decorative Arts,
New York.

135. ABOVE
Man with flowers; study for figure
in *Wedding Procession*, circa
1872, pencil and gouache on
paper, 7½ x 7⅞. S D111. The
Cooper-Hewitt Museum of
Design and Decorative Arts,
New York.

NOTES

1. Elihu Vedder, *The Digressions of V.* (Boston and New York: Houghton Mifflin Company, 1910), pp. 332-33.

2. *Il Gazzettino delle Belle Arti del Disegno* 1, no. 14 (April 20, 1867): 83.

3. Vedder, *Digressions of V.*, pp. 142-45.

4. Ibid., p. 146.

5. On the Caffè Michelangiolo see Piero Bargellini, *Caffè Michelangiolo* (Florence: Bellecchi Editore, 1944) and Telemaco Signorini, *Caricaturisti e Caricatuarati al Caffè Michelangiolo*, ed. Baccio M. Bacci (1893; Florence: Lelice Le Mounier, 1952). See also Telemaco Signorini, "Il Caffè Michelangiolo," *Il Gazzettino delle Belle Arti del Disegno* 1, no. 19 (May 25, 1867); no. 22 (June 15, 1867); no. 25 (July 6, 1867); no. 26 (July 15, 1867); and nos. 27-28 (July 29, 1867). *Il Gazzettino* has been published in facsimile by Gonnelli Figli (Florence, 1968), with an excellent introduction by Alberto Maria Fortuna.

6. On Nino Costa see, in particular, Nino Costa, *Quel che vidi e quel che intesi*, ed. Giorgia Guerrazzi Costa (Milan: Fratelli Treves Editori, 1927); also Olivia Rossetti-Agresti, *Giovanni Costa, his Life, Works and Times* (London, 1904).

7. In the past few years there has been an extraordinary amount of literature on the *Macchiaioli*. The material is well summarized in the catalogue of the exhibition *I Macchiaioli nella cultura toscana del' Ottocento*, Florence, Forte del Velvedere, 1976. (Catalogue edited by Dario Durbé with an essay by Sandra Pinto and documentation by Francesca Errico and Laura Rago.)

8. Regina Soria, *Elihu Vedder: American Visionary Artist in Rome (1836-1923)* (Cranbury, N.J.: Fairleigh Dickinson University Press, 1970), pp. 93-94.

9. Vedder, *Digressions of V.*, p. 164.

10. Ibid.

11. Ibid.

12. Ibid., p. 165.

13. On Mrs. Hay see Alberto Maria Fortuna, introduction to the Gonnelli Figli facsimile of *Il Gazzettino delle Belle Arti del Disegno*, p. 28. This information comes from Mario Simone, ed., *Saverio Altamura, pittore-patriota foggiano nell' autobiografia nella critica e nei documenti* (Foggia, 1965), p. 32 and notes, p. 87. See also Mattia Limoncelli, *Napoli nella pittura dell' Ottocento* (Milan and Naples: Riccardo Ricciardi Editore, 1952), pp. 59-81. Altamura's son Alessandro, by his first wife, whom Vedder mentions, became a painter in Paris. Mrs. Hay bore Altamura two sons, Lello and Pito.

14. The description was published in *Il Gazzettino delle Belle Arti del Disegno* 1, no. 13 (April 13, 1867): 100-101.

15. Simone, *Saverio Altamura*, p. 32.

16. *Il Gazzettino delle Belle Arti del Disegno* 1, no. 14 (April 20, 1867): 405-9.

17. Simone, *Saverio Altamura*, p. 32.

18. Vedder, *Digressions of V.*, p. 159. On Inchbold see Allen Staley, *The Pre-Raphaelite Landscape* (Oxford: Clarendon Press, 1973), pp. 111-23.

19. Vedder, *Digressions of V.*, p. 161.

20. Ibid., p. 159.

21. Ibid., p. 161.

22. Ibid., p. 418.

23. Ibid., p. 160.

24. Stanislao Pointeau (1833-1907) was a Florentine painter, much influenced by Nino Costa, who frequented the Caffè Michelangiolo and later settled in Pisa.

25. Vedder, *Digressions of V.*, pp. 161-62.

26. Mario Bellandi and Carlo Paoletti, eds., *L'Opera di Antonio Marini Pittore 1788-1861* (Florence: Edizione Arnaud, 1961).

27. Vedder, *Digressions of V.*, p. 465. The painting is reproduced in *Digressions of V.*, p. 147, with the title *Enchantment*.

28. Ibid., p. 154. As he did with so many of his friends, he remembered them also for their pleasure in food.

29. Ibid., p. 145.

30. Vedder described him "a wonderfully clever man, whose style changed with every passing whim of the artistic world, and whose facile hand often ran away with his head" (*Digressions of V.*, p. 165).

31. Limoncelli, *Napoli nella pittura dell' Ottocento*, p. 80.

32. On Thomas H. Hotchkiss see Barbara Novak O'Doherty, "Thomas H. Hotchkiss, an American in Italy," *The Art Quarterly* 29, no. 1 (1966): 3-28; and references in Vedder, *Digressions of V.*

33. Hotchkiss arrived in England sometime before February 6, 1860, and by August was painting with Vedder in Volterra. By the winter of 1860 he was in Rome, where he lived primarily until his trip in 1869 to Sicily, where he died. In the summer of 1865 he was in London, the guest at one point of the Pre-Raphaelite painter Henry Wallis, whom he had met in Italy. In September 1868 he made a brief visit to the United States and visited Venice, probably in the early summer of 1869.

34. Vedder, *Digressions of V.*, p. 418.

35. Ibid., p. 418. At some point in his Roman years, Hotchkiss thought so highly of the Italian painter Farruffini, who composed in the *mac-*

chia manner, that he acquired two of his works.

36. Vedder to his father, Dr. Elihu Vedder, March 13, 1860, in Papers of Elihu Vedder, Archives of American Art, Smithsonian Institution, Washington, D.C. (hereafter referred to as "Vedder Papers, AAA").

37. Vedder to his father, June 7, 1860, Vedder Papers, AAA.

38. Mario Giardelli, *I Macchiaioli e l'epoca loro* (Milan: Casa Editrice Ceschina, 1958), pp. 29-33.

39. Vedder, *Digressions of V.*, p. 172.

40. Alexander Vedder to his father, May 5, 1861, Vedder Papers, AAA.

41. Elihu Vedder to his father, September 1, 1869, Vedder Papers, AAA.

42. Elihu Vedder to his father, November 22, 1861, Vedder Papers, AAA.

43. James Jackson Jarves, *The Art-Idea*, ed. B. Rowland, Jr. 2d ed. (Cambridge: Harvard University Press, Belknap Press, 1960), p. 201.

44. The mounted photograph of the painting, with color added to the depicted unfinished sketch, is in the Archives of American Art. It is reproduced, attributed to Vedder, in Soria, *Elihu Vedder*, as illustration no. 6. The painting is discussed in *The New Path* 2, no. 1 (May 1864): 9-10.

45. Jarves, *Art-Idea*, p. 200.

46. Vedder, *Digressions of V.*, p. 451.

47. Jarves, *Art-Idea*, p. 202.

48. F. C. Ewers to Elihu Vedder, June 24, 1864, Vedder Papers, AAA.

49. *The Round Table* 1, no. 19 (April 23, 1864): 296.

50. Ibid. The critic in this issue of *The Round Table* is one who discussed the Doré association and mentions that Vedder had produced a sketch of the *Pit of Hell*. Doré's works could be had in book form or in sets of photographs. Some critics proclaimed him the greatest exponent of French genius.

51. *The New Path* 1, no. 8 (December 1863): 94. The painting was shown at Suedecor's Gallery in New York.

52. Ibid.

53. Ibid.

54. Ibid., p. 101.

55. Jarves, *Art-Idea*, p. 200.

56. *The New Path* 2, no. 1 (May 1864): 15-16.

57. Athenaeum Association to Elihu Vedder, December 15, 1864, Vedder Papers, AAA.

58. Ticknor and Fields sent him an advance copy of the book in December 1864. Letter from Ticknor and Fields, December 8, 1864, and letter from Vedder, December 16, 1864, Vedder Papers, AAA.

59. Jarves, *Art-Idea*, p. 201.

60. Vedder, *Digressions of V.*, p. 292.

61. Ibid., pp. 172-73.

62. H. A. Chapin, Paris, to Elihu Vedder, Rome, December 12, 1866, Vedder Papers, AAA.

63. Elizabeth Caroline B. Rosecrans (signed Bessie) to Dr. Elihu Vedder, March 22, 1868, Vedder Papers, AAA.

64. Vedder, *Digressions of V.*, p. 426.

65. Ibid., p. 145.

66. Ibid., p. 30.

67. Ibid., p. 471. There are many letters in the Vedder Papers, AAA, from Alexander Vedder describing his activities in Japan.

136.
Boy playing a lute: study for figure in *A Florentine Pic-Nic*, circa 1871-72, chalk on paper, 16 x 12. S D109. The Cooper-Hewitt Museum of Design and Decorative Arts, New York.

137.
The Cup of Death, 1885/1911,
oil on canvas, 44⅞ x 22½. S 438.
National Collection of Fine Arts.

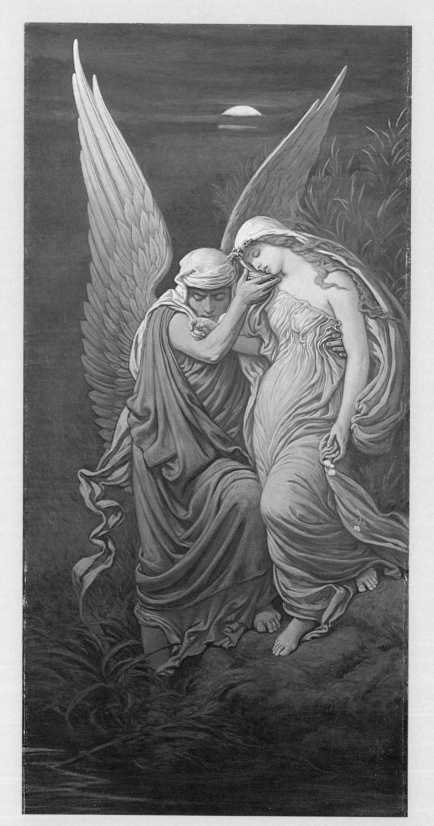

Between Faith and Doubt: Subjects for Meditation

JANE DILLENBERGER

A striking aspect of Vedder's work is the extraordinary change that it manifests from the simple, directly observed works of the 1850s to the formally complex and intellectually suggestive canvases created toward the end of the century. Throughout his career his small landscapes based on studies from nature provided Vedder a constant focus, as if he needed this frank contact with the uncomplicated visual world to stabilize his moods and fancies. But his more ambitious artistic efforts revealed an increasingly thoughtful, ever more questioning mind.

To be sure, the change that began to be evident after Vedder's return to Rome in 1866 was not wholly a reversal of his earlier tendencies; it represented, rather, a gradual shift in emphasis. The melancholy ruminations evident in paintings such as *The Questioner of the Sphinx* and *The Lost Mind* opened the way for more ponderous considerations of the mind in conflict with the temporal world, of the destiny of the sensate individual, and of the relentlessness of fate. More and more Vedder was inclined to search out general truths and spiritual problems and to formulate succinct, symbolic ways of articulating them.

In the late 1860s Vedder made the series of tiny drawings referred to in the introduction by Regina Soria. His English friend, William Davies,[1] described them as being "noteworthy for the serious spiritualism which is in them"; yet Davies went on to remark that the spiritualism is conveyed "with so much substantial realism that they are separated from the work of a mere dreamer."[2]

Vedder clearly thought of twelve of the drawings as a related group, for Davies noted that Vedder intended to reproduce them "in the form of a little table-book."[3] Some had been produced as early as 1866 in Paris and in Dinan, where Vedder had gone to sketch with Charles Caryl Coleman and William Morris Hunt, and some were produced in the United States in 1868 when Vedder had returned there to marry Carrie Rosekrans. The Dinan drawings

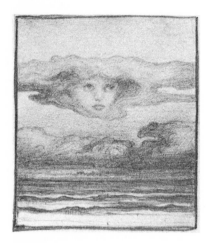

138.
The Face in the Clouds, 1866,
pencil on paper, 3 ¹/₁₆ x 2½.
S D65. The Harold O. Love
Family.

140.
The Shadow of the Cypresses,
1866, pencil on paper mounted on
paperboard, 2⅝ x 2⁷/₁₆. S D74.
Mr. and Mrs. Lawrence A.
Fleischman.

include one that Vedder called *The Face in the Clouds*,[4] which shows the vague
image of a girl's face and hair in the clouds above a lonely seashore. The face
is spectral and insubstantial, yet startlingly human: the sad eyes peer forth
intently, though without focus. Vedder turned back to this conception in 1870,
when he painted *Memory*, a more fully developed version of the same idea, in
which the miragelike face is only visible upon close scrutiny.

In the group of twelve small drawings are several that are related to the
earlier painting, *The Lost Mind*. In these, only the head and shoulders of a
woman with a troubled countenance and downcast eyes is shown, a heavy
scarf wrapped around her head and tied in heavy folds about her neck. The most
finished drawing of this group sets the head against the dark silhouette of
background trees, and the title, *The Shadow of the Cypress*, is inscribed below.
It has been said that this little drawing represents the girl whom Vedder was
to marry in 1869, but if so, it shows a more inwardly directed and reflective
personality for the future Mrs. Vedder than that suggested by the extant photo-
graphs and voluminous correspondence, which evoke a woman of buoyant
spirit, outgoing temperament, forthright character, and practical mind.

To the same series belong the three small pencil drawings of female heads
done in October 1868 while Vedder was staying with the Rosekrans family in
Glens Falls, New York. Each represents a distinct psychic and spiritual state.
The first, dated October 4, is titled *Weirdness* and shows a face surrounded by
hair that seems alive with dark waves below and ascending flames above. The
face, bodiless and neckless, floats above a sharply receding, measureless space;
the woman's dark eyes have a demonic fixity in their constant stare. A drawing
dated October 9 is called *The Soul of the Sunflower* and shows an ardent young
face surrounded by an aura of vibrant petals, looking longingly toward the sun.
If *Weirdness* embodies the demonic and *The Soul of the Sunflower* the angelic, *A
Sea Princess*, dated October 13, suggests a compromise between these opposites.
Davies saw the drawing as symbolizing "in a female head and bust rising from
a turbulent sea, the successful struggles of a soul contending with difficulties,
at last rising above them, and defying the stormy danger which threatens."[5]

Vedder repeatedly painted female heads throughout the years, but he
usually gave them classically regular features and endowed them with a com-
bination of feminine sensuality and serene dignity. The small drawings of the
1860s are different: each embodies a state of the soul.

Among the twelve small drawings was the likeness of *Medusa* (fig. 144)
shown as reflected in Perseus' oval shield, her face a mask of tragedy and grief
as she looks at her hair transformed into fierce snakes tearing at each other with
exposed fangs. Another drawing from the series shows *The Young Medusa*,[6]
whose innocent face is crowned by curling locks, only some of which terminate
in tiny snakes' heads. Vedder was fascinated by Medusa and her tragic history,
and in 1872 privately published in England a short narrative called *The Medusa*

141.
Weirdness, 1868, pencil on paper mounted on paperboard, 2⁷/₁₆ x 2⅝. S D83. The Harold O. Love Family.

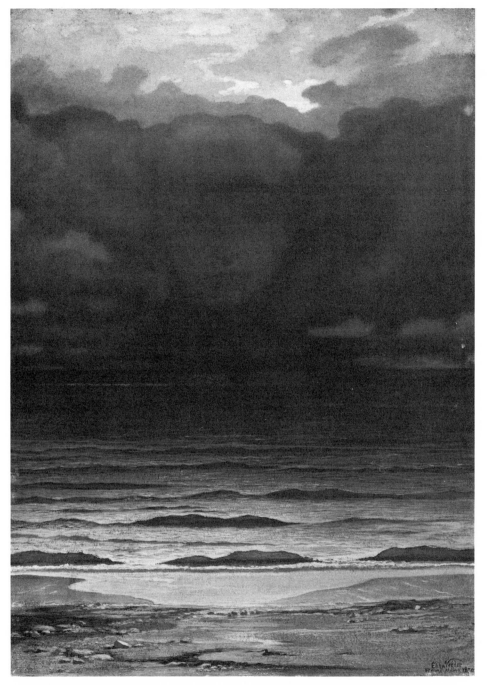

139.
Memory, 1870, oil on wood, 21 x 16. S 202. Los Angeles County Museum of Art; Mr. and Mrs. William Preston Harrison Collection.

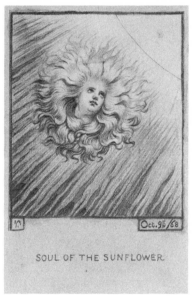

142.
The Soul of the Sunflower, 1868, pencil on paper mounted on paperboard, 3⁷/₁₆ x 2¹³/₁₆. S D84. The Harold O. Love Family.

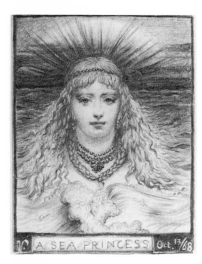

143.
A Sea Princess, 1868, pencil on paper mounted on paperboard, 3½ x 2¾. S D85. Mr. and Mrs. Lawrence A. Fleischman.

144. RIGHT
Medusa, 1867, pencil and ink on paper, 4⁵⁄₁₆ x 3⅜. S D81. Mr. and Mrs. Lawrence A. Fleischman.

145.
The Young Medusa, 1872, pencil on paper, 5⅜ x 4⅛. S D80. Mark Twain Memorial, Hartford, Connecticut.

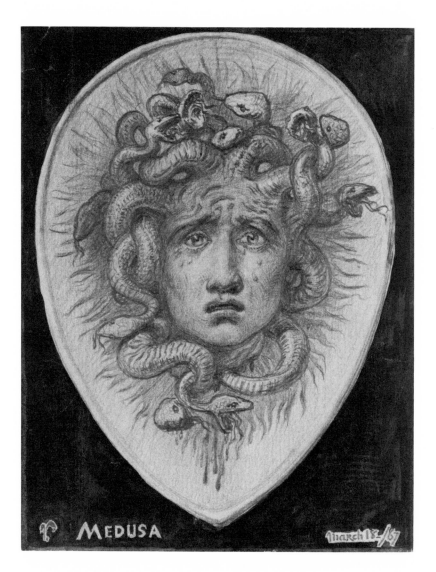

Story. He seemed entranced by the conflict of beauty and ugliness, goodness and evil. By contrast, when he painted his *Medusa* of 1878, he made her heroic, with classical profile and deep-set eyes. Her columnar neck is flanked by flowing hair which, though serpentine, does not terminate in snakes' heads. The intensity of her gaze suggests that her eyes see wondrous sights about which we can only speculate.

In November 1868, while Vedder was still in Glens Falls, he made two small drawings on successive days using a tall, narrow format; both are characterized by a meticulous study of an intimate corner of nature, which sets them apart from the other drawings and, indeed, from the greater body of his work. The first might be an illustration for a poem or a tale: titled *The Elfin Horn*, it represents, as Davies wrote, "a mischievous little Puck, who sits upon a toadstool and blows a mimic tube of hollow club-moss; a tiny forest of the

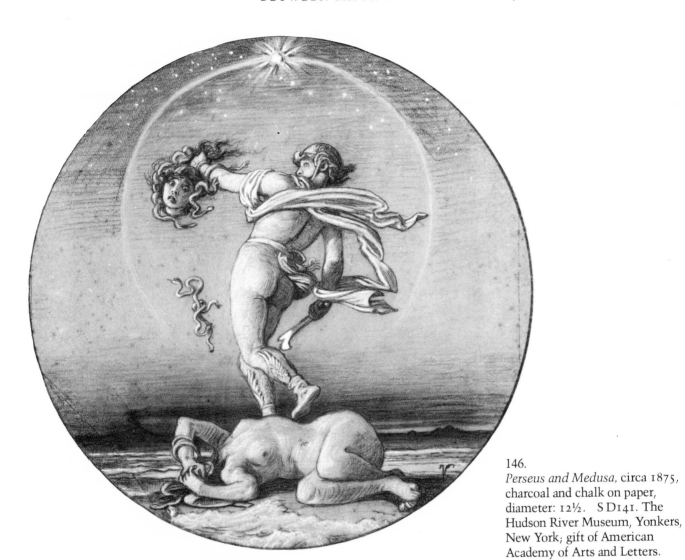

146.
Perseus and Medusa, circa 1875,
charcoal and chalk on paper,
diameter: 12½. S D141. The
Hudson River Museum, Yonkers,
New York; gift of American
Academy of Arts and Letters.

147.
Medusa, 1878, oil on paper
mounted on canvas, 12 x 13.
S 325. The Fine Arts Gallery of
San Diego, California.

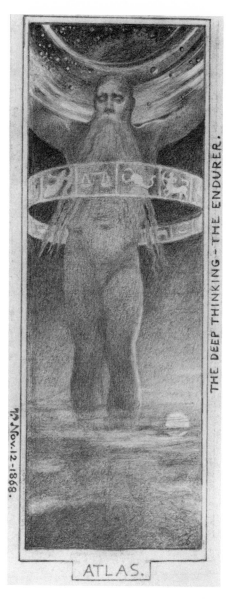

148.
The Elfin Horn, 1868, pencil on paper mounted on paperboard, 4⅞ x 2⅛. S D87. Mr. and Mrs. Lawrence A. Fleischman.

149.
Twilight, 1868, pencil on paper mounted on paperboard, 4¹³⁄₁₆ x 2⅝. S D89. The Harold O. Love Family.

150.
Atlas, The Deep Thinking—The Endurer, 1868, pencil on paper, 6¹¹⁄₁₆ x 2½. S D91. Mr. and Mrs. Lawrence A. Fleischman.

same growth filling the foreground."[7] Something of the mysterious growing properties of toadstools, which sprout up fully grown overnight, is conveyed by these serpentine stems and cuplike crowns. We are given a worm's-eye view of the tiny hummock, which, oddly enough, seems invested with all the vitality and self-sufficiency of a miniature universe.

The second drawing, November 10, is called *Twilight* and shows an autumnal clump of wrinkled seed pods and dried blossoms that fills much of the foreground. A surreal disjunction in space separates these large growths from the background, where a lone, cowled monk is seen near a quaint, thatched monastery with several turrets, reminiscent of those that appear in Vedder's paintings of Vitré. Barren branches of trees are silhouetted against a pale sky in which glows the crescent of a new moon.

As in *The Elfin Horn*, Vedder draws the viewer into his created world, a microcosm complete in itself. There is suggestion of the twilight of the day, the twilight of human life as represented in the distant monk enrapted in his own solitude, and the twilight of the earth's seasons, suggested by the autumnal and desiccated plant forms. Yet the new moon affirms new beginnings, and the coziness of the dwellings locates the scene in a nature that is at harmony with the purposes and presence of man. The eerie and malevolent forces of *The Lair of the Sea Serpent* or the later *Sphinx of the Seashore* do not invade the little worlds of Vedder's *Elfin Horn* and *Twilight*.

Another small drawing dated November 12, 1868, has a cosmic grandeur. Vedder titled it *Atlas, the Deep Thinking—the Endurer*. William Davies, who was alive to, and indeed a stimulus to, the occult dimensions of Vedder's art, described it as "a tall Blake-like figure, supporting the crystal circumference of the universe."[8] In many ways it is remarkably similar to the primordial Adam of the Cabalists, who is represented as a nude giant with flowing beard standing upon the sea and mountainous land, a circular, orbiting band of the planets surrounding his lower torso, and a circular band with the signs of the zodiac about his chest.[9]

Whereas the grand and quiet Atlas seems to hover between dream and myth, the figures in *The Phorcydes*, the last of the series, with their erratic gestures and wildly dancing hair, are animated by a frenetic energy.[10] Vedder seems to have been fascinated by the possibility of a repellent image. The daughters of Phorcys, according to Ovid, "had one eye between them, and they shared it, passing it from one sister to the other."[11]

Many of these small drawings were basic to the themes of Vedder's later painting; *The Phorcydes*, for example, was transformed into a monumental work. Mr. and Mrs. Theodore Shillaber of San Francisco saw the small study in Vedder's Roman studio some years later and commissioned a large painting of the subject. The documentation for the Shillabers' patronage is more extensive than for most of Vedder's commissions and is particularly interesting, since

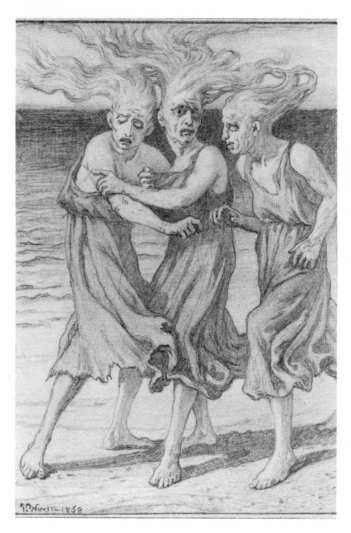

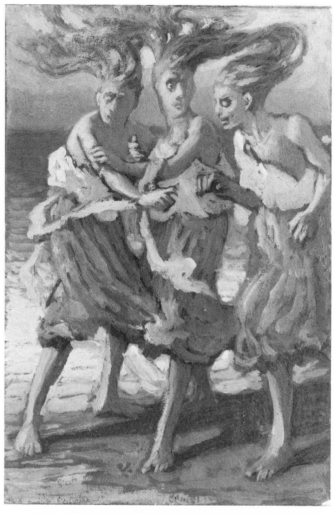

151. ABOVE, LEFT
The Phorcydes, 1868, pencil on
paper mounted on paperboard,
5¼ x 3¾. S D88. The Harold O.
Love Family.

152. ABOVE, RIGHT
The Phorcydes, circa 1868, oil on
paperboard mounted on
paperboard, 5¹/₁₆ x 3⅜. S 138.
The Harold O. Love Family.

Vedder himself provides interpretations for his paintings and gives the reasons
for major changes he made in moving from the first small drawings to the large
painting. As he worked on the figures in his painting of 1878 (fig. 153), many
years after he had made the first drawing, Vedder wrote to Mrs. Shillaber:

> *I have found that in painting them up large that it would not do to
> carry out to the letter my promise to make them as devilish as possible.
> They will be wild enough, but I could not find it in my heart to spoil
> the fine group by making them old and ugly. You will see from the pho-
> tograph what changes I have made, so please get your husband to sus-
> pend judgment until he sees it. As they are at present they are more in
> harmony with the Greek idea from which they were drawn, that is the
> element of beauty enters more largely into them than into the small
> drawing from which they were ordered, which is pretty gothic, but you
> will see for yourself and I am sure you will agree with me and approve
> of this change when you care to think that they are to go on a wall and
> be present to the eye continually.[12]*

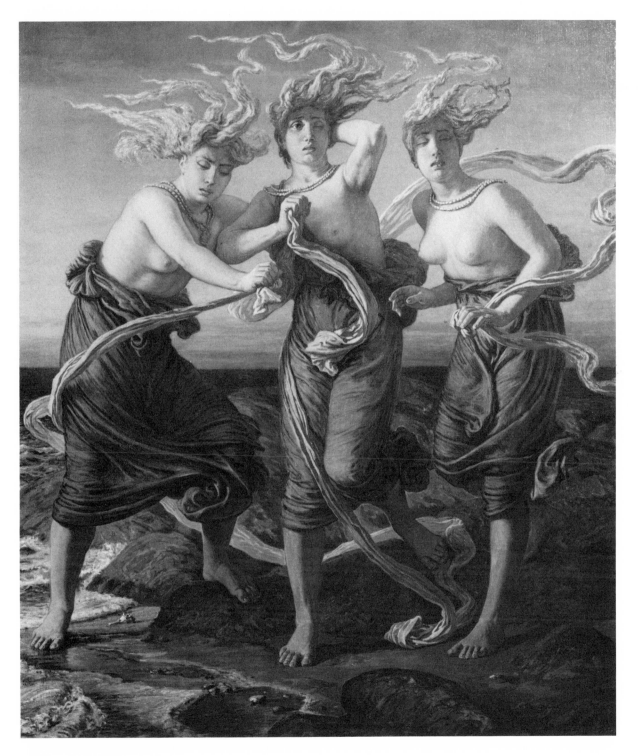

153.
The Phorcydes, 1878, oil on
canvas, 44 x 38⅜. S 310.
Graham Williford.

Mrs. Shillaber was concerned that "the force in the faces" might be lost, but expressed confidence in Vedder's ability to blend the attributes happily. After receiving this painting and the others ordered from Vedder—*The Birth of Spring* and a pair of small paintings, *Hide* and *Seek*—Mrs. Shillaber wrote a lengthy letter to Vedder describing how they were hung in their home and how they were received by their friends:

> *When I drew back the curtain before the picture, the people seemed to feel the cold wind blowing from the seashore, and were almost awe-struck. It seemed as if those poor blind sisters appealed to them for help in their extremity. . . . The drawing and handling of the Phorcydes we think perfection. . . . Some don't like the coloring but that is the great thing which gives feeling to the picture. The sea is cold, the sky is cold, and the wind blows cold, and I think it must be the coloring which pro-duces the effect. . . . The only fault Mr. Shillaber finds is that they are not sufficiently devilish and inasmuch as one was the Shakee or maker of the earthquakes, and one called the Horrifier and one called the Yel-low robed sister, he thinks you have not well carried out the description of them. But what you have done is more powerful and grand . . . it touches everyone, even those who think it no subject for art. Its power is such!*[13]

Vedder was very pleased, and wrote in defense of his larger version that he had made the three gray sisters so alike "because I always saw them so, when I thought of the subject and they for me are so . . . of the same temperament, like Colt revolvers with mutually interchangeable parts."[14]

> *I have intended to hold the mirror up to Nature, only in this case Nature is the little world of my imagination, in which I wander sometimes and I have tried to give my impression on first meeting these strange beings in my wanderings there. So I must use my painting as a mirror and only reflect without explaining. If the scene appears extraordinary all I can say is that it would be still stranger if it were not.*[15]

Vedder's imagination had expanded between 1868 and 1879, encompassing a larger format and a more extensive symbolic repertoire. But the melancholy engendered through the circumstances of his own life brought dimensions of gloom not evident in the earlier paintings.

Vedder and his young American bride settled in Rome in 1869 after a honeymoon at Bordighera, one of Vedder's favorite spots on the Italian coast. Their early married life was marked by financial difficulties and family tragedy. The death of their infant son Alexander in 1872 was followed by that of their five-year-old son Philip, who in 1875 died of diphtheria in Perugia, where the family often went during the summer months to escape the heat and malaria of Rome. Vedder was deeply affected by the death of his sons, especially the loss of Philip, and whatever casualness there may have been in his earlier com-

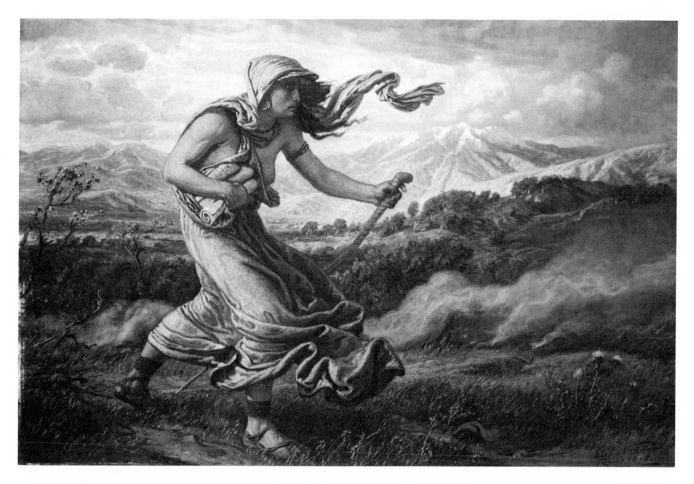

154.
The Cumaean Sibyl, 1876, oil on canvas, 38 x 59. S 298. The Detroit Institute of Arts; Founders Society Purchase.

ments on fate and existence was purged, never to return. The consequent somber mood found artistic expression in *The Cumaean Sibyl*, painted the year following Philip's death, and also in his *Rubáiyát* illustrations. In these, death is the somber accompaniment to the vitalities and joys of life.

THE CUMAEAN SIBYL

Writing about *The Cumaean Sibyl* some time after completing the painting, Vedder said, "I found myself in a mood. As I always try to embody my moods in some picture, this mood found its resting place in the picture 'The Cumaean Sibyl.'" [16] The somber drama of the sibyl, clutching her scrolls as she strides portentously toward Rome, emphasized the new kind of subject matter and a change of style. The subject is epic in its conception, in contrast to the intimate poetic mood of many of the earlier paintings. Also, the painting is larger than Vedder's studio figure pieces or most of his landscapes, and it has bolder rhythms, both in the figure with its convoluted drapery and in the landscape with the turbulent cloudscapes above. All of nature seems involved in the

fateful event. Life, death, and destiny have coalesced in a larger frame of reference.

The face of the sibyl derives from a sketch made several years before in New York, during the Civil War. In his autobiographical *The Digressions of V.*, Vedder wrote:

> At the time I had my studio in the old Gibson Building on Broadway; I used to pass frequently a near corner, where an old negro woman sold peanuts. Her meekly bowed head and a look of patient endurance and resignation touched my heart and we became friends. She had been a slave down South, and had at that time a son, a fine tall fellow, she said, fighting in the Union Army. I finally persuaded her to sit for me and made a drawing of her head and also had her photograph taken.[17]

In 1865 Vedder had made a painting of her, simply called *Jane Jackson* (fig. 156), and had sent it to the National Academy as his diploma piece on being elected an associate member. Years later, when he was formulating his painting

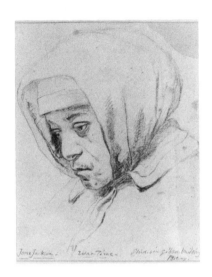

155.
Jane Jackson, circa 1863, colored pencil on paper, 7 x 5¾ (irregular). S D53. The Harold O. Love Family.

156.
Jane Jackson, 1865, oil on canvas, 18 x 18. S 58. National Academy of Design, New York.

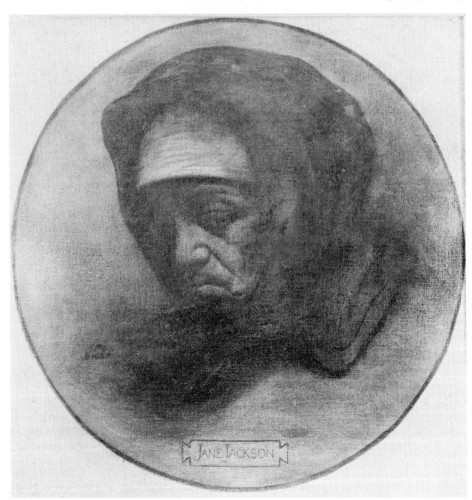

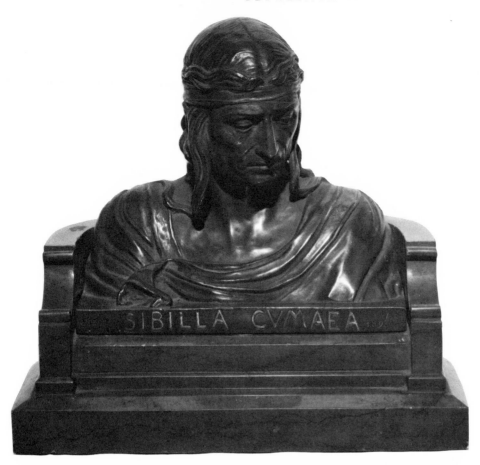

157.
Sibilla Cumaea, 1898, bronze on marble base, 9¾ x 11 x 7¼ (with base). S S17. American Academy and Institute of Arts and Letters, New York.

of the sibyl, the brooding visage of Jane Jackson came to mind and "thus Jane Jackson became the *Cumaean Sibyl*."

The initial drawing of Jane Jackson in 1863 represented her bowed head and sad expression with directness and candor. In the subsequent tondo painting executed two years later, the expression and features had shed their particularity and Jane Jackson emerged as a symbol of suffering and deprivation. Eleven years later, when Vedder returned to her features for *The Cumaean Sibyl*, an even greater transformation occurred. Jane Jackson's expression of meekness and resignation was replaced by bitterness and vengeful determination.

THE RUBÁIYÁT

It was Vedder's introduction to *The Rubáiyát of Omar Khayyám*, however, which served as a catalyst for a more complex and fateful vision. Since the drawings for the *Rubáiyát*, published with the Edward FitzGerald text by Houghton Mifflin in 1884,[18] catapulted Vedder into fame and gave him some financial ease for a time, it was natural for his friends and the world to wonder about the circumstances surrounding the commission. Obligingly, in his

158. OPPOSITE
Title Page for *The Rubáiyát of Omar Khayyám*, 1883-84, chalk, pencil, and watercolor on paper, 14³/₁₆ X 10¹³/₁₆. National Collection of Fine Arts.

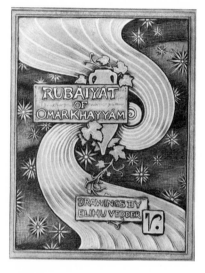

159.
Cover for *The Rubáiyát of Omar Khayyám*, 1883-84, chalk, pencil, and watercolor on paper, 15⁵/₁₆ X 11¾. National Collection of Fine Arts.

Digressions of V. he gave an account of what, as he said, all his friends were "longing to know . . . the *when* and the *where* and the *why* and the *how*" of the making of his drawings for the *Rubáiyát*.[19] Looking back on that period of his life, specifically to the summer of 1871, Vedder wrote:

> *We were living in Perugia when my friend Ellis brought me Omar and introduced him as only Ellis could. Ellis was a man who could read Chaucer, not only so that you understood him, but he converted him into a musical flow of melody. . . . Now this was so far back that it was in the time when Omar, or FitzGerald was only known to Tennyson and his friends as 'Old Fitz' and to a few besides. But in the little Villa Uffreduzi, late in the afternoon, when the sun had gone off the house, in the grateful shade, out of an Etruscan cup, many were the libations of good wine poured on the thirsty earth, to go below and quench the fire of anguish in old Omar's eyes. Thus was the seed of Omar planted in a soil peculiarly adapted to its growth, and it grew and took to itself all of sorrow and of mirth that it could assimilate, and blossomed out into the drawings.*[20]

Immediately, Vedder goes on to tell of the death of his two sons, particularly of Philip who, he says, succeeded in "twining himself about my heart with tendrils nevermore to be relaxed." The death of Philip was associated for Vedder both with the end of his paintings of "dances and picnics—and girls weaving golden nets" and with the eventual development of the *Rubáiyát* drawings.

From the 1870s until his death, FitzGerald's Omar was Vedder's constant companion, a presence that fed his imagination. Just when Vedder conceived of the idea for the *Rubáiyát* illustrations, however, is not clear. In an unpublished preface intended for the *Rubáiyát*, Vedder wrote that he had intended illustrating some of the quatrains many years before he made arrangements with Houghton Mifflin and Company, on a visit to the United States in 1883, to bring out the profusely illustrated volume.[21] He began work on the drawings as soon as the agreement was reached, even before leaving New York in April, and worked on them steadily until March 1884. "I have planned the whole thing, page by page," he wrote in June from Rome to Joseph B. Millet of Houghton Mifflin.

> *I do not intend the drawings to be clear illustrations of the text—except when they naturally happen to be so—they are an accompaniment to the verses, parallel but not identical in thought . . . I fear there are more than 50 designs. The prospect is somewhat formidable but, . . . it is a poem so much in harmony with my thought, that it is suggestion on endless designs . . . My studio is situated in a Villa where it is easy to imagine 'some buried Caesar bled,' and all things conspire to enable me to do justice to the poem."*[22]

RUBÁIYÁT
OF
OMAR KHAYYÁM
THE ASTRONOMER-POET OF PERSIA
RENDERED INTO ENGLISH VERSE BY
EDWARD FITZGERALD
WITH
AN ACCOMPANIMENT
OF
DRAWINGS
BY
ELIHU VEDDER

HOUGHTON MIFFLIN AND COMPANY
BOSTON
COPYRIGHTED BY HOUGHTON, MIFFLIN & CO, 1886

By July 14, seven finished designs were sent off to Boston as samples from which to work out the mechanical procedures.

Vedder planned all aspects of the publication and was in continuous contact with the publisher to have his own way in the choice of format, paper, reproduction method, and binding. He was determined to make it an outstanding work of American book production, even though the publishers were wary of such an expensive venture. Because of the technical demands made by Vedder's plates, usual engraving procedures were impractical and a photomechanical process was finally agreed upon, although Vedder wrote in some consternation: "My idea was that you were going to produce a work by an American artist, engraved by an American engraver, and edited and published by an American firm, which would show that the progress we are so liberal in bragging about had a solid foundation." [23] Once matters were well underway, the publishers gave the venture wide publicity and arrangements were made in England with Bernard Quaritch, who had originally published the FitzGerald translation, to take care of London sales.

The handsomely bound volume, designed throughout by Vedder, was published in Boston on November 8, 1884, and was an immediate success. At the same time, the original drawings could be seen on exhibition at the Arts Club; Vedder had produced fifty-six full-page plates for the book. By Christmas the first of many deluxe editions was issued and before long it was impossible to think of Omar Khayyam without the images of Vedder.

Vedder's illustrated edition of the *Rubáiyát* expresses both his identification with FitzGerald's Omar and the extension of the poet's ideas in Vedder's own thoughts. Omar's message as communicated through the alembic of FitzGerald's versification certainly generated in Vedder what can be described as "the shock of recognition," that experience in which the depths of one human spirit are known by another across dividing time and space. Vedder testified as much in his draft for the "Notes" that always appear, as he requested, after the plates in all editions of his *Rubáiyát*. "Certainly three kindred spirits have here encountered each other and though the first two missed each other on earth by eight centuries, and the last two by twelve months [FitzGerald had died in 1883, just a year before the first Vedder edition was published], still in the heart of the survivor lingers the hope that in life 'sans end' they may all yet meet." [24]

The book provided the occasion and focus for Vedder's own developed and developing ideas. Regarded as such, it is not surprising that the images he made to accompany the works of Omar Khayyám speak more of Vedder and his pictorial world than of the Near East. There is little remaining of the fantasy and strangeness of the Arabian Nights that had been such an attraction for Vedder in his earlier years. Mystery there is, but it is the mystery of Hellenism and Christianity, not of the Orient. In a way, the *Rubáiyát* served only as a catalyst

for Vedder's exploration of his own gradually developed set of values. Although the persistence of fate is a dominating theme for both Omar and Vedder, Vedder is less inclined to accept transciency as the only verity. His attachment to classical philosophy and Christian promise prompted Vedder to emphasize the dilemma of life rather than simply to go along with Omar's acceptance of evanescence. As ever, Vedder preferred to ponder the riddle rather than to embrace a pat solution.

For his own purposes, Vedder rearranged a large central section of Omar's quatrains.[25] Although he used FitzGerald's original sequence for the first thirty verses, he changed the order of verses 31 to 71. Verses 78 to the last, 101, follow FitzGerald's fourth edition of 1879. It should be noted that FitzGerald himself changed the order of the quatrains in the five different editions he produced; Vedder's reordering was not a fracturing of an established unity but the creation of a variant upon a variant.[26] A study of Vedder's plates and the text shows that his purpose in regrouping the quatrains was to present a theme and its complementary themes in a way that would make their relationship more evident and striking in support of his interpretation.

Consistent with Vedder's intentions, the illustrations are indeed "parallel but not identical" to the thought of the poem. One of the first differences that strikes the viewer is the fact that the pictorial idiom is not Iranian but classical. In Vedder's illustrations even Omar himself, in his simple flowing garb, becomes the elderly classical sage; the youths are Praxitelean in their grace and nudity, the nude females are related to Venus and the Fates, and the allegorical youth that appears in a number of plates is distinctly identifiable as Eros. When architectural settings occur they too place the imagery in the antique world with their classically derived arches and carefully rendered mouldings. Yet, ironically, these are all produced in response to the imagery of an Iranian poet.

Vedder's fascination with classical references and antique beauty had begun well before he discovered an affinity with the ideas of the *Rubáiyát*. It had come to the fore already in the 1870s. Undoubtedly, his 1870 trip to England bolstered his interest because there he saw the works of such notable "Olympians" as Frederick Leighton as well as Alma Tadema's domestic glimpses of the ancient world. In 1875 he proposed the subject of "Greek Girls Bathing" to J. P. Morgan. The painting of this subject (fig. 161), which was finished early in 1877, indicates that Vedder had arrived at a female type that would appear in much of his work throughout the rest of his career. Round-breasted and full-hipped with fleshy shoulders and small ovoid heads, these womanly figures express the classical and High Renaissance sense of dignity, grace, and freedom of the human form. Their classical garments flow about their ample bodies, accentuating their easy movements, or fall away to reveal a shapely breast or float, windborn, in an arabesque.

The composition of *Greek Girls Bathing* is complex, including seventeen

160.
Nude Girl Standing on Pedestal, circa 1890, oil on canvas, 18⅞ x 17⅛. S 488. Museum of Fine Arts, Boston.

161.
Greek Girls Bathing or *Roman Girls on the Seashore*, 1877, oil on canvas, 18¼ x 58¾. S 285. The Metropolitan Museum of Art, New York; purchase, A. H. Hearn Fund, 1958.

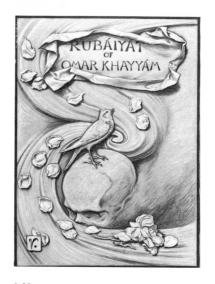

163.
Omar's Emblem, 1883-84, chalk, pencil, and ink on paper, 18¹¹/₁₆ x 14. S D259. National Collection of Fine Arts.

figures, and for it Vedder painted a series of cut-out figures, apparently to try a variety of arrangements. He painted the composition again some thirty years later with changes in detail and proportion, so evidently the theme pleased him. The modeling and detail of the earlier version are more finished than in the later, and the grouping of the charming young women by threes is more of an academic study.

Not only does Vedder's *Rubáiyát* present imagery in classical guise, it reflects also his preoccupation with rather unorthodox Christian formulations, such as those underlying his strange crucifixions in which the living mingled with the resurrected dead. There was another element of expression that found statement in the design of the book that belonged neither to classical style nor Christian thought. Vedder contrived a powerful visual symbol of his own, which, as he said, became an ever-recurring feature in his *Rubáiyát* illustrations. It is a double swirl representing, in Vedder's words, "the gradual concentration of the elements that combine to form life; the sudden pause through the reverse of the movement which marks the instant of life; and then the gradual, ever-widening dispersion again of these elements into space."[27]

This double swirl of two interlocking S shapes (which are mirror images of each other) begins in wide rippling contours at the upper and lower edges of a page, but accelerates and contracts as the swirls meet in a loop. Such a dynamic, interlocking movement serves as a background structure for the frontispiece, which Vedder called *Omar's Emblem*. In the upper swirl is the title and in the lower a skull (the traditional Christian mememto mori); at their junction, which Vedder in his notes termed the "instant of life," is a nightingale, perched upon the skull but singing exultantly. The transciency of life and yet its sensuous delight are symbolized also by the faded rose beneath the skull, its petals carried away by the swirling current.

The same pervasive symbol is used as the background for the poem's most despairing quatrain, here ambiguously related to a Christian reference. Al-

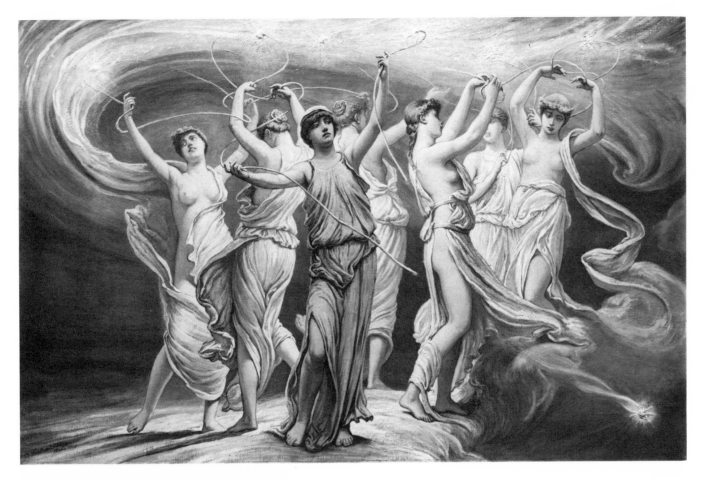

162.
The Pleiades, 1885, oil on canvas, 24⅛ x 37⅝. S 420. The Metropolitan Museum of Art, New York; gift of George A. Hearn, 1910.

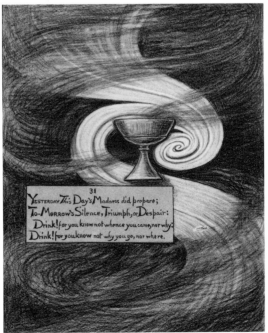

164.
The Cup of Despair, verse 31, 1883-84, chalk, pencil, watercolor and ink on paper, 13⅛ x 10¹⁄₁₆. S D234. National Collection of Fine Arts.

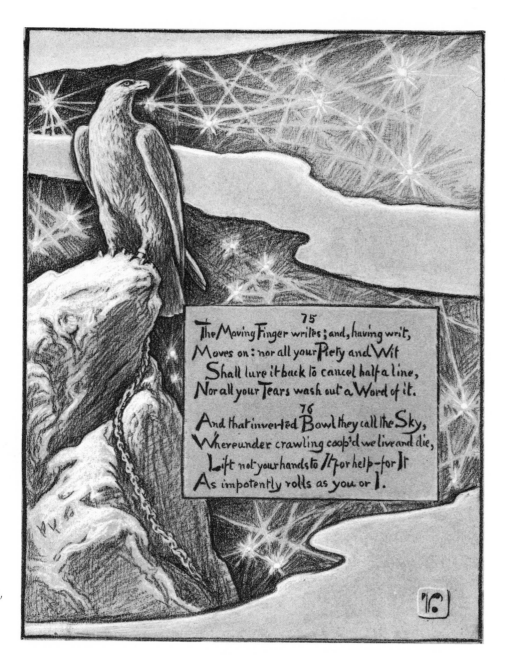

165.
Limitation, verses 75, 76, 1883-84,
chalk, pencil, and watercolor on
paper, 13⁵/₁₆ x 10½. S D257.
National Collection of Fine Arts.

though Vedder titled the drawing *The Cup of Despair*, he placed at its center a
chalice rather than the low, footless wine cup seen in all of the other plates.
The chalice, wreathed in swirling clouds, floats suspended at the central point,
the "instant of life."

By tracing the development of one thematic group of plates, Vedder's way
of using Omar's verses for his own ends, enriching and expanding their mean-
ings through association with a broader context, becomes more evident. There
is, for example, a thematic unity linking verses 75 through 81. The theme is
announced by the familiar quatrains 75 and 76:

The Moving Finger writes; and, having writ,
Moves on: nor all your Piety nor Wit
 Shall lure it back to cancel half a Line,
Nor all your Tears wash out a Word of it.

And that inverted Bowl they call the Sky,
Whereunder crawling coop'd we lived and die,
 Lift not your hands to It for help—for It
As impotently rolls as you or I.

These lines are set by Vedder against a star-pricked, planet-filled darkened sky. At the left a powerful eagle perched on a rocky eminence looks out at the heavens, but its left foot is chained (fig. 165). Vedder, in his Notes, titled this plate *Limitation* and commented that the eagle chained symbolized man's faculties, and that the irrevocability of the laws of nature are symbolized by "the stars bound together with their courses rigidly defined through space." Having established this psychological setting, he goes on in the following plate, for which he does not include the accompanying verse, to "illustrate" more literally the quatrains themselves. In this drawing, titled by Vedder *The Recording Angel*, a sober male angel writes in the book before him. Beneath him are many beseeching hands, and Vedder notes that the attendant angels "may well have ears bandaged to shut out the agonized appeals of humanity lifting up its hands in hopeless supplication." Thus Vedder has taken the disembodied literary image of the "moving finger," with its Eastern anonymity and abstract philosophical connotations, and transformed it in such a way as to add to Omar's imagery the suggestion of a Christian dimension.

The next plate, for quatrain 77, was called by Vedder *The Last Man*. In it an Adam-like nude man leans against a tree trunk about which a great serpent is entwined, its head pressed near the man's ear; this is, said Vedder, "the spirit of Evil whispering hatred of 'this sorry scheme'." A winged adolescent, the figure of Love, lies dead at the figure's feet amid the skulls and bones of past humanity. The meaning of Omar's despair in Christian terms is quite evident.

The next two plates are pendants, again related to each other both through design and meaning. The first of these, quatrains 79 and 80, presents a seated nude woman with bowed head who has all the attributes of the Magdalen of the New Testament as usually depicted—the ointment jar at her feet, the long flowing hair, the attitude of despair, the barren landscape. In fact, Vedder identifies the plate as *The Magdalen* in his Notes. Since the Magdalen has long been identified in traditional Christian hagiography and art with the prostitute who became a follower of Jesus, Vedder's appropriation of the Magdalen image has a kind of justification; the lament and challenge in verse 80 are the archetypal cry of the sinner:

Oh thou, who didst with pitfall and with gin
Beset the Road I was to wander in,
 Thou wilt not with Predestin'd Evil round
Enmesh, and then impute my Fall to Sin!

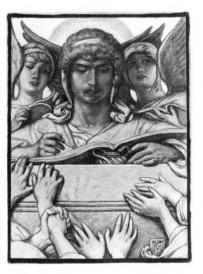

166.
The Recording Angel, 1883-84, chalk, pencil, and watercolor on paper, 16¾ x 12⁹⁄₁₆. S 258. National Collection of Fine Arts.

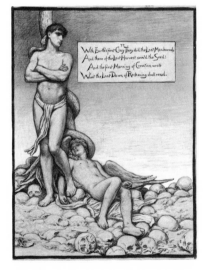

167.
The Last Man, verse 77, 1883-84, chalk, pencil, ink, and watercolor on paper, 18¾ x 14⅜. S D260. National Collection of Fine Arts.

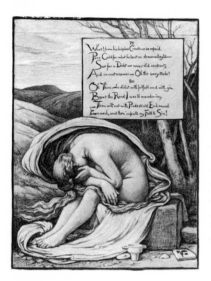

168.
The Magdalen, verses 79, 80,
1883-84, chalk, pencil, and ink on
paper, 19⁷/₁₆ x 14¹³/₁₆. S D262.
National Collection of Fine Arts.

Here it is not so much an expansion of the idea through a biblical context as a reinterpretation of the Magdalen through the verses of Omar.

The bowed nude, self-enclosed in a womblike form, her hair and garments encircling her, is contrasted strikingly with the opulent female figure of the adjoining plate (fig. 169), which stands easily before us, seeming about to advance toward the viewer. Her head is erect, her hair flowing voluptuously about her full form, and her arms and legs seem to radiate from the frontally depicted torso. She presents a vision of sensuous ease, quite the opposite of the indrawn nude Magdalen. The barren trees and bleak landscape of *The Magdalen* make a striking contrast to the garden in full bloom with roses, lilies, and clusters of grapes that surrounds the "Eve-Venus." The serpent appears here as in the earlier plate of *The Last Man* and is certainly one of the most lengthy serpents in art: after encircling the tree three times, a heavy coil supports "Eve," curves behind her body, loops forward beneath her outstretched arm and then ripples forward and rests easily upon her wrist, opening its jaws to bite the apple she offers in her hand. That Eve is also Venus is made clear by the inclusion of the votary-attendant Cupid. The lily in the foreground could also be a reference to Mary the Mother of Jesus, who in Christian iconography is the new Eve, just as Christ is the new Adam.

Paradise and the snake are indeed from Omar, and sinning mankind as well, but Vedder went on to symbolize man's sin also by including a smoking altar in the distance, recalling the offerings of Cain and Abel, which were part of the drama relating to the first murder.

The thematic group, which began with *The Recording Angel* and "the agonized appeals of humanity lifting up its hands in hopeless supplication," ends with a plate titled *Pardon Giving and Pardon Imploring Hands*. The two hands, one in the gesture of giving or blessing, the other palm up, receiving, are at the center of the plate, outlined by a bit of darkened sky in an opening in a clouded zone. The "tangled skein of human life" that fills the hands is represented by the now familiar motif of the S-curve, which symbolizes, as Vedder notes, the concentration of the paradoxical elements that combine to form life. The hands are located in "that sudden pause through the reverse which marks the instant of life." Vedder supplied a statement on the preceding Venus-Eve plate, relating it, somewhat didactically, to *Pardon Giving and Pardon Imploring Hands*:

> Omar's reasoning has carried him so far that he cannot believe he is a *mere irresponsible agent, nor can he persuade himself that he is entirely responsible. He therefore concludes that he is both free and fated, and this conclusion leads to the Pardon giving and Pardon Imploring Hands filled with the tangled skein of human life.*

Although the hands are feminine in their proportion and grace, they are

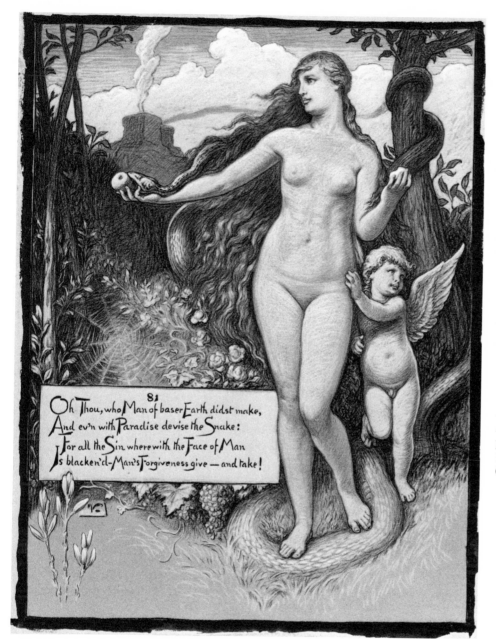

81

Oh Thou, who Man of baser Earth didst make,
And ev'n with Paradise devise the Snake:
For all the Sin wherewith the Face of Man
Is blacken'd-Man's Forgiveness give — and take!

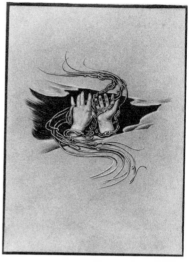

170.
*Pardon Giving and Pardon
Imploring Hands,* 1883-84, chalk,
pencil, and ink on paper, 17¾ x
14⁵/₁₆. S D264. National
Collection of Fine Arts.

169.
In the Beginning, verse 81, 1883-
84, chalk, pencil, and watercolor
on paper, 17¹¹/₁₆ x 13⁵/₁₆. S D263.
National Collection of Fine Arts.

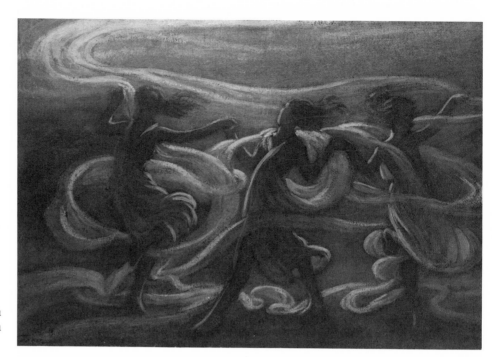

171.
*Music—Girls Dancing with
Floating Hair*, circa 1910, oil on
canvas, 8½ x 13. S 566. The
New Britain Museum of American
Art, Connecticut; gift of American
Academy of Arts and Letters.

172. OPPOSITE
The Fates Gathering in the Stars,
1887, oil on canvas, 45 x 23¼.
S 436. The Art Institute of
Chicago; Friends of American
Art Collection.

based on Vedder's own hands, as can be seen from a photograph published in his
Digressions. This photograph occurs in a passage in which Vedder says of him-
self, "I am not a mystic, or very learned in occult matters. . . . and yet it delights
me to tamper and potter with the unknowable, and I have a strong tendency to
see in things more than meets the eye." [28] He goes on to remark that he can
conjure up visions with ease, but realizes that the same faculty that enables
him "to see as realities most delightful things" would, if it got out of control,
"create images of horror indescribable." The "solid ground of common sense"
was his safeguard. "Blake," he remarks, "can wander with delight and retain
his mental health in an atmosphere which would prove fatal to me."

One reason Omar appealed so to Vedder was surely the fact that the poet
also was willing to speculate, yet was never out of contact with a sensate,
commonsense reality. This quality was not lost on Omar's translator, Edward
FitzGerald. FitzGerald argued against the "learned men" who favored Omar's
being a Sufi, and the import of Omar's message being mystical. He did not see
Omar as "the Poet lost in his Song, the Man in Allegory and Abstraction," but
instead insisted that the verses present "Omar himself, with all his Humours
and Passions, as frankly before us as if we were really at Table with him, after
the Wine had gone around." [29] It is FitzGerald's Omar, not the mystical poet,
whom Vedder perceived in the *Rubáiyát*; it was this Omar who was his kindred
spirit until his life's end.

The "endless designs" that were suggested to Vedder by Omar's quatrains
went well beyond the plates for the book; many of them served as the basis for
major paintings. *The Fates Gathering in the Stars* (fig. 172), Vedder remarked in

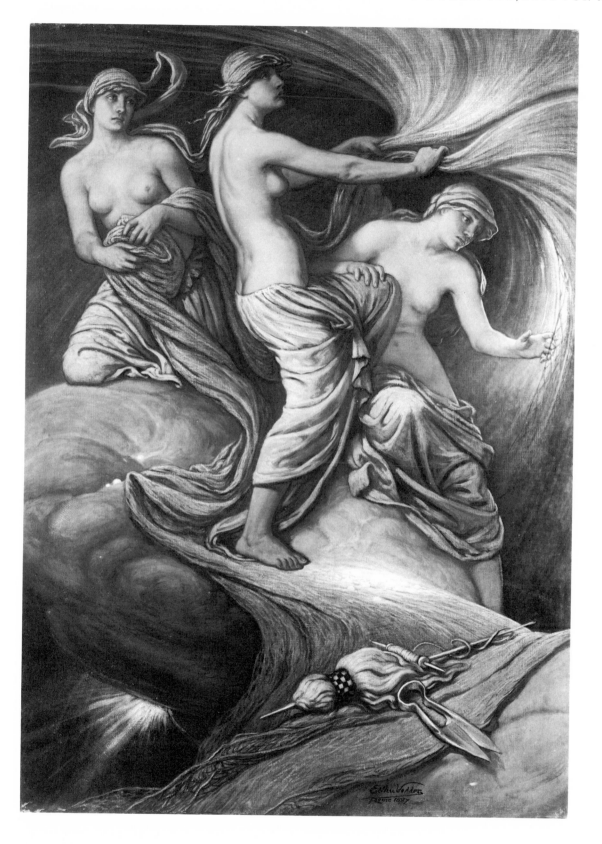

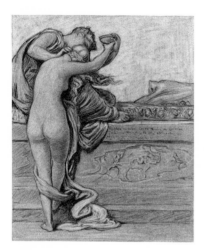

173.
The Cup of Love, 1887, chalk on paper, 16 x 13⅝. Davison Art Center, Wesleyan University, Connecticut.

174.
The Cup of Love, verses 46-48, 1883-84, chalk and pencil on paper, 17¾ x 13⁵⁄₁₆. S D242. National Collection of Fine Arts.

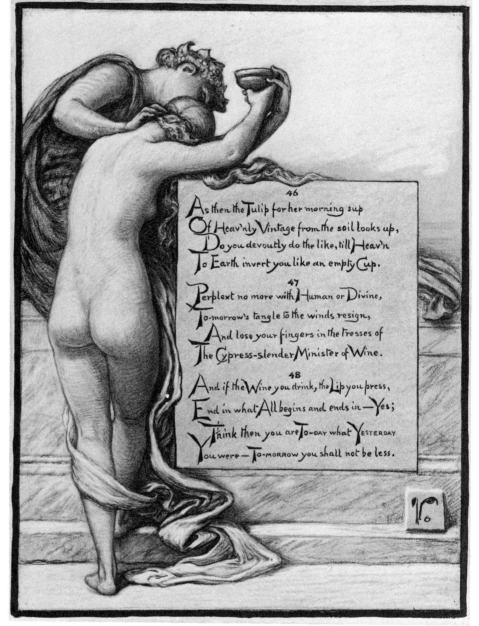

46
As then the Tulip for her morning sup
Of Heav'nly Vintage from the soil looks up,
Do you devoutly do the like, till Heav'n
To Earth invert you like an empty Cup.

47
Perplext no more with Human or Divine,
To-morrow's tangle to the winds resign,
And lose your fingers in the tresses of
The Cypress-slender Minister of Wine.

48
And if the Wine you drink, the Lip you press,
End in what All begins and ends in—Yes;
Think then you are To-day what Yesterday
You were—To-morrow you shall not be less.

the letter to Millet, was his own invention, and he intended to make a picture of it someday. Not only this design, but numerous other *Rubáiyát* subjects as well were translated into paintings. They were enlarged, the text removed, and further details added. *The Cup of Love* underwent a two-fold transformation. In an early drawing Vedder showed the lover sitting with his beloved at his side on a sarcophagus, on which he tentatively lettered a quatrain. In the version that served as a plate in the *Rubáiyát*, a plaque is added with three verses inscribed. This composition was, in turn, strikingly changed when made into a painting.

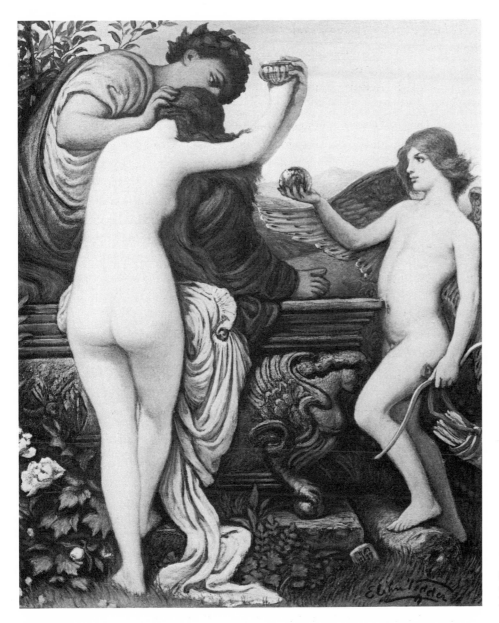

175.
The Cup of Love, 1887, chalk, gouache, and gold on paper, 11 x 8⅞. S D359. Mr. and Mrs. E. P. Richardson.

An adolescent cupid was added who proffers a globe to the unheeding lovers. The sarcophagus became an elaborately sculptured monument with a Greek sphinx at its corners. Roses adorn the earth, boughs with leaves hang from above, and a landscape gives a density of pattern to the small painting that dramatically sets off the opulent nude who lifts the wine cup for her lover.

While working on the *Rubáiyát* subjects Vedder was fully aware that his nude figures would meet with resistance on the part of his publishers, to whom he wrote: "I must insist on my nudes. I will try to make them good, and covering them would suggest their being bad." He went on to say he would "take charge of the dignity of the work." [30] Like those of the Renaissance masters

176. OPPOSITE
The Cup of Death, verse 49,
1883-84, chalk, pencil, and ink on
paper, 19⅜ x 14⅞. S D243.
National Collection of Fine Arts.

177.
Study for *The Cup of Death*, 1884,
charcoal on paper, 17½ x 13¼.
The J. B. Speed Art Museum,
Louisville, Kentucky.

and of the Greeks, Vedder's nudes emanate a radiant sexuality and vitality and are endowed with natural dignity. He would have been distressed to know that many years later his daughter's American friend, Hattie Bishop (Mrs. J. B.) Speed, asked if Vedder's fountain sculpture of a young boy could not have his nudity covered.[31]

The Cup of Death, the opposite plate to *The Cup of Love* in the *Rubáiyát*, also was made into a painting. In it, the winged "Angel of the darker Drink" holds a cup to the lips of a languid female figure whom he supports in his embrace. As Marjorie Reich has pointed out, the conception of death is similar to that depicted by George Watts, the English painter whom Vedder had met in London in 1870.[32] Both reflect a late version of the shift in the image of death that took place at the end of the eighteenth and the beginning of the nineteenth century. The long tradition of fearful skeletons and cadavers common from the late medieval period and still inhabiting the art of Breughel and Holbein, gave way to an idealized human personification reminiscent of the winged figures who escort the departed souls into Hades in late classical reliefs.

Vedder painted at least two full-length versions of this theme, one (fig. 137) in somber tones "with very little color and almost all the reeds painted out leaving the figures standing against the sky."[33] Anita Vedder identified this somber painting as the original *Cup of Death*. In a letter she stated that the unfinished work "looked so dull against the studio walls (of gray-green) that my father took a dislike to the picture, laid out another and repainted it entirely with another coloring more brilliant and rich. . . . The original picture remained always unfinished till 3 years ago about 1909 we changed house and for lack of another space was hung in our drawing-room which has a pale pink tint. The tint of the room was our despair! but by a strange coincidence this picture looked remarkably well and the low gray tones with the contrast of the wall harmonized charmingly. My father became at once interested in it again, it was taken down and he finished it with pleasure."[34]

The other version (fig. 178), now owned by the Virginia Museum of Fine Arts, was painted for a Miss Susan Minns of Boston "whose fad," Vedder wrote, "is to have the greatest collection of dances of death going."[35] This painting, referred to by Anita as more brilliant in color, including abundant reeds at the river edge to form a background pattern for the two figures.

In a variant drawing for *The Cup of Death* in the *Rubáiyát*, Vedder added an omega, the last letter of the Greek alphabet, to the garment of the Angel of Death. The reference is to the biblical declaration, "I am the Alpha and Omega, the beginning and the ending, saith the Lord."[36] Once more Vedder indicated his tendency to fuse Christian references with the Persian poet's verses to extend the range of meaning.

The painting titled *The Marriage of the Daughter of the Vine* was also based on drawings for the *Rubáiyát* and discloses another aspect of the orig-

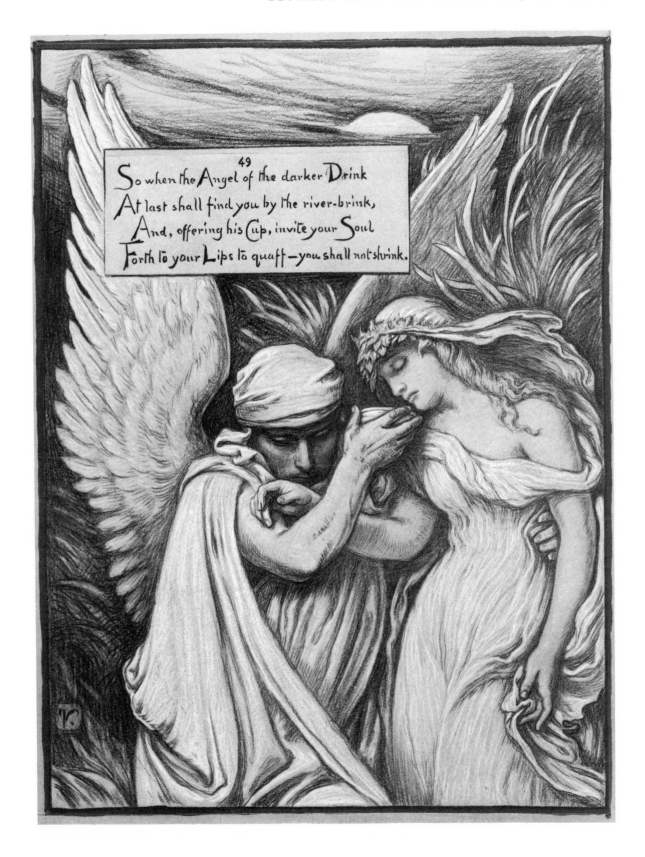

So when the Angel of the darker Drink
At last shall find you by the river-brink,
And, offering his Cup, invite your Soul
Forth to your Lips to quaff—you shall not shrink.

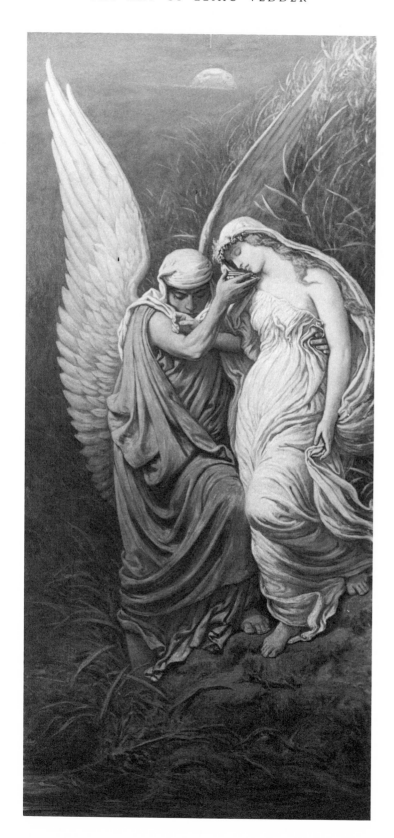

178.
The Cup of Death, 1885, oil on
canvas, 44⅜ x 20¾. S 439.
Virginia Museum of Fine Arts,
Richmond.

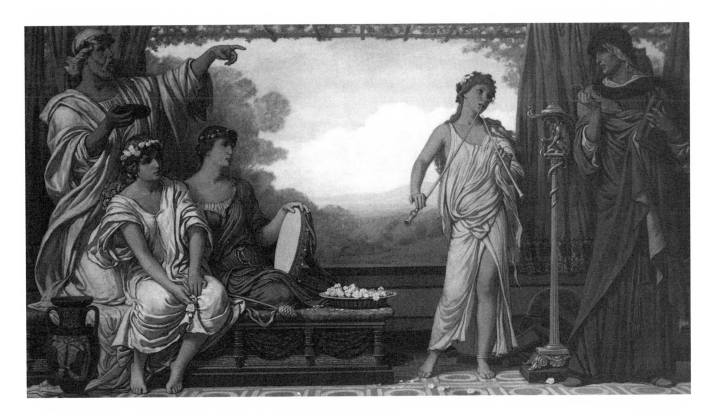

inal design for the volume. From the very outset, the drawings were designed in pairs to be viewed together. A letter to Joseph Millet of September 18, 1883, in which Vedder outlined his early conception of the whole volume, included a layout showing the pages arranged in pairs, beneath which Vedder wrote, "the two pages will make one design." [37] All of the facing pairs are sensitively balanced, but the clearest unity is established between the two drawings for quatrains 59 and 60-61, and these were combined by Vedder to make a single painting, *The Marriage of the Daughter of the Vine*.

Omar, pictured as the type of philosopher, holds the wine bowl, and the two bacchantes who share his couch are supplied with flowers, a thyrsus, and a tambourine, all symbols of pleasure and transcience. In quatrain 59 Omar tells his friends:

> *I made a Second Marriage in my house;*
> *Divorced old barren Reason from my Bed,*
> *And took the Daughter of the Vine to Spouse.*

The graceful young girl with flowers in her hair and a pipe at her lips is the "Daughter of the Vine." She regards somewhat questioningly the tall, somberly garmented figure, surrounded with the attributes and symbols of wisdom, who is "old barren Reason." The meaning of the text is conveyed clearly without the need for verses.

179.
The Marriage of the Daughter of the Vine, circa 1890, oil on canvas, 33½ x 60. S 474. The Hyde Collection, Glens Falls, New York.

145

One of the most powerful of Vedder's paintings, the *Sphinx of the Sea-shore* (fig. 180) was also derived from a plate drawn for the *Rubáiyát*. In his Notes, Vedder called the plate *The Inevitable Fate*. "The all-devouring Sphinx typifies Nature," he wrote, "the Destroyer, eminent above the broken forms of life. . . . The Philosopher [Omar] had evidently pondered on the fact of the disappearance of so many forms of life and the certainty that in time even man himself with all his inventions must disappear from the face of the earth. What wonder that he calls the brief moment of existence between two eternities a spangle or that the artist should represent this idea under the form of the all devouring Sphinx." [38]

Though the painting is dominated by a mythic predatory creature with the head and breasts of a woman and the body of a tiger, its impact is not that of a work of fantasy. Instead, the reality of what is depicted becomes increasingly convincing, leaving the viewer uneasy and uncertain. The everyday environment as usually perceived, "normal reality," becomes a fiction in the presence of this painting, and the grim seashore scattered with detritus, the human and animal bones, the distant crumbling buildings of a vanished race, the barren hills and ominous clouds, become the elements of a more encompassing reality.

A fascinating, strangely ambiguous painting, *Superest Invictus Amor*, while not based on the *Rubaiyat*, was done at the same period as the paintings after the *Rubaiyat*. It is usually called *Love Ever Present*, but the title is more accurately translated as "Love Survives Unconquered." [39] Two extant drawings show the development of the idea for the painting. A sketchy, presumably early study shows a child holding an arrow together with several blossoms at his side as he stands on a two-headed pedestal, amid classical architectural fragments. A second drawing shows a complete study of the adolescent nude as seen in the painting with a background of cypress trees and clouds.

In the final painting (fig. 181) the androgynous character of the languorous adolescent Cupid is accentuated by the extreme clarity of his decorative wings and bow, of the Janus-headed pedestal, and of the mosaic pavement with the broken amphora and bits of sculpture, all of which claim attention somewhat too insistently. The slightly vacuous yet knowing expression of Vedder's Cupid, together with his self-conscious pose, have a touch of fin de siècle eroticism unusual in the work of Vedder.

The Janus head was interpreted by W. H. Downes "as facing two ways, towards the past and towards the future." [40] This questionable interpretation was repeated and elaborated on in the Houghton Mifflin catalogue,[41] which identified the old man as the Past and that of the maiden as the Future. Apparently it had not been noted that the bearded head of the male has ram's horns and pointed ears and thus represents Pan and sensual pleasure. The feminine head is that of Psyche, whom Cupid loved. When the triumvirate of

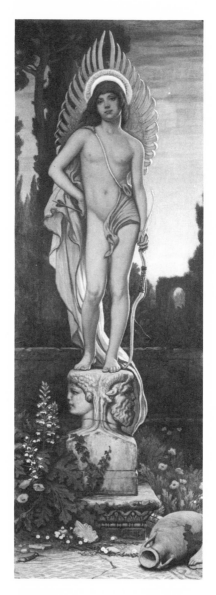

181.
Love Ever Present or *Superest Invictus Amor* or *Amor Omnia Vincit*, 1887-99, oil on canvas, 34¾ x 12¾. S 440. James Ricau.

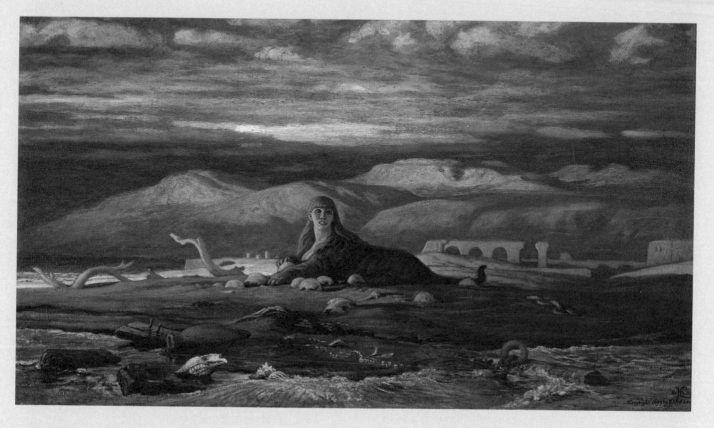

180.
Sphinx of the Seashore, 1879-80,
oil on canvas, 16¼ x 28¼ (sight).
S 379. Mr. and Mrs. John D.
Rockefeller 3rd.

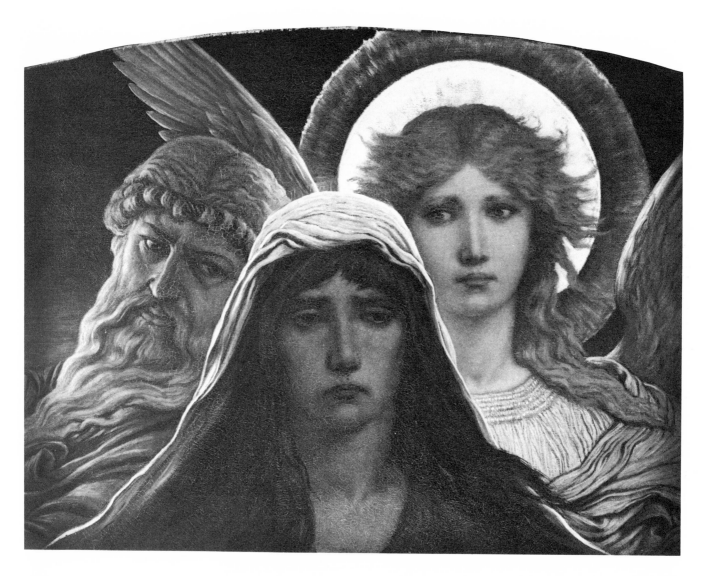

182.
The Soul between Doubt and Faith, circa 1887, oil on canvas, 16 X 21. S 434. The Herbert F. Johnson Museum of Art, Cornell University, New York.

mythological dieties are viewed as a group, it is apparent that the figure of Love stands upon the pedestal between the allegorical images for the two aspects of love, sensuality and the soul.

Vedder's *Rubáiyát* drawings and the paintings related to them, such as his *Sphinx of the Seashore,* deal with the ancient themes of fate, immortality, and the origin and destiny of man. Although analogous, they differ considerably from the philosophical and religious expressions of the *Rubáiyát's* text. Vedder was moved by the *Rubáiyát* to consider not so much the transience of all earthly things, as FitzGerald reckoned its theme to be, but the troubled and continuing quest of the soul, which is faced on the one hand with the allure of sensuous pleasures, with their implications of transciency, and on the other hand with the design for the permanency afforded by Christian faith. He

148

formulated the preoccupying theme in his painting *The Soul between Doubt and Faith*, painted in about 1887. The Soul, depicted as a shadowed, troubled face, inwardly oriented, is shown flanked on one side by Doubt, a worldly classical sage, whose face expresses sensuous vitality and intellectual acuity, and on the other side by Faith, incarnate in a frontally depicted impassive young face surrounded by a halo and a radiance. Vedder suggests no resolution to the wrestlings of the Soul, which remains forever torn between the questions of Doubt, as posed by the world, and the hope of Faith. There is no single painting that is more central to an expression of Vedder's life and thought. In writing to his good friend and loyal patron Agnes Ethel Tracy in 1887, a year in which there were many prospective buyers for his paintings, Vedder urged her to keep the "3 heads" *(The Soul between Doubt and Faith)* and went on to say, "you will never get from me a more remarkable picture." [42]

BIBLICAL THEMES

Vedder drew upon the Old Testament for several paintings on religious themes, among them an early painting, *The Dead Abel* (fig. 113), and another titled *Adam and Eve Mourning the Dead Abel*. His *Rubáiyát* drawings include two subjects that allude to the Genesis narrative, *The Last Man*, with its incorporation of the figure of Adam, and the pendant plate showing Eve and the

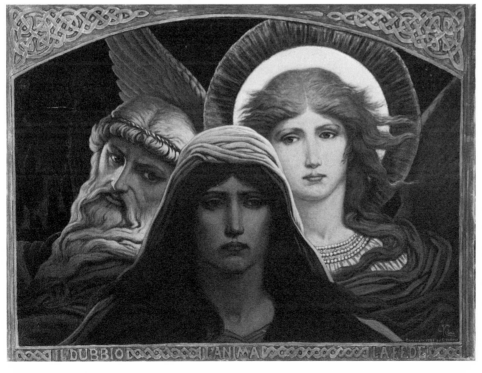

183.
The Soul between Doubt and Faith, 1899, oil on canvas mounted on wood, 16½ x 23. S 530. The Baltimore Museum of Art, Maryland; gift of Mme. A. W. L. Tjarda Van Starkenborg-Stachouwer.

149

184.
Samson and Delilah, circa 1886,
oil on canvas, 5 3/16 x 9 1/4. S 430.
National Academy of Design,
New York.

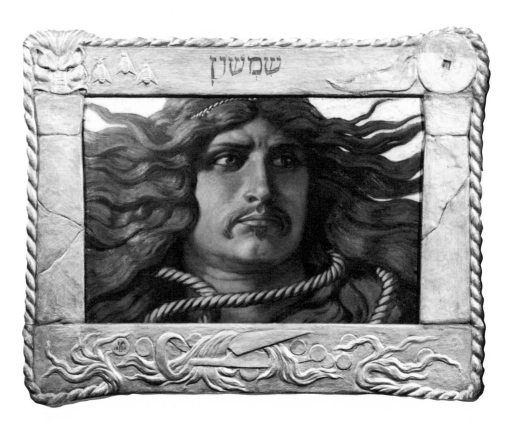

185.
Samson, 1886, oil on wood, 18 x
27 1/2. S 432. Graham Williford.

serpent and titled by Vedder *In the Beginning.* Another Old Testament subject is represented by Vedder in the oil painting *Samson and Delilah* (fig. 184). Small in size, but large in conception and rich in color, the little painting conveys a sense of hushed drama. The nude Delilah arises from the couch where Samson sleeps unheedingly, his shorn locks about him. Her movement is both redolent with sensuality and predatory as she looks toward the entrance where the lords of the Philistines hide. Vedder highlights her arm and the hand holding the fatal, wide-open scissors. Her shadowed face looks toward the curtain at the right and the hand with a dagger ominously advancing. The addition of indications of pattern in the couch, draperies, and background, as well as the force and drama of the composition, suggest that the oil study was prepared for a larger composition, which may never have been executed.

The same subject was treated in a wholly diferent manner by Vedder in two arresting pendant paintings, the heads of Samson and of Delilah (figs. 185, 186). Both are set in handsome wide gold frames, designed by Vedder, which bear symbolic references to the story of Samson: the jawbone of an ass with which he slew a thousand men, the young lion that he killed with his bare hands, the bees that swarmed and produced honey in the carcass of the lion, the scissors with which Delilah cut his hair, the coins she was paid for her perfidy, and the millstone with which Samson ground grain when, sightless, he worked in the Philistines' prison.[43]

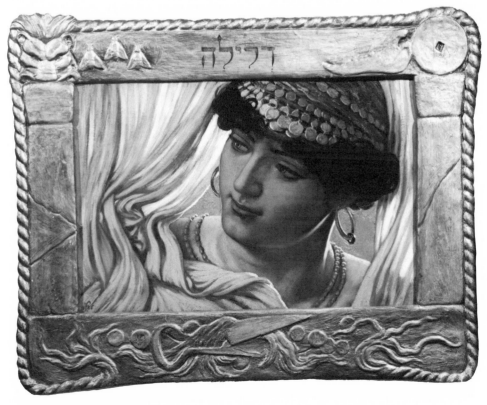

186.
Delilah, 1886, oil on wood, 18 x 27½. S 431. Graham Williford.

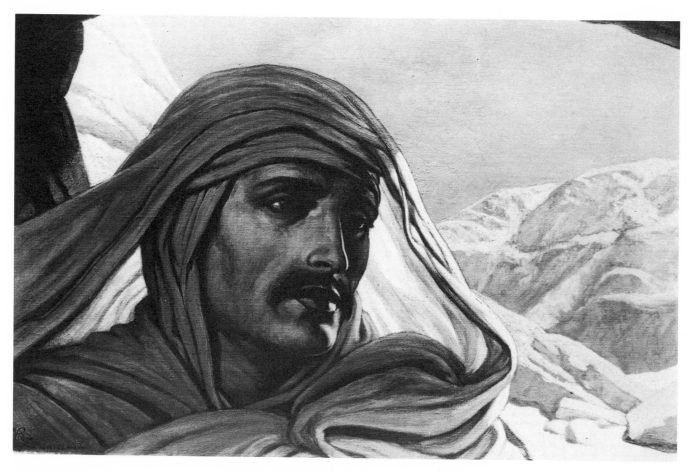

187.
Lazarus, 1899, oil on canvas, 20 x 31½. Museum of Fine Arts, Boston; gift of Edwin Atkins Grozier, 1901.

The subject of Vedder's *Samson* is heroic—its visage larger than life and appearing larger still because of its compression within the frame. Intent and wary, Samson looks grimly into the distance. His serpentine hair seems vibrant with strength, his jaw is set, and his powerful neck is encompassed but not touched by the "two new ropes" [44] with which he was bound.

The companion painting, *Delilah*, shows the shadowed face of the dark-skinned schemer peering intently to one side with an expression of curiosity and expectation. Draperies at either side are in motion, as if she had just pushed them aside. Vedder has deliberately incorporated a spatial ambiguity in that we see Delilah's head behind the frame, yet part of her face curves forward beyond the frame into our space.

The Old Testament subjects chosen by Vedder had to do either with death and mourning, as in the Abel paintings, or treachery and heroism as in the *Samson* and *Delilah* paintings. Of his choice of New Testament subject matter the earliest is *Christ Among the Doctors*, a compositional study showing what Vedder had absorbed from the Venetian masters. As early as 1863, however, with his *Star of Bethlehem*, he produced an original interpretation of an ancient theme, one that is repeated at least five times between then and 1911. [45] Vedder

152

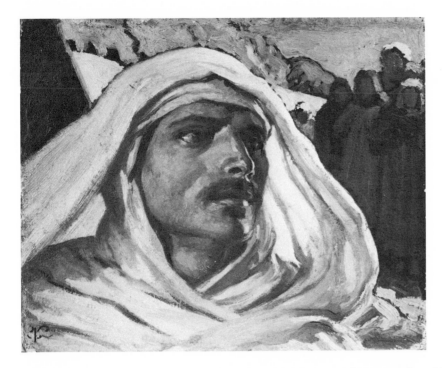

188.
Lazarus, circa 1895-99, oil on canvas, 7⅞ x 9⅝. S 507. The J. B. Speed Art Museum, Louisville, Kentucky.

described the painting in a letter to a Mr. Murray, "In the *Star of Bethlehem* I confined myself to the *star* representing it surrounded by a glorious, luminous host of Saints coming from the dawn—the East—with but one single ray descending through the clouds to the little town on the plains below." [46]

Vedder's *Star of Bethlehem* is a visionary landscape or skyscape joltingly dissimilar in style and interpretation from his most striking painting on a New Testament theme, his *Lazarus.* Rather than focusing upon the miraculous event and showing the Christ confronting his resurrected friend, with Mary and Martha amid the awestruck witnesses, Vedder chose to show only the head of Lazarus and his face, close to us. Life and consciousness are just returning. He is still physically and, one thinks, at least in part psychically within the cave that formed the tomb; his face is in shadow, except for a touch of light along the bridge of the nose, lip, and chin. His handsome Mediterranean features express sadness and stillness; returning life is not embraced but, at this moment, passively accepted. The small study for *Lazarus* has the immediacy of a composition committed to canvas while the conception was freshly in mind. It gains by the complexity and power of Lazarus's expression, a haunting face in which dread seems to dominate expectation.

The theme of death and resurrection was pictured again by Vedder in several drawings of Orpheus, who is represented as just entering or returning from Hades. The conception is similar to that evident in his *Lazarus:* a handsome head swathed in heavy draperies is set against a rocky opening. Vedder's poems and his unpublished writings attest to his preoccupation with faith and doubt, and his querying the end of all earthly things, death.

189.
At the Foot of the Cross, circa 1863-65, oil on academy board, 5⅜ x 12¹⁄₁₆. S 188. American Academy and Institute of Arts and Letters, New York.

The religious theme that preoccupied Vedder throughout his career was that of the crucifixion. In New York during the early 1860s he worked on compositions related to the event. In 1900, the sixty-four-year-old artist, in a letter to Agnes Tracy Roudebush, spoke of wanting to paint a large crucifixion: "I think that I can get on for almost two years doing just the work I want to do before my powers fail—which I believe without undue vanity are at their best now. I should like to paint for a gallery . . . the Crucifiction [sic].[47] He continued that he might, alternatively, paint the eclipse (presumably that which occurred after the crucifixion).

Apparently Vedder and Agnes Roudebush had previously discussed the possibility of his painting a large composition of the crucifixion to be paid for by Agnes and to be given to an art gallery or museum. Vedder went on to say that he had some "really stunning ideas" and urged her to think the thing over, adding that "anything which would be a credit to us both can be paid for when and how you please. . . . The prospect of at last getting a serious work in a permanent gallery fills me with great joy."

Something of the progress of Vedder's *Crucifixion* can be learned from an agitated letter dated May 23, 1891, sent by Carrie Vedder to Agnes Roudebush. Written in Carrie's bold hand, it is punctuated with numerous exclamation points as Carrie expostulates about Charles Coleman's appropriation of the same subject to make a "painting eight by thirteen feet large!"[48]

Anyone acquainted with Coleman, she adds, would know that "he would not have dreamed of touching the subject of the Crucifixion but for his intimacy with Vedder." "Remember," Carrie wrote, "it is since before 1866 that Vedder has been working on this subject and Charlie has watched with his

154

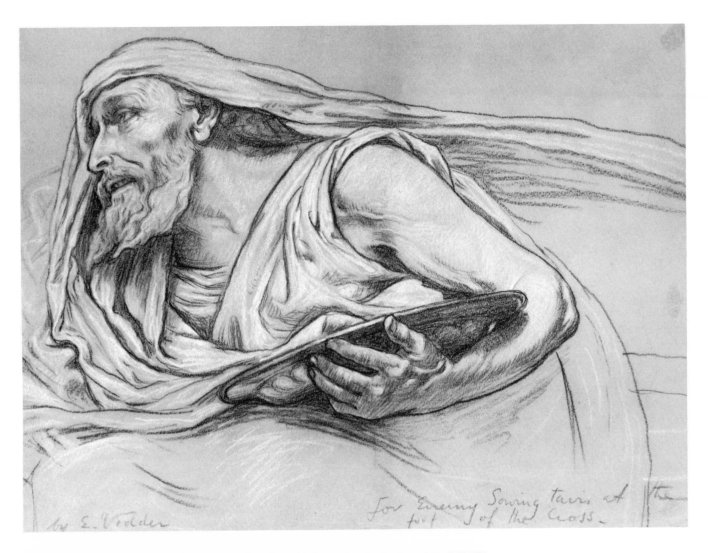

for Enemy Sowing tares at the foot of the Cross.

by E. Vedder

191.
Study of head for _The Enemy Sowing Tares_, circa 1892, charcoal and chalk on paper, 9 x 12. American Academy and Institute of Arts and Letters, New York.

190.
The Enemy Sowing Tares, 1892, oil on canvas, 9¾ x 20½. S 483. The Brooklyn Museum, New York; bequest of William H. Herriman.

usual enthusiasm all Vedder's steps through sketches, drawings, modeling of figures in small to get his groups, cartoon and all." Elsewhere in the same letter, Carrie speaks of Vedder having his canvas out and "his figures (in clay) arranged" and, she continues, he "will next week begin laying in the subject."

Whether Vedder did indeed complete the painting is still unknown, but the letter is of interest in giving evidence of his long preoccupation with the theme. Also to be noted is his use of clay figures to determine the arrangement of large groups and probably also for the study of lighting effects.

Inasmuch as the theme of the crucifixion had preoccupied Vedder since before 1866, it is curious that we have no paintings or drawings that focus on the traditional presentation of the body of Christ on the cross. There are a number of versions of *The Ninth Hour* and *The Eleventh Hour*, in which the crosses at Calvary are seen in the remote background, and there are paintings such as *At the Foot of the Cross* (fig. 189), with its mourners grouped about a figure bent lifelessly forward, with face concealed.[49] *The Enemy Sowing Tares* of 1892 (fig. 190) shows an evil-looking figure scattering coins at the base of the cross; but this painting excludes the crucified subject.

Did Vedder intend to depict the body of Christ on the cross in the large painting that he hoped would be given to an art gallery? The evidence at hand seems to suggest that he would not have, and that the focus as usual would have been elsewhere. Vedder may have recalled his teacher, Bonaiuti, who in painting *The Temptation on the Mount* (fig. 191) composed a satisfactory Devil but could never get the entire composition into proper order.[50]

The depiction of the physiognomy of Christ had presented problems to other American painters who, like Washington Allston, might have been inhibited by the conviction that the image of Christ was "too holy and sacred to be attempted by the pencil."[51] A notable exception is William Page, who after discussing the countenance of Jesus Christ with Theodore Tilton, did a highly individual bust-length painting commissioned by Tilton. The painting met with criticism and even expressions of disgust. The controversy over Page's *Christ* may have been known to Vedder, since Tilton reproduced and defended the painting in his own paper, *The Golden Age* (May 20, 1871).[52]

Vedder's contemporary, Thomas Eakins, also shied away from the problems of the Christ image when he painted his *Crucifixion* (1885) with a life-size Christ hung upon a cross in a minimal landscape against a vague neutral sky. Although the body is painted with an unflinching fidelity to the anatomy and texture of the finite human form, Eakins avoided the depiction of the physiognomy of Christ by showing his head bowed and his features barely visible in the deep shadow. We can only speculate on what Vedder intended for his own *Crucifixion*, what his "really stunning ideas" for the painting were.

At the same time that Vedder was working on plans for the large *Crucifixion*, he completed two complementary paintings that carry the imagery of the

Rubáiyát drawings into the realm of the occult. These two related paintings from the 1890s — *The Soul in Bondage* and *The Keeper of the Threshold* (figs. 192, 194) — exemplify the style and the symbolism of the paintings of Vedder's later years. In these paintings his restless questioning mind created a metaphor for the soul's uneasy sojourn within the pale. Undulating vapors and draperies wreath both the youthful winged Soul, a female, and the Buddha-like adolescent "Keeper," a male. In both cases, the linear rhythms and arabesques accord with that stylistic preference at the end of the century called *l'art nouveau*. But the air of mystery, of a vision revealed to us that lies somewhere between dream and myth, belongs wholly to the art of Vedder.

In his *Digressions*, Vedder recorded the sale of *The Soul in Bondage* in 1891 to his faithful friend and patron Agnes Tracy Roudebush, and said of it, "This is what I call an important picture." [53] Carrie Vedder described the painting in a letter to her mother: the Soul is "in darkness . . . because she is turned from the light, and lightly bound because she may free herself as in each hand she holds the emblem of either good or evil, in the butterfly and the serpent." [54] The fettered Soul is represented as a young nude woman who sits with eyes closed, as if in a trance, at the edge of a worn stone staircase. Behind her the sun penetrates only partially the swirling vapors that surround the still figure. The vapors move in an S-curve, very like the contours of the device used by Vedder in the *Rubáiyát* illustration. The head of the winged, bound subject is at the center of the painting, at the point which Vedder, in his explanation of the swirling lines of the *Rubáiyát* designs, called "the instant of life." The turmoil of the soul's inner consciousness is mirrored by the vapors, the "life" of which is in vivid contrast to the passivity of the face and the closed eyes of the still figure. The strange color scheme and the somewhat erotic suggestions give the painting an ambivalent but forceful impact. [55]

The Keeper of the Threshold of 1898, despite its cool academicism, is a compelling painting. [56] Large in size and light in tonality, it reflects the influence of the mural commissions that Vedder had executed in the preceding years. The painting incorporates Oriental occult symbolism in a mandalalike composition of a circle enclosed within a square. The youth, seated cross-legged upon a coiled serpent, gazes imperturbably at, and beyond, the spectator. Like the subject of *The Soul in Bondage* he sits upon a staircase, and on the step below him a mysterious inscription is visible. The characters are those from a phonetic alphabet which Vedder himself composed, called Alfaru, [57] but what their message may be is not decipherable.

The "threshold" in the painting lies between the here and the hereafter. The artist's reflection on such ultimate questions are given in several typed sheets entitled "Nirvana" in the Vedder papers. "There is no such thing as death, only change. But ceaseless change would be hideous without the rest of Nirvana, in which the Soul gathers fresh strength for its new life. From whence?

192. RIGHT
The Soul in Bondage, 1891, oil on
canvas, 37⅞ x 24. S 475. The
Brooklyn Museum, New York;
gift of Mrs. Harold G. Henderson.

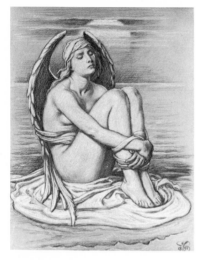

193.
Bound Angel, 1891, charcoal and
chalk on paper, 11½ x 8⅞. The
Brooklyn Museum, New York.

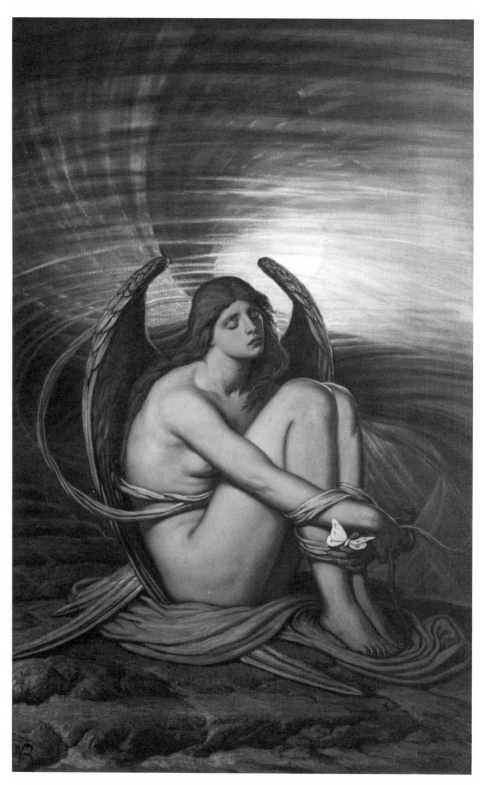

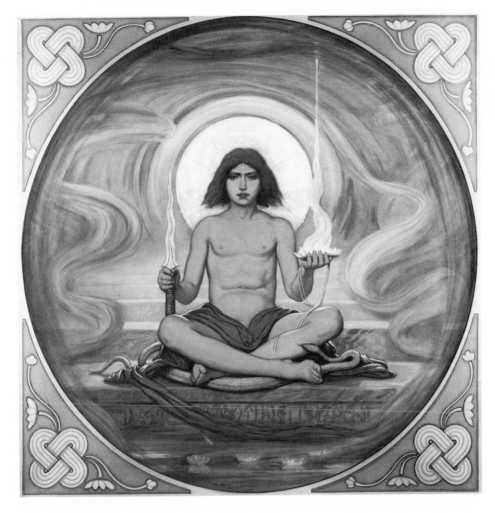

194. LEFT
The Keeper of the Threshold,
1898, oil on canvas, 51¾ x 51¾.
S 527. Museum of Art, Carnegie
Institute, Pittsburgh.

195.
The Keeper of the Threshold,
circa 1890, pastel and gouache on
paper, 16 x 12. S D442. Georgia
Museum of Art, University of
Georgia; gift of American
Academy of Arts and Letters.

From that which pervades all and delight[s] in all, suffers with all and is all,
of which we are a distinct portion."[58]

Vedder's autobiographical *Digressions of V.*, his poems, and his unpub-
lished writings give evidence of his knowledge of, and interest in, Buddhism,
occult symbolism, and theosophy. It is characteristic of Vedder's restless prob-
ing of the meaning of existence that he should have worked on the *Crucifixion*
studies at the same time that he painted *The Keeper of the Threshold.*

A more despondent and world-weary side of the artist is seen in his *Eclipse
of the Sun by the Moon,* also of the late 1890s. In this painting, a typical Vedder
nude with wide-open dark wings, crouching languidly, holds a stylus that
traces a pattern in an open book. One hand rests upon the great orb of the
moon, and in the background the sun is seen wreathed by clouds. The painting
is certainly related to the series of astronomical subjects that Vedder contem-
plated doing, most of which are known to us through preparatory drawings.

197.
Eclipse of the Sun by the Moon,
1892, charcoal and chalk on
paper, 12⅜ x 18⅞. Corcoran
Gallery of Art, Washington, D.C.

196.
Eclipse of the Sun by the Moon,
circa 1893-99, oil on canvas, 20¼
x 26½. S 535. Kennedy
Galleries, Inc., New York.

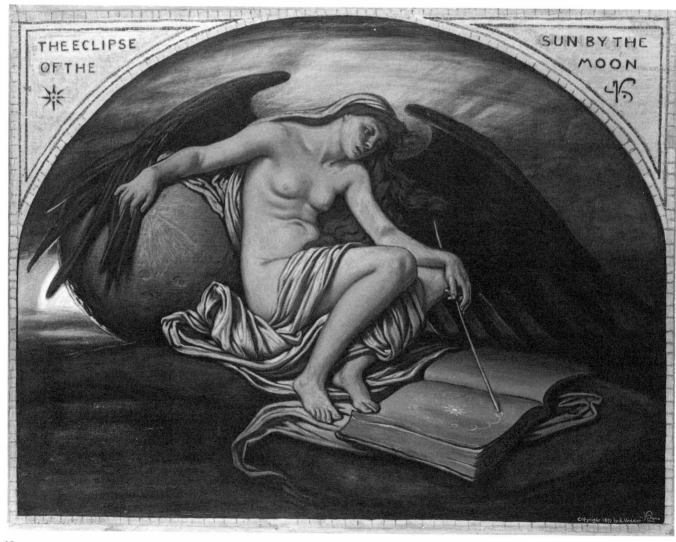

160

FINAL SUBJECTS

During the late nineties, when Vedder was at work on the *Lazarus, Keeper of the Threshold,* and *Eclipse,* he began studies for a new volume, "The Book of Mushrooms." If the studies began as a change from his highly finished symbolical and allegorical paintings to the refreshing immediacy of the minute aspects of Nature, they soon became a program in their own right. Several notebooks of carefully annotated studies of the various species of mushrooms are extant. There are also several sheafs of drawings in graphite and colored pencil showing the mushrooms and puffballs whole and in section, beautifully placed upon the page with Vedder's notations about texture, smell, and taste.

After 1900 Vedder continued to paint, basing his work on designs created at an earlier date. There were, however, no new easel paintings. He became

198.
Plate from "The Book of Mushrooms," 1895-1900, pencil, crayon, watercolor, and pen and ink on paper. Mr. and Mrs. Lawrence A. Fleischman.

absorbed in writing the *Digressions* and his two subsequent collections of poetry. The *Digressions* was illustrated with reproductions of his drawings and paintings, and photographs of himself and his family and his friends. Both volumes of poetry have Vedder's decorative designs on the text pages and reproductions of earlier paintings. Especially notable in the volumes of poetry are a group of drawings dating from the second decade of the twentieth century. They vary in style and substance, but the most interesting have the sense of mystery, of a dream recorded without revision. Such is the drawing *The Elements Gazing on the First Man*,[59] in which the three central figures seem sprung from the rocky terrain on which they stand. The older man, with a protective gesture, supports the first man, while a hooded female figure bears within her arm a tiny crouching female form. The uneven and ragged quality of the line and the simplified forms present an irregular primeval mass outlined against the cloudy sky. The thoughtful, questioning mind of Vedder's mature years, which produced *The Soul between Doubt and Faith*, turned in his last years to more elemental conceptions.

Vedder's drawing for his own tombstone shows a Buddhist temple gate with stairs leading to another gate and pagoda: on the first step of the stairs a low wine cup is turned down, and written nearby are the last words from the last quatrain of the *Rubáiyát*:

> *And when like her, oh Sáki, you shall pass*
> *Among the Guests Star-scatter'd on the Grass,*
> *And in your blissful errand reach the spot*
> *Where I made One—turn down an empty glass.*

NOTES

1. William Davies had met Vedder in London in 1870 and soon became a close friend, sharing many of Vedder's sketching trips in Umbria and persuading Vedder to accompany him on a trip to the source of the Tiber. He became a friend of the family and the godparent of the Vedders' third son, Enoch. Writing to his parents, Vedder described William Davies as "an Englishman and one of the salt of the earth kind. He is the author of a very fine book called *The Pilgrimage of the Tiber*, also *The Life of Lord Collingwood*" (letter dated August 6, 1867, in Papers of Elihu Vedder, Archives of American Art, Smithsonian Institution, Washington, D. C. (hereafter referred to as "Vedder Papers, AAA").

2. William Davies, "Drawings by Mr. E. Vedder," *Art Pictorial and Industrial: An Illustrated Magazine* 1 (1870-71): 49.

3. A small album with this group of drawings reproduced and also several woodcuts of his paintings is owned by the American Academy in Rome and may be one of the "table-books."

4. Reproduced in Elihu Vedder, *Digressions of V.* (Boston and New York: Houghton Mifflin Company, 1910), p. 287, and given this title in the list of illustrations.

5. Davies, "Drawings by Mr. E. Vedder," p. 49.

6. A *Head of Medusa* was purchased by Samuel L. Clemens from Vedder in 1878. Vedder described it as "What I call the large 'Medusa,' which I painted in Perugia this summer." The drawing now owned by the Mark Twain Memorial in Hartford, Connecticut, is similar but not identical to the larger oil painting. Regina Soria, "Mark Twain and Vedder's *Medusa*," *American Quarterly* 16 (Winter 1964) has additional information about Vedder's association with the American writer and humorist.

7. Davies, "Drawings by Mr. E. Vedder," p. 49.

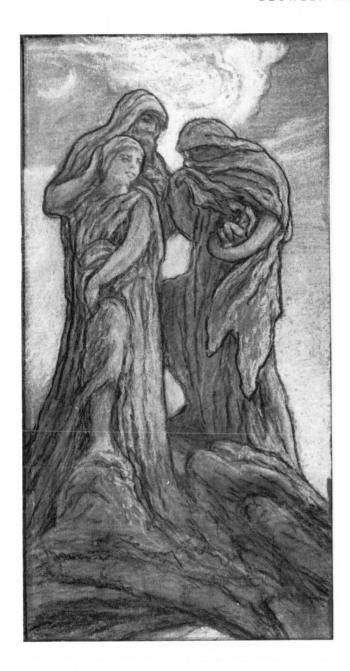

199.
The Elements Gazing on the First Man, circa 1913, charcoal and chalk on paper, 19½ x 14½. S D456. American Academy and Institute of Arts and Letters, New York.

This drawing is early evidence of Vedder's careful study of fungi. Thirty years later, in the 1890s, he made several folios of accurate, annotated studies of the varieties of mushrooms to be found in and around Rome. He intended to publish a book on the subject, but never completed it.
8. Davies, "Drawings by Mr. E. Vedder," p. 49.
9. The Cabalist primordial Adam is illustrated in Manly P. Hall, *The Secret Teachings of All*

Ages: An Encyclopedic Outline of Masonic, Hermetic, Qabbalistic and Rosicrucian Symbolic Philosophy (Los Angeles: The Philosophical Research Society, Inc., 1973), opposite p. cxvii.
10. Many of Vedder's choices of subjects from classical mythology relate to the story of Perseus. Medusa was one of the Phorcydes, whom Perseus slew by looking in his mirrorlike shield so that he would not be turned to stone

by looking upon her visage. It is said that Perseus changed Atlas into a mountain by showing Medusa's head to the giant.

11. Ovid, *Metamorphoses*, trans. Rolfe Humphries (Bloomington: Indiana University Press, 1957), p. 106.

12. Regina Soria, *Elihu Vedder: American Visionary Artist in Rome (1836-1923)* (Cranbury, N.J.: Fairleigh Dickinson University Press, 1970), p. 113.

13. Ibid., pp. 114-15.

14. Ibid., p. 115.

15. Ibid., p. 116.

16. Vedder, *Digressions of V.*, pp. 236-37.

17. Ibid., p. 236.

18. Edward FitzGerald, the poet and translator, rendered *The Rubáiyát of Omar Khayyám* into English for the first time in 1858 in an edition of 200 copies, most of which were remaindered. Among the purchasers, however, were Dante Gabriel Rossetti and several other writers who called enthusiastic attention to the work. FitzGerald published four successive translations of the quatrains, rearranging the sequence of the verses each time.

19. Vedder, *Digressions of V.*, p. 403.

20. Ibid., p. 404.

21. This document is in the files of the American Academy and National Institute of Arts and Letters, New York.

22. Vedder to Joseph B. Millet of Houghton Mifflin Co. (dated 1883 but not in Vedder's hand), in Papers of The Houghton Mifflin Company, Houghton Library, Harvard University, Cambridge, Massachusetts (hereafter referred to as "Houghton Mifflin Papers, Houghton Library").

23. Ibid.

24. From "Notes for Preface to Omar Khayyam Drawings," undated, unpaginated manuscript in Vedder's hand, Papers of Elihu Vedder, American Academy and National Institute of Arts and Letters, New York.

25. In the "Notes for Preface" (see note 24 above) Vedder related, in the third person, how "in the course of a fortnight after his arrival in Rome, May 7, 1883, he was enabled to separate the verses into proper groups and by notes and slight sketches indicate his intended treatment of each. This was the great work of the book; and in very few instances has he departed from the outline sketches."

26. Scholars point out that there was no inherent unity to Omar's verses: The *Rubáiyát* (quatrains) was simply a collection of four-line verses by the poet.

27. All editions of Vedder's *Rubáiyát* have a section titled "Notes," which follow the plates. The Notes are an edited version of the longer manuscript referred to in footnote 24. In them

Vedder commented on his plates, interpreting both his own symbolism and Omar's quatrains. The following comments on the plates come from this source.

28. Vedder, *Digressions of V.*, pp. 408-9.

29. Edward FitzGerald's "Omar Khayyám, the Astronomer-Poet of Persia" is published as an appendix to the editions of the *Rubáiyát* illustrated by Vedder.

30. Vedder to Joseph B. Millet, November 17, 1883, Houghton Mifflin Papers, Houghton Library.

31. Anita Vedder's reply is preserved in her letter to Mrs. Speed, dated January 20, 1929, in the J. B. Speed Art Museum, Louisville, Kentucky: "This is such a small boy, I never thought of it as a *nude* but if required a fig-leaf could be added." Anita described the sculpture as "the charming bronze fountain modeled mostly by Charles Keck from Father's small model." Four bronze replicas were made, and two of them have draperies drawn across the loins.

32. Marjorie Reich, "The Imagination of Elihu Vedder — As Revealed in His Book Illustrations," *The American Art Journal* 6 (May 1974): 47.

33. Vedder to Agnes Ethel Tracy, March 28, 1887, in the possession of Mrs. Francis T. Henderson, New York. In the same letter he speaks of this painting as a replica, which he painted for reproduction, and remarks that it was stored with Joe Millet.

34. Anita Vedder, statement in the curatorial files of the National Collection of Fine Arts, Smithsonian Institution, Washington, D. C.

35. Vedder to Carrie Vedder, January 23, 1900, Vedder Papers, AAA.

36. Rev. 1:8.

37. Houghton Mifflin Papers, Houghton Library.

38. This statement is from the manuscript for Vedder's Notes (see footnote 24).

39. Always strongly supportive of her husband's aspirations as an artist, Carrie Vedder over the years increasingly took on the role of Vedder's agent, treasurer, and correspondent. In a lengthy letter to Agnes Ethel Tracy, dated December 8, 1886, she mentions "*Love Amid the Ruins* about 30 × 12," as a painting then in progress. The first version of the painting, dated 1887, is known through a photograph, printed in reverse, in the Harold O. Love collection. In the introduction, Regina Soria notes the discovery of a frame for the painting inscribed "Amor Omnia Vincit." With her husband, Agnes Tracy visited Vedder's studio in Rome in 1878, and this slender, auburn-haired young woman became an admiring purchaser and even something of an entrepreneur in the placing of Vedder's paintings. She purchased the entire set of

Vedder's drawings for the *Rubáiyát* for $5,000. It is thanks to her and her collateral relatives, the Francis T. Hendersons, who inherited the drawings, that they have remained together as a group.

40. *Exhibition of Works by Elihu Vedder* (Pittsburgh: Carnegie Institute, 1901).

41. Houghton Mifflin and Co., *Reproductions of Works by Elihu Vedder*, n.d.

42. Vedder to Agnes Ethel Tracy, March 28, 1887, in the possession of Mrs. Francis T. Henderson, New York. Vedder must have referred here to the oil now owned by the Herbert F. Johnson Museum at Cornell University, which was painted in 1886-87. Another version, copyrighted in 1887 and 1898, is owned by the Baltimore Museum of Art. A third version, which was copyrighted in 1887 and 1898, is reproduced in *The Digressions of V.*, p. 393. The painting was also used as the frontispiece for Vedder's book of poems, *Doubt and Other Things*, published in Boston in 1922. Agnes Ethel had been on the American stage before her marriage to Frank W. Tracy, a wealthy businessman from Buffalo. After making a popular hit in a light piece called *Frou Frou*, she starred in several other productions before playing "a perfect picture of the most beautiful Ophelia" to Edward L. Davenport's Hamlet. See Laurence Hutton, *Curiosities of the American Stage* (New York, 1891), p. 289. Possibly her most important contribution to Vedder's career was that she purchased and preserved the *Rubáiyát* drawings as an entity.

43. Judg. 14-15.

44. Judg. 13:13.

45. Regina Soria lists four examples; a fifth is at the Hudson River Museum in Yonkers, New York, and is catalogued under the title *Eastern Landscape*.

46. The letter continues, "Had I made the Kings prominent I most certainly would have put in the black one according to tradition" (undated letter, Archives of American Art). Vedder refers here to the tradition since the Renaissance of making one of the three kings a black to symbolize Christ's coming to all mankind.

47. Vedder to Agnes Tracy Roudebush, March 1, 1900, in the possession of Mrs. Francis T. Henderson, New York.

48. Carrie Vedder to Agnes Tracy Roudebush, May 23, 1891, in the possession of Mrs. Francis T. Henderson, New York. C. C. Coleman, Vedder's long-time friend, completed a large painting, *Return from Calvary* (almost 6 × 9 feet), in 1915. It is now at the J. B. Speed Art Museum in Louisville, Kentucky. The museum also owns a study for it, which is dated 1882.

49. *At the Foot of the Cross* has this title written on the back, and on the cardboard behind the panel, the inscription "The Deposition Crucifixion No. 1," and also the note, "Made a second one with three figures in the background in Rome now." This latter painting was given to the pastor of Saint Paul's Within the Walls after Anita Vedder's funeral in 1954. Vedder had been on the vestry of this Episcopal church at the time the new building was erected and dedicated in Rome. His relationship with the church, however, seems to have been pro forma.

50. Vedder, *Digressions of V.*, p. 152.

51. Jared B. Flagg, *The Life and Letters of Washington Allston* (New York, 1892), p. 120.

52. Joshua C. Taylor, *William Page, the American Titian* (Chicago: University of Chicago Press, 1957), p. 190ff.

53. Vedder, *Digressions of V.*, p. 187.

54. Carrie Vedder to her mother, Caroline E. Beach Rosekrans (Mrs. Enoch H.), 1892, Vedder Papers, AAA.

55. A drawing of *The Soul in Bondage*, almost as large (34 3/4 × 23 1/2 inches) as the Brooklyn painting, is owned by the Addison Gallery of American Art in Andover, Massachusetts. This version has the butterfly and serpent, but shows the Soul seated upon what appears to be a great glove. In another version in oil on paper, owned by the Houston Museum of Fine Arts, the Soul is bound by cords that tie her to an orb; at the left a turtle crawls up the steps that recede to the horizon line behind the figure.

56. A series of small studies of *The Keeper of the Threshold* exists in the Archives of American Art, showing a more Oriental winged figure seated in the lotus position with outstretched arms; behind the figure is a large disk.

57. A poem in Vedder's *Doubt and Other Things*, page 136, describes how in Alfaru "each sound had its proper Sign" and "each Sign did with the Sound agree." In his *Miscellaneous Moods in Verse* (Boston, 1914), Vedder described his alphabet as having characters that "are ingenuously derived from . . . natural objects . . . if generally adopted would remove difficulties of spelling, permit the 'divine afflatus' of poets, reduce 'education' to a minimum and lighten the burden of the human race."

58. Vedder Papers, AAA.

59. *The Elements Gazing at the First Man* was given the title *Advent of Man* and dated 1913 when published in *Doubt and Other Things*, page 193. Opposite is a poem of the latter title, which tells of the Elements' delight with man until his destructive and creative character was witnessed.

200.
Decorative design, circa 1900,
watercolor and pastel on paper,
mounted on gouache and pastel
on paper, mounted on pastel on
paperboard, 11¾ x 7⅜. The
Harold O. Love Family.

The Art of Decoration

RICHARD MURRAY

In 1879 Elihu Vedder arrived in New York City for his first visit to the United States since 1869. He encountered a city that had changed markedly since his visit ten years earlier. The center of business and shopping was moving uptown, and elevated cars were noisily changing old established patterns of housing and work. The tremendously expanded urban limits now reached to the end of a recently completed Central Park. On Fifth Avenue, vast, audaciously ornamented mansions that proclaimed the owners' wealth and genteel taste were beginning to appear. In art, too, a spirit of change was evident: it was, to be sure, an exhilaration with the new, but in a special sense. A band of brash artists, many of whom were young and but recently returned from study at European academies, was intent on altering the course of American art by looking anew at the art of the past. Trained chiefly in Munich and Paris, these artists considered themselves thoroughly international and modern. They were proud of their newly acquired knowledge of the history of art and the technical proficiency they had acquired in academic studios abroad. They had very little esteem for the older American artists who concentrated on local subject matter, whether it be the picturesque or eccentric traits of some of their countrymen or special virtues seemingly inherent in American nature. One well-known critic noted that the distinguishing characteristic of the older art was "tameness" and added, "We heard all this tameness summed up in the newly invented stigma 'the Hudson River School,' with which our pastoral and chromo-lithographic art, till then firm seated in the popular heart, was now daily pestered by the confident lovers of the new." [1] Charged by the new aesthetic of historical periods and national schools, the younger artists found only what they perceived to be a local backwater in the mainstream of history, art, and society. There was no "American school," they decided, only pleasant paintings of the Hudson River and its environs.

In a very short time, new institutions founded by younger artists sprang up to oppose the old. The National Academy of Design, the bulwark of values thought of as traditional, had been the center of the artistic life in New York City since its founding in 1825. Now, however, its leadership in the teaching of

167

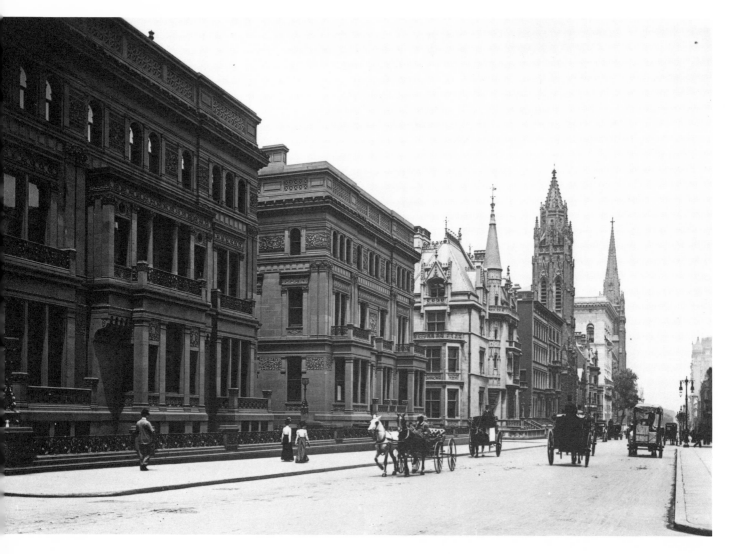

201.
Fifth Avenue, north from
Fifty-first Street, New York City,
circa 1882.

art was challenged by the Art Students League, organized in 1875 as a school that more nearly represented European academic training. Further, the National Academy's exhibitions, once the most important event in New York's art world, were rivaled in popularity by those of the Society of American Artists, founded in 1877 as an organization to provide exhibitions for the new art that was considered "foreign" by the old guard.[2] Soon other exhibitions of art of the "new movement" were crowded to the point of overflow and contention for valuable space.[3]

To many, the increase in number and kinds of institutions, societies, and exhibitions of art seemed to bespeak a rejuvenation of American art, a renaissance that some believed could be dated from the surprising popularity of the vast exhibits of art at the Centennial Exposition. As one commentator noted, of the five major societies of art in New York City—the National Academy of Design, American Water Color Society, Art Students League, Society of Ameri-

202.
Samuel Colman, wall decoration,
circa 1880. From Clarence Cook,
*What Shall We do with Our
Walls?* (1881).

203.
Interior decorations (1876-78) by
John LaFarge in place in Trinity
Church, Boston. From M. G. Van
Rensselaer, *Henry Hobson
Richardson and His Work* (1881).

can Artists, and New York Etching Club—all but the National Academy were
"the fruits of the renaissance in art which began during the Centennial year." [4]
To others, the phenomenon was a harbinger of a cultural reawakening that re-
called, in their historically oriented view, that of the Italian Renaissance. As
they had read in the widely popular works of historians John Addington
Symonds and Jacob Burckhardt, such a renaissance involved all aspects of the
culture, and a salient proof of a new age was the popular or widespread appre-
ciation of art. The new criticism by Walter Pater, in books such as his *The
Renaissance* (1873)—already a major contribution to the "aesthetic move-
ment" in England—helped Americans toward a new appreciation of the alle-
gories and themes that appealed to mind, fantasy, and historical reverie. [5]

It was in the decorative arts that the new sensibility to works drawn from
the history of art was most evident, and, as in architecture, painting, and sculp-
ture, there was a split between the older and younger generations. It was thought
that the older, workmanlike conventions of decoration had been overturned by
younger, professionally trained artists who were open to the full range of his-
torical precedent and turned their knowledge and proficiency to the decoration

204.
Interior decorations (1877) by John LaFarge and Augustus Saint-Gaudens, in place in Saint Thomas Church, New York, 1877.

of all manner of things, especially architectural environments. John LaFarge, and others working under his direction, had completed the celebrated decorations for Trinity Church in Boston only a year previous to Elihu Vedder's arrival in New York.[6] LaFarge and Augustus Saint-Gaudens, inspired by the Italian Renaissance, had recently completed their decoration of Saint Thomas Church on Fifth Avenue,[7] and LaFarge, Saint-Gaudens, and Louis Tiffany were about to begin the extensive project of decorating the interior of George B. Post's residence for Cornelius Vanderbilt II. Tiffany, Samuel Colman, Lockwood de Forest, and Candace Wheeler had in 1879 formed the firm of Associated Artists to promote and ride the early crest of the new movement in decorative arts and were at work on the firm's commission to decorate the Veterans' Room and the Library of the Seventh Regiment Armory. Two years earlier, in 1877, Candace Wheeler had established the Society of Decorative Art in New York, the forerunner of many such societies throughout the nation,[8] and Renaissance-inspired works by its members were much in demand.

The new directions in the decorative arts gained support from many critics who pleaded for an "intelligent eclecticism" to replace what they considered to be a degraded vernacular of historical decorative forms.[9] Marianna Griswold Van Renssaelaer, for one, believed it necessary to discount the older "decorative art and its dogmas," the principles of decoration as preached by Charles L. Eastlake in his *Hints on Household Taste* (1868) and carried on in Clarence Cook's *The House Beautiful* (1877). There was, she insisted, no particular virtue in the principle of "sincere construction," nor was it necessary to be-

205.
View of gallery showing oriental screen (with details) by Associated Artists for Seventh Regiment Armory, New York, 1879. From *Scribner's Monthly* (July 1881).

lieve in the virtues of "dead colors, and half tints and manifold slight contrasts and nearly allied shades." Citing instead the need to look intelligently at all historical works for guidance, Mrs. Van Renssaelear declared, "We may not put aside the world's best work and weave a narrow theory afresh." [10] Many artists agreed with her contention that the long-standing distinction between representative and decorative—or conventional—art was false, for the tradition of Western art was essentially both representative and decorative, especially the art of the now cherished Italian Renaissance.

Vedder was much at home in this new world of art in America. He was asked to show some of his work at the Art Students League (and in 1881 was elected to the Society of American Artists), and, as an academician since 1865, was also hailed by old friends as fresh support for established institutions. "The old fellows consider I belong to them, so do the young," [11] wrote Vedder, not without amusement. Too, long before his visit to New York, Vedder had been fascinated by the decorative qualities of things culled from the history of art; tapestries, cassoni, and costumes, which he used in paintings such as *Girl with a Lute* (fig. 207, 1866), *Musical Inspiration* (fig. 208, 1875), and *The Little Venetian Model* (fig. 127, 1878), as well as other details that appear in his many paintings of Renaissance subjects, which were as carefully studied as his landscape paintings. In Perugia during the years 1872-77, Vedder had made designs of a king and a reader that may have been destined for translation into pyrography, as was his intricate design for a bench or case depicting a Renaissance maiden with a lute and a poet with a scroll. The new interests in the decorative arts that Vedder encountered in New York City, however, spurred him on to

206.
Top of box carved by members of the New York Society of Decorative Art. From *Scribner's Monthly* (September 1881).

207. LEFT
Girl with a Lute, 1866, oil on
canvas, 16 x 9. S 78. Jo Ann and
Julian Ganz, Jr. (See also
figure 70.)

208. RIGHT
Musical Inspiration, 1875, oil on
canvas, 28½ x 15½. The
Parthenon, Nashville, Tennessee;
James M. Cowan Collection.

make other designs that would become increasingly complex examples of his
fascination with the art of decoration.

While Vedder was in New York during the winter of 1879-80, Louis Prang
organized his first competition for designs for his popular Christmas cards.
Among the entries he received were many that reflected the growing taste for
decoration based on studied adaptations of historical ornament and on stylized
natural forms. Although Vedder had returned to Rome in mid-1880, he was
well aware of Prang's much publicized second competition, held in February
1881. He submitted two designs to this competition: a woman in Renaissance
costume set against a blue sky and framed by a border of stylized leaves and
flowers in subtle tones of green and gold, and a half-nude goddess of Fortune.
These were, to be sure, designs quite different from the stylish linear decora-
tions produced by members of the various societies of decorative arts and were
even further from the sentimental scenes that had characterized most of
Prang's earlier Christmas cards, which he had been producing since 1873.[12] To
those attuned to traditional seasonal or Christmas scenes or symbols, Vedder's
designs were shocking. They carried no special Christmas symbols, nor had
they any special religious significance. The only identification with the season
was a boss inscribed "Xmas 1882." These designs, however, pleased the taste of
the competition's judges—John LaFarge, Stanford White, and Samuel Colman—

209.
Study for decorative panel,
Reader, circa 1872-77, chalk on
paper, 10¾ x 6¹⁵/₁₆. The
Harold O. Love Family.

210.
Study for decorative panel, *King*,
circa 1872-77, chalk on paper,
10½ x 6¾. The Harold O. Love
Family.

211.
Design for pyrograph for bench or
case, circa 1872-77, pencil, chalk,
and watercolor on paper, 13 9/16 x
20¼. The Harold O. Love Family.

213.
Christmas card designed 1880 by
Rosina Emmet for L. Prang & Co.
Hallmark Historical Collection,
Kansas City, Missouri.

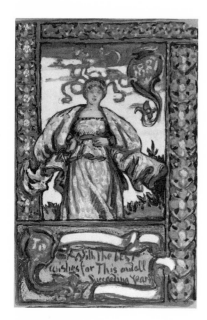

212.
Design for Christmas card by
Elihu Vedder, 1881, for L. Prang &
Co., watercolor and gold on paper,
8⅞ x 5¹⁵⁄₁₆. The Harold O. Love
Family.

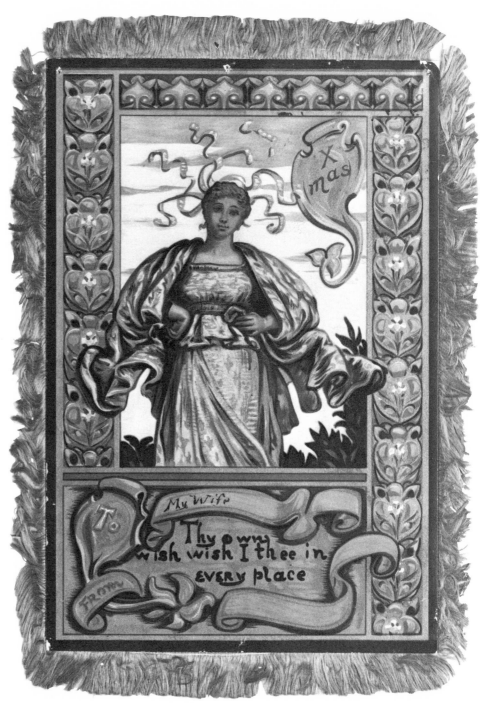

214.
Christmas card designed by Elihu Vedder for L. Prang & Co., 1882,
chromolithograph on paperboard, 8⅞ x 6¹⁄₁₆. Archives of American
Art, Smithsonian Institution, Washington, D. C.

215.
Section of dining-room ceiling
designed 1880-81 by John LaFarge
for the Union League Club,
New York. From *The Century
Illustrated Magazine* (March
1882).

for Renaissance ornament and classical subject matter, and despite a protest
by the critic Clarence Cook, they awarded first prize of $1,000 to Vedder's
Renaissance maiden. Louis Prang, recognizing the prestige involved in printing
work by important artists (as one critic put it, "It is easy to see that art is ad-
vancing in this country when Elihu Vedder makes our Christmas Cards" [13])
also bought the design of Vedder's Goddess of Fortune.

The success of his foray into what was perhaps an inauspicious form of the
decorative arts prompted Vedder to think seriously about the opportunities
offered by the new interest in them. With an unexpected but welcome com-
mission in June 1881 from *The Century Illustrated Magazine* to design a stand-
ard cover and four others to be used for mid-season issues, Vedder needed little
convincing to decide that he should return to America.

By October 1881, when Vedder was again in New York, the nascent decora-
tive arts movement that he had seen in 1879 and 1880 had in only a short time
grown complex and varied, and had become popularly accepted. Magazines
such as *Art Amateur* were spreading the gospel of a new decorative art, and
firms such as Warren, Fuller and Company were doing a brisk business in wall-
paper designed by Tiffany and Colman. The Associated Artists and John
LaFarge, among others, had completed an important new project at the new
Union League Club in New York; the decorations in the mansion of Cornelius

177

216.
John LaFarge (1836-1910) and
Augustus Saint-Gaudens (1848-
1907), *Bacchus* and *Pomona*,
1881-82, in place (top) in dining
room of residence of Cornelius
Vanderbilt II, New York.

217. LEFT
Design for Christmas card, *Peace
on Earth, Good Will to Man*,
1882-83, watercolor, pen and ink,
and chalk on paper mounted on
paperboard, 9 x 7 (sight) S D171.
The Harold O. Love Family.

218. RIGHT
Design for greeting card,
Aladdin's Lamp, 1882-83, pencil,
gouache, and gold on paper,
9⁷/₁₆ x 7⁵/₁₆. Fogg Art Museum,
Harvard University,
Massachusetts; Winthrop
Collection.

Vanderbilt II were being completed by LaFarge, Saint-Gaudens, and Tiffany;
and Herter Brothers, another firm of decorative artists, was at work on several
projects, including the decoration of a mansion for William Henry Vanderbilt.
Frederic Crowninshield and David Maitland Armstrong, Vedder's old friends
from Rome, were also becoming well known for their mosaic and stained glass,
designed for homes and churches in Boston and New York.

Had he chosen to do so, Vedder could have joined one of these firms or
collaborative associations and produced large architectural decorations.[14] He
preferred, however, to design his own smaller scaled works and sell them to es-
tablished firms. He continued to design greeting cards, such as one of three
spritely Christmas angels (fig. 217) and another he titled *Aladdin's Lamp* (fig.
218), a subject from the Arabian Nights that had so fascinated Vedder in the
1860s while he was in New York. A variant of *Aladdin's Lamp* was made in
1883 for a stained-glass window design (fig. 219) purchased by Frederic Crown-
inshield for Tiffany's firm.

Stained-glass designs were, in fact, a major occupation for Vedder during
this very productive trip to New York. He made designs for at least five win-
dows, most of which were produced by Louis Tiffany. Besides his *Aladdin's
Lamp*, Vedder also designed *Aladdin's Window*, a complicated work that he
regarded as his favorite.[15] The design called for some fifty glass rings in leading
that provided only a fragile supporting web. The window was a variant of
Vedder's own design for glass rings with metal flanges, which he had brought to
New York and tried unsuccessfully to patent and place on the market. While
the designs by many other artists working in stained glass were made mainly
for churches, Vedder made only one that had traditional religious significance,
an angel with outspread arms and wings set against a flaming sun.

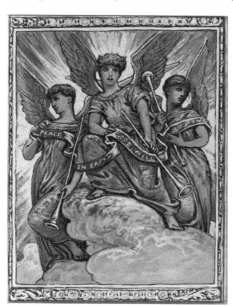

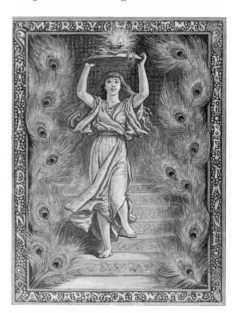

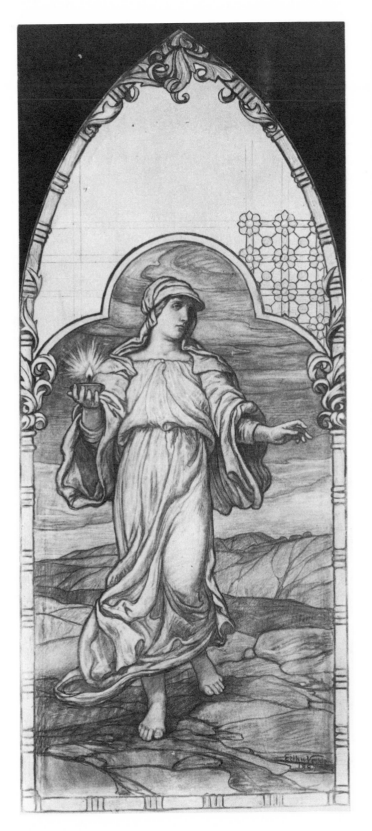

220.
Design for *Aladdin's Window*,
1882-83, gouache on paper, 13 x
9½. Kennedy Galleries, Inc.,
New York.

219.
Design for stained-glass window,
Aladdin's Lamp, 1883. S D181.
Unlocated.

Vedder also designed two windows on the theme of "the fisherman and the mermaid," an underwater fantasy in twelve scenes that traced the tale of a fisherman's encounter with the mythical creatures, his complete fascination by them, and his death and final union with the sirens in their underwater world. Beginning in 1878, Vedder made many drawings and several paintings of the individual scenes. Although he did not finish the projected series, he did use the mermaid theme in many of his decorative works, including an ambitious stained-glass window designed in 1882, which was produced by Tiffany for the residence of A. H. Barney in New York City. Vedder spared none of his imagination on this design, which is replete with shell bosses, seaweed, and fish, all of which swirl around the seated mermaid. Indeed, he changed the mermaid to a girdled undersea Venus peering at her reflection in her shell mirror while strings of pearls hang lasciviously from her ringed fingers. A second design that relates to the mermaid theme was a woman in flowing robes, seated upon a marble bench and opening a curtain onto a multicolored pattern of submarine currents; fantastic sea creatures with ruffled gills and conch-shaped shells housing eyes that peer outward and toward one another inhabit the complex border and base.

The designs for greeting cards and stained glass were not, however, a source of continuing income. Vedder was anxious to patent his own inventions in the field of decorative arts and to have them produced under contract with a large firm. He would then be assured of an income, however small, from royalties and other fees. In November 1881, only a month after arriving in New York City, Vedder was making designs for tiles and firebacks, and inquiring into patent rights for his invention of glass rings. He designed two tiles and succeeded in gaining a patent for a new method of joining metal frame and tile without baking, which unfortunately proved too costly for mass production.[16] His design for glass rings with metal flanges that could be joined by cornices and columns to make screens of variable sizes, was, he found, too similar to Louis Tiffany's preceding design of the same year to be patented; he later sold it to Tiffany rather than carry on a court battle to establish his claim.[17] The firebacks that Vedder designed were, however, put into limited production; the *Sun God*, *Japanese Dragon*, and *Soul of the Sun Flower*, one of Vedder's favorite subjects, were moderately successful through distribution by John G. Low's Chelsea Tile Works, but collecting the commission caused Vedder much anguish.[18]

Vedder's designs for magazine covers are yet another form of decorative art that he produced during this stay in New York. Those designs for *Century* magazine, the commission for which Vedder had received while in Rome in June 1881, began to appear with the February, or Midwinter, issue of 1882. With these covers, and those he designed for *The Studio* magazine and *Harper's New Monthly Magazine*, Vedder's long-sustained interest in astrological signs and symbols began to appear with greater public frequency.

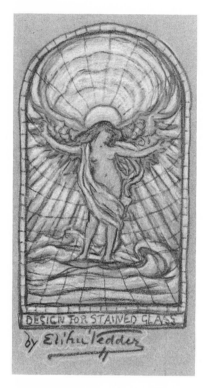

221.
Design for stained glass, 1882-83, pencil and pastel on paper, 6½ x 3⅝. S D179. The Harold O. Love Family.

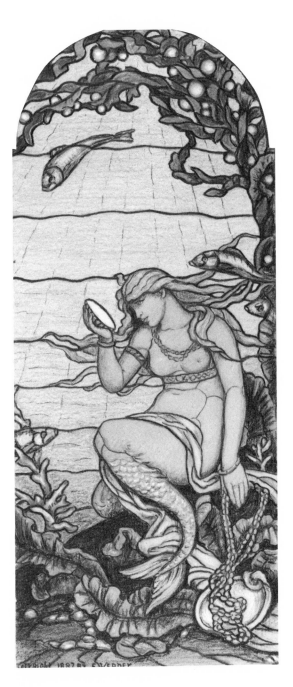

222.
Design for stained glass, *The Mermaid Window*, 1882, crayon and gold on paper, side panels 7¼ x 2⅛, center panel 8⅞ x 7¹³⁄₁₆. S D183. The Cooper-Hewitt Museum of Design and Decorative Arts, New York.

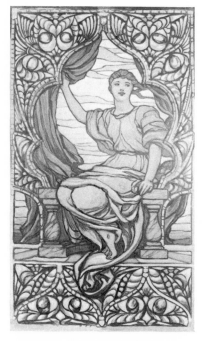

223.
Design for stained glass, 1882-83,
watercolor on paper, 21½ x 12¾.
S D182. The J. B. Speed Art
Museum, Louisville, Kentucky.

224.
Design for glass rings, circa 1882,
pencil and pen and ink on paper,
4¾ x 8½. The Harold O. Love
Family.

225. BELOW
Fireback, *The Soul of the
Sunflower*, 1882, cast iron, side
panels 31 x 15, center panel
31 x 23.

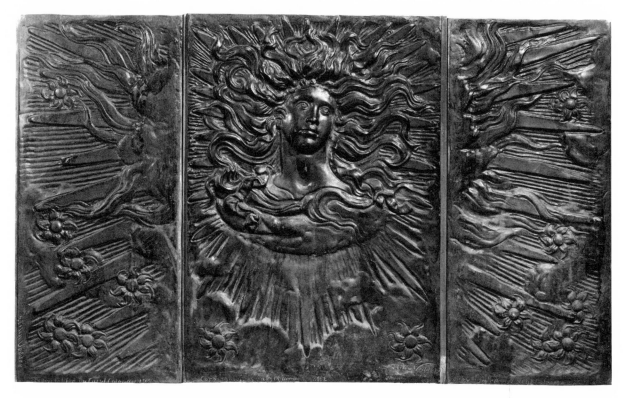

In his autobiographical *The Digressions of V.*,[19] Vedder mentions his interest in astrology (or astronomy) as one of his "fads," or passing fancies. To be sure, there is no evidence that the skeptical artist ever committed himself to a literal belief in this or any other form of mysticism, although mystical and esoteric subjects, such as astrology, stimulated his imagination. He was especially attracted by imaginative symbols, with which astrology is prolix. Also, possibly because of the early deaths of two of his children, Vedder was emotionally attracted to the notion of some sort of impersonal cosmic principle that, for good or for evil, influences men's lives.

Vedder's early interest in astrology is shown in a drawing that he made on November 12, 1868, while he was in Glens Falls, New York, in preparation for his wedding. Entitled *Atlas, the Deep Thinking—the Endurer*, it is one of the series of small drawings from 1866 and 1868 that Jane Dillenberger discusses in her essay. These drawings include *Weirdness*, *The Elfin Horn*, and *The Face in the Clouds*, which suggest states of mind or probe the metamorphosis of reality into fantasy. The drawing of Atlas is Vedder's first flight into the cosmic realm. In it, the astrological ecliptic ringing the figure that supports the universe suggests that the key to natural order is to be found in deciphering the cosmic code.

During the late 1870s and 1880s, Vedder became much interested in the iconography used in ancient and Renaissance art, in which mythological and astrological deities are inseparable. He began to think of using the old zodiacal figures, signs, and glyphs not only as decorative devices to satisfy a new popular taste for themes drawn from earlier historical periods, but as devices to give cosmic significance to objects otherwise commonplace. In a drawing from about 1878, he worked out the entire system of astrological signs and glyphs, and experimented with complicated arrangements of the mystical figures associated with them.

Although it was probably Stanford White who suggested to Vedder that he include astrological symbols in his designs for special numbers of *Century* magazine,[20] it was Vedder who worked out the ways in which they were used in several of the covers. The first of his designs to be published was for the cover of the Midwinter issue of February 1882 (fig. 228). It encompassed the figures signifying Capricorn, Aquarius, and Pisces. These signs were carried in a medallion and their corresponding glyphs in a celestial band that could either be the zodiacal ecliptic or the aurora borealis. A figure, seemingly entranced and clad in vaguely antique, possibly near Eastern, robes, holds the nonastrological but equally traditional symbols of a lamp of knowledge and a book with a reference conveniently marked by a finger. The entire composition is framed by stout ivy vines, the plant associated with Capricorn. The wintery mystery suggested by this cover is quite opposite to the effect of that of the Midsummer issue, published in August (fig. 229). Here, Vedder depicts a young woman lying on a beach in a most languorous way, with a parasol behind her. A medallion

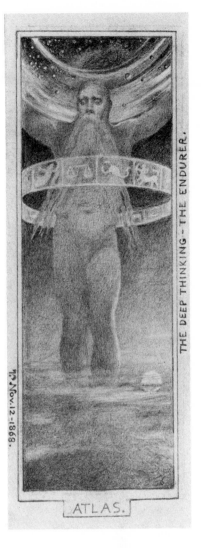

226.
Atlas, The Deep Thinking—The Endurer, 1868, pencil on paper, 6¹¹/₁₆ x 2½. S D91. Mr. and Mrs. Lawrence A. Fleischman.

227.
Study of the signs of the zodiac,
circa 1878, charcoal and gouache
on paper, 6½ x 25½. Kennedy
Galleries, Inc., New York.

228.
Cover of *The Century Illustrated
Magazine* (February 1882)
designed by Elihu Vedder.
S D173. Library of Congress,
Washington, D. C.

with the zodiacal figures of Cancer, Leo, and Virgo is placed behind her head, and sunflowers, the plant associated with Leo, make up the border and are strewn through the title heading.

In late 1882 when *The Studio*, a magazine devoted to the arts, was preparing for its first issue, Vedder was commissioned to design its cover. The magazine appeared on January 6, 1883, carrying an unusual design (fig. 230), also related to astrology. Within each of four interlocking rings, Vedder placed a head representing the elements of air, earth, fire, and water, the basic "natures" of zodiacal signs, which are linked to planetary "personalities." Vedder was so intrigued with this formulation of universal elements that he used it as his bookplate; much later, in 1899, he altered these figures somewhat and used them for a mantelpiece design, for his "Omar Cup," and finally, in 1910, for the frontispiece of his autobiography, *The Digressions of V.*

Vedder received yet another commission for a magazine cover that, too, was to carry a design with astrological significance. For the Christmas supplement of *Harper's*, Vedder was asked in March 1882 to provide a special illustra-

229. ABOVE, LEFT
Drawing by Elihu Vedder for cover of *The Century Illustrated Magazine* (August 1882), pen and ink, pencil, and colored pencil on paper, 10¼ x 7⁹/₁₆. S D174. Mr. and Mrs. Lawrence A. Fleischman.

230. ABOVE, RIGHT
Cover of *The Studio* (March 24, 1882) designed by Elihu Vedder, letterpress with watercolor, 12⅛ x 9⅝. S D222. The Harold O. Love Family.

185

231.
Bookplate of Elihu Vedder, circa
1882, mechanical reproduction on
paper mounted on paper, 2 x 1.
Mr. and Mrs. Lawrence A.
Fleischman.

232.
Design for mantelpiece, 1899,
chalk, pencil, watercolor, and
gold on paper, 7¾ x 14¼.
The Harold O. Love Family.

233. BELOW
Design for bronze cup ("The Omar
Cup"), 1899, pencil and chalk on
paper, 12¹¹/₁₆ x 9¼. The Harold O.
Love Family.

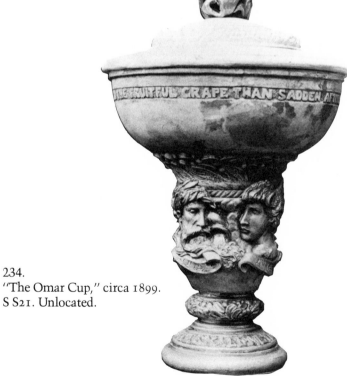

234.
"The Omar Cup," circa 1899.
S S21. Unlocated.

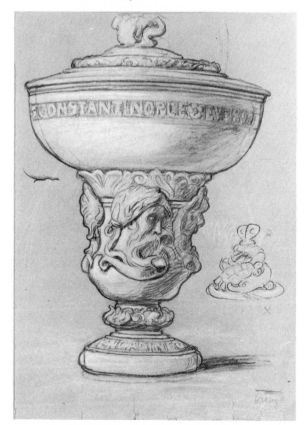

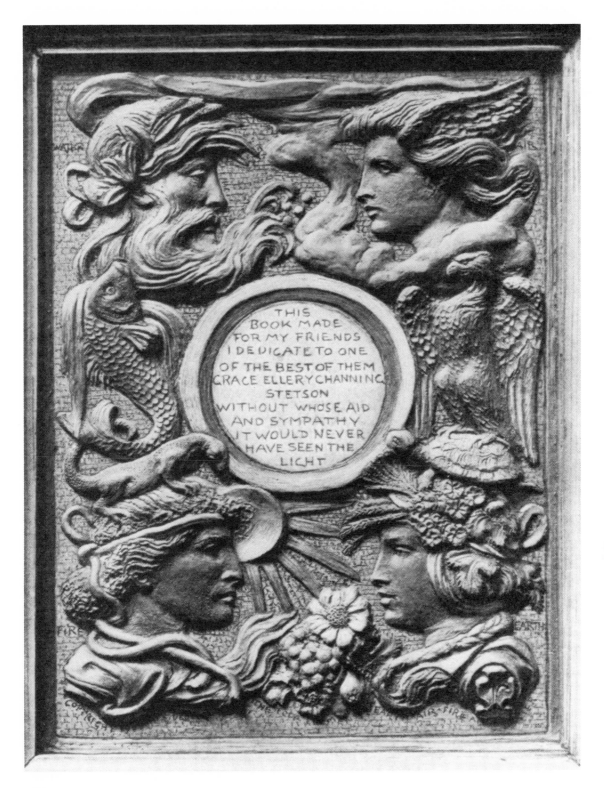

235.
Frontispiece to *The Digressions of V.* (1910).

236.
Luna, study for cover of *Harper's New Monthly Magazine* (Christmas issue, 1882), border by Alfred Parsons (1847-1920), pastel and watercolor on paper, 11 x 12. St. Augustine Historical Society, Florida.

tion for the cover. He designed a remarkably evocative head of Luna (fig. 236), the astrological "planetary" sign that is second in significance only to the Sun. Vedder's *Luna* was hardly traditional for Christmas, unless one was willing to include in tradition much more than scriptural homelectics. The subject could, in fact, recall for those so attuned the myriad associations of Luna in ancient and Christian myths and literature, which many were willing to do; not only did the figure of Luna appear as the magazine cover, but it was also made into a very popular calendar plate. In a practical sense, Vedder relied on his drawing of the head of Earth for his *Studio* cover, which was probably designed around the same time.

If Vedder looked upon astrology as symbolic of cosmic destiny, malignant for some, benevolent for others, he was also fascinated with the concept of

random chance, or fortune, within the larger order. This concept, too, was to play an important role in his decorative designs. An early occurrence of the symbols associated with chance was in one of Vedder's most appealing figures, the *Dancing Girl* of 1871. Lushly painted but precisely observed, the decorative details of the tapestry and Renaissance dress testify to Vedder's interest in the complexity of artifice. The painting is, to be sure, an early example of a decorative impulse in Vedder's work that would intensify within the next decade. It might be considered nothing more had Vedder not added the wheel of fortune, the first instance of his use of the symbols of chance and fortune, leaning against the tapestry at the lower right. With the addition of this one element, the possibilities for another level of meaning increase substantially. The figure can be seen as simply a model supporting rich drapery, but she may also be interpreted as a symbol for present gratification in the face of unreckoning chance.

Vedder's attention to decorative details was soon paralleled by attention to details of iconography, which began to crowd into his work as an insistent language of symbols. Significantly, his first painting to be wholly dependent upon iconography was the *Fortune* of 1877 (fig. 238). Enveloped in swirling draperies, the rhythms of which would become symbolic of the flow of cosmic life when modified and used in the illustrations to *The Rubáiyát of Omar Khayyám*, Fortune stands on her wheel and is set against the background of an expanse of sea and a deftly painted island. From her right arm hangs a flask of potion and her keys to fortune, and she holds an urn of money, from which coins fall through a crack. Dice, symbols of chance, fall freely beneath the wheel as Fortune gazes at a bubble threatened by encircling bees. Clearly, this is a goddess who does not easily give up her riches, for she is at the same time the goddess of wealth and chance, who bestows her favors at random. This particular figure and the concept of randomness that it represented assumed a tragic and somber meaning when in 1879 Vedder painted *In Memoriam* (fig. 239), a tribute to his son Philip who had died in 1875. Vedder used the mourning figure in the same pose as *Fortune*, as well as the same urn, with some modification of the decoration, to transfer in an astonishingly direct way the concept that misfortune, too, is bestowed at random. Dead poppies surround a column on which is placed the skull of a boar sacrificed to the manes.[21] Vedder joined this classical reference to sacrifice to that of Christian symbols by placing a passion flower, the parts of which seemingly represent the instruments of Christ's Passion, above a plaque with a Latin inscription, which can be translated as

> *Also, as one surviving flower*
> *Lives among his dead companions,*
> *Thus in the desolated heart still*
> *That name lives.*[22]

237.
Detail from *Dancing Girl*, 1871, oil on canvas, 39 x 20. S 207 or 209. Barbara B. Millhouse.

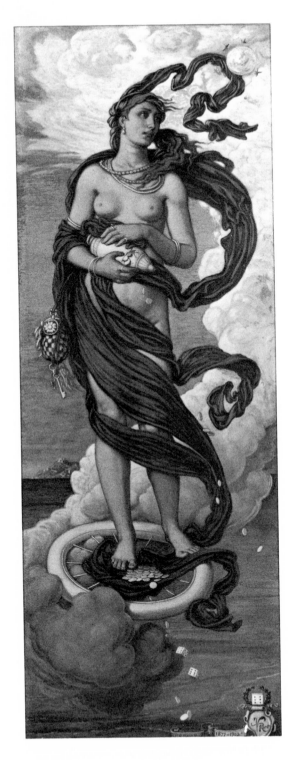

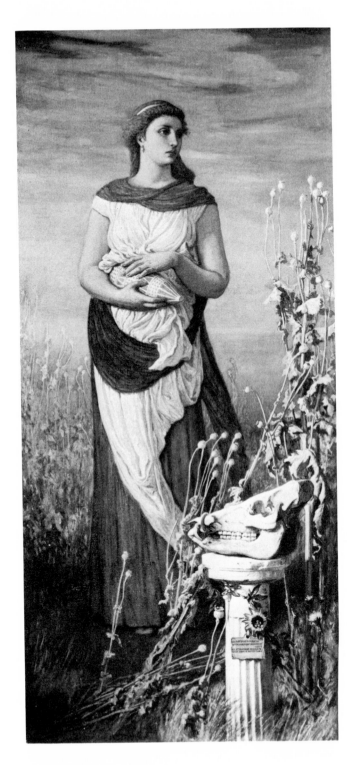

238.
Fortune, 1877/1902, oil on canvas,
49¼ x 18½. S 313. Mrs. Charles
Keck, Sr.

239.
In Memoriam, 1879, oil on
canvas, 44¼ x 20. S 337.
Corcoran Gallery of Art,
Washington, D. C.

190

Vedder's next composition of Fortune was yet another, certainly less lugubrious, aspect of the associations of the concept. It was one of the designs for greeting cards that he submitted to Louis Prang's second competition in 1881, described in the press as "a half nude young goddess of Fortune, sitting on her inclined wheel and extending her arms beneficently, showering 'good luck' pearls, while the Sun, in the shape of a wheel, shed its beams upon her."[23] It will be recalled that Prang purchased this design (fig. 240) as well as the prize-winning woman in a Renaissance costume. Vedder, however, was so enamoured of this *Fortune* that he reserved the right to make one painting of the subject. Later he did paint one large-scale version (fig. 241), now at the J. B. Speed Art Museum, but also executed many drawings based upon the original design, which unfortunately remains unlocated.

Vedder returned to Rome in April 1883 and thereafter produced few decorative designs—other than those for the splendid, hand-carved frames for several of his paintings—until the 1890s. His illustrations for *The Rubáiyát of Omar Khayyám*, begun while he was in New York and published in 1884, should, however, be counted among Vedder's most successful work related to astrological subjects. The *Rubáiyát* drawings, more than any other of his works, were Vedder's fullest expressions of a pessimistic response to the relentlessness of fate and chance. Omar, the astronomer-poet of Persia, counsels the acceptance of the present, for he has found that his own famed astrological calculations, meant to trace precisely the course of the stars and man's destiny, are of little assistance in explaining the phenomenology of life and that chance, fortune, and unpredictability only tighten the knot of man's fate. Omar's response to the question of fate, as Vedder suggested in his frontispiece to the *Rubáiyát*, was to accept the transcience of life and rise above contending wills of the present by relinquishing his own will, in much the way as was suggested by Arthur Schopenhauer in his *The World as Will and Idea* or more popular *Parerga und paralipomena*.[24] Considered as a statement of philosophical pessimism, the *Rubáiyát* and Vedder's accompaniments are among the most important works of the nineteenth century in that vein.

Vedder's designs for greeting cards, stained glass, magazine covers, tiles, and firebacks had in the short period of eighteen months established his name in what was for him a new direction of art. The *Rubáiyát* illustrations kept his name in circulation among the architects and artists of the self-conscious American renaissance. Old friendships were renewed with artists such as Francis D. Millet and George Willoughby Maynard, and Vedder's membership in the Tile Club, which Regina Soria describes in detail in her biography of Vedder, increased his popularity among the younger generation of American artists. In 1887 he returned briefly to the United States to arrange for an exhibition of his work. In New York he sold nothing. Added to this shock was another, the notification he received that his friend and supporter Mrs. Agnes

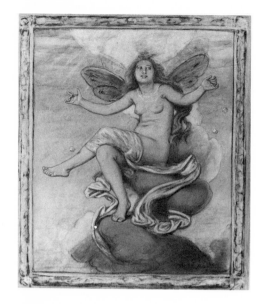

240.
Study for *Fortune*, circa 1882,
pastel on paper, 20⅛ x 17⁷/₁₆.
S D470. Robert E. Love.

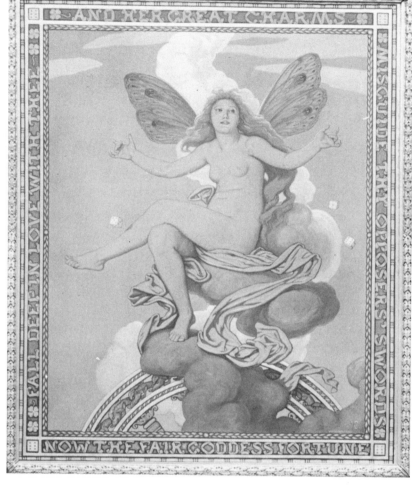

241.
Fortune, circa 1899, oil on canvas,
approximately 81 x 69. S 491.
The J. B. Speed Art Museum,
Louisville, Kentucky.

243.
Study for frame design, circa
1885-90, charcoal and chalk on
paper, 15 x 16. Kennedy
Galleries, Inc., New York.

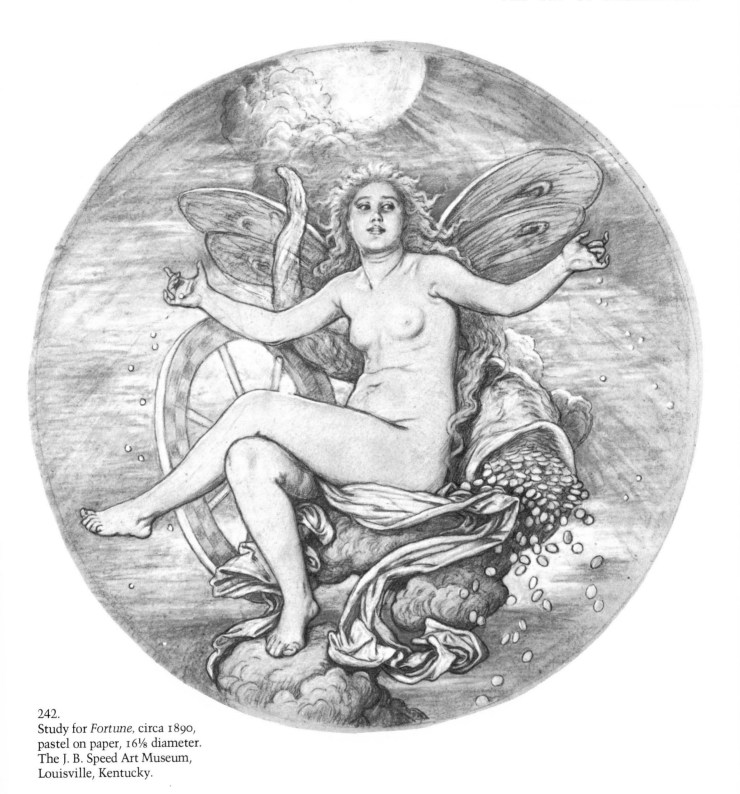

242.
Study for *Fortune*, circa 1890,
pastel on paper, 16⅛ diameter.
The J. B. Speed Art Museum,
Louisville, Kentucky.

Tracy might possibly cancel her agreement to buy some $5,000 worth of his work. At this point Vedder wrote to his wife, "It seems the wheel of Fortune is going down just now."²⁵ As was usual, however, his exhibition in Boston was successful and he sold some $6,600 in paintings. Vedder did not produce any decorative works during this trip and may have decided not to invest large amounts of time on work that brought such little monetary return: his activity in the decorative arts from 1881 until 1883 had been intense, but he had received only a little more than three thousand dollars for his work, including the $1,000 award from Prang for his Christmas card designs.

Larger and more financially rewarding commissions for decorative art were promised in June 1891, when Charles McKim of the architectural firm of McKim, Mead and White visited Rome in the company of Samuel A. B. Abbott, Chairman of the Board of the Boston Public Library and supporter of the firm's extravagant plans for a new library building, a Renaissance palace, on Copley Square. Previously, they had been to England, to talk with John Singer Sargent and Edwin Abbey about proposed murals for the building and had made initial contact with Puvis de Chavannes and J. A. M. Whistler in Paris.²⁶ McKim at that moment was involved not only in the design of the new Boston Public Library, but also that for the Walker Art Building at Bowdoin College, and in planning for the World's Columbian Exposition in Chicago. The Vedders entertained McKim and Abbott, and during the course of their visit Carrie Vedder was asked by McKim to oversee a "large amount of casting in plaster from the Villa Medici, Forum, Farnasina, Villa Madama . . . for the Boston Public Library, as also with the purchasing of a large amount of bric à brac and tapestries for the same place for the firm of McKim, Mead and White who are the architects and decorators of the Library."²⁷ McKim and Abbott also suggested that Vedder might possibly participate in the project of designing mural decorations for the library,²⁸ and Vedder, in preparation for a possible mural commission, cut short a painting trip to Viterbo that summer to return to Rome and his studio and to make notes of Pintoricchio's murals in the recently opened Borgia apartments in the Vatican.²⁹

Without specific commitments, but with the probability of commissions from McKim, Mead and White for one of their buildings, Vedder arrived in New York on July 31, 1892, and began yet another short but intense period in his career as a decorative artist, this time as a mural painter. The Boston Public Library work was much in his mind, and McKim had an informal agreement with Mary and Harriet Walker that Vedder would paint a mural for the new art museum to bear their name on the campus of Bowdoin College in Brunswick, Maine. Too, the architectural firm was among the major organizers of the World's Columbian Exposition in Chicago, and the news of the vast amount of decoration to be executed there dominated conversations about art. Since at least February 1892, Vedder had been thinking of subjects that he might use in

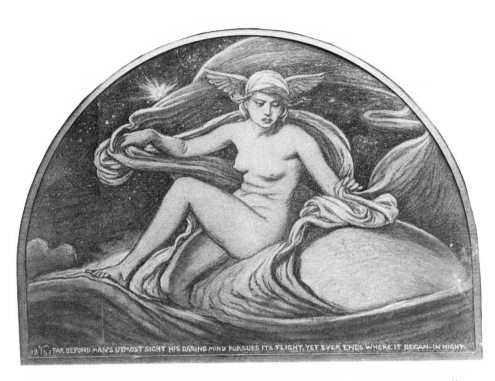

244.
Man's Mind, 1892. Unlocated.

any of these buildings should he receive a commission. In declining an offer to paint a mural for the Saturn Club in New York, Vedder wrote to Sherman Rogers, "I am at present making studies for a series of decorative subjects — which if the Chicago people conclude to pay the transportation you will see at the exhibition [World's Columbian Exposition]." In May, Carrie Vedder wrote to a friend, "My husband is deep in his Astronomy designs and other work." [30] After arriving in New York, Vedder met with McKim, Augustus Saint-Gaudens, and Stanford White in White's tower apartment in Madison Square Garden and showed his studies to the group as possible subjects for mural paintings. Their initial reaction was enthusiastic, as he wrote to Carrie. "Saint Gaudens comforted me by appearing very much impressed with one or two drawings I showed him. Said 'what an imagination you have got,' etc." In a letter following soon thereafter, he wrote: "They are delighted with the drawings. Saint Gaudens says don't show anything to others." [31]

Consisting of five subjects, each distinct but with the possibility of forming an architectural unit, the series was a continuation of Vedder's earlier interest in astrological subjects, with a clear emphasis on the philosophical pessimism of *The Rubáiyát of Omar Khayyám*. One composition, for example, *Man's Mind*, was accompanied by the legend "Far Beyond Man's Utmost Sight His Daring Mind Pursues Its Flight, Yet Ever Ends Where It Began — In Night." The series also included two ominous subjects, *Eclipse of the Sun by the Moon* and *Stella Funesta (The Evil Star)*. In the *Eclipse* (fig. 245) an angel traces the planetary course around the sun toward an eventual eclipse, which in astrology

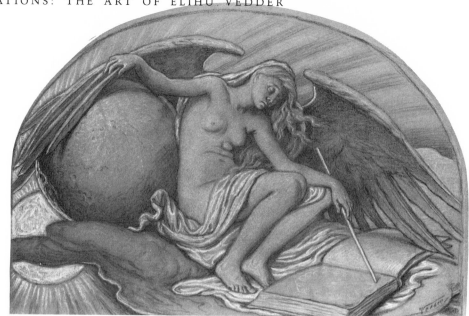

245.
Eclipse of the Sun by the Moon,
1892, charcoal and chalk on paper,
12⅜ x 18⅞. Corcoran Gallery of
Art, Washington, D. C.

246.
Study for *Stella Funesta* (or *The
Evil Star*), 1892, crayon and pastel
on paper, 17⅛ x 15¾. Los Angeles
County Museum of Art,
California; gift of American
Art Council.

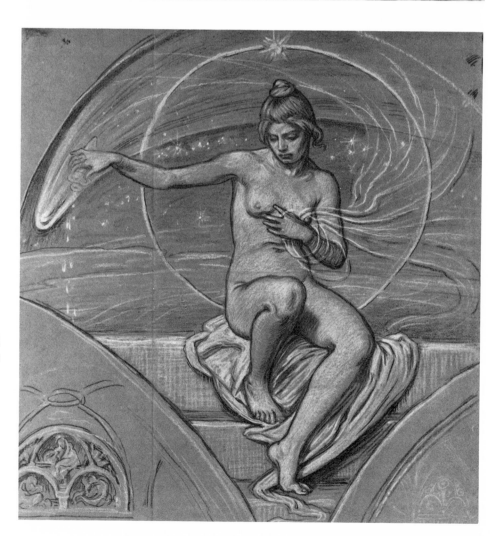

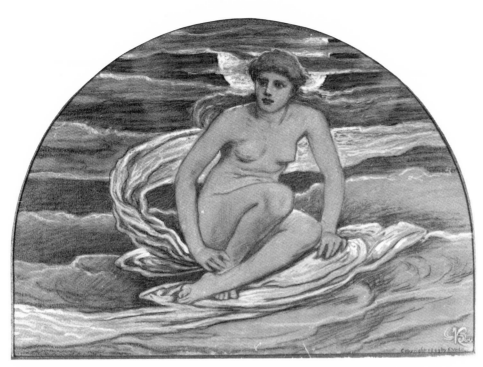

247.
Diana Passes, 1892, charcoal,
pastel, and gouache on paper,
12 x 17. S D458. Georgia
Museum of Art, The University of
Georgia; gift of American
Academy of Arts and Letters.

is an event thought to exert powerful impulses for good or ill far into the future.
In *Stella Funesta* (fig. 246) a figure, ringed by an orbit and star and backed by a
comet (also a portentous symbol), empties downward a flask of evil potion. A
more benign aspect of the cosmos is represented by *Diana Passes* (fig. 247), in
which the goddess has assumed the attributes of a lunar goddess of abundance
and constancy. The final composition exists in two versions: one, *Astronomy*
(fig. 248), a figure with hourglass in hand meditating on the passage of time and
the other, *Astronomia* (fig. 249), a figure with calipers in hand resting on a
globe. Both compositions are, of course, rebuttals to the vicissitudes of the
present, for the first drawing measures the present against all time while the
second suggests that the order of human events is determined by cosmic order.

In contrast to the meditative moods suggested by his drawings, Vedder was
thrown into a whirlwind of activity and confusion that he had rarely experi-
enced. In the first place, he was constantly beset by the realities of daily ex-
penses, and although he was in New York at the behest of McKim, he was
forced to support himself and had to turn to borrowing money, an irony in the
face of the mural commissions that seemed certain to be forthcoming. An offi-
cial request for Vedder's presence was dispatched to him from the offices of
Daniel Burnham on the grounds of the World's Columbian Exposition, yet
the artist was totally unaware of what he might be requested to do at the
fair. On August 4, 1892, only five days after his arrival in New York, Vedder
went with McKim to Boston to meet the Misses Walker and discuss the pro-
posed mural for Bowdoin College. He also spoke with Samuel A. B. Abbott, as

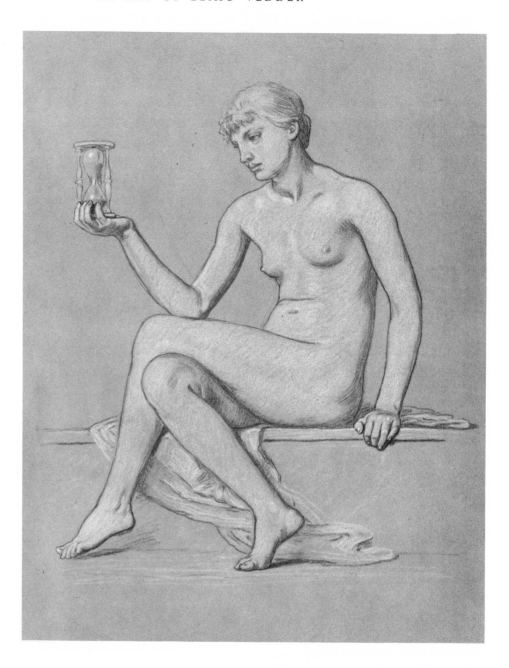

248.
Astronomy, 1892, pencil and
chalk on paper, 14¼ x 11¼.
American Academy and Institute
of Arts and Letters, New York.

well, about a possible commission for the Boston Public Library, suggesting the
subject of "Silence," or "Study," which delighted the architects and also was,
in general, the subject of the painting that Vedder also discussed informally
with the Walker sisters. Much to McKim's and Abbott's satisfaction, Vedder had
the same reaction as many who saw the Renaissance-inspired building set
against the various medieval stylizations around Copley Square: H. H.
Richardson's Trinity Church, N. J. Bradlee's Second Church, Cummings and
Sear's New Old South Church with its aggressive, ornamental campanile, and

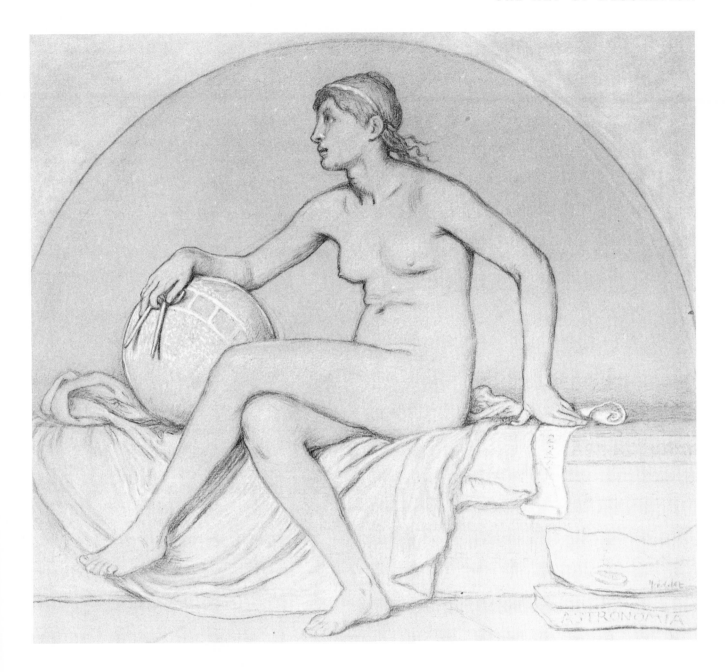

Russel Sturgis's red brick and yellow terracotta Museum of Fine Arts. To Vedder, the library "looked like the moon after the Girandola—a calm reproof to the jig-sawing all about, which McKim says will be a great comfort to him as they have had nothing but fault finding so far." [32]

With the mural commission for the Walker Art Building being agreed upon, even if informally, and with growing hopes for a commission for the Boston Public Library, Vedder set out for Chicago on August 10 with McKim. In spite of his favorable prospects, he was suffering from much anxiety. Al-

249.
Astronomia, 1892, crayon and gouache on paper, 11⅞ x 13. S D453. Corcoran Gallery of Art, Washington, D. C.

250.
Trinity Church, Boston, 1873-77;
H. H. Richardson, architect.

though the spirit of unity and cooperation in the arts was much in evidence, the venture of decorating such large public spaces as the buildings at the fair would inevitably result in competition. Vedder knew full well that his work, the subject of which was still undecided, would be measured against that of the younger artists of the "new movement," who had more academic training than he and were much more in tune with the new public taste for allegories. In the early plans for decorations at the fair, it also appeared that Vedder would be pitted against the old master of the new American renaissance, John LaFarge. "I am of course frightened," he wrote to Carrie, "—especially when I think of the really clever men they have. They want LaFarge, myself, and two more to do four of the most important things there. We shall see." [33]

When Vedder arrived in Chicago, the apparent confusion on the fairgrounds and the vastness of the construction projects only increased his uneasiness. Overwhelmed by the army of officials and architects and the size of the operations, he wrote,

> . . . the number and extent of things yet to be done discouraged me. The difficulty of getting anything positive out of anyone reduced me to despair. Besides, I hadn't my [astrological] drawings to show but had to get them on from New York and I felt I could not really take a stand without them. I could not seem to get at anything or get anything out of McKim or [Francis] Millet. Nothing seemed ready for me. Didn't know where to get rooms, didn't know nothing.—Nothing about the chief of construction building. Like a strange lost dog." [34]

After wandering the grounds for several days, Vedder finally met with Charles Atwood, designer-in-chief of the exposition and the architect of the Art Building. Atwood, McKim, and Vedder decided that Vedder should paint four murals, each twelve feet in diameter, for the circular spaces in the dome of the Art Building.[35] Vedder wrote to his wife the outline of his plan:

> This thing has to be done on broad lines I tell you or not at all. I am in for it now and it is neck or nothing. . . . My treatment is to give the artistic aspirations of the various arts and a hint of the embodiment. Music with her hand on the keys of an organ turns and listens to a spirit whispering in her ear from out of a cloud in the sky. Painting is grasping at the colors of a rainbow with one hand and trying to transfer them to a canvas while an amore is painting a jug. The Sculptor sees against a sky a figure of Victory while his assistant angel is modelling a small statue of the Sun. The Architect sees his building [as] golden cloud domes against the sky. He holds his compasses and his assistant figure is asking him something about a plan on a scroll of paper. The big figures only represent the dreaming or striving after the idea . . . the small ones,—boys—show the embodying of the thought.[36]

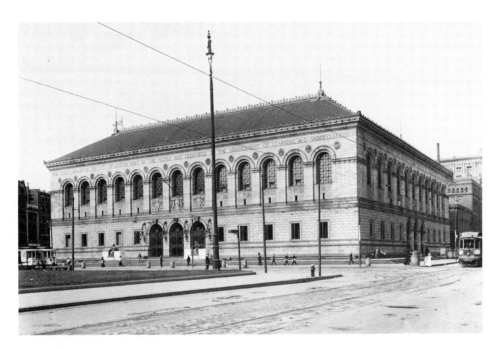

251.
Boston Public Library, 1888-95;
McKim, Mead and White,
architects.

252.
Art Building, 1892-93, constructed
for World's Columbian Exposition
of 1893, Chicago.

Around the collar of the dome were to be ten masks, carved from wood and gilded, linked together by ornamental swags. Vedder also proposed that four fountains after his designs be placed at the corners of the building, and that his design for the Columbian medal, "Fortune on a Car," be used as grill-work in the doorways. For the murals alone Vedder was to receive $6,000 and was to finish the work in four months. His work, unfortunately, was not completed, and, in fact, there is some doubt if Vedder ever commenced seriously on it, for no drawings for the compositions have been found. In a general way, however, the ideas that he worked out for these murals would be used again in the Walker Art Building at Bowdoin College.

Vedder was unable to get underway with the murals, although he was given a large studio on the grounds of the fair and had the necessary technical assistance from his old friend Francis Millet, who was chief of color at the exposition. He was much admired by the younger artists and since LaFarge did not participate in the decoration of the exposition, Vedder was the elder artist in residence. Yet this assistance and support counted for very little when he came to grappling with the size and theme of the paintings. He tried reworking some of his astrological drawings, which had arrived from New York, but apparently could not recast the figures into new compositions. By early September 1892, Vedder wrote, "I am still unable to get at my work here, don't seem to have an idea, although all the rest seem to think that I can do anything I wish to." [37] Beset by self-doubt and no small amount of fear for his safety at working at the great heights within the building, Vedder also had to consider the commission for the Walker Art Building, and a new commission from the architect George B. Post that was delivered to him at the fair.

The first week that Vedder was on the grounds of the Columbian Exposition, George Post had written to McKim to inquire if Vedder was available for a mural commission for the Collis P. Huntington house in New York. Begun in 1889, the Huntington house was among Post's most extravagant mansions; when it was finished in January 1896, the cost was nearly 1.5 million dollars. [38] Huntington, a railroad magnate who was among the wealthiest of the late nineteenth-century caste of baronial millionaires, and his wife Arabella were inclined toward lavish decorations. [39] They had had Post commission H. Siddons Mowbray to paint nineteen mural panels in the second floor of the atrium of the residence, and the sculptor Karl Bitter to make some twenty-two panels for a frieze representing the muses and the months, and a mantle for the library. Eventually, the house was also to have murals by Edwin Blashfield and Francis Lathrop. In August 1892, it was time to plan for decorations in the dining room, and it was Vedder whom Post wished to do the work. On September 6, Post saw Vedder in Chicago and discussed the architectural requirements for the room. A week later Vedder was requested to state his terms, which he did at "not much under twenty thousand." [40]

253.
Design (1892) for medal for
World's Columbian Exposition of
1893, charcoal and chalk on paper,
19 diameter. S D451. The J. B.
Speed Art Museum, Louisville,
Kentucky.

254.
Mural paintings (top) by
H. Siddons Mowbray and
sculpture panels (frieze below
balustrade) by Karl Bitter, 1892-93,
shown in place in atrium,
residence of Collis P. Huntington,
New York; George B. Post,
architect.

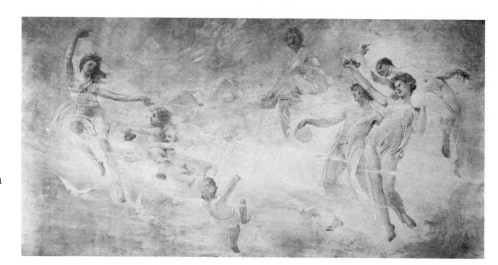

255.
Edwin Howland Blashfield (1848-1936), ceiling panel, 1892-93, from residence of Collis P. Huntington, New York, oil on canvas, 94⅞ x 191⅛. Yale University Art Gallery; gift of Archer M. Huntington, B.A., 1897.

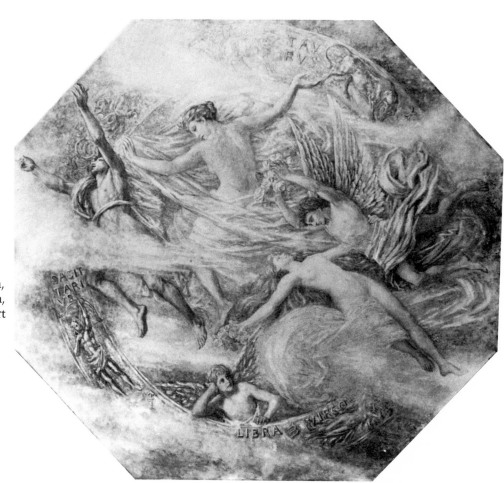

256.
Francis Lathrop (1849-1909), ceiling panel, 1892-93, from residence of Collis P. Huntington, New York, oil on canvas, octagon, 134½ x 149½. Yale University Art Gallery; gift of Archer M. Huntington, B.A., 1897.

With the prospect of receiving a large commission for the Huntington house and with the necessity of finding a subject for the Walker Art Building hovering over him, Vedder wrestled with the idea of leaving Chicago without completing any of his work for the Art Building. On September 15, the date on which Post was authorized by the Huntingtons to commission Vedder's murals, Vedder decided to rid himself of the uncertainty surrounding his work at the fair and commence plans for the other projects, which, in addition to bringing him more money, would provide him with peace of mind, for they could be painted in his studio in Rome. On September 20, Vedder wrote to his wife, "This is the last time I write from this damnable place." [41] It was not easy, however, to get away from the architects and artists who expected much from him. McKim, Charles Atwood, and Francis Millet argued that the Post commission could be put off for some time, that Vedder had received the Huntington house offer only because he had been chosen to work at the exposition, and that his chief reason for leaving was to accept a commission for more money. Amid his protestations of the unjustness of this point of view, Vedder left Chicago for New York. Even though he did not contribute to the mural paintings at the fair, he was more than adequately represented when the exposition officially opened on May 1, 1893: the design for the Columbian Medal was his and eleven of his paintings, ranging in subject from the early *Lair of the Sea Serpent* (1864) to *The Soul in Bondage* (1891), were exhibited in the same building in which his murals were to have been seen in the dome. [42]

In New York, Vedder made final arrangements with George B. Post for his decorations in the Huntington house. The contract was made on October 19, 1892, and called for the murals to be in place by October 1893 for a sum of $20,000, [43] the most money Vedder had ever been paid for any single work or group of works. In late October, he set out for Rome to paint the panels in the familiar atmosphere of his studio.

The commission for the Huntington house was Vedder's first attempt at mural painting, although, as Regina Soria points out in her introduction, he had planned murals for the American Church in Rome, and his experience at the Columbian Exposition had given him some notion of the extended process of planning and executing large-scale works. Yet, the murals occupied nearly his entire time and energy from October 1892 until August 1893, when he returned to New York to deliver the finished panels. Post's initial plan was to have Vedder design a large mosaic floor as well as a ceiling panel and eight lunettes to fit the spaces in the coping between wall and ceiling. [44] The plan for a mosaic floor was quickly abandoned in favor of a lunette-shaped mosaic above the mantle, for which Vedder proposed a design based upon the similar shape in the upper part of his frontispiece to *The Rubáiyát of Omar Khayyám*. Had this proposal been implemented, it would have been a curious but humorous use of the *Rubáiyát* theme. Omar, with wine cup in hand amid his jovial companions

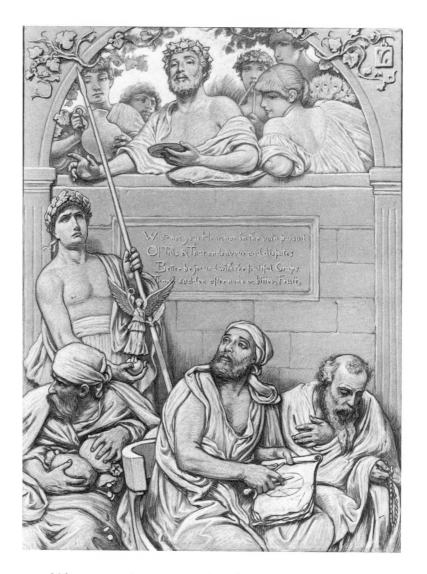

257.
Frontispiece for The Rubáiyát of Omar Khayyám, 1883-84, chalk, pencil, ink, and watercolor on paper, 25⅛ x 18⁹⁄₁₆. S D237. National Collection of Fine Arts.

would have peered out upon a lavishly decorated room to rebuke the very impulse that made the decorations possible—that of amassing wealth. Said Omar,

> *Waste not your Hour, nor in the vain pursuit*
> *Of This and That endeavor or dispute;*
> *Better be jocund with the fruitful Grape*
> *Than sadder after more or bitter, Fruit.*

Vedder did not use the *Rubáiyát* theme, nor did he execute any work in mosaic. He did, however, return to his much-used astrological subjects. The ceiling panel had as its theme the "Abundance of the Days of the Week," with each day represented by its corresponding god or goddess and planet. A preliminary study (fig. 258) shows Vedder's basic plans, with Apollo and the four seasons spread through three center panels, with the remaining deities at cen-

258.
Preliminary study for ceiling in residence of Collis P. Huntington, New York, 1892-93, chalk, pastel, gouache, and gold on paper, 8⅝ x 17½. Yale University Art Gallery; gift of American Academy of Arts and Letters.

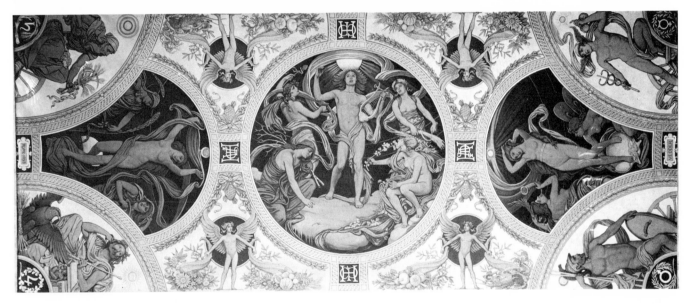

ter top and bottom (Vedder mistakenly included Neptune) and at the four corners, these last also including one-fourth of the zodiac ecliptic. The final compositional plan (fig. 259) is much more compact and dense in its decorative detail, astonishingly rich in gold and deep blues punctuated by warm browns and reds, the whole bespeaking "abundance." Vedder placed Apollo (Sunday) at the center in an exaggerated stance probably taken from *The Apoxymenos*, and surrounded by the four seasons, each of which is laden with appropriate seasonal attributes. To the left of Apollo is Luna (Monday) with the attendant figures of Sleep (with a soporific poppy) and a shrouded Night. To the right is the sensual Venus (Friday), girdled and rising from her shell and flanked by figures signifying spiritual and worldly love. At the upper right corner is Mercury (Wednesday) with caduceus and winged helmet, and below is Mars (Tuesday). At the upper left is the aged Saturn (Saturday) and below is Jupiter (Thursday).

259.
Abundance of the Days of the Week, 1893, ceiling panel from residence of Collis P. Huntington, New York, oil on canvas, 71 x 196¾. S 489. Yale University Art Gallery; gift of Archer M. Huntington, B.A., 1897.

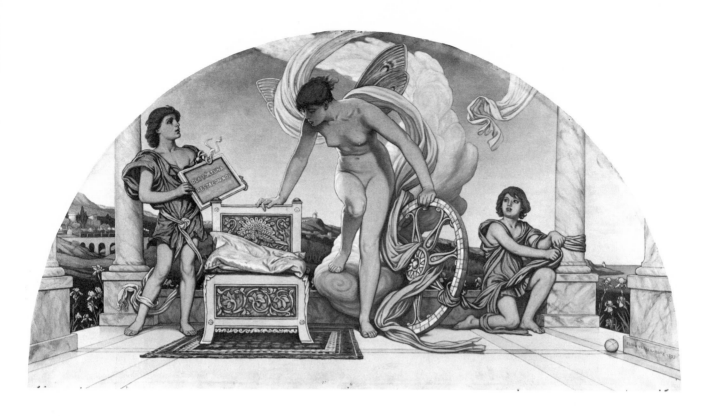

260.

Dea Fortuna Resta Con Noi, 1893, panel from residence of Collis P. Huntington, New York, oil on canvas, 30¾ x 58¾. S 493. Yale University Art Gallery; gift of Archer M. Huntington, B.A., 1897.

As William C. Brownell noted, Vedder provided sufficient iconographical details for multiple levels of identification and interpretation.[45] Each figure representing a planet is identified with a depiction of the planet, and those at the corners each have, in addition, their appropriate astral glyph. The planetary figures convey, according to their classical associations, an abundance of their attributes. The theme is continued by the four genii with cornucopia from which flow the abundance of the land and sea.

Vedder provided Huntington with an assemblage of cosmic symbols that can be read as offering more than the abundance of the days of the week. There is also the abundance of the year, represented by the seasons gathered around Apollo, and the abundance of the signs of the zodiac, which appear faintly in the ecliptic behind Apollo, Luna, and Venus.[46]

To these multiple levels of cosmic plenty Vedder also added the wish for constancy from the fickle goddess of Fortune, the subject of the overmantel lunette, *Dea Fortuna Resta Con Noi* (Goddess of Fortune Stay With Us). A broadly painted landscape is background for the porch upon which the goddess has just arrived: her wheel is being lashed to one of the columns by a genius, while another holds a plaque with an entreaty to the goddess to remain on a peacock-backed chair. It is, to be sure, a felicitous composition, meant to be decorative and lighthearted to correspond with the densely ornamented fire-

261.
Dining room in residence of
Collis P. Huntington, New York,
circa 1895.

262.
Study for lunette in residence of
Collis P. Huntington, New York,
circa 1892-93. Yale University Art
Gallery; gift of American
Academy of Arts and Letters.

place, but it is also the first time that Vedder united the two themes of order and randomness in the cosmos.

To complete the decorations for the Huntington house, Vedder designed eight lunettes to fit into the coping between the walls and ceiling. These he at first planned as a series of classical or mythological heads, an example of which is shown in figure 262 (strongly reminiscent of his *Medusa* of 1878). This plan was apparently abandoned in favor of scenes from classical mythology, such as that of "Diana at the Hunt" (fig. 263), which, considering the association of the goddess with the moon, may have been an effort to reconcile the iconography of the lunettes with that of the ceiling. Vedder finally arrived at a plan by which the eight panels would carry on the general theme of "abundance." His first thought was to have genii harvesting the riches of the land and sea, but in the final murals he used figures representing Victory, Poetry, Fame (figs. 265-267), Drama, Wealth, Frivolity, Bounty, and Music. These figures, surrounded by a garland and ribbons, were simply called "dancing girls" by Vedder and were intended to provide a festive transition between the ceiling and the lower overmantle lunette.[47]

Vedder completed the Huntington murals in Rome and brought them to New York in August 1893, expecting to supervise their installation in the house.[48] To his astonishment, the interior of the dining room was not nearly

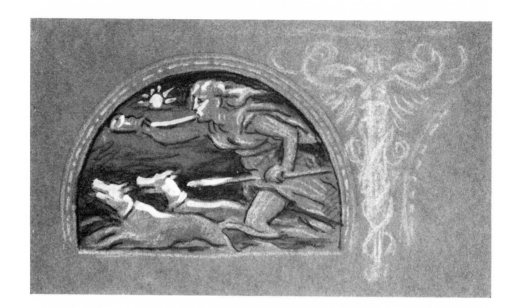

263.
"Diana at the Hunt," study for lunette in residence of Collis P. Huntington, New York, circa 1892-93, chalk and gouache on paper, 4⅜ x 8³⁄₁₆. The Harold O. Love Family.

264.
Studies for lunettes in residence of Collis P. Huntington, New York, circa 1892-93, gouache and gold on paper; top, 3¾ x 7¹⁄₁₆, bottom, 3¾ x 7¼. The Harold O. Love Family.

finished: the final stages of completing the interior had been suspended by the economic panic of 1893. Only the stark white stone ceiling was in place (it would eventually be paneled in deep brown natural wood with a heavy and brilliant gold frame for the mural). The walls were still brick and the mantelpiece, which was to contain his lunette, was nowhere to be seen. He did not, in fact, see his murals installed until a year later.

During this trip to New York, Vedder turned his attention to the long-contemplated commission for a panel in the Walker Art Building at Bowdoin College. During his discussion a year earlier with the Walker sisters in Boston, they had come to an understanding that he would paint a mural for the sculpture gallery, which also served as an entrance hall. No specific subject had been discussed, although Vedder did mention a painting to be entitled "Silence," or "Study," which he had also proposed to McKim as a mural for the Boston Public Library. In any case, few specifics could have been discussed, for McKim's final proposal to the Walker sisters for his architectural plans was not made until March 1892.[49] As Vedder was preparing to leave for Rome, buoyed by his sizable commission for the Huntington mural, he visited the Walker sisters in Boston and informed them that he wanted $6,000 for his work, one thousand more than previously agreed upon, and an installation date of May 1, 1894, rather than September 1, 1893. Charles McKim, who advised the Walkers at every stop of the project, became so angered that he suggested to the Misses Walker that not only should they insist upon the original agreement, but that other artists might be employed for similar works at a much lower price.[50] Indeed, McKim had already begun to think of additional murals for the building, and since April 1893 had been talking with Kenyon Cox, Abbott Thayer, and John LaFarge about a much enlarged mural program for the art museum.[51]

210

265.
Victory, 1893, oil on canvas, 23 x 42½. Yale University Art Gallery; gift of Archer M. Huntington.

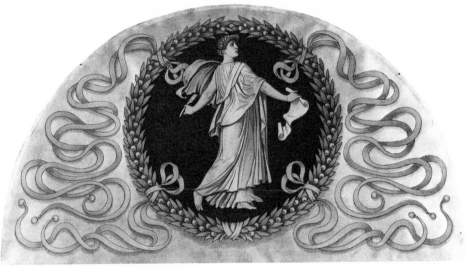

266.
Poetry, 1893, oil on canvas, 23 x 42½. Yale University Art Gallery; gift of Archer M. Huntington.

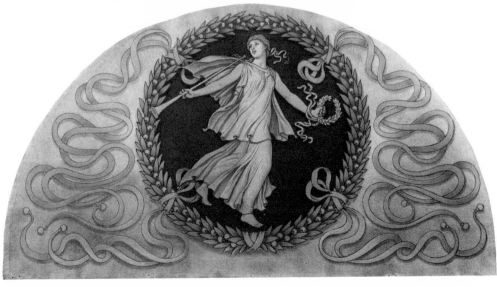

267.
Fame, 1893, oil on canvas, 23 x 42½. Yale University Art Gallery; gift of Archer M. Huntington.

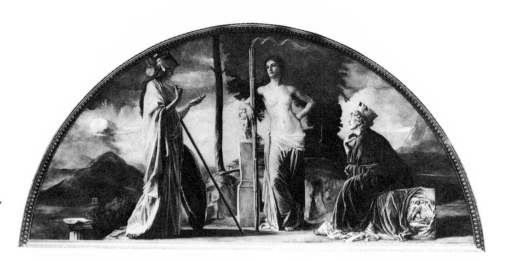

268.
John LaFarge (1835-1910), *Athens*,
1898, oil on canvas, 86 x 240.
Bowdoin College Museum of Art;
gift of the Misses Walker.

While these negotiations were underway, Vedder was in Rome giving his full attention to the paintings for Huntington's mansion. He had some perfunctory thoughts about the Walker commission,[52] but he did not decide upon a subject until he arrived in New York to deliver the Huntington murals. By late August he still had not signed a contract for the Walker painting, but upon discovering that Cox, Thayer, and LaFarge were to be included in the project, he officially confirmed his agreement with McKim, Mead and White, who acquiesced to Vedder's stipulations about completion date and fee.[53] With no indication of what the other artists were planning, other than the titles of their works, Vedder left for Rome in November 1893 to make firm in his mind the design for his mural.

The program devised by McKim and the other artists centered on the four cities that, they believed, had contributed most to the history of art and culture and by extension to the popular concept of an American renaissance. LaFarge would depict Athens, Cox would treat symbolically the art and commerce of Venice, and Thayer would provide a mural on the role of Florence as protector of the arts. Vedder had for some time thought of his mural, which he then believed would be the only one in the museum, as being expressive of "the art idea," a statement of general principles governing the creation of a work of art. With the program now encompassing the centers of ancient and Renaissance art and culture, Vedder was given the subject of Rome. "Fortunately," he said, "the 'Art Idea,' for want of a better name, suited this scheme admirably." [54]

During the winter and spring of 1894 Vedder worked in his studio on the painting that would state, in a complex allegory, his personal views of the relationship of contemporary art to that of the past, more particularly to the Renaissance art of Rome. His procedure, as in all his murals, was not programmatic, as, for example, was that of Kenyon Cox, who worked from precisely scaled drawings of individual figures that were then fitted into a proportionately larger grid on the final study. Vedder made numerous drawings of each figure,

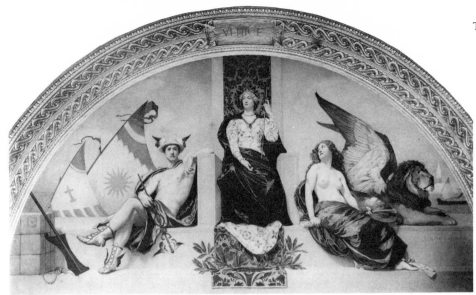

269.
Kenyon Cox (1856-1919), *Venice*,
1894, oil on canvas, 144 x 288.
Bowdoin College Museum of Art;
gift of the Misses Walker.

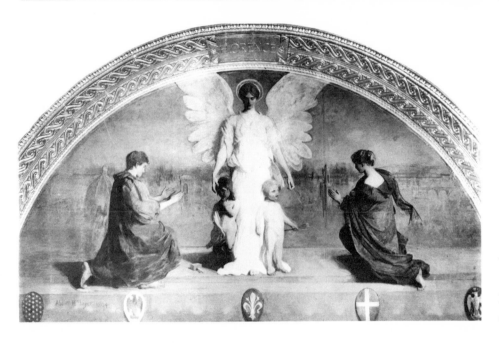

270.
Abbott Thayer (1847-1921),
Florence, 1894 (with later
changes), oil on canvas, 144 x 288.
Bowdoin College Museum of Art;
gift of the Misses Walker.

carefully adjusting the rhythms to suit an arabesque charged with an almost ir-
resistible empathic flow, such as the several studies for Natura, the center fig-
ure in the mural. These drawings were then brought together in a finished
painted study, from which Vedder departed only slightly when painting the
mural itself. But Vedder worked simultaneously at two levels of meaning; the
abstract decorative unity of the work and its allegorical substance were equally
important. When a study for the mural was exhibited in 1895, it was accompa-
nied by Vedder's description:

> *In the center stands the figure of Nature. Her right hand rests on the*
> *trunk and roots of the Tree of Life; her left holds a detached branch*
> *with its fruit—an art having reached its culmination never lives again;*

213

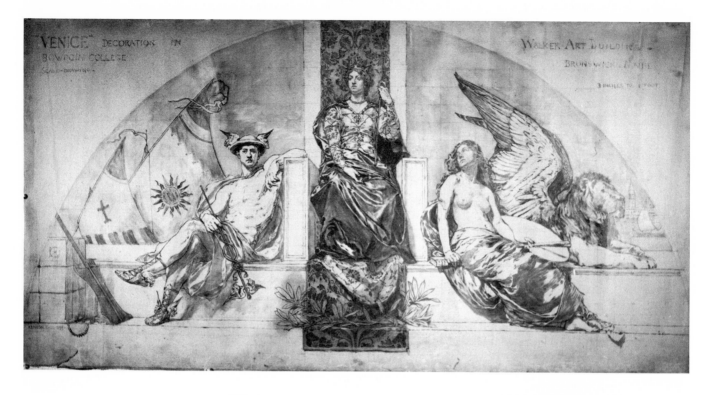

271. ABOVE
Kenyon Cox (1856-1919), scale
cartoon for *Venice*, 1894, oil and
pencil on canvas, 29¾ x 61.
Bowdoin College Museum of Art;
gift of Col. Leonard Cox,
Mrs. Caroline Cox Lansing, and
Mr. Allyn Cox.

272. LEFT
Natura; study for *Rome* or *The
Art Idea*, 1893-94, chalk on paper,
16¾ x 12¾. S D486. Bowdoin
College Museum of Art; gift of
American Academy of Arts and
Letters.

273. RIGHT
Natura; study for *Rome* or *The
Art Idea*, 1894, pastel on paper,
23¼ x 15. S D484. Bowdoin
College Museum of Art; gift of
American Academy of Arts and
Letters.

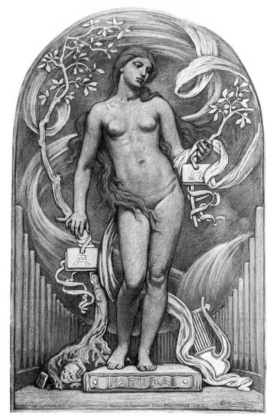

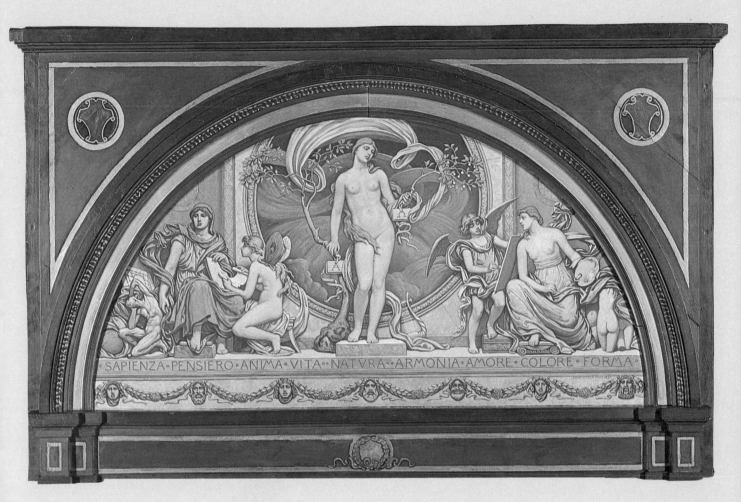

274.
Finished study for *Rome* or *The
Art Idea,* 1894, oil on canvas,
29½ x 55½. S 504. The
Brooklyn Museum, New York;
gift of William T. Evans.

*its fruit, however, contains the seeds of another development; She holds
two letters, Alpha and Omega, Nature being the beginning and end of
art. Harmony is indicated by drapery which, rising from a harp, floats
incircling her, and disappears into space. To her left a figure of Thought
uncovers an anatomical study and listens to the voice of Soul—knowl-
edge inspired by imagination. To the right a figure of Painting is listen-
ing to the promptings of Love. The corner is filled with fragments of
antique sculpture—fragments to be consulted, not copied.*[55]

To many American artists of the late nineteenth century, "nature" as a
touchstone of verity existed not in natural fact as perceived, but in the master-
pieces of the art of antiquity and the Renaissance.[56] The mind's ruminations on
history and art were as true as perceptions of the present. This was, perhaps,
Vedder's intention in adjusting his drawings of a studio model for the figure of
Nature so as to recall the rhythms of antique sculpture, casts of which were
originally to be seen directly below the mural. The two subsidiary groups were
thought by Vedder to have special reference to the art of Rome in the Renais-
sance. That on the left represented the art of Michelangelo, with the inwardly
pensive figure of Thought, wrapped in addled drapery, being prompted by Soul
or Imagination while uncovering symbols of Knowledge—specialized Knowl-
edge exemplified by an anatomical study attributed to Michelangelo,[57] and uni-
versal Knowledge symbolized by a globe ringed with the zodiac ecliptic. The
architectural plan makes special reference to Michelangelo. The group on the
right refers to the art of Raphael: the bare-breasted figure of Color looking out-
ward to a prompting Love. To the right, with reference to Raphael, is a group of
The Three Graces based upon the late Hellenistic group at Sienna, long con-
sidered perfection of rhythmic classical form, on which the youthful Raphael
is said to have based his painting.[58]

Vedder returned to New York with his mural panel in mid-September
1894. After seeing his murals finally installed in the Huntington house,[59] he
quickly went to Brunswick, Maine, to oversee the installation of *Rome* or *The
Art Idea* in the Walker Art Building, which, after some difficulties in place-
ment, was in position on September 28.[60] The painting was, in Vedder's opin-
ion, the best of the works then in place, and without being self-serving, he was
probably correct in saying that *"nel complessivo,* it is the most distinctly
mural painting of the three."[61] Vedder then went to Boston to arrange for an
exhibition of the study for the mural and his easel paintings at Doll and
Richards Gallery. To his surprise he was invited to a dinner given by local archi-
tects, during which he was much lauded for his mural work. "It appears," said
Vedder with amusement, "that I am really quite famous."[62]

Indeed, *Rome* was the first mural by Vedder to be seen publicly, for much
to his chagrin, the Huntington murals were restricted from publication and
exhibition by the owners.[63] But the recognition of Vedder's abilities as a mural

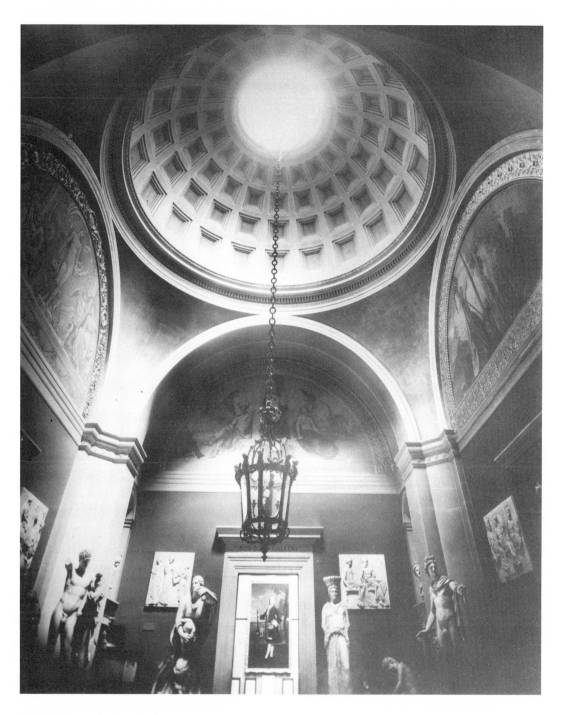

275.
View of entrance hall and
sculpture gallery of the Walker Art
Building, Bowdoin College,
Brunswick, Maine, circa 1895-
1900.

painter did him little good in his attempt to secure his most sought-after commission—one for the Boston Public Library. It seemed that no amount of questions directed to McKim or Abbott or letters of support from friends could induce the architects or the library's authorities to offer Vedder the space he wanted for a large mural painting, which from the time of McKim and Abbott's visit to Rome in 1891 Vedder had thought would be his. McKim finally offered Vedder one of the eight panels in Bates Hall, the large reading room in the library, for which Vedder would be paid $4,000.[64] In refusing this proposal Vedder wrote to a Mrs. Chapin, who was organizing a subscription drive to provide him a larger commission, and to Charles McKim and Abbott:

> For all sorts of good reasons I do not wish to undertake the isolated panel in Bates Hall, but do see that I could do the widest of the two long rooms we looked at—the second beyond Abbey's room. I should make it an astronomical hall. I would take at least two years and require a great deal of assistance. I should propose to color it all down to the floor and make it a credit to the library, to my self, and to those who assisted me to get the commission. I cannot see, taking into account the help I should require, how it could be done for less than $20,000. I will do it for that and this is my final decision.[65]

Unfortunately, the room that Vedder wanted to decorate was not to be public, and when Abbott informed Vedder of this fact the latter dropped his plans for a mural in the library. It was, Vedder said, later, one of his bitterest disappointments. Had he painted the murals, Boston would have had his last, and perhaps his most complete statement of the course of human fate as exemplified in astrology.

The loss of the Boston Public Library commission did not, however, dampen Vedder's enthusiasm in seeking other opportunities for mural paintings. Returning to New York in early November, he was eagerly seeking commissions from the architectural firm of Carrére and Hastings and in the company of Elmer Garnsey, a mural painter and designer of mosaics for the Boston Public Library and the Library of Congress, he spoke with William N. Frew, an associate of Andrew Carnegie, about a commission for the new Carnegie Library in Pittsburgh. Although these commissions did not materialize,[66] Vedder learned of another project, vast in scope, then being planned in Washington, D. C.—the decoration of the interior of the Library of Congress. Vedder went to Washington in early January 1895 and conferred with Bernard Green, superintendent of construction, who immediately gave him a commission for his best known mural paintings, the series of five panels on the theme of "Government."

Since 1888, the construction of the Library of Congress had been under the able supervision of General Thomas Lincoln Casey, who assumed control after much controversy had halted previous building progress.[67] General Casey's son Edward had joined the architectural staff in 1892 after receiving training in

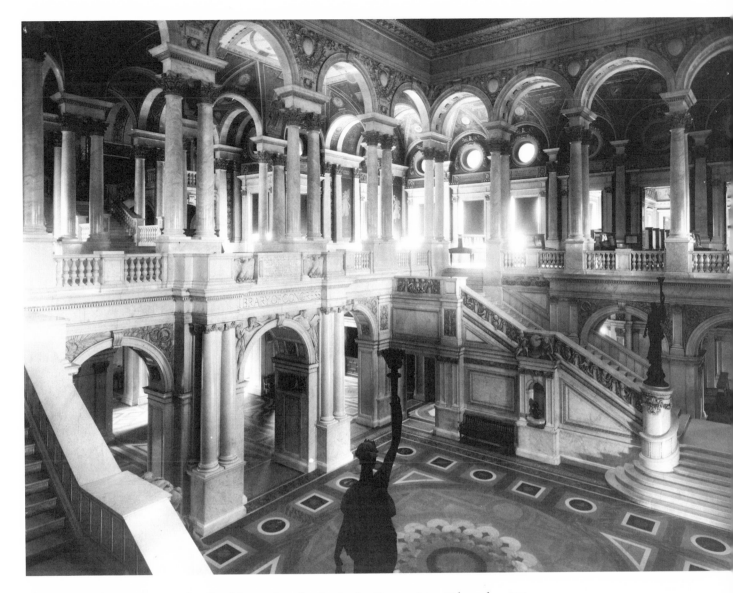

the offices of McKim, Mead and White and at the Ecole des Beaux-Arts. Edward Casey and Bernard Green then proceeded to plan the decorations for the building. Eventually, 19 painters would contribute 112 murals and 22 sculptors would provide embellishments that would make the Library of Congress, as one critic said, "Our National Monument to Art." [68]

Vedder's conversation with Bernard Green on January 8, 1895, came at a propitious moment, for the mural painters were beginning to be selected and Vedder had his choice of several attractive spaces. Edwin Blashfield had been given the large collar of the dome, on which he would paint *The Progress of Civilization*, Kenyon Cox had been given the two tympanums in the southwest second-floor exhibition hall for his murals *The Arts* and *The Sciences*, and George Maynard had accepted a commission for the vaults and tympanums in

276.
Great Hall of the Library of Congress, Washington, D. C.

219

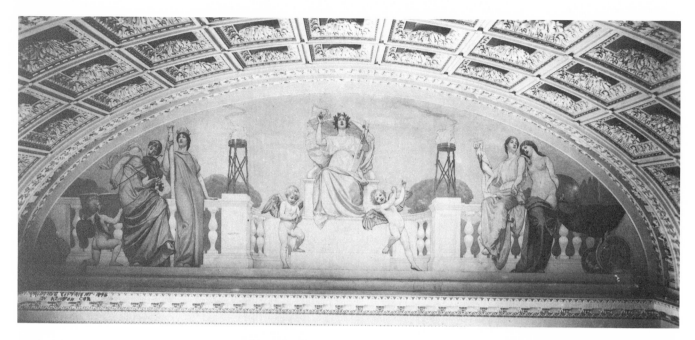

277.
Kenyon Cox (1856-1919), *The Arts*, 1896, oil on canvas, 114 x 408. Library of Congress, Washington, D. C.

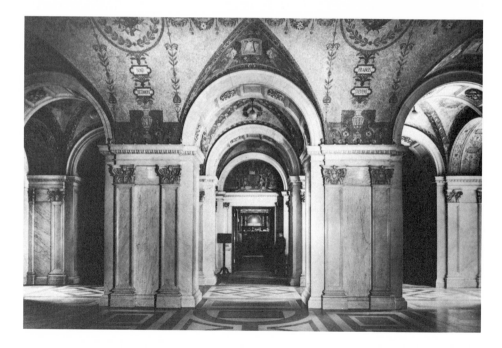

278.
Government (center), shown in place in the foyer of the Reading Room, Library of Congress, Washington, D. C.

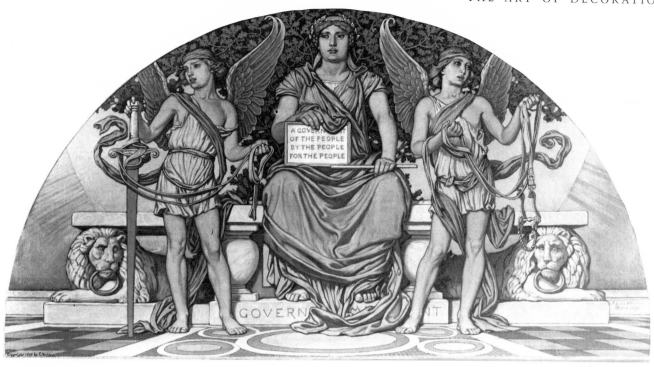

the southwest pavilion. Vedder chose the very desirable space at the entrance to the main reading room, which is among the most heavily traveled areas in the library. After making an agreement to complete the murals for $5,000,[69] Vedder went to Florida to visit his father and other relatives and then returned to Rome to work on the commission.

The entire mural project for the Library of Congress was not especially programmatic. There was little coordination among the various themes, and, in fact, the artists were left free to choose their own subjects,[70] which accounts for the several repetitions of broadly humanistic subjects that lent themselves to allegory. By late May 1895, Vedder had worked out the basic theme and compositional structure for his murals, which are the only paintings in the library to take up the theme of government. They are testimony to Vedder's inventiveness, but also to his recognition of the need to account for the purpose of the building. The national library was, after all, for the use of Congress, and Vedder set about making a series at once formally decorative and moralistic.

Rather than taking one panel to contain a single large allegory, Vedder chose to work in five panels and developed a series that is to be read in sequence. Beginning with the central panel of *Government*, one either reads left to *Corrupt Legislation* and the resulting *Anarchy*, or to the right through *Good Administration* to *Peace and Prosperity*. Initially it may seem that the statement is uncomplicated, but Vedder organized the theme in terms of an iconography that is anything but simple and, much as in the Huntington murals, is capable of being read on several different levels.[71]

279.
Finished study for *Government*, 1896, oil on canvas mounted on wood, 25 x 49. S 514. Williams College Museum of Art, Massachusetts; gift of Miss Anita Vedder.

221

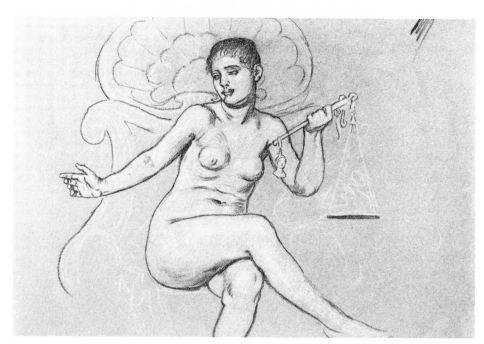

280.
Study for figure in *Corrupt Legislation*, 1895, conté crayon and gouache on paper, 13½ x 18⅞. S D521. Library of Congress, Washington, D. C.

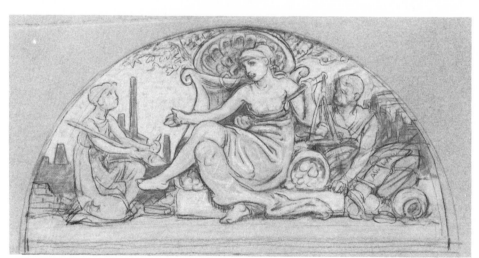

281.
Study for *Corrupt Legislation*, 1895, chalk and pencil on paper, 11¼ x 17¾. The Harold O. Love Family.

The central panel of *Government* (fig. 279) depicts the proper state of rule for a republic, symbolized by the central figure, swathed in classical drapery, crowned by a wreath of laurel, and holding a golden scepter (signifying the "golden rule") while she displays Abraham Lincoln's much quoted phrase from the Gettysburg Address. The goddess of the republic, "for so, perhaps, she is to be considered," is seated upon a marble bench supported by posts in the shape of ancient voting urns, symbols of a free and secure election, and by two crouching lions, symbols for a state moored to strength. A winged figure to the left holds the sword of justice and protection and to the right another holds the

222

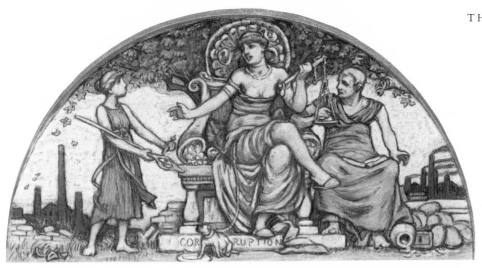

282.
Study for *Corrupt Legislation*, 1895, pencil and chalk on paper, 9 x 16. S D518. The Harold O. Love Family.

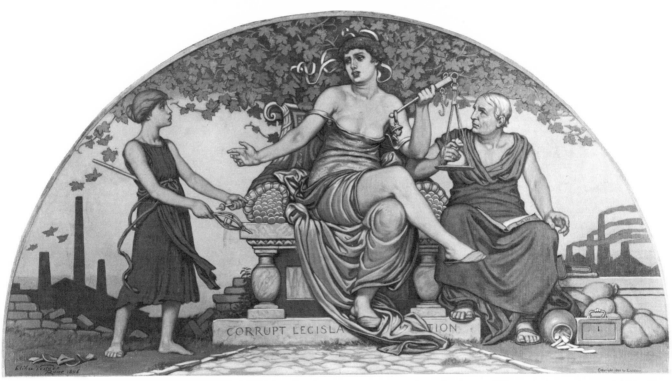

283.
Finished study for *Corrupt Legislation*, 1896, oil on canvas mounted on wood, 25 x 49. S 517. Williams College Museum of Art, Massachusetts; gift of Miss Anita Vedder.

bridle of restraint and order. In the background are oak leaves, which Vedder used as traditional symbols of strength and vigorous stability.

To the left of *Government* is *Corrupt Legislation* (fig. 283) represented by a figure in a pose that Vedder found a fascinating study in the expression of depravity. She exists in several preliminary versions, all of which have her bare-breasted and sitting lasciviously upon an ornamental throne, the arms of which are coin-filled cornucopia turned inward to herself. A plaintive figure with an empty distaff and spindle and backed by idle factories is waved away in favor of the bribe given on a sliding weight scale, "a parody of the scales of Jus-

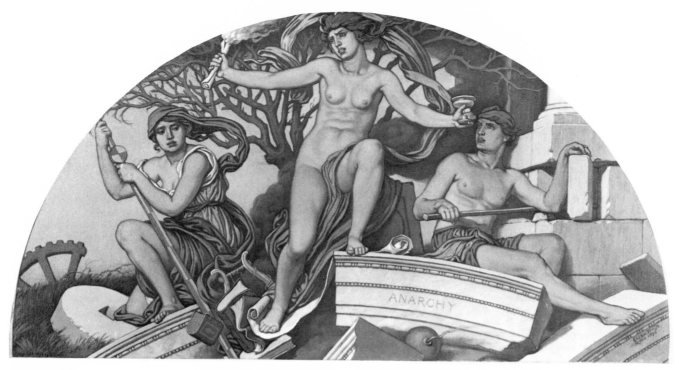

285.
Finished study for *Anarchy*, 1896,
oil on canvas mounted on wood,
25 x 49. S 518. Williams College
Museum of Art, Massachusetts;
gift of Miss Anita Vedder.

284.
Study for figure in *Anarchy*, 1895,
pastel on paper, 17¾ x 12¾.
S D521. Library of Congress,
Washington, D. C.

tice'' and a device ''more easily susceptible of fraud than a pair of balances.'' Industry churns out the smoke of prosperity behind the figure of Corrupting Wealth, who presides over bags of money and a strongbox as well as an overturned voting urn: ''In his lap he holds the book of law, which he is skilled to pervert to his own ends.'' Behind the throne is an autumnal vine, ''hinting at too abundant luxury, and with its falling leaves presaging decay.''

The fruits of corrupt legislation lead to the second panel to the left, *Anarchy* (fig. 285), which is represented by a nude figure maddened by wine and ''raving upon the ruins of the civilization she has destroyed.'' She is a figure that Vedder drew with much relish, likening her to an enraged Medusa with writhing snakes in her hair. Torch in hand (formed from a scroll), she is trampling scholarship, art, religion, and law represented by a book, lyre, Bible, and scroll. Anarchy is assisted in her destructive work by a figure of Ignorance at the left, who, amid the scattered remnants of industry and an untended field, is prying a broken arch into a chasm, and a figure representing Violence, who is working loose the cornerstone of a temple. A fused bomb lies below amid the rubble, ''a reminder that anarchy contains within itself the seed of its own destruction.'' Smoke billows around a tree, now bare and dying.

To the right of the center panel is *Good Administration* (fig. 286), represented by a figure holding evenly balanced scales of justice and an open book of public law. Her throne is topped by an arch, ''in which the admirable fitted blocks signify the interdependence of the elements of a well-governed state.'' An equally divided shield holds symbols of unprejudiced rule—even scales, a weight, and a measure. An educated electorate is represented by a boy at the

224

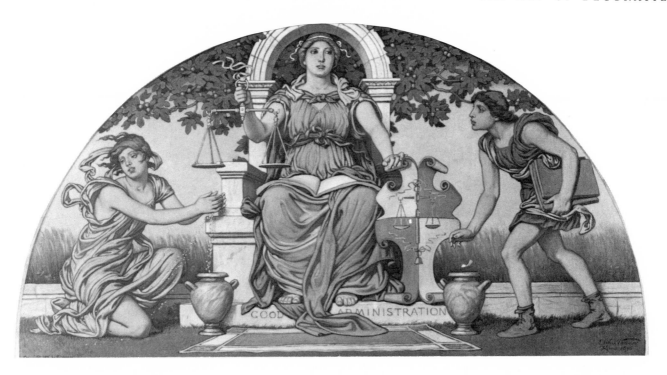

right with books in hand dropping a vote into an urn, and the selection of sound from unsound candidates by a figure at the left winnowing wheat from chaff. The background of a productive wheatfield and a bounteous fig tree symbolizes the benefits of a well-administered state.

The final panel in the series is an allegory of the product of good administration, *Peace and Prosperity* (fig. 287). Arts and Agriculture are about to be awarded an olive wreath by Peace, a female figure seated on a marble bench and backed by a fulsome olive tree.

Installed in the library in March 1896, Vedder's murals quickly became among the most popular works in the densely ornamented building. The iconography was complex, yet easily readable, and the classical references in dress and symbol brought the past forward to support the present. For, although Vedder's murals were abstract statements of principles, they were not far from the actuality of the period, during which flagrant political corruption and anarchist activities were not, to say the least, uncommon.

Vedder's last architectural decoration, a mosaic entitled *Minerva*, was also for the Library of Congress. As with the murals for the building, the commission for the mosaic came to him by chance. After seeing his murals installed in the library, Vedder had gone to New York in search of other commissions from architects or firms of decorative art. Exasperated, he found that "all the glass men and decorators do their own designs or get them done cheap or steal," and added, "Art is absolutely flat—apparently done for—no one is selling anything." [72] Abbott Thayer had, however, given up his commission for a mosaic in the Library of Congress and Vedder, quick to recognize an opportunity, im-

286.
Finished study for *Good Administration*, 1896, oil on canvas mounted on wood, 25 x 49. S 515. Williams College Museum of Art, Massachusetts; gift of Miss Anita Vedder.

225

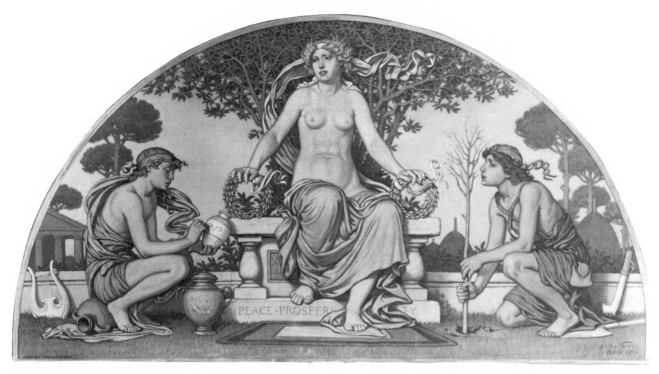

287.
Finished study for *Peace and Prosperity*, 1896, oil on canvas mounted on wood, 25 x 49. S 516. Williams College Museum of Art, Massachusetts; gift of Miss Anita Vedder.

mediately applied to Edward Casey for the work. John LaFarge, who had been given first refusal, did not accept the commission and it then went to Vedder. After visiting the library and checking the space for the mosaic, which was in an advantageous location, on the second floor at the entrance to the rotunda, Vedder pronounced it "the choicest place in the whole Library." [73] After making a brief visit to Boston to see the first sections of murals by John Singer Sargent, Edwin Abbey, and Puvis de Chavannes installed in the Public Library, he set off for Rome to design the mosaic.

Initially, Vedder thought of emphasizing the traditional warlike attributes of Minerva as Pallas Athena (fig. 288), not an especially appropriate theme for a library. His final design, however, incorporates the equally traditional associations of Minerva as patroness and protector of learning, art, and industry as exemplified by the inscription taken from Horace, which can be translated as "Not unwilling, Minerva erects a monument more lasting than Brass." [74] Vedder found the appropriate attributes of Minerva in several familiar ancient sculptures, such as the Athena Farnese with the Ionic chiton and clearly defined *aegis* bordered with *gorgoneion*, or the Athena Giustiniani, which supplied Vedder with a model for the helmet with rams' heads and sphinx. Although the design was particularly crisp and even startingly neo-grec in its jewelled patterns, Vedder did not consider it to be among his better works of decoration. [75]

Vedder's murals for Collis P. Huntington's mansion, the Walker Art Building, and the Library of Congress were painted at the beginning of the

288. LEFT
Study for *Minerva*, 1896, pencil
and chalk on paper, 8¾ x 4¾.
S D525. The Harold O. Love
Family.

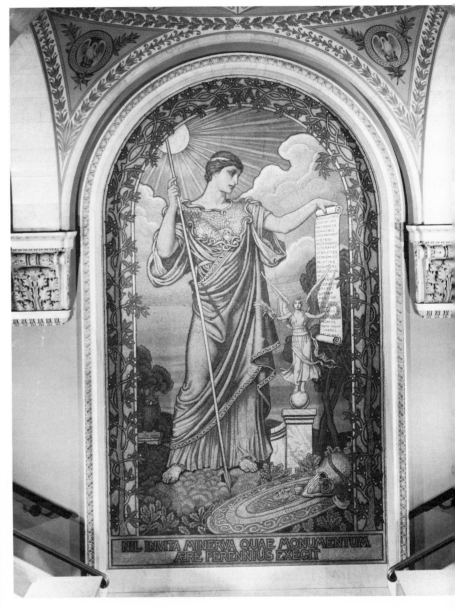

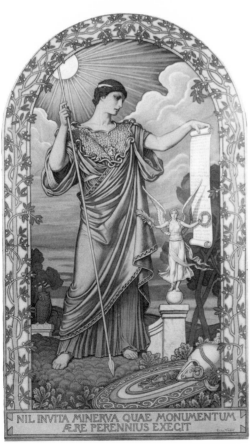

289. LEFT
Finished study for *Minerva*, circa
1897, oil on canvas, 62 x 36½.
S 520. The J. B. Speed Art
Museum, Louisville, Kentucky.

290. ABOVE
Minerva, 1897, mosaic, 186 x 108.
Library of Congress,
Washington, D. C.

291. RIGHT
Study for decoration of courtroom,
Baltimore Courts Building, 1901,
charcoal on paper, 15¼ x 10.
Kennedy Galleries, Inc.,
New York.

292.
Design for stand with oriental
motifs, circa 1900, pencil, crayon,
and pastel on paper, 19½ x 6⁵/₁₆.
The Harold O. Love Family.

nationwide movement for mural painting, and had he wished to continue such work there would have been ample commissions for him in the some 400 public and private buildings that were decorated with murals during the years from 1893 until 1920. With increased opportunities for mural paintings and mosaics, however, came tighter controls by architects and the public commissioners for whom they often worked.

Deadlines, contract stipulations, and predetermined subjects were not especially comfortable working conditions for Vedder. Although during the five years from 1892 until 1897 his murals and mosaic had earned for him some $33,600, he determined not to pursue more commissions for large decorative

works for public or private buildings. In 1901 Vedder was offered an extraordinary commission to decorate an entire room in the Baltimore Courts Building as part of a large project sponsored by the Municipal Art Society of Baltimore,[76] but only a few perfunctory sketches survive as testimony to his lack of serious interest in new and increasingly demanding public commissions. Yet his interest in decorative art did not wane but followed another, more private direction.

After 1900 Vedder painted little, preferring, as Joshua Taylor notes in his essay, to use words to express an ever more complex humor, and ruminations laced with contradiction and enigma. Too, his decorative art became intricately ornamental rather than broadly allegorical, and the arabesque that was an essential element in the decorative structure of the murals became in itself a source of pure decorative fascination. He designed several pieces of furniture that recall oriental motifs yet are dependent upon sensuous linear design that has assumed a psychological life of its own. One suspects that many of these works were planned for the decoration of Vedder's Four Winds Tower, his villa on Capri, for which he designed a complex seal (fig. 295) that was carried on many objects associated with the house.

Vedder also renewed his interest in sculpture, which from early in his career had been part of his work. Among his many designs were those for small-scale useful objects, such as a bell pull in the shape of an impish face (fig. 296), and door knockers in the form of an angel (fig. 297) and a Bacchus (fig. 298), but he also reworked some earlier subjects into small sculptural studies, such as *The Phorcydes* (see fig. 152) and a plate from his planned series of the "Fisher-

293.
Design for chair with oriental motifs, circa 1900, pencil, crayon, and pastel on paper, 12¾ x 6¹¹⁄₁₆. The Harold O. Love Family.

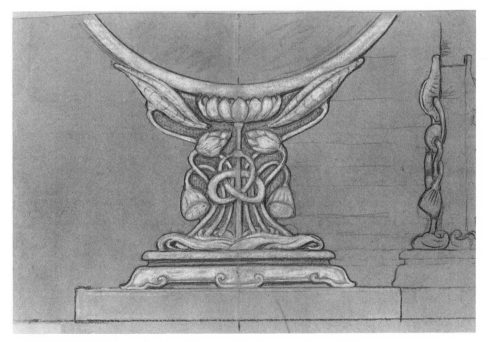

294.
Design for base of mirror, circa 1900, pencil and chalk on paper, 8⅝ x 13¼. The Harold O. Love Family.

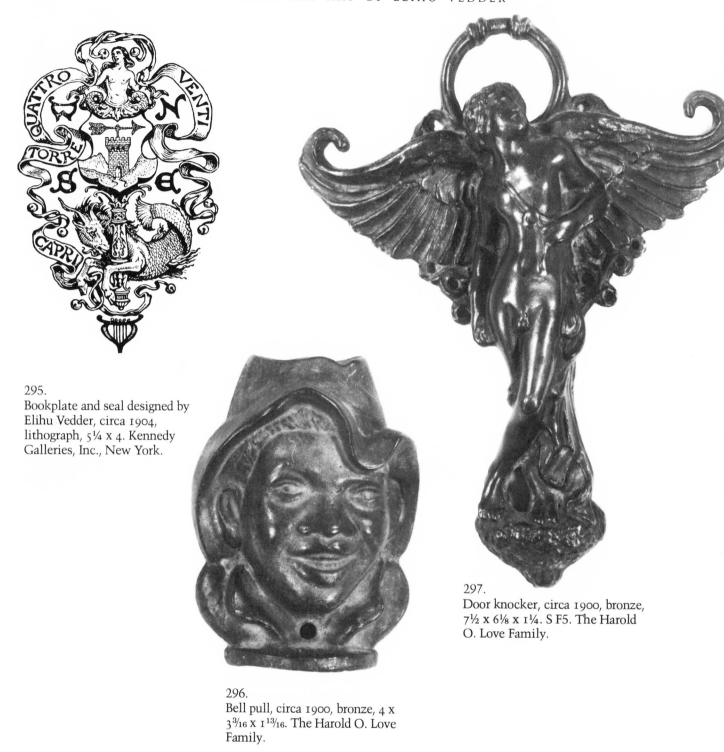

295.
Bookplate and seal designed by
Elihu Vedder, circa 1904,
lithograph, 5¼ x 4. Kennedy
Galleries, Inc., New York.

296.
Bell pull, circa 1900, bronze, 4 x
3³⁄₁₆ x 1¹³⁄₁₆. The Harold O. Love
Family.

297.
Door knocker, circa 1900, bronze,
7½ x 6⅛ x 1¼. S F5. The Harold
O. Love Family.

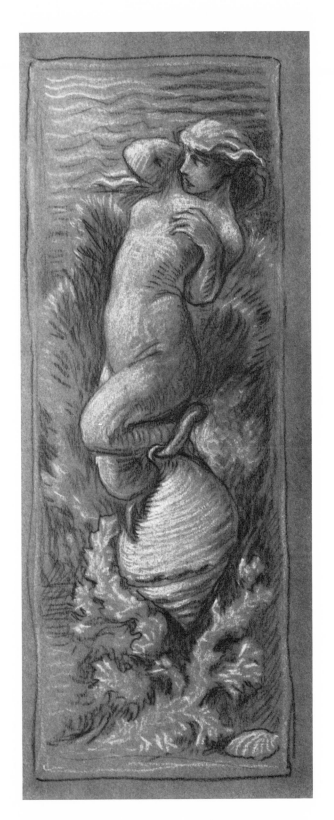

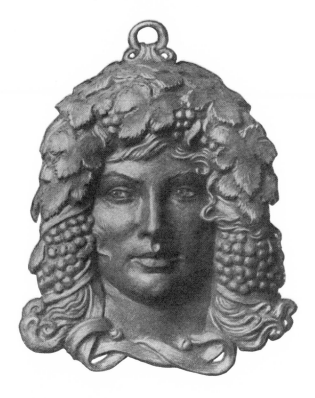

298.
Door knocker, circa 1900.
Unlocated. Photograph from *The Digressions of V.* (1910).

299. LEFT
Study of mermaid, circa 1878,
chalk on paper, 13 x 4¾. S D197.
Wadsworth Athenaeum, Hartford,
Connecticut.

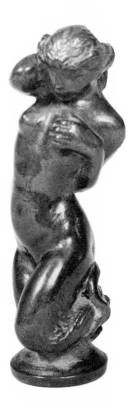

300.
Study for sculpture, *The Mermaid*,
circa 1902, bronze, 4½ x 1¾ x 1¼.
Herbert Chase, Wilton,
Connecticut.

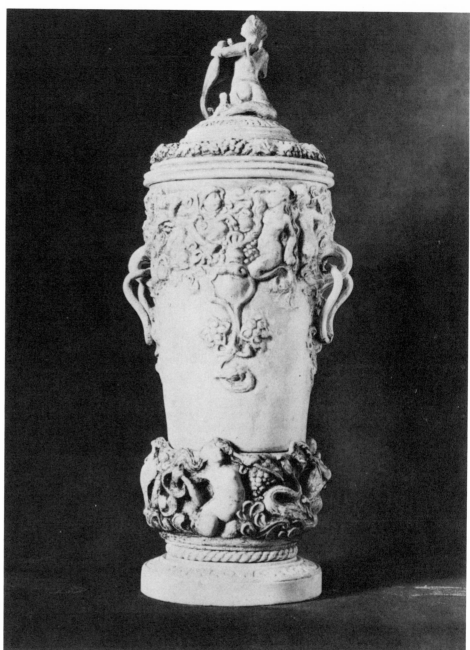

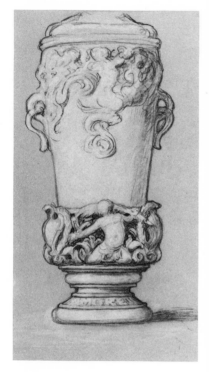

301.
Design for silver wedding cup, 1899, pencil and chalk on paper, 12¾ x 9. The Harold O. Love Family.

302. RIGHT
Silver wedding cup, 1899. S 510. Unlocated.

man and the Mermaid" (figs. 299, 300). The mermaid theme also supplied the decorative motif for a silver wedding cup (figs. 301, 302) designed as an anniversary gift to his longtime friends Daniel and Helen Merriman: in turgid groups interlaced with grapes and vines, the mermaids encircle the base and the lip, while one beckons from the top of the lid. Vedder's only piece of sculpture that reached large scale was, however, his design for a fountain, which he called simply *The Boy* (figs. 303, 304). It was enlarged from Vedder's studies by

303.
Study for *The Boy* fountain, circa
1902, pencil and colored pencil on
paper, 10⅝ x 8¼. The Harold O.
Love Family.

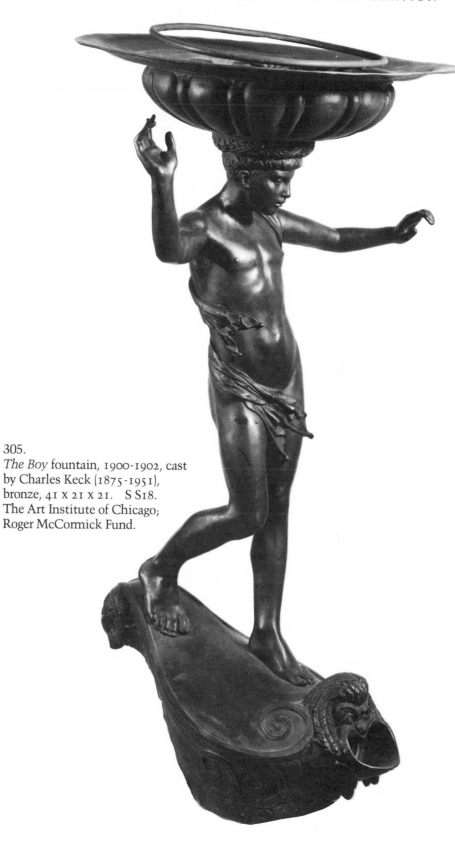

305.
The Boy fountain, 1900-1902, cast
by Charles Keck (1875-1951),
bronze, 41 x 21 x 21. S S18.
The Art Institute of Chicago;
Roger McCormick Fund.

304.
Study for *The Boy* fountain, circa
1902, bronze, 5⅜ x 5¼ x 5¼.
Herbert Chase, Wilton,
Connecticut.

307.
A Mystery in Lines and Spaces
from *Doubt and Other Things*
(1922).

306.
Decorative emblem from *Doubt
and Other Things* (1922).

the sculptor Charles Keck, who had come to Rome in 1900 and soon became Vedder's close friend, and was cast in bronze in 1902 in an edition of at least four. Originally nude, the figure of a young boy was later clothed with a modest bit of drapery (fig. 305), an addition that would have distressed Vedder, who many times had to insist that his figures remain nude.[77]

Among Vedder's last works of decorative art were the illustrations to his several books, *The Digressions of V.* (1910), *Miscellaneous Moods in Verse* (1914), and *Doubt and Other Things* (1922). Their contortions, which often took the form of mocking masks and enigmatic figures, are perhaps the graphic expressions of the complexity of Vedder's thought in his later years, when perception and evocation, the two directions of his work, were finally united into speculative musings that took the form of such verse as "The Pessimistic Maze":

Fancy its circlings — canyons great
Where light can scarcely penetrate,
Its lofty walls o'erwrit with lies
Or Nature's mysterious verities.

The center vast, dense silence fills
Or at the best vague whisperings;
No certainty has yet been found
But Death to end the weary round.

What scheme imagine! What device
To find your way amid these lies!
You wander by a dubious light
While all about reigns hopeless night.

How came you there, you do not know;
Nor whence, nor where, nor why, you go.[78]

234

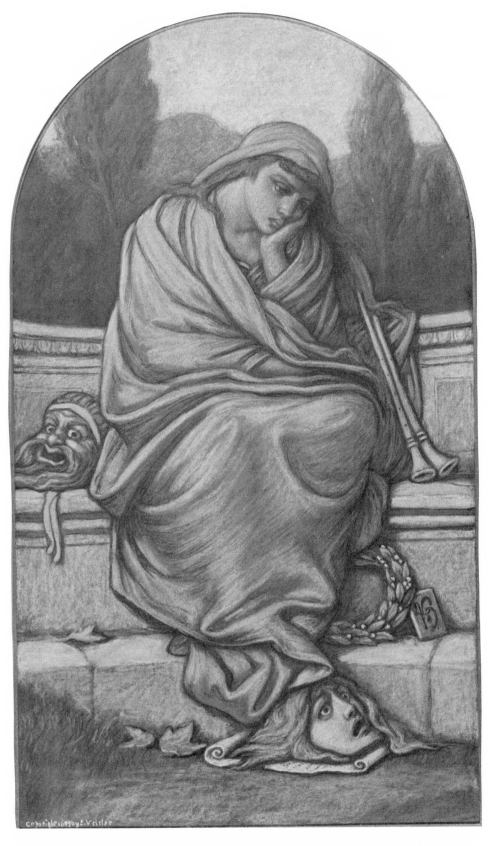

308.
Muse of Tragedy, circa 1899,
pastel on paper, 15¼ x 9¼.
National Collection of Fine Arts.

NOTES

1. Clarence Cook, "Art in America in 1883," *The Princeton Review* 59 (May 1883): 311-20. Cook was recalling events related to art in New York during 1877-79.

2. For an analysis of the conflict between the two groups, see Lois M. Fink and Joshua C. Taylor, *Academy: The Academic Tradition in American Art* (Washington, D. C.: Smithsonian Institution Press for the National Collection of Fine Arts, 1975).

3. For example, of the 1,662 works submitted in 1882 to an exhibition sponsored by the American Water Color Society nearly 1,000 were rejected because of space limitations. (See "Art and Art Life in New York City," *Lippincott's Magazine* 29 [June 1882]: 597-605.)

4. Ibid. This is not strictly correct. The American Water Color Society was founded in 1867, but reorganized in the late 1870s under the domination of the younger artists.

5. On the American reception of Pater's work, see "The Renaissance," *The Nation* 17 (October 1873): 243-44.

6. The complex history of LaFarge's decorations for Trinity Church is admirably treated by Helene Barbara Weinberg in her "John LaFarge and the Decoration of Trinity Church, Boston," *Journal of the Society of Architectural Historians* 33 (December 1974): 323-53.

7. For the history of LaFarge's decorations in Saint Thomas Church, as well as his work in the Church of the Incarnation and the Church of the Ascension, see Helene Barbara Weinberg, "LaFarge's Eclectic Idealism in Three New York Churches," *Winterthur Portfolio* 10 (1975): 199-228.

8. Wilson H. Faude, "Associated Artists and the American Renaissance in the Decorative Arts," *Winterthur Portfolio* 10 (1975): 101-30.

9. See especially Henry Van Brunt, "The Growth of Conscience in Decorative Arts," *Atlantic Monthly* 42 (August 1878): 204-15.

10. Marianna Griswold Van Renssaelear, "Decorative Art and Its Dogmas," *Lippincott's Magazine* 25 (February-March 1880): 213-20; 342-51.

11. Vedder to Carrie Vedder, March 1, 1880, in Papers of Elihu Vedder, Archives of American Art, Smithsonian Institution, Washington, D. C. (hereafter referred to as "Vedder Papers, AAA").

12. On Prang's greeting cards and his several competitions for new designs, see Katharine Morrison McClinton, *The Chromolithographs of Louis Prang* (New York: Clarkson N. Potter, Inc., 1973), and Larry Freeman, *Louis Prang, Color Lithographer* (Watkins Glen, N.Y.: Century House, 1971).

13. *New York Evening Post*, February 24, 1881.

14. Both Tiffany and Armstrong asked Vedder to work with them on their various projects. (See Vedder to Carrie Vedder, November 5, 1881, Vedder Papers, AAA.)

15. Elihu Vedder, *The Digressions of V.* (Boston and New York: Houghton Mifflin Company, 1910), p. 316.

16. Vedder's description of the design called for "porcelain, glass, or earthenware of all colors and shapes so cast or stamped as to correspond to a metal framework in which it fits—which framework is filled with a design, the interstices of which are so filled up with the porcelain, earthenware or glass form, when fitted into its place, so as to produce the effect of the design in metal being sunk into the glass, porcelain, or earthenware. The two materials thus strengthening each other." Description in the collection of the Harold O. Love Family. Regina Soria notes in her biography of Vedder that Vedder and John G. Low had thought of forming a company for the production of the metal framed tiles, but that the cost of production was prohibitive.

17. Regina Soria, *Elihu Vedder: American Visionary Artist in Rome (1836-1923)* (Cranbury, N.J.: Fairleigh Dickinson University Press, 1970), pp. 162, 388.

18. The firebacks were copyrighted in 1882 by Charles Caryl Coleman and distributed through the Chelsea Tile Works, manufacturers of many forms of art tiles. See Barbara White Morse, "John G. Low and Elihu Vedder as Artist Dreamers," *Spinning Wheel* 32 (May 1976): 24-27. According to Carrie Vedder, the firebacks had earned only $104 by April 1883, when the Vedder family left New York. She received no royalties from them until August 1885, at which time she found that Coleman had not forwarded payment due from forty-eight sets, amounting to $312. This revelation nearly ruptured a long friendship between Coleman and Vedder. (See Carrie Vedder to Caryl Coleman, August 9, 1885, Vedder Papers, AAA.)

19. Vedder, *Digressions of V.*, p. 316. Vedder's interest in astrology and astronomy was not unusual. Indeed, the "science" of astrology was among the more popular of nineteenth-century studies in the occult and mysterious. Robert Cross Smith (1795-1832), known as "Raphael," who published among other works *The Familiar Astrologer* (1831), *Manual of Astrology* (1828), and *Raphael's Witch; or, The Oracle of the Future* (1831) remained a popular source for astrological information for later readers through the revision and republication of his works by Robert Cross (died 1923). Richard James Morrison (1795-1874), known as "Zadkiel," was

236

another popularizer of astrology through his many works, including *Zadkiel's Almanac* (1884) and *The Seer's Calendar of Events Showing the Future of America* (1863). The works of Smith, Cross, and Morrison went through many editions during the century, but a more serious and comprehensive study of the history of astrology and astronomy was not available until 1899, when Richard Hinckley Allen published *Star-Names and Their Meanings*.

20. Soria, *Elihu Vedder*, p. 155; note 7, p. 264.

21. This interpretation was suggested by W. H. Bishop in his "Elihu Vedder," *American Art Review* 1 (June-July 1880): 325-71.

22. Translation from Soria, *Elihu Vedder*, p. 321.

23. As quoted in Soria, *Elihu Vedder*, p. 152.

24. Schopenhauer's ideas were in wide circulation not through the ponderous *The World as Will and Idea*, which was first published in 1819 and revised in 1844, but through the popularity of his essays *Parerga und paralipomena*, first published in 1851. Many editions of Schopenhauer's works were available in the 1880s, such as the *Select Essays of Arthur Schopenhauer*, published in Milwaukee in 1881, which included selections such as "The Misery of Life," "Genius," and "The Aesthetics of Poetry." On the response of artists and writers to Schopenhauer's work, see Elme Caro, *Le pessisme au XIX siècle: Leopardi, Schopenhauer, Hartman* (Paris: Hachette, 1878) and John S. Adams, *The Aesthetics of Pessimism* (Philadelphia: University of Pennsylvania, 1940).

25. Vedder to Carrie Vedder, April 23, 1887, Vedder Papers, AAA.

26. Charles Moore, *The Life and Times of Charles Follen McKim* (Boston and New York: Houghton Mifflin Co., 1929), p. 320.

27. Carrie Vedder to Annie Vedder, June 13, 1891, Vedder Papers, AAA.

28. Carrie Vedder to Agnes Ethel Tracy, June 26, 1891, in the possession of Mrs. Francis T. Henderson, New York. Also, Amelia Edwards to Carrie Vedder, June 13, 1891, Vedder Papers, AAA.

29. The Borgia apartments, which contain Pintoricchio's frescoes on themes, among others, of Science, Mathematics and Astrology, were decorated by commission from Pope Alexander VI (1492-1503). After the death of Alexander VI, the rooms remained virtually unused until 1816 when they served as a storeroom for paintings taken by the French and returned after the Treaty of Tolentina. The paintings were soon removed and the apartments became a museum and library until

1891, when Pope Leo XIII began restoration of the apartments. Pintoricchio's murals were cleaned and partially restored by Ludovico Seitz. (See Evelyn March Phillips, *Pintoricchio* [London: George Bell and Sons, 1901] and Franz Ehrle, *Les fresques du Pintoricchio dans les salles Borgia au Vatican* [Rome: Danesi, 1898]).

30. Vedder to Sherman Rogers, February 9, 1892, and Carrie Vedder to Mary Garrett, May 30, 1892, Vedder Papers, AAA.

31. Vedder to Carrie Vedder, August 2, 1892, August 4, 1892, Vedder Papers, AAA.

32. Vedder to Carrie Vedder, August 7, 1892, Vedder Papers, AAA. For a history of the construction of the library, see Walter Muir Whitehill, "The Making of an Architectural Masterpiece—The Boston Public Library," *The American Art Journal* 2 (Fall 1970): 13-35.

33. Vedder to Carrie Vedder, August 7, 1892, Vedder Papers, AAA.

34. Vedder to Carrie Vedder, August 14, 1892, Vedder Papers, AAA.

35. It remains unclear why Vedder was not informed beforehand of what he was to do at the fair. Other artists were aware of their assignments, and as early as two months before Vedder arrived in New York, McKim had planned to have Vedder paint murals in the Art Building and the New York State Building. The commission for the latter building went to Francis D. Millet. (See Charles F. McKim to E. J. Gale, June 15, 1892, Charles Follen McKim Papers, Letterbook 1891-93, Manuscript Division, Library of Congress, Washington, D. C.)

36. Vedder to Carrie Vedder, August 14, 1892, Vedder Papers, AAA.

37. Vedder to Carrie Vedder, September 6, 1892, Vedder Papers, AAA.

38. George B. Post Papers, Job Record Ledgers 2, New-York Historical Society, New York.

39. For the Huntingtons' mansion on Fifth Avenue, see James T. Maher, *The Twilight of Splendor: Chronicles of the Age of American Palaces* (Boston: Little, Brown and Co., 1975): 276-81.

40. Vedder to Carrie Vedder, September 12, 1892, Vedder Papers, AAA. Vedder received $20,000 for his work, while Blashfield and Mowbray each received $8,000 and Lathrop received slightly more than $7,000. Karl Bitter received $17,800 for his work.

41. Vedder to Carrie Vedder, September 20, 1892, Vedder Papers, AAA.

42. *World's Columbian Exposition, 1893. Official Catalogue, Part X, Department K. Fine Arts* (Chicago: W. B. Gonkey, 1893), p. 28.

43. Post Papers, Job Record Ledgers, 2:102, New-York Historical Society, New York.

44. Vedder to Caroline E. Smith Vedder, August 21, 1892, Vedder Papers, AAA.

45. William C. Brownell, "Recent Work of Elihu Vedder," *Scribner's Magazine* 17 (February 1895): 157-64.

46. I much appreciate the generosity of Ann Jensen Adams, now a graduate student at the Fogg Art Museum, in sharing her research on Vedder's murals for the dining room of the Collis P. Huntington house.

47. There is some doubt as to whether Vedder painted these panels, although they are his designs, as is attested to by his drawings for them, which are now at the Bowdoin College Museum of Art. When compared to the overmantel and ceiling panels, these eight lunettes are crudely painted and several figures have improbable anatomical features. They may have been painted by Bravi, Vedder's assistant. When Vedder saw the complete set of murals in place, he noted that "the size of the figures is about right and mine are perfectly clear, but Bravi's work looks too weak." He may have referred to several of the smaller lunettes. (See Vedder to Carrie Vedder, September 14, 1894, Vedder Papers, AAA.)

48. All of Vedder's murals were painted with a mixture of wax and oil on canvas in his studio in Rome. Those for Huntington's mansion were placed on stretchers and installed in the dining room, and were easily removed when the house was demolished. Vedder's murals in the Walker Art Building and the Library of Congress were installed by using a method called *marouflage*, which was popular in France throughout the nineteenth century. The canvas back and the facing wall are coated with a mixture of white lead and varnish, which is allowed to dry partially before the canvas is rolled onto the surface. When the adhesive is dry, the canvas is then bonded permanently to the wall. (See the chapter on oil painting in Frederic Crowninshield, *Mural Painting* [Boston: Ticknor and Company, 1887].)

49. Charles F. McKim to Edward J. Gale, March 11, 1892, Charles F. McKim Papers, Letterbook 1891-93, Manuscript Division, Library of Congress, Washington, D. C.

50. Charles F. McKim to the Misses Walker, November 21, 1892, Letterbook 1891-93, McKim Papers, Library of Congress, Washington, D. C.

51. Richard V. West, *The Walker Art Building Murals*, Occasional Papers I (Brunswick, Me.: Bowdoin College Museum of Art, 1972), p. 4.

52. In answer to a pointed question by the Misses Walker as to Vedder's plans, Carrie Vedder replied that Vedder was hard at work on the murals for Collis P. Huntington, but that he had talked at length about the commission for the Walker Art Building. "He has warned me, however, that he does not intend to put a stroke to paper until the thing is concrete in his own mind." (Carrie Vedder to the Misses Walker, April 3, 1893, in the possession of Mrs. Francis T. Henderson.)

53. Vedder to Carrie Vedder, October 6, 1893, Vedder Papers, AAA.

54. *The Digressions of V.*, p. 492.

55. *Catalog of the Tenth Annual Exhibition of the Architectural League of New York* (New York, 1895), p. 49, no. 75.

56. The most thorough statement of this principle by a late-nineteenth-century American artist was written by John LaFarge in his *Considerations on Painting: Lectures given in the year 1893 at the Metropolitan Museum of Art* (New York: The Macmillan Co., 1901).

57. Casts of the figure were offered for sale through the firm of P. D. Caproni and Brother. This figure does not, however, appear in de Tolnay's catalogue of Michelangelo's works although it has been traditionally associated with Michelangelo. (See Zofia Ameisenowa, *The Problem of the Écorché and Three Anatomical Models in the Jagiellonian Library* [Warsaw: Polska Akademia Nauk, 1963]: 31-33.)

58. For an account of different versions of the group see Margarite Bieber, *The Sculpture of the Hellenistic Age* (New York: Columbia University Press, 1961), p. 149. The sources for Raphael's painting are discussed in E. Tea, "Le fonti delle Grazi di Raffaello," *L'Arte* 17 (1914): 41-48.

59. Vedder was not appreciative of the murals by other artists in the mansion of C. P. Huntington. He thought Mowbray's work to be dangerously close to illustrations on superior grades of candy boxes.

60. McKim stipulated in his agreement with all of the artists that their murals be in place by May 1 to complete the building by its dedication date of June 7. When Martin Brimmer gave the dedication address, only the murals by Kenyon Cox and possibly those by Abbott Thayer were installed. Vedder's mural was, as mentioned, installed on September 28, and that by John LaFarge was not completed and installed until 1898.

61. Vedder to Carrie Vedder, September 28, 1894, Vedder Papers, AAA.

62. Vedder to Carrie Vedder, October 2, 1894, Vedder Papers, AAA.

63. Brownell, "The Recent Works of Elihu Vedder." At the time that Brownell published his article, which included illustrations of the murals in the Huntington's house, he was al-

lowed to use only a line drawing of the ceiling (which showed the figures representing the planets arranged in the wrong position) and preliminary sketches for the figure of Fortune in *Dea Fortuna Resta Con Noi*. The public and Vedder's artist friends could have had little notion of the richness or complexity of the murals. A reduced version was available, but apparently was never exhibited.

64. Vedder to Carrie Vedder, December 28, 1894, Vedder Papers, AAA.

65. Vedder to Mrs. Chapin, Charles McKim, and Samuel Abbott, January 3, 1895, Vedder Papers, AAA.

66. The proposal was for six panels in the Carnegie Library in Pittsburgh, for which Vedder suggested that he receive $20,000 (Vedder to Carrie Vedder, November 30, 1894, Vedder Papers, AAA). This commission was eventually given to John White Alexander, who painted the large mural cycle of the "Apotheosis of Pittsburgh" in the staircase hall. Alexander received the commission in 1905 and finished most of the work by 1908. (See Mary Anne Goley, *John White Alexander, 1856-1915*. Washington, D.C.: Smithsonian Institution Press for the National Collection of Fine Arts, 1977.)

67. For a history of the construction of the Library of Congress see Helen-Ann Hilker, "Monument to Civilization: Diary of a Building," pp. 234-667 and John Y. Cole, "Smithmeyer and Pelz: Embattled Architects of the Library of Congress," pp. 282-307, both in *The Quarterly Journal of the Library of Congress* 29 (October 1972).

68. Royal Cortissoz, "Our National Monument to Art: The Congressional Library at Washington," *Harper's Weekly* 39 (December 28, 1895): 1240-41.

69. The artists who worked on the decorations for the library were paid only minimal amounts for their work. The commissions ranged from $4,000 to $8,000 depending upon the amount of work to be done. Vedder was not alone in painting his murals in Europe—Walter McEwen, William de Leftwich Dodge, and Gari Melchers received their commissions while they were in Europe and painted their murals without having seen the architectural spaces in the library.

70. "Painting and Sculpture in the New Library Building," *The Evening Star* (Washington, D.C.), October 26, 1895.

71. The following quotations are from Herbert Small, *Handbook of the New Library of Congress* (Boston: Curtis and Cameron, 1901), and Royal Cortissoz, "Painting and Sculpture in the New Congressional Library, II: The Decorations of Mr. Elihu Vedder," *Harper's Weekly* 40 (February 15, 1896): 156-58.

72. Vedder to Carrie Vedder, April 20, 1896, Vedder Papers, AAA.

73. Vedder to Carrie Vedder, May 2, 1896, Vedder Papers, AAA.

74. Horace, *Ars Poetica* 35; *Carminum* iii. 30.I. Translation provided by the Library of Congress, Information Office.

75. Vedder said of the finished mosaic, "Not the greatest thing in the world—not the worst; it might have been a 'Fluffy Ruffles' posing as Minerva. About half the price went in expenses." (*The Digressions of V.*, p. 494.)

76. For a brief history of this mural project, see *Murals in the Baltimore Court House* (Baltimore: Munder-Thompson Company, 1912).

77. The date of this addition is unknown, although it may have been around 1929, when Anita Vedder argued against Hattina Speed's suggestion that a bit of drapery be added. (See letter from Anita Vedder to Hattina Speed, J. B. Speed Art Museum, Louisville, Kentucky.)

78. Elihu Vedder, *Doubt and Other Things* (Boston: Porter Sargent, 1922).

Supplementary Bibliography

The entries included below are recent supplements to the extensive bibliography in Regina Soria, *Elihu Vedder: American Visionary Artist in Rome (1836-1923)*. Soria's bibliography contains the basic sources on Vedder's life and work.

MANUSCRIPTS

Louisville, Kentucky. J. B. Speed Art Museum. Letters from Anita Vedder to Mrs. J. B. Speed, photographs, and memorabilia.

New York, New York. Mrs. Francis T. Henderson. Letters from Carrie and Elihu Vedder to Agnes Ethel Tracy Roudebush.

NEWSPAPERS AND PERIODICALS

"An American in Japan, 1863-1870." *Journal of the Archives of American Art* (January 1966): 11-17. (Based on correspondence to the family of Elihu Vedder from Alexander Vedder, brother of the artist and a surgeon in the United States Navy.)

Canaday, John. "The Revival of a Long-Lost Reputation." *New York Times*, December 8, 1974, section D, pp. 35-36.

Reich, Marjorie. "The Imagination of Elihu Vedder—As Revealed in his Book Illustrations." *The American Art Journal* 7, no. 1 (May 1974): 39-53.

Soria, Regina. "Mark Twain and Vedder's *Medusa*." *American Quarterly* 16, no. 4 (Winter 1964): 602-6.

———. "Vedder's Happy Days in Bordighera." *The Currier Gallery of Art Bulletin* (January-March 1970).

———. "Elihu Vedder, American Old Master." *Georgia Museum of Art Bulletin* 2, no. 1 (Spring 1976): 25-31.

West, Richard V. *The Walker Art Building Murals*. Bowdoin College Museum of Art Occasional Papers no. 1 (1972).

EXHIBITION CATALOGUES

Elihu Vedder, An American Visionary in Rome. Catalogue of an exhibition held at Graham Gallery, New York, November 19-December 14, 1974. Essay by Regina Soria.

Elihu Vedder (1836-1923). Paintings and Drawings. Catalogue of an exhibition held at Glens Falls, New York, June 28-August 31, 1975. Essay by Regina Soria.

Index to Illustrated Works of Art

ARRANGED BY ARTISTS

The list is arranged alphabetically by artist and by title or description of work.

PHOTOGRAPHIC CREDITS

American Academy and Institute of Arts and Letters, New York City; Geoffrey Clements, photographer: figs. 39, 189, 191, 199, 248.

Archives of American Art, Smithsonian Institution, Washington, D. C.: figs. 1, 5, 6, 7, 14, 46, 219, 234, 244, 302.

The Art Institute of Chicago, Illinois: fig. 116.

The Baltimore Museum of Art, Maryland: fig. 183.

Bowdoin College Museum of Art, Maine: figs. 268, 269, 270, 271, 272, 273, 275.

The Brooklyn Museum, New York: figs. 110, 115, 126, 131, 133, 181, 190, 192, 193, 274.

Mr. and Mrs. John H. Brooks; Vose Galleries of Boston, Inc.: fig. 86.

The Butler Institute of American Art, Youngstown, Ohio: figs. 43, 95.

Columbus Gallery of Fine Arts, Ohio; Brenwasser, photographer: fig. 127.

The Cooper-Hewitt Museum, New York City: figs. 134, 135, 136; Scott Hyde, photographer: fig. 222.

The Corcoran Gallery of Art, Washington, D. C.: figs. 197, 239, 245, 249.

The Currier Gallery of Art, Manchester, New Hampshire; Eric M. Sanford, photographer: fig. 90.

Davison Art Center, Wesleyan University, Connecticut; E. Irving Blomstrann, photographer: figs. 22, 93, 173.

The Detroit Institute of Arts, Michigan: figs. 93, 114, 154.

Galleria d'Arte Moderna, Rome; Cabinetto Fotographico: figs. 21, 28.

Georgia Museum of Art, The University of Georgia, Athens: figs. 195, 247.

Graham Gallery, New York City: figs. 80, 132; Geoffrey Clements, photographer: fig. 102.

The Fine Arts Gallery of San Diego, California: fig. 147.

Fogg Art Museum, Harvard University, Massachusetts: fig. 218.

Herbert F. Johnson Museum of Art, Ithaca, New York: fig. 182.

The Hyde Collection, Glens Falls, New York: fig. 122.

The J. B. Speed Art Museum, Louisville, Kentucky; Moseley Photographer: figs. 45, 83, 84, 177, 188, 223, 242, 253, 289.

Kennedy Galleries, Inc., New York City: figs. 29, 47, 48, 68, 70 a-i, 79, 105, 106, 107, 108, 179, 180, 196; Brenwasser, photographer: fig. 96; Taylor and Dull, Inc., photographers: figs. 220, 227, 243, 291, 295, 305.

Library of Congress, Washington, D. C.: figs. 201, 228, 250, 251, 252, 276, 277, 278, 280, 284, 290.

Los Angeles County Museum of Art, California: figs. 129, 139, 246.

The Metropolitan Museum of Art, New York City: figs. 58, 61, 64, 161, 162.

Munson-Williams-Proctor Institute, Utica, New York: fig. 88.

Museum of Art, Carnegie Institute, Pittsburgh, Pennsylvania; Elton Schnellbacher, photographer: fig. 194.

Museum of Art, Rhode Island School of Design, Providence: fig. 97.

Museum of Fine Arts, Boston: figs. 23, 50, 52, 54, 57, 121, 160; University Art Museum, University of California, Berkeley, photographer: fig. 187.

The Museums at Stony Brook, Stony Brook, New York: figs. 77, 81.

National Academy of Design, New York City; photograph courtesy of Frick Art Reference Library: fig. 156.

Negro, Silvio, *Album Romano* (Rome: Gherado Casini, Editore, 1956); figs. 2, 3, 4, reprinted by permission, All rights reserved.

The New Britain Museum of American Art, Connecticut; E. Irving Blomstrann, photographer: figs. 82, 171.

New-York Historical Society, New York City: figs. 42, 73, 216, 254, 261.

The Newark Museum, New Jersey: fig. 109.

Post Road Gallery, Larchmont, New York; Helga Photo Studio, photographer: fig. 225.

Mr. and Mrs. John D. Rockefeller 3rd; O. E. Nelson, photographer: fig. 25.

Saint Thomas Church, New York City: fig. 204.

Smith College Art Museum, Northampton, Massachusetts; Edelstein, photographer: fig. 86.

Staten Island Museum, New York City; Geoffrey Clements, photographer: figs. 69, 100.

University Art Museum, University of California, Berkeley: fig. 137.

University of Kansas Museum of Art, Lawrence: fig. 62.

The University of Michigan Museum of Art, Ann Arbor: fig. 81.

University of Virginia Art Museum, Charlottesville; Edwin S. Roseberry, photographer: fig. 78.

Victoria and Albert Museum, London: fig. 30.

Virginia Museum of Art, Richmond; Herbert P. Vose, photographer: fig. 178.

Vose Galleries of Boston, Inc.; Herbert P. Vose, photographer: figs. 113, 178.

The Wadsworth Atheneum, Hartford, Connecticut; E. Irving Blomstrann, photographer: fig. 299.

Williams College Museum of Art, Massachusetts; Williamstown (Mass.) Regional Art Conservation Laboratory, Inc.: figs. 279, 283, 285, 286.

Worcester Art Museum, Massachusetts: fig. 51.

Yale University Art Gallery, Connecticut; Joseph Szaszfai, photographer: figs. 255, 258, 260, 261.